A SHORT HISTORY OF THE ANCIENT WORLD

A SHORT HISTORY OF THE ANCIENT WORLD

NICHOLAS K. RAUH

WITH HEIDI E. KRAUS

UNIVERSITY OF TORONTO PRESS

Library and Archives Canada Cataloguing in Publication

Rauh, Nicholas K., author
 A short history of the ancient world/ Nicholas K. Rauh with Heidi Kraus.

Includes bibliographical references and index. Issued in print and electronic formats.
Issued in print and electronic formats.
ISBN 978-1-4426-0829-0 (hardcover).—ISBN 978-1-4426-0385-1 (softcover).—ISBN 978-1-4426-0386-8 (PDF). —ISBN 978-1-4426-0387-5 (HTML)

 1. History, Ancient. I. Kraus, Heidi, author II. Title.

D59.R38 2017 930 C2017-900663-0
 C2017-900664-9

We welcome comments and suggestions regarding any aspect of our publications—please feel free to contact us at news@utphighereducation.com or visit our Internet site at www.utppublishing.com.

North America
5201 Dufferin Street
North York, Ontario, Canada, M3H 5T8
ORDERS PHONE: 44 (0) 1752 202301
2250 Military Road
Tonawanda, New York, USA, 14150

ORDERS PHONE: 1–800–565–9523
ORDERS FAX: 1–800–221–9985
ORDERS E-MAIL: utpbooks@utpress.utoronto.ca

UK, Ireland, and continental Europe
NBN International
Estover Road, Plymouth, PL6 7PY, UK

ORDERS FAX: 44 (0) 1752 202333
ORDERS E-MAIL: enquiries@nbninternational.com

Every effort has been made to contact copyright holders; in the event of an error or omission, please notify the publisher.

Cartography: Lawrence Theller, Purdue University
Artwork: John Hill and Herb Rauh
Contributors: Peter Aicher, Matthew Dillon, Elizabeth Rauh

The University of Toronto Press acknowledges the financial support for its publishing activities of the Government of Canada through the Canada Book Fund.

Printed in Canada

To Henry C. Boren
who taught me how to write one of these

CONTENTS

FIGURES

SIDEBARS

ART IN FOCUS

MATERIALS AND TECHNIQUES

PRIMARY SOURCE

MAPS

CHRONOLOGIES

TABLES

PREFACE

THE APPROACH TO CLASSICAL WORLD CIVILIZATIONS

Several of the terms used in this textbook require definitions. For example, what precisely defines a civilization, not to mention a world system? To understand how the human experience has undulated between dispersed rural populations and interconnected world systems, we must delve somewhat deeper into some of the basic principles of social theory and come to terms with concepts such as culture, state formation, civilization, world system, and globalism.

DEFINING CIVILIZATION

Civilizations represent periods of heightened engagement in the processual (step-by-step) development of human culture. Culture represents a crucial building block of civilization. Human cultures evolve, expand, merge, and progress to the point where a "critical mass" of civilization takes hold. So what does culture entail? Anthropologists define **culture** as *a uniquely human system of habits and customs acquired by humans through exosomatic processes, carried by their society and used as their primary means of adapting to their environment*. Inherent in this definition is the insistence on learned as opposed to genetic behavior. Birds migrate seasonally as a result of millions of years of genetic hard-wiring; humans harnessed fire through a process of discovery, observation, and retention of acquired knowledge. In other words, humans in isolated cultural contexts, such as those that existed in prehistory, acquired skills, experience, and knowledge over time regarding ways to improve their well-being and to adapt to a changing environment. They simultaneously handed these skills down from one generation to the next through forms of education. **Recursive forms of education** (that is, the transfer of knowledge that repeats itself indefinitely) enable human cultures to sustain themselves across distances of space and time. Prehistoric humans learned to fashion tools for specific purposes, to remodel landscapes for various needs, to express themselves through language and art, to formulate hierarchies, to articulate a sense of awareness of their place in the universe, to revere deities, and ultimately to devise appropriate ways to commemorate their dead. Handed down from one generation to the next, these recursive processes can be likened to **memory**. Societies rely on past and living memory of their acquired attributes to perpetuate their existence. Awareness of the existence of unique sets of cultural attributes holds the key to explaining past human experience. In brief, culture reflects the single most distinctive trait that separates humankind from other natural species.

Another essential component to urban civilization is something commonly referred to as the process of **state formation**, or *the identification of definable stages in human social organization*. Since all ancient civilizations underwent some process of state formation, the mechanisms by which this occurred in each instance become important to their development. Social theorists have traditionally argued that the process of state formation entailed an evolutionary progression from minimal forms of social organization such as hunting bands, tribes, and chiefdoms to more advanced forms such as states, civilizations, and world systems. **Hunting bands** and **tribes**, for example, *are loosely organized formations based on lineage or kinship ties, or the perception of the group as an extended family or clan*. A **chiefdom** is defined as an autonomous political unit comprising a number of such entities under the permanent control of a paramount chief. A **state**, however, is organized according to permanent institutions that exist and perpetuate themselves independent of lineage connections. A state typically displays a centralized government that maintains a monopoly on the legitimate use of force within a specified territory. Social structure within a state tended to be highly stratified.

For the purposes of this book, we define a **civilization** as a social organization that transcended states both in terms of the breadth of its territorial extent and its population base. A civilization typically incorporated numerous states within its reach. As such it might be referred to as an extraterritorial state or an empire. We define a civilization as a uniform society that exhibits the following characteristics.

THE SEVEN CRITERIA FOR ANCIENT CIVILIZATION

Urban Centers (cities or large dense settlements)

All civilizations arose from settled agricultural communities. These communities produced food surpluses to sustain growing populations. As clusters of small agricultural settlements expanded within the limits of a given ecological niche, urban centers typically emerged.

Professions (the separation of population into specialized occupational groups)

All civilizations developed labor elements that specialized in activities other than food production. Craft, artisan, metallurgy, forestry, mercantile, finance, and other nonagricultural professions emerged by exchanging the results of their labor (metal wares, pottery, timber, stone) for food produced by farming populations.

Elites (a social hierarchy that was exempt from subsistence labor)

At the top of all stratified population elements in a civilization were the elites, which usually included some combination of warrior elites, priestly castes, noble aristocracies, and/or royal dynasties. Elite elements dominated "inferior" social orders and drew upon their surpluses to sustain themselves, thus freeing themselves from participation in every day subsistence labor. These elites invariably justified their elevated status by furnishing military protection, religious direction, political representation, legal authority, infrastructure, and civic order to those below.

Public Wealth (the ability to extract and store surpluses in the form of taxes and tribute)

In addition to rents and dues obtained by elites to sustain themselves, ruling hierarchies also imposed various forms of taxes in the interest of the state. These resources would be used to finance activities to benefit the common good, such as offerings to the gods or the construction of urban defenses. Poll taxes, property taxes, income taxes, import and export duties, manumission, and sales taxes were all devised by early civilizations. Tribute was slightly different in that it was a tax imposed on subject states by a dominant state, which indicated the existence of an empire or extraterritorial state. From the perspective of a dominant imperial hierarchy, tribute enabled it to sustain itself, to obtain prestige goods from distant populations, and to deploy its forces against outside threats, thus furnishing security to subject states. From the vantage point of the subject states, however, tribute amounted to a form of extortion imposed on an already overburdened native population. Tribute payments inevitably provoked impoverishment, resentment, and rebellion.

Canonical Expressions of Aesthetic Achievement (or fine arts and monumental architecture)

Civilizations encouraged the development of formal schools of art and design, which enabled the inhabitants to generate more finely articulated expressions of aesthetic achievement than those possible in less complex societies. Most high art during antiquity was rooted in religion and was used to articulate a prevailing ideology. While the fine arts of any civilization inevitably emerge from more primitive forms of artistic expression, recursive institutions were essential to the development and sustainability of high art. As schools emerged, their graduates designed canonical forms of aesthetic expression that became recognized and reproduced as the emblems of their society's collective cultural memory. The vestiges of these expressions in monumental architecture, sculpture, and the arts tended to distinguish the cultural attributes of one civilization from another and are very much a part of their historical record.

Creature Comforts (or the development of permanent forms of domestic shelter)

One of the principal requirements of any urban civilization is to generate habitats or safe, secure means of shelter for its inhabitants. Most civilizations developed primitive systems of urban infrastructure to improve the general quality of life. Houses might contain indoor plumbing; means of heating and cooking; furnishings such as tables, chairs, and beds; and bathing and toilet facilities. Large-scale, well-organized water systems were essential to direct and distribute fresh, clean water across urban landscapes. Sewerage systems were equally necessary to draw away waste materials and to diminish the risk of contagion or disease. Streets and roads were used to import bulk quantities of agricultural goods from surrounding hinterlands, just as massive storage facilities and market places distributed surplus commodities throughout the population. One of the ways to assess the achievements of past civilizations is to calibrate the quality of creature comforts (quality of life or well-being) that it furnished to its residents.

Literacy (a system of writing)

All great civilizations developed a system of writing, preserving for us at least some partial record of their historical experience. Writing enabled inhabitants to record their accomplishments and cultural achievements, and usually some manifestation of an articulated worldview, whether philosophical or religious. Even when restricted to a limited elite, literacy helped to sustain the recursive process of stored cultural memory. It not only enabled societies to hand down knowledge from one generation to the next, but it also facilitated the assimilation of that knowledge by newly arrived outsiders, or the exportation of the same to neighboring societies (something referred to as **cultural diffusion**), thus enabling outsiders to adapt to their new situation and gradually to merge with the core population.

Due to their superior labor power, surplus resources, stratified societies, military capacity, accessible technologies, and in many instances the advantageous environments in which they settled (something referred to as **geographical determinism**), certain civilizations managed to exert authority over less developed populations and natural resources within their horizons. These states successfully tapped into new and different resources further abroad, while retaining neighboring peoples in subordinate positions. Asymmetrical relationships, in which more advanced civilizations, or *core polities*, dominated the activities of subordinate or *periphery polities* form the basis of social constructs known as **world systems**. Simply put, a world system emerged when a more advanced civilization assumed control over the economic activities of less advanced neighboring populations, particularly by exploiting the neighboring peoples' available natural resources. Invariably, the relationship emerged as one in which the core polity exported costly, technologically more advanced finished goods (such as metal wares, ceramic finewares,

household furnishings, textiles, works of art, wine, and olive oil) to peripheral states in exchange for abundant, unfinished natural resources such as timber, stone, metals, human prisoners, and raw foodstuffs. The more advanced core polity used its wealth and power to manipulate flows of material, energy, and people at a **macro-regional (world-system)** scale through the establishment of ties of super ordinance and dependency.

One scenario posits that the wider the range of a civilization's trading capacity the larger its capacity for growth. This is where **globalism** enters the picture. Implied in each of these assumptions is the tendency for urban societies to expand and grow to some undeterminable size. Typically, a society will expand to the limits of the carrying capacity of its immediate ecological niche. The question at that point becomes one of sustainability. Control of peoples and resources on the periphery typically enabled localized economies to continue to expand; they could also lead to contact with civilizations further removed. The extension of communications further and further abroad formed the basis of an emerging macro-regional or global world system. This is what appears to have occurred during the Early and Late Bronze Ages and again during the Roman Era. It needs to be emphasized, however, that no past civilization was monolithic in character; each civilization consisted of a patchwork of neighboring cultural entities that tended more often than not to preserve their own separate identities while assimilating some veneer of the mainstream culture espoused by the hierarchy. In each instance, however, cultural attributes of the dominant society tended to remodel those of neighboring peoples. This propelled them through space and time along common cultural trajectories.

FURTHER READING

Davies, Stephen. *The Philosophy of Art*. Malden, MA: Blackwell, 2006.

Dewey, John. *Art as Experience*. New York: Penguin, 2005.

Earle, Timothy. *How Chiefs Come to Power: The Political Economy in Prehistory*. Stanford: Stanford University Press, 1997.

Giddens, Anthony. *The Constitution of Society: Outline of the Theory of Structuration*. Berkeley: University of California Press, 1984.

Olson, Steve. *Mapping Human History: Genes, Race, and Our Common Origins*. Boston: Houghton Mifflin, 2003.

Service, Elman R. *Origins of the State and Civilization: The Process of Cultural Evolution*. New York: Norton, 1975.

Wallerstein, Immanuel. *World-Systems Analysis: An Introduction*. Durham: Duke University Press, 2004.

Yoffee, Norman. *Myths of the Archaic State: Evolution of the Earliest Cities, States, and Civilizations*. Cambridge: Cambridge University Press, 2004.

INTRODUCTION

FROM HUMAN PREHISTORY TO THE ANCIENT WORLD

The purpose of this book is to examine the emergence of ancient urban civilizations on three continents: Africa, Europe, and Asia. We will identify the classical traits of each civilization—traits that gave each regional culture its individual character and traits that are inherently recognizable in modern cultures that evolved in the same regions. The chief premise is that civilizations thriving in distant continents during these eras increasingly came in contact with one another to form an interconnected or **global world system**. At the height of the second century AD, interconnectivity enabled societies such as the Roman Mediterranean, East Africa, various principalities in India, and the Han Dynasty in China to attain their greatest levels of urban expansion, material prosperity, and cultural achievement prior to modern times. By 600 AD all these societies collapsed. In the case of Rome, collapse was dramatic; in India and China, however, traditional societies recovered within a relatively brief period of time.

It is important to stress the lack of commonality to the patterns of growth and decline. Each era of interconnectivity between civilizations exhibited variable characteristics and was exponentially larger (in size, in expanse, in cultural attributes) than the one that preceded. Yet, each of the four ancient phases of global world system (Early Bronze Age, Middle Bronze Age, Late Bronze Age, Roman Era) ultimately came unraveled and collapsed. This suggests that there is something implicitly unsustainable about the foundations of complex urban societies, not to mention the demands they impose on their environment and human resources. The undulating pattern of development, interdependency, and growth, followed by economic disruptions, political disturbances, and societal collapse, appears to furnish an essential rhythm to the history of human experience. The transition from scattered, highly diverse rural populations to more centralized complex urban societies (what archaeologists refer to as the transition from dispersed to nucleated settlements) forms a central theme and underlying premise to this text.

Therefore, this introduction will contextualize the development of human societies and determine the key factors in the transition from human prehistory—characterized by small groups of migrating hunter-gatherers—to ancient civilizations, "periods of heightened engagement in the processual (step-by-step) development of human culture," as defined in this volume's preface. Additionally, the three eras (the Bronze Age [Early, Middle, Late], the Classical/Iron Age, and the Roman Era) will be generally defined, and we will

provide a brief overview of the overarching theme of this textbook—the rise and fall of civilizations in the ancient world, and the various causes for these moments in history.

KEY FACTORS IN THE TRANSITION FROM HUMAN PREHISTORY TO ANCIENT CIVILIZATION

Human remains recovered in Ethiopia combined with recent strides in DNA mapping indicate that modern "anatomically correct" humans, known scientifically as *homo sapiens*, emerged in central Africa ca. 197,000 years ago. Like all living species, humans were confronted by the highly erratic climate of the Pleistocene Era, a geological time period characterized by extreme changes in cold and warm weather across the globe, otherwise known as the Ice Age, ca. 2.2 million years Before Present (BC). Since the reversal of the earth's magnetic field about 750,000 years ago, the planet has undergone at least seven phases of extreme glaciation. Sustained periods of cold climate were interspersed by much shorter warm periods known as interglacials, thus lending the temperature record a remarkable saw tooth appearance. Many species (including those of other hominids) went extinct during this challenging epoch. To survive the Ice Age, early humans displayed remarkable adaptability and resilience. Already 70,000 BC, humans dwelling in Africa exhibited components of what is referred to as a Paleolithic Revolution, including blade and microlithic technology, bone tools, increased geographic range, specialized hunting, exploitation of aquatic resources, long distance exchange networks, systematic processing of pigment, art and body decoration. By 16,000 BC human populations migrated long distances to occupy all inhabitable continents of the globe. As the global climate stabilized around 9000 BC, humans throughout the planet adapted from hunting and gathering to a new strategy for survival that focused increasingly on the domestication of plants and animals. This strategy held the greatest potential to sustain ever growing populations in a sedentary manner.

This development, known as the Neolithic Revolution, marked a transitional phase in human existence, engendering the transition from human prehistory to ancient civilizations. It occurred first in the highlands of the Near East ca. 10,000–7000 BC. The technology then radiated outward to neighboring regions and occurred at sometimes markedly different times. The first Neolithic culture to evolve into urban civilizations arose in the Ancient Near East, a large region extending from the shores of the eastern Mediterranean Sea and Egypt across Mesopotamia and the Persian Gulf to the Iranian plateau. Early settlements were seasonally sedentary and village-oriented: they were characterized by the construction of circular dwellings of mud brick and unworked stone, the cultivation of grain crops, and unique burial customs entailing the interment of deceased family members directly beneath the floors of dwellings. As these cultures evolved, they tended to be more heavily dependent on **domesticated animals** to supplement the mixed hunter-gatherer/semi-agrarian diet, which is one of the key factors in the metamorphosis

from prehistory to ancient civilization. For example, in the Zagros Mountains of Iran, there is evidence of domesticated sheep and goats and the importation of nonnative strains of wheat and barley, and at Jarmo in neighboring Iraq (7100–5000 BC) domesticated pigs were added to the herding repertoire.

Sedentism and domestication of plants and animals enabled societies to develop into **food producers** as opposed to **food gatherers**. Food production inevitably led to surpluses capable of sustaining populations through fallow winter months. Stable food supplies also enabled populations (or some elements thereof) to focus on activities unrelated to food production. Other innovations such as weaving and ceramic production (wheel-turned pottery) appeared by 6500 BC, and metallurgy rapidly followed (e.g., copper tools by 5000 BC). Since a family of four requires essentially a metric ton of grain per year to survive, food storage facilities became essential. The permanence of these features not only reinforced sedentism as a way of life, but it possibly helped to stimulate concepts of ownership and private property. Settled agricultural existence may likewise have altered gender roles. Abundant food supplies and sedentary lifestyles possible raised levels of female body fat, thus triggering more frequent cycles of menstruation and shortening the elapsed time between pregnancies. Since increased pregnancies produced more labor for farm work, this change was probably viewed as advantageous by emerging farmers and assigned selective genetic preference. However, the evidence also indicates that increased child-rearing generated higher rates of female and infant mortality. In addition, the reliance on the limited dietary intake of agricultural foodstuffs appears to have induced various forms of malnutrition, tooth decay, vitamin and mineral deficiencies. Although Neolithic culture furnished the advantages of greater food supply and larger laboring populations, the trade-offs appear to have been reduced life expectancies and a diminished quality of life.

Slightly later Near Eastern sites exhibited important innovations in stone tool manufacture and rectilinear architectural construction. The processing of clay and crushed limestone is believed to have led to the development of fired pottery (7000 BC). Since houses in these settlements varied in size, they indicate emerging disparities in wealth and social status. Such settlements also exhibited more elaborate systems of public rituals and ceremonies: sites such as Ain Ghazal in Jordan (7250–5000 BC) have revealed remains of human statues styled from lime plaster worked over reed and grass cores. The statues exhibit painted faces and clothes and eyes made of inlaid shells. On one recovered statue a wig of bitumen (asphalt in its natural form) was added to resemble hair. By this time unique sites situated along important nodes of communication and resource production, such as Jericho (8300–7500 BC) in modern-day Israel, and Çatal Höyük (7300–6200 BC) in south-central Turkey, began to develop sizeable populations, estimated at 12,000 and 6,000 respectively.

Alternative life strategies such as herding, fishing, and hunting underwent similar technological advances to remain viable. For example, agro-pastoralists dwelling in the Eurasian steppes between the Caspian and the Aral Seas domesticated horses and adapted to horse riding ca. 5000–4000 BC. Horse mobility enabled fewer people to control larger herds over wider expanses of terrain. This ultimately enabled the pastoralists of this region

to mediate communications between emerging agricultural civilizations in the great river basins of the world. Experimentation with fishing undoubtedly led to seafaring and to the construction of large sea-going vessels in the Mediterranean by 3000 BC. By 2200 BC (the Egyptian Middle Kingdom), large cargoes of staple goods such as timber and stone, and grain were being shipped along the urban centers of the eastern Mediterranean coast. Hunter-gatherers dwelling in mountains in the vicinity of the Fertile Crescent appear to have invented bronze metallurgy by 3500 BC. An alloy of copper and tin that benefits from the low smelting temperatures required for each metal, bronze facilitated the casting of tools and weapons that bore a harder edge than either of its parent materials. Bronze tools facilitated the expansion of agricultural technology to riverine landscapes in Mesopotamia, Egypt, India, and China and ultimately generated advanced cultures with large dense settlements. The point remains that all of these developments and others that go unmentioned appear to have been interrelated in time and space. Their common denominator was the development of Neolithic agricultural technologies and concomitant advances in stored agricultural surpluses. Specialized activities such as herding, mining, artisanal and forestry production were not sustainable without the benefit of exchanges of stored food supplies. In short, sedentism had the capacity to generate sufficient levels of stored wealth to trigger technological advances for those engaged in alternative life strategies, which enabled human populations to harness natural resources and to develop cultures in nearly every known environment of the globe. By 4000–3000 BC human cultures assumed mastery over natural resources extending from the Atlantic to the Indian and the Pacific Oceans and beyond.

The highly Eurocentric character of archaeological research should not be allowed to disguise the fact that rising sedentism and adaptation to the domestication of plants and animals was a global phenomenon. As the modern climate took hold, human elements worldwide were compelled to accept new subsistence strategies entailing sedentism. In this respect the decline in climatic variability played a formative role in the development of more settled societies.

THE THREE MAIN PERIODS OF ANCIENT HISTORY

Around 5000 BC, sustained agricultural settlement arose globally, particularly in broad flat river valleys where large scale irrigation projects were possible. Following the invention of technologies such as ceramics, weaving, and textile production (the mastery of all of which occurred by ca. 6500 BC), metallurgists in the region of Mesopotamia generated bronze tools around 3500 BC. The invention of bronze tools revolutionized laboring activities, most significantly, farming. This enabled settled agricultural communities to harness the rich alluvial soils and abundant water of large river basins such as the Tigris and Euphrates in Mesopotamia, the Nile in Egypt, the Indus in south Asia, and the Yangtze and the Huanghe in East Asia. The ensuing era is known as the Bronze Age (3300–1100 BC:

Early, Middle, and Late), and the large urban societies that emerged in riverine environments at this time are often referred to as *hydraulic civilizations*. The Bronze Age was dominated largely by societies such as these. With the advent of iron tools, the density of urban civilizations intensified during the Classical or Early Iron Age (ca. 1000–27 BC), and large extraterritorial states extended their reach to harness resources and populations in their general vicinity and to trade with those at a distance. During the Roman Era (27 BC–565 AD), these developments achieved their highest levels of integration, population size, and geographical extent prior to modern times.

The chief premise of this book is that civilizations thriving in distant continents during these eras increasingly came in contact with one another to form an interconnected or global world system. Despite the limitations posed by preindustrial technologies, large urban societies were thriving in the Mediterranean, East Africa, the Indian subcontinent, and China, thus, representing human mastery of a broad expanse of landmass, sea, and ocean. By 600 AD all of these societies had collapsed. Although it is harder to document, something very similar appears to have happened at earlier points in the ancient experience, for example, at the end of the Early Bronze Age (2200–2100 BC), at the end of the Middle Bronze Age (ca. 1550 BC), and most particularly at the end of the Late Bronze Age (1200–1100 BC). At these moments highly integrated economies and hierarchies in Egypt, the Aegean, Anatolia, Syria-Palestine, and Mesopotamia appear to have experienced simultaneous setbacks such as population decline, loss of advanced skills, and a reversion from urban to rural settlement patterns. As schools disappeared and cultural memory subsided, the benefits furnished by complex urban societies—literacy, monumental architecture, advanced creature comforts—declined into phases invariably referred to as "Dark Ages." Based on this pattern, one could argue that the growth of urban populations in antiquity has experienced undulating peaks and valleys since the Neolithic Era.

THEORIES FOR WORLD SYSTEMS COLLAPSE

It is precisely at the juncture between societal growth and collapse that arguments derived from **resilience theory** become pivotal. According to resilience theory, the natural world exists generally in a dynamic state of change, invariably cycling through four recognizable phases: *rapid growth, conservation, release*, and *reorganization*. Those who adhere to the argument of ecological economics recognize this process of rise and fall, or growth and collapse, as inevitable phases of systems dynamics. When applied to human activity, in other words, resilience theory posits that human social-ecological systems cycle through the same four recognizable phases as other natural systems. In the human historical experience the fore loop of rapid growth and conservation may be identified with eras of large urban civilizations; the back loop of release and reorganization with societal collapse and a reversion back to subsistence forms of production. If dynamic change is the one constant variable in nature, then the tendency of human societies to sustain themselves, or even

to attempt to sustain themselves, at peak levels of urban complexity becomes counterintuitive. Inevitably significant changes will occur. Despite a number of issues that remain unanswered, it is important to recognize for now that the undulating pattern of rise and fall visible in the history of human experience appears to resemble the recurring fore loops and back loops of the wider ecosystem.

FURTHER READING

Burroughs, William James. *Climate Change in Prehistory: The End of the Reign of Chaos*. Cambridge: Cambridge University Press, 2005. https://doi.org/10.1017/CBO9780511535826.

Frachetti, Michael D. *Pastoralist Landscapes and Social Interaction in Bronze Age Eurasia*. Berkeley: University of California Press, 2008.

Montgomery, David R. *Dirt: The Erosion of Civilizations*. Berkeley: University of California Press, 2012.

Tainter, Joseph A. *The Collapse of Complex Societies*. Cambridge: Cambridge University Press, 1988.

Walker, Brian, and David Salt. *Resilience Thinking, Sustaining Ecosystems and People in a Changing World*. Washington, DC: Island Press, 2006.

Wenke, Robert J. *Patterns in Prehistory: Humankind's First Three Million Years*. 4th ed. Oxford: Oxford University Press, 1999.

PART I
EMERGING CIVILIZATIONS: THE BRONZE AGE

ONE

THE NEAR EAST IN THE EARLY AND MIDDLE BRONZE AGE (3300–1600 BC)

WHAT HAVE WE LEARNED?

- ► That modern humans (*Homo sapiens sapiens*) originated around 200,000 BP in Ethiopia.
- ► That human evolution was heavily influenced by the Pleistocene Era, a geological time period characterized by variable climate punctuated by extreme changes between cold and warm weather across the globe.
- ► That most early modern human population remained in Africa, but that some small portion of the population migrated out of Africa, occupying all inhabitable continents of the globe by 16,000 BC.
- ► That the stable, warm climate that we know today arrived around 9000 BC, altering lifestyles for numerous modern human populations by forcing them to adapt to sedentism or settled agricultural existence.
- ► That the Neolithic Revolution helped human settlements to generate sufficient "stored wealth" to trigger technological advances in a variety of "disciplines" and enabled human populations to assume mastery over natural resources throughout the globe.
- ► That the rise of populations throughout Eurasia led to three significant eras of urban civilization: namely, the Bronze Age (3300–1100 BC), the Classical or Early Iron Age 1000–27 BC, and the Roman Era (27 BC–612 AD).
- ► That during these periods large urban civilizations thriving in distant continents increasingly came in contact with one another to form an interconnected or global world system.
- ► That ancient civilizations exhibit undulating patterns of growth and collapse similar to natural adaptive cycles (fore loops of rapid growth and conservation followed by back loops of release and reorganization).

Based on the domestication of plants and animals, human settlement has long been identified as having occurred around 9000 BC in ancient Iraq. The broad arid region of the parallel basins of the Tigris and Euphrates Rivers was surrounded on three sides (west, north, and east) by a sinuous range of mountains that trapped moisture flowing from the Mediterranean and Black Sea basins along their slopes, forming a narrow "rain shadow." This region is known to scholars as the Ancient Near East, the Fertile Crescent, or Mesopotamia. Here, adequate rainfall enabled dry farming agriculture of emmer wheat and barley, grains that grew naturally in this region. The slash-and-burn character of early agricultural activity caused adaptation of this technology to radiate outward to neighboring regions, more importantly, inland to the alluvial plains surrounding the Tigris and Euphrates Rivers.

The invention of bronze tools around 3500 BC revolutionized laboring activities, most significantly farming. This enabled settled agricultural communities to harness the rich alluvial soils and abundant water of river basins such as the Tigris and Euphrates in Mesopotamia. The ensuing era is known as the Bronze Age (3300–1100 BC), and the large urban societies that emerged in riverine environments at this time are often referred to as **hydraulic civilizations**. As opposed to dry farming techniques employed in the surrounding highlands, farmers settling in river valleys had the advantage of harnessing their water supply by trapping and storing floodwaters for sustained use in crop production. The inhabitants of Mesopotamia, for example, learned to conserve flood waters by opening networks of canals along the Tigris and Euphrates Rivers (approximately 50 km apart in central Iraq). The vestiges of these vast canal networks remain visible today in aerial and satellite photography.

Flooding in Mesopotamia tended to occur in two phases: the first was generated by winter rains in the distant mountains of Anatolia, and the second phase came with the spring snowmelt in the same highlands. Given the fact that the origins of flooding events lay far beyond the horizon of Mesopotamian settlements, the flooding appeared to the inhabitants to arrive violently and unpredictably. The natural topography of the river plains compounded the challenge—large meandering rivers tend to build up natural levies that gradually lift the level of the river above that of the surrounding flood plain. Early settlers learned to tap these levies to direct water onto neighboring lowlands. However, during surging floods the rivers themselves could breach the levies and forge new channels across farmland and settlements, causing extensive damage to man-made landscapes. Sudden adaptation to changing circumstances was necessary, therefore, and helps to explain the frequent relocation of settlements in Mesopotamia. Otherwise the climate had little to recommend. The land between the rivers presented itself as a hot, dry, mostly flat, seemingly barren stretch of desert. Natural resources such as stone, timber, or metals were nonexistent and needed to be imported from neighboring regions. Mesopotamia's chief natural resource, the deep layers of soil deposited by the rivers at the end of the Ice Age, served multiple purposes. By means of irrigation the earth furnished abundant food supplies. Through the adaptation of frame-formed, sun-dried mud bricks, it furnished an essential construction material, and through its flat, open terrain it offered

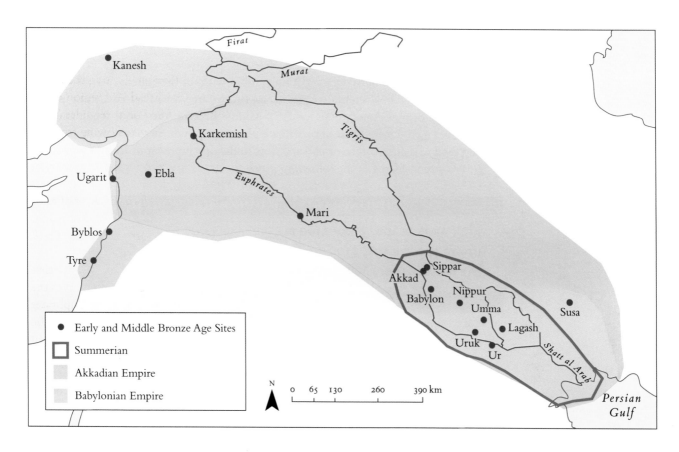

Map 1 The Early and Middle Bronze Age in the Near East.

mobility—essentially an open highway—to assorted peoples who migrated into the region. In addition, the terrain beyond the river basin rose into low hills and valleys that furnished grazing land for herders who could supplement agricultural food production with abundant livestock. The inhabitants of Mesopotamia thus produced ample surpluses of food, principally grain, but a host of garden crops as well, enough to sustain an estimated population of one to two million people by Roman times. With temperatures attaining 140°F during the summer months, the climate can best be described as daunting. Shade furnished by date palm trees, lush canal-fed gardens, and mud brick domestic quarters, not to mention abundant food and water, made life bearable.

HISTORICAL OUTLINE OF BRONZE AGE MESOPOTAMIA, 3300–1100 BC

Writing technology was achieved in Sumer, in southern Mesopotamia, by 3100 BC, enabling us to obtain a better grasp on developments and events in this area. Although we will discuss the character of this technology below, for the moment a basic outline of Bronze Age history becomes essential. The complexity of Bronze Age chronological systems largely arises from the fact that early archaeologists working locally throughout

the Near East devised idiosyncratic dating systems without the benefit of coordination. In broadest terms, scholars tend to characterize Bronze Age Near Eastern history in three phases: Early Bronze Age (3100–2100 BC), Middle Bronze Age (2100–1600), and Late Bronze Age (1600–1200). These approximate phases are of course subject to dispute, but they do tend to map a pattern of ebb and flow in the development of Bronze Age world systems to be considered in the following pages.

CHRONOLOGY 1. BRONZE AGE WORLD

EARLY BRONZE AGE, 3100–2100 BC

MIDDLE BRONZE AGE, 2100–1600 BC

LATE BRONZE AGE, 1600–1200 BC

CHRONOLOGY 2. BRONZE AGE NEAR EAST

3700–3300 BC	Pre-dynastic Sumer: Uruk Phase
3300–3000 BC	Pre-dynastic Sumer: Jemdet Nasr Phase

EARLY BRONZE AGE, 3100–2100 BC

3300–2300 BC	Early dynastic Sumer (Death Pit at Ur, 2600 BC)
2300–2150 BC	Akkadia
	(Sargon the Great, 2334–2279 BC; Naram Sin, 2190–2154 BC)
2150 BC	Akkadian regional collapse (climate flicker)
(2180 BC	Collapse of Old Kingdom Egypt)
2119–1940 BC	Third Dynasty of Ur
ca. 1940–1750 BC	Early Bronze Age regional collapse

MIDDLE BRONZE AGE, 2100–1600 BC

ca. 1800 BC	Rise of Assyria, Babylonia, and Mari
ca. 1792–1750 BC	Hammurabi's Babylonia (dynasty lasted until 1590 BC)
ca. 1600–1500 BC	Middle Bronze Age regional collapse
	Hurrians, Kassites, Mitanni (Indo-Europeans)
(ca. 1720 BC	Collapse of Egyptian Middle Kingdom; Hyksos invasions)
ca. 1600 BC	Minoan destruction

LATE BRONZE AGE, 1600–1200 BC

1600–1070 BC	Competing Territorial States
	Mitanni (1600–1400 BC), Assyria (1800 through the end of the Bronze Age), Kassite Babylonia (1600–1200 BC), New Kingdom Hittite Empire (ca. 1400–1100 BC), New Kingdom Egypt (1550–1070 BC), the Mycenaeans (1600–1200 BC)
ca. 1200–1000 BC	Collapse of Late Bronze Age world system

During the Early Bronze Age, the chief cultural unit in Mesopotamia was the independent, autonomous city-state with its surrounding hinterland of irrigated agricultural terrain. As many as 20 of these existed in southern Mesopotamia by the Early Dynastic Period (3300–2300 BC). However, written sources such as the **Sumerian Kings List** (ca. 1900 BC) indicate that by 2700 BC neighboring city-states in Sumer were increasingly embroiled in conflict. Within each Sumerian city a military leader known as a *lugal* supplanted the *en*, or priest king, and essentially eliminated any prior distinction between secular and religious authority. Competition and military rivalry among city-states gradually forced inhabitants to accept the hegemonial authority of individual ***lugals*** over increasingly larger territory. This authority was rationalized in the Kings List as a process of divine selection—only one divinely legitimized ruler could exist at a time, and the selection was restricted to a handful of ruling houses. The result was a gradual development of extraterritorial states or empires. Although the early parts of the Sumerian Kings List were plainly legendary (with reigns of kings extending hundreds if not thousands of years), the accuracy of later parts of the list are corroborated by externally dated texts. By 2700 BC, for example, Lugal Emmerbaragesi of the city of Kish overwhelmed his neighbors to establish a wider hegemony. His example was followed by Lugal Gilgamesh of Uruk (ca. 2500 BC), Lugal Mesannepadda of Ur (ca. 2600 BC), Lugal Eannatum of Lagash (2450–2360 BC), and Lugal Zagesi of Umma (2360–2350 BC). As regional authorities the lugals continued to recognize the legitimacy of neighboring communities and to respect the authority of associated patron deities. The priests of Nippur enjoyed inordinate status due to the importance of the town's patron deity, the chief god of the Sumerian pantheon, Enlil. The priests used this authority to demand and to obtain regional contributions to support the cult of Enlil and on occasion to mediate boundary disputes between neighboring states. By extension they maintained the right to anoint, and thus to legitimize, a regional lugal. Successful kings such as Sargon of Akkad (2334–2279 BC) responded to these circumstances by designating relatives to preside over the cult of Enlil as well as those of other Sumerian patron deities.

The architecture for Mesopotamian hegemony was first crafted by this last mentioned king, Sargon of Akkad, who rose allegedly from humble origins to assume the office of royal cupbearer to the king of Kish. He then usurped the throne, defeated neighboring rivals, and claimed authority throughout Sumer. Founding a new dynasty, he built a new capital for himself at Akkad, believed to lie beneath the modern city of Baghdad. After defeating the Elamite king of Anshan (and establishing a provincial headquarters at Susa), he marched northward along the Euphrates, conquering other important settlements such as Mari and Ebla and pushing all the way to the Tauros Mountains. Sargon exerted forceful control over subject populations, demolishing the defenses of rebellious communities, removing and replacing local kings with personally appointed governors (who received the title of *ensi*). He appointed relatives such as his daughter Enheduanna (2285–2250 BC) to important priesthoods throughout the realm. Outside Sumer he enslaved conquered populations and expropriated their lands. He forcibly relocated prisoners to work areas in distant regions of the empire and distributed land allotments to warriors recruited from

The visual arts were increasingly used under the Akkadians to solidify and reflect the new concept of absolute monarchy. A copper head of an Akkadian king (perhaps Naram Sin himself) is the most impressive surviving work of this kind. Noteworthy for its abstract treatment of the king's beard and hair, simplicity, and use of symmetry, the vandalized portrait head is all that survives of a statue likely destroyed during the Medes invasion of Nineveh in 612 BC. The head is also the oldest known example of life-size, hollow-cast metal sculpture. Monumental sculptures of this type required multiple steps, great skill on the part of the artist, and were quite expensive to produce. The expertise of the metalworker is evident in the intricate, precise pattering and the use of varying textures in the sculpture, contributing to an overall sense of balance and naturalism. The careful observation and recording of the man's distinctive features reveals the artist's masterful attention to detail and sophisticated skill in casting, polishing, and engraving.

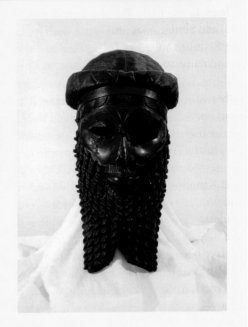

Figure 1.1 Head of an Akkadian ruler, from Nineveh (modern Kuyunjik), Iraq, ca. 2250–2200 BC. Copper, 30.7 cm high. Iraq Museum, Baghdad.

unruly pastoral elements. One inscribed document records that he dined regularly with 5400 such retainers. He extended trade lines from the Mediterranean in the west to the Indus and the Oxus valleys in the east, opening up exchanges of bitumen, agricultural produce, and textiles for gold, silver, copper, lead, stone, timber, spices, and resins. The Akkadian dynasty had its ups and downs: both Sargon and his successor had to suppress coordinated rebellions. His grandson Naram Sin (2190–2154 BC) eventually reasserted Akkadian supremacy throughout the region and assumed divine status, boasting that his rule extended to the "four corners of the earth." The Akkadian Dynasty thus established a model for Near Eastern empire-building that would be imitated for centuries.

SOCIETAL COLLAPSE AT THE END OF THE EARLY BRONZE AGE (2200–2100 BC)

Shortly thereafter, the Akkadian Empire collapsed and along with it the trade links of the wider world system. Contemporary sources blamed this on the invasion of a migrating people called the Gutians who probably originated in the Zagros Mountains; however, the extent of the disturbances appears to have been much wider and far more significant. Not all constituent societies were affected in the same manner or at the same time. In Sumer a hierarchy known as the Third Dynasty of Ur (2119–1940 BC) was able to flourish for

at least another century, commanded by two notable kings, Ur Nammu (ca. 2047–2030 BC) and Shulgi (2029–1982 BC). However, this too collapsed amid crushing conflicts with the Elamites and with semi-pastoral elements known as the Amorites. The last king of Ur actually attempted to construct a defensive line of fortifications between the Tigris and the Euphrates Rivers to stem the tide of these intruders. The Semitic Amorites seem either to have migrated into Mesopotamia around 2000 BC—driven by disturbed conditions elsewhere—or to have dwelled there all along. Regardless, they were now becoming increasingly troublesome. Bronze Age societal collapse also occurred at this time (ca. 1900 BC) in the Indus Valley (Harappan civilization), suggesting that this too was somehow connected to the overall pattern. Likewise, a sustained thousand-year era of stability in Old Kingdom Egypt came to a close (2100 BC) amid reports of lowered river volume and famine in the Nile Valley. Settlements in Palestine and the Negev likewise exhibit evidence of destruction ca. 2200 BC, followed by abandonment for nearly two centuries. Even agro-pastoral peoples beyond the immediate horizon of the Near East appear to have been set in motion at this time. Indo-Europeans dwelling in the steppes north of the Black and Caspian Seas migrated into Greece ca. 2200–2000 BC (where evidence of destruction is less significant but material contexts show dramatic changes), as well as into Anatolia (where survey data indicates a 75 percent decline in settlement occupation) and the Caucasus. Culturally related Indo-Iranians or Aryans migrated from the same region into Central Asia (where they possibly conveyed their agro-pastoral lifestyle to the Oxus River civilization ca. 2200–1700 BC), the Iranian plateau, and the Indus Valley (arriving by 1700 BC). Another element known as the Hurrians moved from the highlands of eastern Anatolia (modern-day Armenia) into northern Mesopotamia to play an influential role in the following era. A combination of accumulating textual and archaeological evidence demonstrates, accordingly, that something dramatic, if not transformative, occurred at the close of the Early Bronze Age. When urban societies reemerged shortly afterward, their complexion was dramatically altered in most if not all affected regions.

During the Middle Bronze Age (2100–1600 BC) the earlier urban states of Sumer remained core repositories of religious authority, agriculture, craft production, and knowledge, but political authority gravitated increasingly toward emerging polities in central and northern Mesopotamia such as Babylonia (ca. 1700 BC), Assyria (ca. 1800 BC), and Mari (ca. 1800 BC) as well as to the powerful regional polities of Elam (Susa and Anshan) to the east. Amorite warrior chieftains assumed control of numerous communities throughout the region, including Sumer. Several of these emerged as kings of comparably sized states to compete for regional domination. Despite their pastoral origins, these dynasties assimilated the prevailing urban attributes of the region and became indistinguishable from their Sumerian neighbors, even as additional non-sedentary peoples, such as the Hurrians and Kassites (from the Zagros Mountains), infiltrated the basin. In general, states were larger in this era and incorporated numerous villages and city-states within their territories. Hammurabi (1792–1750 BC), the king of a small and previously unimportant city of Babylon, ultimately defeated his rivals to impose a brief tenure of world order comparable to that of Akkad and the Third Dynasty of Ur during the previous era

(we will discuss the significance of Hammurabi's celebrated law code below). Although Hammurabi's dynasty persisted for 150 years, its control of the region proved tenuous and his empire began to unravel following the death of his son Samsu-iluna (1686–1648 BC). Simultaneously, emerging powers just beyond the horizon began to target the stored riches and resources of Mesopotamia by marauding the region with devastating effect. The Hittite king Mursilis I (1620–1590 BC) invaded Mesopotamia from central Anatolia around 1600 BC, destroying Mari and neighboring polities in the north and sacking the capital of Babylon. His sizeable army was spearheaded by squadrons of horse chariots, an emerging technology from Central Asia that would revolutionize military tactics in the coming era. The consequences of this momentary razzia ushered in a century of political confusion throughout the region.

Although the overall chronology of Middle Bronze Age developments remains disputed, the Hittite campaign in Mesopotamia is increasingly recognized as a second marker for system-wide societal collapse. Once again polities throughout the region underwent transformation as interregional connectivity subsided. The King Mursilis I returned to Anatolia in triumph only to be assassinated in a palace coup, thereby plunging his realm into a century of political disturbance. These difficulties were compounded by evidence of a plague that his army contracted during the invasion: similar reports of plague were recorded in Syria, Mesopotamia, and Egypt, leading to the suspicion that a regional pandemic possibly occurred. Meanwhile, political hierarchies collapsed throughout the region. For example, the Egyptian Middle Kingdom (2100–1750 BC), which had become increasingly engaged with neighboring communities along the eastern Mediterranean coast, relinquished control of its crucial delta region to an influx of Semitic peoples referred to as the Hyksos. For nearly two centuries, Hyksos kings based at Avaris on the Nile Delta directed the flow of prestige goods in and out of the Nile basin, diminishing the power of native Egyptian hierarchies in Upper Egypt. Between 1700 and 1600 BC, palace-based Bronze Age communities in Minoan Crete experienced a rash of cataclysms, some possibly the result of conflict but others apparently induced by natural disasters such as a conjectured earthquake storm (a wave of successive earthquakes) followed by a powerful volcanic eruption at the nearby island of Thera. The latter event, carbon dated to 1600 BC, emitted four times the seismic energy of the eruption of Mount Krakatoa in 1883 AD, the greatest known volcanic eruption of modern times. Although Minoan inhabitants survived this event and eventually restored their communities, the disturbances appear to have enabled neighboring Mycenaean hierarchies on the Greek mainland to supplant Minoan influence throughout the Aegean. In a similar manner, following the sack of Babylon, Hurrian warrior elites, many of them bearing Indo-European names, filled the vacuum created by the Hittite invasion in 1600 BC, along with the Assyrians and the Kassites, the last of whom seized control of Babylon. As the Mitanni, the Assyrians, and the Kassites, these hierarchies would dominate Mesopotamia and become recognized parties of the international ruling order that controlled the Near East during the Late Bronze Age.

Several additional features about the Middle Bronze Age appear noteworthy. First, the chronology of the Middle Bronze Age was shorter than the Early Bronze Age

(approximately 500 years as opposed to a thousand), as was its duration of collapse, depending on the region. Societal ebb and flow during the Middle Bronze Age appears to have resulted more directly from anthropogenic forces. Second, the era could more accurately be described as one dominated by regional polities—Assyria, Mari, Babylon, Sealand, Elam, Minoan Crete, Mycenaean Greece, Hittite Anatolia, Canaan, and Egypt— as opposed to city-states or larger empires like Akkadia or that of the Third Dynasty of Ur, the brief hegemony of Babylon notwithstanding. Few rulers during the Middle Bronze Age presumed to refer to themselves as god kings, as Naram Sin and the pharaohs of Old Kingdom Egypt had done during the previous era. Third, the flow of communications during the Middle Bronze Age appears to have shifted away from the Persian Gulf and toward the basin of the Mediterranean Sea. Prestige goods undoubtedly continued to flow along the first-mentioned waterway, but major polities such as Harappan civilization in the Indus Valley collapsed by 1900 BC, leaving the political lines of material transfers more difficult to follow. In the eastern Mediterranean basin, meanwhile, the royal dynasties in Middle Kingdom Egypt became actively engaged with neighboring communities, trading surplus resources from the Nile for timber, wine, and oil from Canaanite cities such as Byblos and Ugarit. With the advent of sea-going cargo ships in this era, urban societies in Cyprus, Cilicia, and Crete began to ship resources to the Near East in increasing volumes, with the result again that older societies increasingly looked westward for staple and exotic goods. In short, a much wider radius of urban states came into existence during the Middle Bronze Age, and the volume of extra-regional exchanges continued to expand. Instead of building empires, the polities of the Middle Bronze Age appear to have concentrated on developing local resources, maximizing agricultural output, and expanding urban landscapes within their respective territories. Material transfers were secured more through negotiation and diplomacy than through outright conquest. At the same time, mobile foreign elements, such as the Hurrians, Indo-Europeans, Kassites, and Hyksos, simultaneously infiltrated the perimeters of developing principalities to pose significant military distractions: on the one hand, these newcomers infused the established societies with additional laboring power and new technologies such as the horse chariot and the compound bow; on the other hand, they destabilized regional hierarchies by virtue of their growing and unruly presence. As a result, the Middle Bronze Age in the Near East resembled a transitory period in which newly developing cultures absorbed and assimilated the legacy of the previous era while expanding the dominant urban lifestyle of the region and harnessing the available resource capacity of their immediate vicinities. This dynamic grassroots investment ultimately laid the foundation for the powerful and more sustainable civilizations that would emerge during the Late Bronze Age (1600–1200 BC).

The Late Bronze Age was characterized by a new, much broader, and more highly integrated network of world powers than in either of the previous two eras. Large imperial hegemonies such as the New Kingdom of Egypt, the Hittite Empire of Anatolia, the Mycenaean civilization in the Aegean, and the Mitanni, Assyrian, and Kassite realms in Mesopotamia engaged in close economic and political communication throughout the period. The hierarchies of these empires displayed a remarkable degree of diplomatic

correspondence, crucial vestiges of which survive. Trade between these realms was significant and likewise directed by royal bureaucracies. Treaty relations and marriage alliances between dynasties were commonplace, as rival powers attempted to forge alliances, intimidate neighbors, and achieve a balance of power. Since displays of force were necessary to secure territory and to assert boundaries, the primary expenditure of each competing hierarchy went to the military. Rival kings conducted repeated military campaigns with sizeable armies spearheaded by squadrons of horse chariots. Each king attempted to expand his territory by picking off the border states of his neighbors. These exercises culminated in the greatest military event of the era, the Battle of Kadesh in 1274 BC, between the forces of the Hittite king Muwatallis II and King Ramses II of New Kingdom Egypt. Some 40,000 chariots and 80,000 infantry reportedly fought to a standstill on the plains of western Syria during this clash. The Late Bronze Age world system persisted until approximately 1200–1000 BC when widespread, even catastrophic, collapse affected the entire region from the Greek mainland to Egypt, Anatolia, Canaan, Syria, Mesopotamia, and beyond. The records of this era and the events, the societies, and the personages they record are so detailed that they warrant particular attention in the chapters that follow. In the meantime, a number of details presented above require explanation, including the cultural attributes of Early and Middle Bronze Age societies, the nature of early written records, the economic and social organization of Near Eastern societies in general, and the status of their inhabitants, especially women.

THE CULTURAL ATTRIBUTES OF ANCIENT MESOPOTAMIAN POPULATIONS

The historical outline presented above raises a number of issues that require sorting out. First, we need to identify as best we can the cultural distinctions that separated the Sumerians from neighboring peoples such as the Elamites, the Akkadians, the Assyrians, the Amorites, the Hurrians, the Gutians, and the Kassites. To do this, one must inevitably resort to language distinctions, at least insofar as they are used to identify cultural heritage. Invariably when investigating early historical societies scholars rely on linguistic tools. It is important to recall that culture remains an artificial construct, slowly developed through human experience and preserved through recursive memory. One must avoid confusing culture and ethnicity in what follows.

Cuneiform Writing Technology: Language Families of the Ancient Near East

Although the precise origins of the Sumerians remain uncertain, they were the first to develop an urban civilization complete with a written language. The Sumerians devised a

system of writing based on wedge-like characters that were impressed on clay tablets with a reed stylus. Hence, the Latin *cuneiform*, "wedge-like characters." These were inscribed on a number of writing mediums, including clay tablets, cylinder seals, and *bullae* (stamped lumps of clay used to seal documents). The earliest known written texts were found in Uruk and date to ca. 3600–3500 BC. They amount to little more than temple inventories detailing the assets, labor force, and stored resources at the disposal of a priestly establishment. Temple priests attempted to catalogue these resources using pictographic representations of items such as sheep or measures of grain. Eventually they were able to create shorthand symbols representing the same. From these pictographic characters early chroniclers came to the realization that the symbol for something such as the human foot could also be used as a measurement or for the action of "walking" itself, and, hence, that written characters could assume more flexible, abstract functions as *ideograms* (signs used to represent ideas). In addition, some symbols came to represent the sounds of words or the ideas they represented. Cuneiform symbols thus became syllabic and could be used to write any word in the spoken language, including many words that were impossible to convey through pictures. As a spoken language, Sumerian was well suited for the development of syllabic writing because it consisted largely of monosyllabic words and contained many homophones (words having the same sound but different meanings). To avoid confusion scribes added signs called determinatives to distinguish between similar sounding words. Eventually hundreds of such characters were devised, rendering Sumerian cuneiform a difficult, highly complex writing technology that required years of training to master. By 2500 BC most Sumerian cities supported schools known as *edubba*, or tablet houses, to train scribes and officials. Although the day-long regimen of studies was demanding and punctuated by instances of corporal punishment, the graduates of these schools rose to become government officials, military officers, sea captains, public works supervisors, construction foremen, accountants, scribes, and other professionals. The *edubba* thus facilitated the recursive memory of Sumerian civilization, inventing new systems of learning and culture while preserving and disseminating the knowledge and traditions of the past. Due to its complexity, cuneiform remained the exclusive property of a limited elite, such as the priestly authorities, and the scribal elements that supported these hierarchies. Most rulers probably could not read or write cuneiform, for example.

Cuneiform was one of several competing writing systems to develop in the Early Bronze Age, but it gradually acquired the most practitioners and thus attained regional ascendancy. The presence of competing writing systems reminds us, however, that Mesopotamia was inhabited by a diverse variety of cultures. The capacity of Mesopotamian resources to sustain expanding populations appears to have attracted a diverse yet blended population by the Early Bronze Age. Despite speaking multiple languages, the inhabitants of Sumerian cities appear to have ceased to identify themselves according to tribal or cultural origins. Sargon of Akkad (2334–2279 BC), for example, was a Semitic speaker but a resident of Sumerian Kish. Although his father was allegedly a commoner, his mother was a temple priestess. Hence, the family was fully integrated in Sumerian culture. As Semitic-speaking rulers like Sargon assumed control of urban hierarchies, they adapted cuneiform script to

their own spoken language, known today as *Akkadian*. To do this, scribes added phonetic signs behind Sumerian ideograms to indicate that the symbol in question was meant to be read as an Akkadian word instead of the original Sumerian. Akkadian script remained the primary written language, or *lingua franca*, of the ancient Near East for centuries, and was used until the collapse of the Persian Empire (330 BC). (The last known recorded cuneiform tablet is dated to the first century AD.) Making things more complicated still, Indo-European and other elements in the region such as the Mitanni, the Luwians, and the Hittites likewise adapted Akkadian cuneiform to their spoken languages, adding yet another layer of complexity and diversity to the resulting script. Despite its modern status as a dead language, cuneiform enjoyed long and widespread use for nearly 3,000 years in the ancient Near East. We owe our understanding of cuneiform to Sir Henry Rawlinson, a British officer and classicist who carefully recorded the inscribed text of the royal inscription of King Darius I of Persia at Behistun in 1838. The text was inscribed in three languages: Old Persian, Elamite, and Babylonian-Akkadian. Rawlinson and others were able to use their knowledge of Old Persian to decipher the cuneiform versions of the text.

Ancient Near Eastern Language Families

Which languages were 'native' to the Ancient Near East, and what do they tell us about the origins of various ancient Near Eastern peoples? Linguists who tend to "lump" languages together argue that all spoken languages arose from common root languages that lend themselves to reconstruction. According to this line of reasoning, all existing languages descend from some 19 original language families. Moreover, at the foundation of each language family was an original proto-language that was spoken by a small isolated population living in a specific place during prehistoric antiquity. Civilizations that preserved written records of themselves furnish us with insight to their cultural attributes undeniably in far greater detail than those obtainable solely from material remains. This is why investigators place so much emphasis on the language properties of early historical peoples.

Some of the language families present in Mesopotamia during the Bronze Age appear to have been native to the region. Subarian and Hurrian, for example, are believed to have originated in the mountains of eastern Anatolia (modern-day Armenia), whereas Gutian and Kassite possibly emerged from the Zagros Mountains to the east (modern-day Iran). Although their prevalence and influence on neighboring language cultures during the Bronze Age was significant, like Sumerian they failed to endure to modern times. Three language groups that did survive were Semitic, Indo-European, and Elamitic (Dravidian). Each of these will be considered in turn.

Semitic languages represent the largest subfamily of the Afro-Asiatic family of languages spoken throughout the Middle East and northern Africa. Ancient Semitic languages included Akkadian, Babylonian, Ugaritic, Canaanite, Phoenician, Hebrew,

Moabite, Aramaic, and Nabataean, from which arose modern Arabic, Hebrew, Ethiopic, and Amharic. As one scholar has observed, Semitic language speakers have furnished us with the Old Testament (Hebrew), the New Testament (Aramaic), and the Koran (Arabic). Afro-Asiatic languages are believed to have descended from a single language originally spoken in a narrowly conscribed region. The question remains where. One theory posits that Semitic languages descend from the language spoken by the Natufians in Israel (ca. 12,500–9500 BC) and that they spread out across the region in conjunction with the diffusion of Natufian agricultural technology. Another points to the Red Sea shore, where highland rainfall along the arid Red Sea coast presented humans with an extremely fragile habitat. Excess population may repeatedly have surpassed the limited carrying capacity of this region, inducing out-migration, which may explain the recurring pattern of migration among Semitic peoples not only toward Mesopotamia but also into the Nile delta of Egypt (the Hyksos, on which see below). As with all cultural attributes, Semitic languages, particularly Akkadian, were borrowed and/or assimilated by people bearing non-Semitic ethnic backgrounds, such as the Elamites, the Hurrians, the Luwians, and the Hittites. To suggest that people who spoke the same language necessarily shared the same culture is logically unsound. Accordingly, it becomes dangerous to read into language heritage anything beyond what the languages themselves have to offer.

Elamite offers some alternative insights to cultural development in the Ancient Near East. Elamite was present in Khuzistan (western Iran) by the Jemdet Nasr Period (3300–3000 BC). Close contact with Ubaid and Uruk cultures in Mesopotamia led to the emergence of urban communities in the region of Anshan and Susa. These expanded into the Iranian plateau by a process either of colonization, conquest, or cultural diffusion. Unlike the prevailing pattern of independent city-states in Sumer, the Elamites relied on their extensive cultural horizon to collaborate as a wider hegemony centered around three separate polities—Awan (later known as Susa), Shimashki (in a region north of the Susan plain), and Anshan (modern Fars in southwestern Iran). At different times each of these regions gained power over the wider federation and the capital shifted accordingly. The polities of Elam remained menacing to those in Mesopotamia, whose inhabitants depended on them, nonetheless, for natural resources such as timber, metals, and stone. Control of so many important resources insured them an important place in Near Eastern history from the Bronze Age to the rise of the Persian Empire (539 BC). Notwithstanding this long Near Eastern heritage, linguists have suggested that Elamitic is most closely related to Dravidian languages that are more generally spoken today in southern India. Based on the location of ancient Elam along the southern flank of the Zagros Mountains. in Iran (none too far from the Persian Gulf), some have suggested that Elamitic-Dravidian languages were once widespread along coastal lowlands from the Persian Gulf to India. Around 2000–1800 BC Elamite-Dravidian language speakers were driven farther eastward and southward by northern invaders speaking Indo-European languages. Today, Dravidian languages, such as Tamil, Malayalam, Kannada, and Telugu, are spoken principally in southern India and Sri Lanka.

Scholars have known for centuries that most of the languages spoken across western Eurasia (from Britain to India) were derived from a common ancestral language known as **proto–Indo-European**. Today Indo-European languages are spoken by more people on the planet than any comparable language family and include Indic languages such as Hindi and Urdu; Iranian languages such as Farsi and Kurdish; Slavic languages such as Russian, Polish, and Serbo-Croatian; ancient and modern Greek; Latin and its derivative "romance" languages (French, Italian, Spanish, Portuguese, and Romanian); Germanic languages such as German, Norwegian and English; and Celtic languages such as Irish. Linguistic historians believe that these languages were all descended from a single language originally spoken by a small group of people, probably a few thousand, living somewhere in the vicinity of the Black or Caspian Seas. Around 2200–2000 BC these people began to radiate outward in various directions—southward to the Balkans, Anatolia, Mesopotamia, Iran and the Indus; northward to the Baltic and Scandinavia; westward to Europe and Britain; and eastward into Central Asia (the Tocharians). Based on the reconstructed proto–Indo-European language, investigators argue that Indo-Europeans raised cattle, grew crops, kept dogs as pets, used bows and arrows in battle, and worshiped a male god associated with the sky. Indo-European languages bear several related words for wool, for example, and an equally rich vocabulary for trees, indicating the likely importance of herding and wooded environments to their origins. Naturally, the reservations expressed earlier about Semitic language heritage apply equally as much to Indo-European; however, we are able to obtain a fairly good idea not only of the points of origin of peoples who migrated into Mesopotamia, but also of their remarkable diversity.

SOCIAL ORGANIZATION OF MESOPOTAMIAN COMMUNITIES

Along with the remains of ziggurats (step-like raised platforms), one of the most telling artifacts in the assemblages of Sumerian urban sites is the ubiquitous ration bowl, a hastily worked, gray ceramic bowl with an angled or beveled rim. These bowls were typically mold-made, of uniform size, and produced in large quantities. At some sites they represent more than 75 per cent of the excavated pottery. Ration bowls were used to distribute food rations to members of large autonomous units known as **households**, making these the fundamental building blocks of the Sumerian urban revolution. Households formed closed, self-contained, and self-sustaining corporate entities. Early Sumerian households were organized hierarchically by members of the social elite (priests, kings, queens, nobles), but unlike modern notions of family, they incorporated potentially scores of unrelated people, including farmers, herders, artisans, and fishermen. Numerous male and female laborers existed at the bottom of the household and were rewarded for their labor with rations of barley, oil, and wood. By working together, these large combines generated the necessary food and material to sustain the organization as a whole. While many dependents

lived separately with their families, others dwelled in institutional lodgings furnished for their particular element of the household. Widows, children, and the elderly likewise found shelter in these combines.

The emergence of households ultimately enabled limited elements of population not engaged in agricultural work to sustain themselves while pursuing alternative activities in crafts, accounting, the military, administration, and the priesthood. This becomes important for two reasons: first, it suggests that early urban societies evolved from redistributive patterns of economic behavior; second, these entities developed sufficient scale and complexity to sustain themselves corporately, that is, independent of family structure. This development marked a fundamental requirement in the process of state formation. In complex societies such as Mesopotamian city-states, no one individual, family, or profession was crucial to the survival of the community. Lugals and ens could come and go, but the society was sufficiently well trained and staffed and its resources sufficiently abundant and organized to allow for the selection of replacements as life went on. In Mesopotamian city-states cultural forms of identity, such as membership in a community's priestly and royal hierarchies and its constituent households, gradually transcended the bonds of lineage-based social formations (hunting bands, clans, or tribes). The ration bowl thus becomes a crucial bell weather for the development of urban states throughout the region; its remains are found not only in emerging city-states in northern Mesopotamia and Syria, but also in Elamite settlements as far removed as the Caspian Sea.

HAMMURABI'S LAW CODE

The development of complex societies in Mesopotamia becomes clearer when we consider the contents of the inscribed Law Code of King Hammurabi of Babylon (1792–1750 BC). In this document we can see that despite the rise and fall of large territorial states such as the Akkadian Empire and the Third Dynasty of Ur, Mesopotamian society still depended greatly on collectives and exhibited a relatively limited range of complexity. Before considering in greater detail what the Law Code reveals about status hierarchy in Babylonian society, we need to assess briefly the code as a legal document. In structure Hammurabi's Law Code presents itself as a list of seemingly unrelated rulings that in some respects resemble the decisions of the US Supreme Court. Framed between a prologue and an epilogue are some 282 statements all structured on the same pattern: *if…, then….* There is no actual code, in other words, but rather a list of settlements and punishments to be imposed depending on circumstances or the seriousness of the crime. Closer inspection of the code does seem to indicate, however, that the king's rulings are arranged according to types of offenses. It begins with a section addressing abuses by aristocratic legal authorities and progresses through abuses by military hierarchy, fraudulent aristocratic business dealings (again indicating that aristocratic abuses formed a large part of the problem), fraudulent contracts, issues of marriage disputes, divorce, widow and child support, crimes of

The Law Code of Hammurabi survives as one of the earliest written bodies of law. Engraved on a black basalt stele reaching over seven feet tall, Hammurabi's law code consists of 3,500 lines—written in Akkadian cuneiform—that address all aspects of governance in Babylonia, including commercial and property law, domestic issues, and the treatment of slaves. In addition to its socio-political significance, the stele is an important work of sculpture that combines both text and image.

The top of the stele depicts Hammurabi, seen in relief and smaller in scale, standing with his arm raised in greeting before the enthroned sun god, Shamash. Holding a rope ring and the measuring rod of kingship, Shamash extends his hand to Hammurabi in a gesture that both unifies the composition and, metaphorically, the two figures. The image effectively conveys Hammurabi's status as "the favorite shepherd" of Shamash, the former's power having been divinely ordained. The image shares familiar conventions with Akkadian relief, such as the combined front and side views of Shamash known as a composite view.

Yet the depiction of the seated sun god at a slight angle rather than frontally or in profile is significant. Furthermore, the stele survives as one of the earliest examples of foreshortening—a means of suggesting depth by representing a figure or object at an angle. This use of foreshortening is enhanced by the artist's employment of diagonal rather than horizontal lines in Shamash's beard and the depiction of his throne at an angle, both suggesting recession into space.

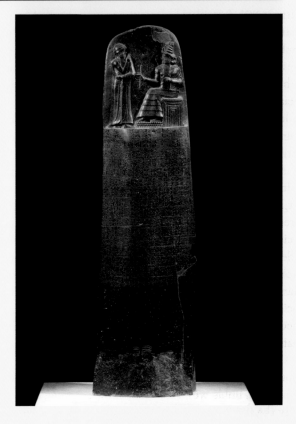

Figure 1.2 Stele with law code of Hammurabi, from Susa, Iran, ca. 1780 BC. Basalt, 2.25 m high. Musée du Louvre, Paris.

passion, inheritance disputes, and it concludes with a list of punishments for acts of physical abuse and negligence. The organization of the code appears to contain bracketed rubrics of legal precedents that in some respects resemble classic Roman legal notions; namely, the laws of person, property, obligation, and actions.

Beyond this there is serious disagreement concerning the actual purpose of the code. Some have argued that the code represented Hammurabi's attempt to resolve disputes that had arisen between the crown and elements of the Babylonian hierarchy, others that it represented a selection of royal decisions to be made available as precedents, and still others that the code actually functioned as a textbook containing sample tractates on law to train bureaucrats aspiring to become judges and legal experts. Taking issue with this logic, many scholars have observed that the entries do not cover an adequate range of legal outcomes and exhibit a number of contradictions. This has led to yet another hypothesis that the stone was never really intended to furnish a functioning law code. Rather, its

purpose was to serve as a memorial erected to glorify the king as an exemplary enforcer of justice. Instead of a list of legal precepts, in other words, the code served to demonstrate to the gods and the Babylonian people that the king had fulfilled his judicial responsibilities. The imperfect nature of the code and the uncertainty of its intended purpose need to be recognized, therefore, notwithstanding the value it holds for our understanding of social organization in Middle Bronze Age Mesopotamia. What is certain is that the process of legal formulation and compilation in Mesopotamia had been ongoing for centuries: fragments of Sumerian law codes predating that of Hammurabi survive and most probably furnished models for his code.

Ancient law codes serve as useful barometers for the political health of societies undergoing transition from rural to urban lifestyles. The same pattern can be demonstrated for law codes recorded in Mesopotamia, Hittite Anatolia, Iron Age Israel, and archaic Greece and Rome. On the surface ancient law codes demonstrate the existence of a rigid social hierarchy, usually entailing brutal disregard for human rights. The codes typically reflect the dominance of a hierarchy based on autocratic or at best aristocratic rule. Falling back on the Latin expression *lex talionis* (the law of retribution in kind), the Law Code of Hammurabi imposed legal punishments based entirely on one's status in the Babylonian society. For crimes committed by a noble against another noble, justice was meted out according to the biblical dictum "an eye for an eye." However, the Law Code asserts that if a noble were to commit an offense against a "commoner," he would pay one mina of silver for a damaged eye or broken bone, and one-third mina of silver for a damaged tooth. Were a noble to destroy the eye or break the bone of a slave belonging to another noble, that noble would pay one-third the monetary value of the slave. To comprehend fully the significance of this logic, one must know that a mina equaled approximately a third of a year's income and was no trifling amount. Notwithstanding the value of the imposed penalty, aristocrats enjoyed higher status than ordinary citizens, whose status in turn ranked above that of slaves. The importance of law codes as a progressive influence on society seemingly becomes lost in all this, yet it remains a salient truth.

What the Law Code tells us is that Babylonian society still very much relied on systems of dependence such as the Sumerian household, but that the expanding urban landscape and the development of extraterritorial states had induced significant societal dislocations with a growing tendency toward privatization and piecemeal contract labor. This created opportunities for some but placed far greater burdens on the majority. Below the monarch, whose powers were nearly unrestricted, the code distinguished Babylonian society

TABLE 1. MESOPOTAMIAN SOCIAL STATUS ACCORDING TO HAMMURABI'S LAW CODE		
KING		
Nobles	**City Council**	**Priests**
Soldiers	Merchants, Artisans, Traders	Scribes, Hierodules, Servants
Farmers	Farmers	Farmers
Dependents and Slaves	Dependents and Slaves	Dependents and Slaves

according to three social orders (avoiding the modern expression of *class* with its anachronistic implications): the *awelum* or nobles, the *mushkenum* or commoners, and the *wardum* or slaves or dependents. While none of these elements was monolithic, in general we can identify the nobility as freeborn, landholding property elites, the commoners as those that enjoyed free status and some hold on property, and the slaves and dependents as serfs who tilled the lands of their superiors to furnish resources for everyone above.

The Law Code demonstrates that the king enjoyed extremely close ties with his nobility and his army. Nobles, who descended from wealthy landholding families typically related by blood or marriage to the royal family itself, pledged their loyalty and service to the king in exchange for offices, commissions, and gifts of land and wealth, thus enjoying privileges of appointed positions of authority. As generations passed these resources became hereditary within specific aristocratic families, inevitably weakening the king's hold on his elite. Aristocrats remained privileged elements in all ancient societies, and every urban society to be discussed in this book was dominated to a large degree by some form of local landholding elite.

Beneath the aristocracy but standing in similarly close relation to the king was the army. Individual soldiers tended to be commoners who pledged unquestioned loyalty and service to the king in exchange for allotments of land, assigned and monitored by the king's bureaucracy. These land grants sustained the warrior and his family and enabled him to maintain his abilities as a professional soldier. In addition to land, the king might award the soldier laborers, slaves, and livestock to work the land. Soldiers formed the backbone of the king's power and authority, and the Law Code details at considerable length the kinds of abuses they endured: taken prisoner in battle and ransomed, missing in action for years on end, and forced to sell their property and livestock to corrupt officers to pay off debts. In every instance the king took measures to protect the soldier's interest and the king's own land allotments with decided firmness. The king not only viewed the soldier's land allotment as royal property, but he also regarded the soldier's service as a civic burden to be borne by all subordinate institutions, including priestly hierarchies.

With respect to city councils, the Law Code demonstrates that the king delegated considerable authority and responsibility to this hierarchy insofar as the governance of the urban population was concerned. Contractual disputes, marriage and divorce disputes, and various offenses concerning women were assigned by the king to the adjudication of city councils. Even disputes involving nobles were sometimes adjudicated by the councils. The role of city councils was obviously pivotal to the maintenance of public order in various Mesopotamian cities within the empire. Membership in the councils was probably determined by election or co-option to municipal offices, such as judge, festival manager, or tax collector, after the tenure of which the ex-magistrate would enter the council for life. Whether or not the councils co-opted wealthy nonaristocrats such as financiers and merchants remains an open question, but it stands to reason that the latter professionals undertook extensive dealings with the councils merely to conduct their business activities. Even the palace administration relied extensively on merchants to manage credit transactions related to long-distance trade and military logistics. The widespread reliance on

such financiers and petty usurers could occasionally lead to debt crises and public disturbances. Although Hammurabi and other monarchs made a point of proclaiming that they successfully intervened to annul debts (and that they did so on more than one occasion), the very fact that they had to revisit the matter demonstrates the recurring tendency of merchants to gain the upper hand in these transactions. One needs to distinguish, in any event, between the local nobility that staffed the city councils of individual Mesopotamian cities and the aristocrats who served as courtiers for Hammurabi's wider empire. (Imperial authorities enjoyed much greater status, as will become apparent below.)

The Law Code records the activities of merchants and traders, who ranked as the leading urban professionals (and whose distinction becomes less apparent when rendered into English). Merchants, better translated as moneylenders or financiers, were self-made businessmen who began their careers as traders and toiled successfully to accumulate the necessary assets to lend at high rates of interest to traders, soldiers, and nobles: they successfully transformed surplus wealth into metal bullion in order both to store it and to use it in commercial transactions. Traders were more typically small-scale businessmen who borrowed extensively from merchants to purchase commodities with which to traffic abroad through caravan trade. These were the professionals largely responsible for the actual conveyance of resources such as metals, stone, timber, spices, and resins.

In addition to these two recurring professionals, the Law Code mentions a plethora of skilled laborers, including boatmen, ferrymen, builders, contractors, carpenters, hired cultivators, livestock branders, cattle herders, shepherds, wagoners, laborers, brick makers, weavers, seal cutters, jewel makers, smiths, leather and basket makers. According to the Law Code, all dealings between these professionals required the completion of formally witnessed contracts.

Religious administrators of the major cults were typically appointed by the king and enjoyed noble status, not to mention the benefit of a large household. They also employed an array of religious staff, including scribes, servants, hierodules, and nuns (*naditu*). Many of these last were aristocratic females assigned to the orders and sustained in part by their families. While their purpose appears to have been to perform religious observances in the interest of their families, at the same time they furnished noble houses with direct contacts and leverage inside the temple hierarchies. Much like the nobility the administrators of temple complexes owned significant landholdings that they rented out to tenant farmers or farmed directly through dependents and slaves. Their household staffs also included skilled slaves and artisans to manufacture the necessary elements of cult.

Lower Orders in the Law Code

Skilled professionals, including merchants and traders, typically began their careers as slaves or were otherwise of low origin. They themselves purchased additional slaves to work as laborers. Investment in slaves reaped greater benefit depending on the skill set of the laborer. The most highly prized slaves were those who could earn significant profits

for their masters, such as accountants, financiers, traders, jewelers, and gem cutters, not to mention teachers, artists, performers, philosophers, gourmet cooks, prostitutes, and undertakers. Honing these skills through apprenticeship represented an investment that was more safely rewarded within one's household through ownership of the apprentice's labor rather than by contracting out for the same. Skills led to profits, and from early antiquity slave-owners came to understand that more profit could be reaped from slave laborers by allowing them to keep some small portion of their earnings (in Latin, a *peculium*). Over the course of a career a skilled slave could expect to save a sufficient amount of capital eventually to purchase his or her freedom. Manumission was a common component to slavery in all ancient societies, some more than others as we shall see. The matter-of-fact acceptance of slavery remains one of the least savory aspects of ancient societies: slavery reflected the cold, harsh reality that humans were considered potential commodities in antiquity and were exploited for manifold purposes.

At the bottom of Babylonian society existed a vast, historically muted population of farmers. One estimate holds that half the population of ancient Babylon was represented by free farmers. Given the size of this element, it is disconcerting that we know so little about it. Presumably uneducated and illiterate, farmers tended to represent elements of indigenous population that sustained the cosmopolitan hierarchies of their respective cities. In several instances during the Bronze Age victorious kings relocated whole populations of conquered cities and regions to build and populate newly founded cities in their home territories. Although the people were not treated as slaves, they were assigned to land that remained the property of the king. One of the postulated reasons for the rapid collapse of the Assyrian empire in 612 BC, for example, was that the populations of its three capital cities, Assur, Nineveh, and Khorsabad, consisted largely of alienated inhabitants such as these. Later, Hellenistic Greek sources would refer to the broad farming populations of the rural landscape somewhat generically as the *laoi*, a nameless, faceless population that tilled the land. This population appears to have worked incessantly in the fields not only to sustain their own immediate families but also to provide surpluses to social elements that stood above them—soldiers, priests, merchants, nobles, and kings. Some significant portion of their yield was seized by the hierarchy in the form of rent, taxes, tribute, customary duties, and interest. Unlike skilled slaves, we hear nothing about farmers growing rich and rising into higher social orders: their role in society tended to be fixed and their places locked in. In essence, farmers were tied to the land but enjoyed higher status than slaves. Barring warfare, they could not be bought and sold, nor could their land be taken away from them and given to someone else. This gave them a certain degree of leverage over their societies, not to mention their own immediate futures. Urban hierarchies depended on the back-breaking efforts of these rural populations to sustain their communities. It was counterproductive ultimately to disturb their laboring activities other than through the implementation of measures intended to enhance agricultural output. In the Ancient Near East in particular farmers enjoyed the unique position of staying put, securely harnessing the land, and enjoying the benefits of family and community while watching the better recorded elements of the social hierarchy pass by. As societies grew

increasingly complex and empires came to control large swaths of distant rural terrain, the dislocation between the *laoi* of local farming communities and the ruling classes in distant urban centers became extreme.

THE ROLE OF WOMEN IN HAMMURABI'S LAW CODE

Aristocratic and Middle Class Women

As one of the earliest recorded signposts for the status of women in antiquity, Hammurabi's Law Code possesses unsurpassed value. To be sure, generalizations derived from this evidence carry obvious and significant risks. However, the data obtained from the Law Code are remarkably consistent with information furnished by external records not only in Bronze Age Mesopotamia but in other civilizations defined as traditional societies. At this point, we will establish a general working construct for the role of women in antiquity, or at least for the period of the Bronze Age, while acknowledging where possible its parallels in neighboring and/or later civilizations.

From a modern perspective the construct of women's place in society was not a happy one. In Mesopotamia and elsewhere women enjoyed status best described as *separate but parallel* to that of men. Women did not serve in the military, nor did they engage in public life; as such, they lacked commensurate socio-political status. Women were recognized as the social agents most responsible for the reproduction of the family, the maintenance of household, and the longevity of society. At least among property-holding elements of society, therefore, respectable, freeborn, property-holding women were accorded enormous respect. For this reason, their role could be viewed as parallel. In other respects, attitudes toward women could be described as patriarchal. The space they typically occupied in life and in work was rigorously segregated according to ancient notions of public and private, with a woman's place located decidedly in the private sphere. Hence, their world was separate. Therein lay the dichotomy of female status in most ancient societies: women were not regarded as equals, but they were recognized as crucial to the well-being of Babylonian society.

Respectable women were expected to maintain the household, to manage its daily tasks, to raise children, and if necessary to tend to agricultural work. From a strictly legal perspective women were regarded somewhere between the status of a man's property and his ward. As a child a woman lived under the protection of her father's household. When she reached puberty she was transferred from the protection of her father to that of her husband through a marriage agreement. Marriages were arranged, and the agreements were decidedly contractual, with women being exchanged as commodities. The husband typically paid a purchase price to acquire the bride, and the woman's family furnished a dowry to assist with the costs of forming a new household. In essence, the woman was

sold to the husband to furnish him with children and to establish and maintain his household. Before and after marriage, a woman's world was largely restricted to the domestic areas of the family dwelling. A respectable matron was also restricted by social norms from leaving the household unless modestly dressed (her person fully covered by clothing) and accompanied by chaperones. It needs to be reiterated that this description is based on the assumption that the woman was of freeborn status, raised by a respectable, property-holding family, and married according to all the necessary procedures and rituals. Otherwise, a woman's treatment tended to be considerably worse and her exposure to potential physical abuse significantly greater. In other words, apart from the autonomy enjoyed by female members of the aristocracy, this description was about as good as it got.

Within the household the predominant hierarchy was patriarchal. The oldest surviving male controlled everyone and everything within his domain. Any man who had successfully created and/or inherited a viable agricultural concern regarded all living and inert elements of the farm as his property, including the worked land itself, the stored grain, the farm implements, the farm animals, the slaves and servants, and even the members of his own family. He determined the legitimacy of infants born to him (and could deny it). Through his power to determine the distribution of surplus, he acquired the absolute authority of life and death over everyone and everything in his possession. The male patriarch was the dominant figure at the core of most ancient social structures. In the Indo-Iranian Vedic culture of early Iron Age India (northwest Pakistan), for example, the central importance of the husband was demonstrated by a custom known as Sati, where the wife immolated herself over her deceased husband's remains. This ritual functioned simultaneously as a form of human sacrifice and as an acknowledgement by the dutiful wife that with the demise of her husband her own life had no further purpose.

The range of a woman's behavior depended significantly on her place in society. Those at the top of society, aristocrats and members of royal dynasties, enjoyed considerable freedom and opportunity because of their wealth, upbringing, and social status. The lives of those in the middle of society—free-born, property-holding families—were considerably constrained by norms of propriety, but their status was protected, nonetheless, and accorded respect. Those living at the bottom of society, impoverished women without the benefit of a family safety net, such as slaves and orphans, were treated terribly. Due to their lack of means, they enjoyed greater freedom but only at the lowest possible thresholds of existence. Any number of variables could influence the outcome of a given female's experience, including family dynamics and her own unique talents and quality as a person.

Aristocratic women, for example, were valued for the worth they stood to inherit from their families as well as for the important roles they played in political marriages. Aristocratic families vied with one another to arrange worthwhile marriages for their children in order to position young males for highly competitive public careers in politics, the military, or religion. Aristocratic women were typically accorded some degree of education, therefore. There was no way to predict the inevitable dynamic that would emerge in such a household. Women with powerful personalities could potentially dominate both their households and their husbands, particularly if their own families enjoyed

Enheduanna, daughter of King Sargon and priestess of the moon god Nanna at Ur, is an exceptional figure in the male-dominated world of ancient Akkad. She has the distinction of being the first poet—male or female—whose name is known today, having authored a series of hymns in honor of the goddess Inanna. A fragmented alabaster disk found at Ur is the most important object associated with Enheduanna to survive from antiquity. The front of the disk depicts four figures approaching a four-story ziggurat; the reverse contains cuneiform inscriptions identifying Enheduanna as the "wife of Nanna" and "daughter of Sargon, king of the world." Furthermore, the inscriptions credit Enheduanna with building an altar to Nanna in his temple—thus explaining the round, full moon shape of the votive.

On the front of the disk, the figure of Enheduanna is shown slightly taller than the nude man at left (perhaps a priest or assistant), or the two clothed female attendants at her right. In addition to this use of hieratic scale, Enheduanna is depicted wearing a headgear that distinguishes her as a priestess.

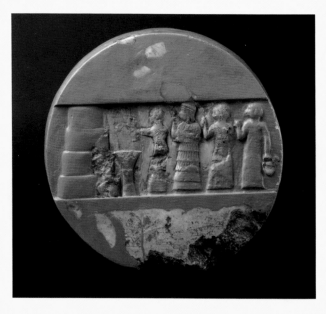

Figure 1.3 Votive disk of Enheduanna, from Ur (modern Tell Muqayyar), Iraq, ca. 2300–2275 BC. Alabaster, diameter 25 cm. University of Pennsylvania Museum of Archaeology and Anthropology, Philadelphia.

greater status. Despite the fact that the model of the respectable matron remained the norm in aristocratic society, individual females at this level of society enjoyed a considerably greater range of freedom.

Women of gifted intelligence often pursued intellectual careers. Female poets were recorded in all civilizations covered in this book. In Sumer, in particular, all love poetry was written in a feminine dialect called *emesal*, which presumably imitated the high-pitched voice associated with females. Female poets and composers of religious hymns likely played a role in its development. Enheduanna (2285–2250 BC), the daughter of King Sargon of Akkad, who was appointed head priestess of the moon god Nanna (Sin) at Ur, composed ritual hymns, including the *Exaltation of Inanna*, that were recited for centuries. She left behind a corpus of literary works that are regarded today as one of the first attempts at a systematic theology. Typically, women had to sacrifice the more typical expectations of their aristocratic upbringing to pursue intellectual careers.

Significantly greater status was accorded female members of ancient monarchies and imperial families, but this was offset by the tendency among these elites to employ polygamy or royal harems for political and diplomatic purposes. Not only was polygamy commonplace in royal households throughout the ancient world, but in addition to wives,

kings tended to acquire numerous concubines, reportedly dozens, if not one for every day of the year, as symbols of royal wealth. The evidence obtained from several Bronze Age Near Eastern dynasties does indicate a tendency for polygamy on a much smaller scale. Typically, the number of queens was quite small, two or three, with one invariably recognized as the main queen and the others typically referred to as minor wives. Most were native princesses possibly of the same royal family, many hailed from leading aristocratic families of the realm, and still others were foreign princesses used in this manner for diplomatic purposes.

A queen's influence was largely determined by her place within the harem, therefore, and the mother of the heir apparent typically enjoyed the highest status as the chief queen. Mesopotamian queens frequently possessed separate palaces, bureaucracies, and households, sometimes managed by powerful female officials. Several Near Eastern queens took advantage of the power vacuum created by the demise of their husbands to act as royal regents, particularly in those instances when the heir apparent was too young to rule. Precisely how the heir apparent was determined varied not only according to civilization, but even according to dynasty, and ultimately depended on personal dynamics within the royal family. For the best examples, we must extend our search beyond the realm of Babylon, once again. On at least seven occasions Bronze Age Egyptian queens assumed the throne on behalf of infant sons, three as kings and four as regents (the reigns of all but two are disputed). In the traditional venues of religion, politics, and warfare, therefore, Mesopotamian queens, princesses, and aristocratic females and those from other ancient civilizations closely shadowed those of males. On occasion queens and princesses assumed active roles in the men's arena. In virtually every phase of activity, women born to wealth and high aristocratic status chose individual paths and pursued careers and activities similar to those of men. As poets, queens, regents, priestesses, philosophers, historians, and warriors, women at the top of ancient society tended to leave an indelible mark.

As opposed to royal spouses, Mesopotamian concubines were typically women of inferior social status who were selected and cared for by the ruler for personal reasons. Royal concubines typically arose from affairs of the heart, and kings tended to collect them like trophies. Concubines apparently were commonplace among the freeborn property-holding social strata as well. In Hammurabi's Law Code a concubine was viewed legitimately as a wife, though not of the same rank as a husband's formally recognized wife. She was usually a free woman (with a dowry) selected to produce children in the event that the wife proved incapable. Her children were viewed as legitimate although they would not necessarily be eligible to acquire inheritance alongside the husband's legally recognized children. Although the offspring of such relationships could not expect to be in line for the throne, it is certain that they participated in the palace hierarchy.

Underclass Women

Looking more specifically at Hammurabi's Law Code, women arising from nonaristocratic, freeborn, property-holding families tended to experience more constrained circumstances in conformance with prevailing mores. Yet it is precisely here that the nuances to the existing constraints on women's behavior are best illuminated. The emergence of urban societies inevitably bred underclasses that included women among their constituencies. Underclass women found themselves in much harsher circumstances: they enjoyed greater freedom to the extent that they were left to fend for themselves, but typically they were accorded little to no protection under the law. Urban society imposed a significant financial burden on families that many were unable to endure, culminating in a breakdown of the traditional safety net afforded by households and family networks. Widows, orphans, and impoverished citizens fell through the cracks in Babylonian society and ended up on the streets, oftentimes homeless and without means of support. In ancient Mesopotamian cities, impoverished unattached women labored in a variety of ways. They ran bars and taverns, sold produce in the market places, performed artisan tasks, and engaged in menial labor, such as milling grain, baking bread, brewing beer, and washing and dyeing clothes. Not coincidentally most of these activities entailed services to patrons who were principally males. At the bottom of society the status of females, slave or free, hardly mattered because they stood at the mercy of their predicament and at risk of physical and sexual abuse. Regardless, any woman who engaged in activity in the public environment crossed the rigidly segregated boundaries of ancient gender relations and in the eyes of the law abandoned all claim to respectability. All those existing outside the protection of Mesopotamian patriarchal households lived implicitly in ill repute. No unattached laboring women were afforded legal protection from physical abuse, and in the case of females laboring in public establishments such as taverns and inns, it was generally assumed by the authorities that they also freelanced as sex laborers. As the Law Code demonstrates (109), taverns and inns and the women who worked in them incurred unsavory reputations: "If felons are banded together in an ale-wife's house and she does not seize those felons and she has not haled (them) to the palace, that ale-wife shall be put to death."[1] Women working in other menial establishments were subjected to similar physical abuse by their masters, employers, and patrons. In such an environment and under such circumstances, marriage and family were inconceivable depending as they did on nonexistent foundations of dowry, bride-price, household, and the property necessary to support a family.

Even at the bottom of society, social stratification becomes observable. Underclass women blessed with enormous talent, attractiveness, and energy could sometimes rise above their station to become public figures as actors, mimes, and dancers, not to mention professional high-priced sex-laborers known as courtesans. Courtesans usually rose from slave or nonnative origins to be raised by pimps, the latter of whom invested in their

1 *The Babylonian Laws*, ed. D.R. Driver and J.C. Miles (Oxford: Clarendon Press, 1956, reprinted 1968), Vol. 2, p. 45.

potential as entertainers. Courtesans typically offered their sexual favors for a price, but to describe them narrowly as prostitutes diminishes their true capacities. They worked primarily as entertainers and performers: their abilities and celebrity as performers sometimes obtained courtesans access to the highest levels of society, particularly since the wealthiest elements of society were invariably the ones most able to afford their services. Courtesans, thus, existed in all ancient societies; their talents made them attractive to men at the highest levels of society, including to kings and aristocrats. Their professions represented the most visible avenue by which women at the bottom of society could rise above their station to mingle with the urban elite.

CONCLUSION

From royalty to slavery, Hammurabi's Law Code demonstrates rigid status orientation in Bronze Age Mesopotamian culture. However, along the margins of each gradation the nuances of an ongoing process of blending and variation point to a society in a dynamic state of development. Large household combines of the Early Bronze Age gradually yielded place to more privatized collectives, including the development of stored wealth by individuals, the activities of independent merchants and traders in long-distance trade, and the advancement of professionals in a variety of trades. In many ways the social constructs that would more or less dominate the urban landscape of various later civilizations were already functioning in Middle Bronze Age Babylon.

FURTHER READING

Curatola, Giovanni. *The Art and Architecture of Mesopotamia*. New York: Enfield, 2007.

Kleiner, Fred S. *Gardner's Art through the Ages: A Global History*. 13th ed. Boston: Cengage, 2011.

Kuhrt, Amélie. *The Ancient Near East*. London: Routledge, 1995.

Meador, Betty De Shong. *Inanna, Lady of Largest Heart: Poems of the Sumerian High Priestess Enheduanna*. Austin: University of Texas Press, 2000.

Reade, Julian E. *Assyrian Sculpture*. Cambridge, MA: Harvard University Press, 1999.

Stiebing, William H., Jr. *Ancient Near Eastern History and Culture*. New York: Longman, 2003.

Van De Mieroop, Marc. *A History of the Ancient Near East ca. 3000–323 BC*. 2nd ed. Oxford: Blackwell, 2007.

———. *King Hammurabi of Babylon: A Biography*. Oxford: Blackwell, 2004.

TWO

ANCIENT EGYPT (CA. 3100–1069 BC)

WHAT HAVE WE LEARNED?

- ► That the earliest urban civilizations occurred in Mesopotamia, the flat, barren region lying between the Euphrates and the Tigris Rivers in modern-day Iraq.
- ► That investigators of early historical societies rely on linguistic tools, identifying the cultures that existed in Mesopotamia according to the origins of their preserved written languages: Sumerian, Semitic, Indo-European, and Elamite.
- ► That farmers furnished the backbone to Mesopotamian society, representing perhaps 85 per cent of the overall population.
- ► That ancient law codes such as Hammurabi's invariably demonstrate the existence of a rigid social hierarchy with minimal regard for human rights.
- ► That slavery was commonplace in ancient societies.
- ► That most ancient societies were patriarchal; the oldest surviving male controlled everyone and everything in his household.
- ► That women enjoyed social status best described as *separate but parallel* in this era. However, they were recognized as the social agents most responsible for the reproduction of the family, the maintenance of household, and the preservation of society.
- ► That the range of freedom enjoyed by a woman in ancient society depended very much on her status. Those living at the bottom of society survived at the lowest possible threshold of existence.

NEOLITHIC EGYPT

Developments in the Nile Valley of Egypt pursued a different path than those in Mesopotamia. Widespread desiccation around 10,000 BC compelled inhabitants of the Sahara, as well as neighboring regions such as the Sinai and Palestine, to follow their food sources to the North African coast, most particularly to the long slender valley of the Nile. Evidence suggests that these inhabitants adapted to animal husbandry by 8000 BC and to agriculture by 5000 BC. However, they did not acquire bronze technology until 2000 BC. By 4000 BC several Neolithic cultures emerged along the river basin, most notably Omari culture near the mouth of the river (Lower Egypt) and Naqada culture in the highlands to the south (Upper Egypt). Upstream in the Naqada horizon archaeologists have revealed an increasingly homogenous pattern of small but disparate fortified communities with rectangular mud brick houses. These settlements gradually grew to become small principalities or kingdoms corresponding to those of the later **nomes** or administrative districts of the Egyptian unified kingdom. By the Pre-Dynastic Era (3100–2700 BC) there were some 22 nomes in Upper Egypt and 20 in Lower Egypt (the Nile Delta), each governed by a ruler later known as a **nomarch**. During three sustained periods of Egyptian unification, all nomes were absorbed into a centralized state governed by a king with absolute authority. These eras of "united kingdom" eventually collapsed again to the lesser threshold of nomarchic principalities. In anthropological terms the capacity of Egyptian civilization to reconstruct itself from decentralized nomes into unified kingdoms qualifies it as a **nearly decomposable state**. The concept of Egypt as a land of two kingdoms, Upper and Lower Egypt, united by one king who controlled Egypt from the delta in the north to the First Cataract in the south, formed a fundamental truth of the Egyptian worldview. Otherwise, early civilization in Egypt remained isolated for a thousand years. The vast, lifeless desert of the Sahara closed the inhabitants of the river valley off from the west; similarly barren mountains from the east; the narrow gorges, desert reaches, and complicated watersheds of the Nile itself from the south; and the deep waters of the Mediterranean Sea to the north. The formidable nature of these barriers kept the Egyptian population secure from external threats, yet technologically backward and slow to change. By and large, topography and environment worked to the advantage of a central hierarchy.

THE NILE ENVIRONMENT

The Nile river basin forms one of the most unique ecological niches of the world. The river rises in July and attains peak flood stage in August and September. Finally, in October the waters subside. In ancient Egypt, the flood waters would inundate the entire length of the Nile basin, and the contrast between the flood zone and the barren earth would be palpable to the naked eye. Egyptians referred to the area of deposited soil as the Black Earth; the unaffected regions as the Red Earth, with the line so distinct that one could

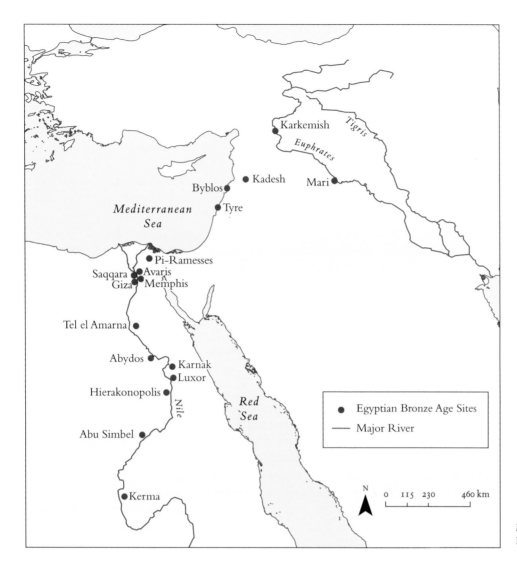

Map 2 Bronze Age Egyptian Empires.

literally stand with one foot in either terrain. Beyond this narrow band the region of barren earth ascended to a range of hills or low mountains on either side of the river valley. Beyond the hills lay the desert, the Sahara to the west and the eastern desert opposite. Low-lying basins behind the riverbanks (known as *wadis*) and similar lowlands in the delta tended to retain water as marshes and swamps. Dense areas of reed plants such as papyrus also thrived in the marshes proving useful to the manufacture of mats and paper.

As early as 5000 BC the height of the flooding along the entire length of the Nile valley was recognized as an important indicator of potential crop yields. The rhythm of the Nile floods determined the agricultural cycle in Egypt. Farmers typically divided their year into three seasons: the Inundation (July through October), the Planting (November through February), and the Drought (March through June). Careful adaptation to this predictable cycle enabled the Egyptians to generate the highest agricultural yields recorded anywhere in the Ancient Near East. According to the Greek historian Herodotus (fifth century BC),

when the floods subsided, the inhabitants returned to the river valley from its desert banks and reconfigured the land into agricultural plots. Farmers would then walk barefoot through the mud bearing bags of seed that they would scatter by hand. They would then have their animals trod the seed into the soil, resulting in rich harvests of wheat and barley. Despite the undoubted exaggeration of this description, few places in the ancient world furnished an easier environment for food production. By organizing irrigation systems and expanding agricultural production into dried out *wadis*, ancient inhabitants of Egypt produced grain surpluses sufficient not only to sustain their own population but to export to populations overseas. To facilitate this commerce, Egyptians appear to have been the first to design sea-going cargo vessels (by 2500 BC). Relying on the natural currents and winds of the Mediterranean Sea, the Egyptians and their neighbors were able to transport heavy staple goods such as grain, stone, timber, textiles, wine, and oil at volumes inconceivable by land. During the Roman era (first to sixth centuries AD) the farmers of the Nile produced sufficient foodstuffs to feed an estimated 7.5 million inhabitants in Egypt proper and another one to two million overseas, not least of which the burgeoning population at Rome.

The natural advantages of Egypt were hardly limited to agriculture. The hills along the river and eastern mountains furnished a variety of stone (granite, marble, and limestone) for building projects, statuary, sarcophagi, and housewares. The Egyptians were the first civilization to master the technique of stone masonry and to construct complex stone edifices. Papyrus reed generated another important product, namely, paper. The reed would be harvested, mashed on stone platforms, left to dry, and then cut into rectangular sheets to be rolled on spindles. Egyptian papyrus quickly became the principal writing medium of the entire Mediterranean world and remained so until well into Roman times. In addition, the Nile valley offered the one significant communications link between Mediterranean populations and those of sub-Saharan Africa. A string of oases in the Libyan Desert west of Egypt (Dakhla, Kharga, Bahriya, and Farafra) formed an alternate route to Nubia. When dominated by the armies and bureaucrats of the pharaohs, these natural highways furnished Egypt with African prisoners, exotic animals, precious metals, aromatic plants, ivory, and ebony.

Last to be noted are the climate and topography of Egypt. The arid climate (ca. 80 mm of annual rainfall) meant that the Egyptians lived beneath a nearly constant sky of brilliant sunshine. The sun rose and set over the desert horizons in the same predictable pattern as the current of the Nile River.

HIEROGLYPHIC SCRIPT

Egyptian history remains the most thoroughly recorded of any Bronze Age civilization due to its extensive use of a pictographic writing system known as **hieroglyphics** or as the Egyptians themselves referred to it, the language of divine words (*medu netjer*). These

PRIMARY SOURCE: THE ROSETTA STONE

Decipherment of the Egyptian hieroglyphic system was made possible by the discovery of the Rosetta Stone in 1799 AD by Napoleon's cavalry during his disastrous Egyptian Campaign (1798–1801). Captain François-Xavier Bouchard was charged with the demolition of an ancient wall in the city of Rosetta, in which the stele was contained. Recognizing its potential importance, the officer spared the stone and, in August 1799, took it to the newly formed Institute of Egypt in Cairo to be studied by French scientists.

Inscribed in Egyptian hieroglyphic, Egyptian demotic, and ancient Greek, the stele dates to the Ptolemaic era, ca. 196 BC, and records a tax dispensation conferred on the priests of an Egyptian temple by King Ptolemy V. Later captured by the British and brought to the British Museum, it was ultimately deciphered by the French linguist Jean-François Champollion in 1822 following its publication in the *Description de l'Égypte*, in which the first full-size reproductions of the Rosetta Stone were published in 1822.

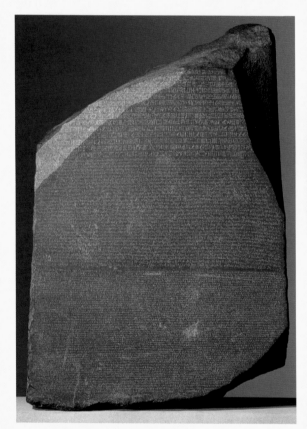

Figure 2.1 The Rosetta Stone.

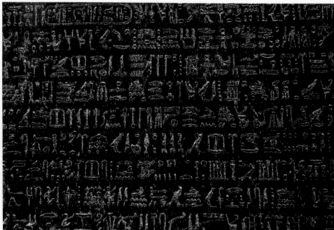

Figure 2.2 Detail of the Rosetta Stone.

Figure 2.3 Léon Cogniet, *Portrait of Jean-François Champollion*, 1831 AD. Oil on canvas, 73.5 x 60 cm. Musée du Louvre, Paris.

characters were phonetically based but relied heavily on the principles of rebus script. In rebus script, words or phrases are constructed from a combination of letters, numbers, symbols, and pictures to sound out meanings. For example, in rebus script the English word *belief* can be written with the images of a bee and a leaf. By 3100 BC Egyptian scribes devised a combination of ideograms, bi-consonantal and tri-consonantal phonetic signs, and determinatives to clarify the meaning of their inscribed texts. Determinatives, such as a straight vertical line drawn below a symbol, informed the reader whether the character was meant to be taken for its meaning (ideogram) or its sound; the drawing of a seated man following a symbol would indicate that the word in question was masculine in form; small running legs placed behind a verb would indicate motion, and so forth. The associated symbols were set in box-like panels with rounded edges known as *cartouches*. Although the hieroglyphic script ultimately devised some 24 signs to represent individual consonants and to this degree verged on a true alphabet, it continued to employ a combination of ideograms, phonetic signs, and determinatives until the end of the Roman era. Since the scripts lacked phonetic symbols for vowels, the pronunciation of ancient Egyptian words remains problematic. This explains the variant spellings of the names of Egyptian kings and queens in modern texts.

Due to their reliance on stone construction techniques, the Egyptians created an abundance of dressed building surfaces suitable for record-keeping. Walls, doorways, even rounded column drums that survive in the great temple complexes along the Nile were decorated with the cartouches of hieroglyphic records. In addition, the climate of Egypt is so arid that highly fragile papyrus scrolls withstand the elements and are discovered almost annually by excavators. By and large, Egyptian records provide the few hard dates that exist for the international events of the Late Bronze Age (1600-1200 BC).

EGYPTIAN CHRONOLOGY

After Egypt was conquered by the Macedonian king Alexander the Great in 331 BC, it was ruled by a dynasty descended from one of Alexander's generals, Ptolemy I (367–283 BC). Educated Egyptians were naturally anxious about the new rulers' lack of appreciation for the cultural heritage of their homeland and sought to enlighten them. One in particular, a priest named Manetho (early third century BC), relied on remarkably well-preserved records to write a history of ancient Egypt organized according to the tradition of its 31 dynasties extending back to prehistoric times. Manetho's treatise presented Egyptian history as three periods of centralized authority, stability, and order, when the kingdom of the Nile was unified under a centralized monarchy. These are known as the Old Kingdom (2700–2200 BC), the Middle Kingdom (2040–1720 BC), and the New Kingdom (1550–1069 BC). These periods of unified kingdom were sustained for incomparable spans of time (500 years in the case of the Old Kingdom, more than 300 each for the Middle and New Kingdom). Eventually each of these kingdoms collapsed, however, and power devolved

back to the local level of the nomitic principalities and their nomarchs. These shorter periods are known as the First, Second, and Third Intermediate Periods.

<table>
<tr><td colspan="2">CHRONOLOGY 3. BRONZE AGE EGYPT</td></tr>
<tr><td>3100–2700 BC</td><td>Pre-Dynastic Era
(Narmer Palette, formation of the Egyptian state)</td></tr>
<tr><td>2700–2200 BC</td><td>Old Kingdom
(dynasties 4–6; era of the pyramids and the godlike pharoah)</td></tr>
<tr><td>2200–2040 BC</td><td>First Intermediate Period
(collapse of unified kingdom, anarchy, return to nomic hierarchy)</td></tr>
<tr><td>2040–1720 BC</td><td>Middle Kingdom
(dynasty 12; the classic era of Egyptian scribal culture)</td></tr>
<tr><td>1720–1550 BC</td><td>Second Intermediate Period
(Hyksos invasions; likely time of Hebrew infiltration of Egypt as recorded in the Old Testament)</td></tr>
<tr><td>1550–1069 BC</td><td>New Kingdom
(dynasties 18–20; era of external empire, expansion into Canaan and Mesopotamia, mercenary armies and imported wealth from conquest and tribute)</td></tr>
<tr><td>ca. 1200–1000 BC</td><td>Collapse of Bronze Age Mediterranean societies (abandonment of external empire; invasion of Sea Peoples; dismemberment of Egyptian empire and united kingdom)</td></tr>
</table>

Manetho's chronology has in large part been confirmed by contemporary source materials such as the Narmer Palette (ca. 3100), which depicts the Pre-Dynastic king Narmer forcibly conquering his neighbors, the records inscribed on surviving Egyptian monuments, and by other records such as tomb dedications and limited finds of royal archives. Since survival in this barren environment depended on the mastery and control of the force of the river, the Egyptian kings, or *pharaohs*, of the Pre-Dynastic Era (3100–2700 BC) assumed political ascendancy by demonstrating their success at organizing the irrigation systems and storage facilities of the agricultural landscape. Control of these enabled them to sustain their subject populations through periods of agricultural shortfall. Regional differences were gradually replaced by a homogenous culture. Memphis gradually emerged as an important administrative center in the delta. By the time of the Fourth Dynasty (ca. 2700 BC), one king, one dynasty, and one central hierarchy was able to consolidate authority along the entire length of the river. This became known as the Old Kingdom (2700–2200 BC).

While artists played a central role in the creation and development of its rich material culture, art—in the modern understanding of the word—did not exist in ancient Egypt. For the ancient Egyptian, every human activity was governed by one's religious cognizance, that is, by a profound belief in the existence and active worship of all-pervading, invisible and superhuman forces that would keep the universe in balance. Art in ancient Egypt referred to the skill of execution, that is, the masterful ability of the artist to create material objects with tools. In this regard, Egyptian art made under the pharaohs is largely unrivaled in the ancient world.

Every work of art in ancient Egypt served a practical purpose. The prolific number of art objects that have survived from antiquity underscores this point. However, whether a funerary sculpture or libation vessel, artworks from this period were devised with creative intent. Much of the art made in ancient Egypt serves as a reflection on man and his humanity, as well as the heroic and benevolent nature of gods and kings. Piety, family, and social harmony are important themes. Likewise important was a rational, disciplined approach to life. This emphasis on order over chaos (imposed by the "creator," Ptah of Memphis) underlies the restraint and mathematical framework of Egyptian artwork.

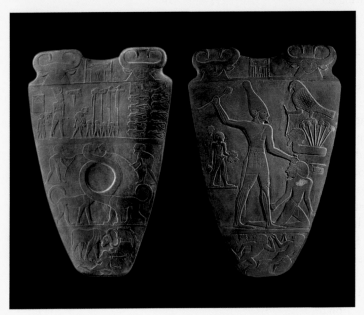

Figure 2.4: Palette of King Narmer (back and front), from Hierakonpolis, Egypt, Pre-dynastic, ca. 3000–2920 BC. Slate, 64 cm x 42 cm. Egyptian Museum, Cairo.

STATE AND SOCIETY IN OLD KINGDOM EGYPT

To rule the unified realm of the Old Kingdom, the pharaohs employed an elaborate bureaucratic hierarchy, including a vizier (or prime minister, e.g., Imhotep, the vizier to the pharaoh Djoser) and a bureaucracy organized according to five separate ministries—agriculture, justice, labor, treasury, and trade. The vizier controlled all the ministries and answered directly and exclusively to the king. Beneath the vizier stood a second echelon of high-ranking officials, including the state granary official, the state treasurer, and the overseer of the great courts. Below this group came the relatives of the vizier, the provincial governors, the priests of the major temples, minor officials within the bureaucracy, and the priests of local deities. The offices of all these administrators were staffed by an educated hierarchy of scribes.

Beneath the bureaucracy stood a population of farmers whose lives were minutely controlled by the hierarchy. The primary focus of the Egyptian economy was the production of stored food surpluses, and the pharaohs used the extensive reach of their bureaucracy

to harness the full laboring potential of the inhabitants of the Nile Valley. Egyptian authorities relied extensively on forced labor, the corvée system, to complete public works projects such as pyramid construction. Hard work was expected in short bursts during peak laboring periods. During the flood season, for example, laborers were drafted for nonagricultural tasks, such as monument construction. Completion of one task would merely lead to the assignment of another. Rebellious subjects, assuming there were any, were faced with an imponderable predicament—how to escape? The inhabitable region was so restricted and the desert expanses on the periphery so vast and lifeless that flight was hardly an option. By and large, the farming population remained restricted to an isolated, highly localized existence of sustained menial labor. But despite its vast production, the Egyptian population remained relatively small and rural. Apart from Memphis, few of the urban centers qualified as genuine cities. These factors render the architectural achievements of the Old Kingdom all the more spectacular.

TABLE 2. EGYPTIAN POPULATION ESTIMATES THROUGH TIME	
Year	Population
before 3100 BC	less than ½ million
3000 BC	1 million
2500 BC	1.5 million
1400 BC (New Kingdom)	3 million
100 AD	7.5 million
1882 AD	7 million
Today	90 million

Such achievements would not have been possible without the benefit of intellectual skill sets attained by the scribal schools. The Egyptians excelled in mathematics and geometry, they devised a decimal-based numerical system, they mastered the ability to calculate areas and volumes of spaces and voids, and through astrological research they determined the direction of True North and the precise movements of the constellations. The daily practice of mummification made Egyptian doctors masters of human anatomy and remarkably skilled with surgical procedures. Therefore, Egyptian knowledge tended to be applied rather than theoretical. Egyptian bureaucrats needed to solve practical problems such as determining the amount of men and material necessary to build a large ramp or a pyramid of a specific size or to calculate the amount of food and supplies necessary to equip a work crew. Numerous accomplishments achieved under the security and stability of the Old Kingdom regime remain visible to this day.

RELIGIOUS IDEOLOGY AND PHARAONIC AUTHORITY IN THE OLD KINGDOM

As noted above, to achieve supremacy the early pharaohs had to conquer and absorb nomitic populations of the Nile through a gradual process of consolidation. They attempted to win the hearts and minds of their subjects by syncretizing the religious worldview of each distinct culture into a comprehensive belief system. These efforts led to an elaborate and richly textured cosmology. Egyptian cosmology was highly polytheistic and intently

focused on notions of magic: they revered a multitude of deities that combined aspects of animals, humans, and natural phenomena; many of these were rooted to the cults of specific nomes and communities. The Egyptians infused their worldview with notions of **sympathetic transference**, or the belief that through spells and rituals one could magically transform a representation of a god or divine entity into the very essence it represented. To construct an effective ideology, one that would successfully unify all subjects of the realm, Egyptian authorities wove together strands of competing and even contradictory religious dogma to construct an argument for unquestioned royal authority. The end result was the nationalization of local religious traditions to formulate an ideology for the Egyptian ruler cult. Once established, the ideology could then be transformed, reinterpreted, or reinvented by succeeding dynasties, invariably to their own advantage. Godheads could be renamed and/or merged; centers of worship could be relocated, renovated, redefined, opened, and closed. Implicit in this dogma was the notion that the chief job of the king was to maintain **Ma'at**, that is, the balance and harmony that prevailed in the universe. He was also expected to renew the rhythmic cycle of the creation deities, Amon (Thebes) and Ptah (Memphis), and to furnish protection to Egypt in the afterlife as the son of other gods, including the sun god Re (originally the chief deity of Heliopolis, Re was later merged with Amon of Thebes to form Amon-Re), and Horus the son of Osiris (Hierakonpolis). Since these three spheres (the balance of Ma'at, the creation cycle, and the afterworld) furnished the religious basis to pharaonic authority, we need to consider each of these in turn.

Ma'at represented the balance of the forces of the universe that necessarily must be maintained if harmony, order, stability, and justice were to prevail. Ma'at was typically personified as a goddess, the daughter of the sun god Re; in iconography she would appear as a woman bearing a feather in a headband or simply as the feather itself. Ma'at was the state in which everything existed in its right place in accordance with the wishes of the gods. Although the balance of the universe was viewed multi-dimensionally, in at least one respect it was expressed as the balance of the river and the land, the phases of the Nile flooding, and the ability of the pharaoh to control this. To the Egyptians the pharaoh represented the bond between nature and humankind. Since the pharaoh alone could secure the benefits of Ma'at, all cult in Egypt was essentially royal cult. The pharaoh preserved Ma'at by offering the gods the fruits of the earth; in exchange he obtained for the Egyptian people the blessings of heaven. The pharaoh's adherence to Ma'at, thus, furnished an implicit moral code. Failure to provide moral leadership could undermine the stability of the kingdom and with it the pharaoh's legitimacy. Natural phenomena indicative of a lack of divine favor was widely interpreted as a failure on the part of the regime.

Unlike neighboring peoples the Egyptians did not create law codes; as a god-king the pharaoh's word was law. This status did not permit him unrestrained license, however. In accordance with Ma'at the pharaoh's legal decisions were expected to adhere to traditional mores and to preserve the status quo. Since his office, if not his actual person, was divine, the pharaoh's role as king placed him in direct harmony with Ma'at. At the same time, he and his administrators remained subject to Ma'at and were duty bound to rule

in accordance with it. This becomes evident from tomb autobiographies recorded by members of the pharaonic administration. Furnishing one of the most important sources for the Old Kingdom, these autobiographies were inscribed in the tombs of deceased bureaucrats and arise mainly from the great necropoles near Memphis (Giza and Saqqara). Along with a request for prayers and offerings to be furnished after death, an autobiography typically listed the ranks and privileges accorded to the deceased during the course of his career. By tracing the various honors he acquired, the tomb occupant composed his life story. The ideals established for promotion and advancement within the pharaonic administration, as documented by these autobiographies, underline the pragmatic morality that sustained the political ideology of the ruler cult. Successful careers were expressed in terms of one's role in the maintenance of the cults of the gods, services performed in the interests of the state, dedication to the requirements of one's office, and fair and equitable treatment of ordinary Egyptians. Belief in Ma'at imposed a moral order, an ethos developed and promulgated by the central authority to legitimize the sanctity of the pharaoh's rule.

Creation myths added a second important dimension to the pharaonic ideology, particularly in later eras. Although these myths varied widely, the main one concerned the Atum of Heliopolis, or the primeval island from which all matter had come into being. According to this tradition, in the beginning there was nothing but the sea, then a mound of earth (the Atum) emerged above the water to furnish the origins of life. Much like the Black Earth rising from the receding waters of the Nile, all life ultimately arose from this mound. Other traditions coexisted with this principal version of creation. In a second tradition two gods of opposite sex mated to produce the sky and the earth, which in turned generated all other elements of life. A third myth, known as the Memphite theology, explained that Ptah, the heart and tongue of all the gods, generated the gods Atum, Re, and Horus (who in turn created all living things). Despite so many strands of myth, the Heliopolitan myth of Atum became dominant. Its power was expressed by the design of the Egyptian temple, in which the high ground beneath the inner sanctum not only symbolized the Atum, but it became the creation mound itself, with all the power and energy of the original.

With Ma'at and the energy force of creation thus established, the third component to the tripartite ideology of the pharaoh was the divine status of the monarch himself. The origins of this notion are detectable already in the Narmer Palette, where the king is portrayed in stature larger than that of his foes. By the time of the Old Kingdom, the monarch possessed five separate names that associated him with divine ancestors (son of Horus, son of Re, son of Ptah, etc.). The most salient among these was his status as the direct descendant of **Horus** and the living embodiment of the river god **Osiris**. According to this tradition Osiris was the Egyptian river god who annually replenished the earth by bearing down the nutrient-rich seed of the flood waters to impregnate the earth, personified by his wife, Isis. Osiris's jealous brother, Seth (the crocodile god), made repeated attempts to destroy him, however, and ultimately prevailed. But Isis carefully employed her life-giving powers to restore Osiris to vigor as a god, enabling him to ascend into the heavens to defend the Egyptian people in the afterlife. Their son Horus, who was

portrayed as the falcon god, defeated Seth and then assumed Osiris's place as the earthly protector of Egypt and the direct ancestor of all Egyptian kings. Since the throne of Egypt was perceived as embodying the essence of Isis, once the pharaoh physically took his seat on the throne he became Horus, the divine son of Isis and Osiris. By claiming descent from Horus, in other words, Old Kingdom pharaohs posed as gods walking on the earth. Each king labored on earth to maintain Ma'at and to restore the creation cycle, yet each king after death would rise into the heavens to protect the Egyptian people from the dark forces of the afterworld. Pharaonic ideology and Egyptian beliefs about afterlife in general insisted on a need to preserve the pharaohs' remains after death in order to bind their spirits and hence their divine power to the land of Egypt. This requirement gave rise to the Old Kingdom's **cult of the dead pharaohs**. An ever-growing portion of the Egyptian economy became committed to the maintenance of this cult.

Like so many other aspects of Egyptian religion, the concept of pharaonic divinity was complex. The Egyptians clearly realized that their kings were mortal: they saw that the pharaohs could not perform miracles and that they grew old and died like everybody else. At its most sophisticated level, proponents of this ideology rationalized that the office of the pharaoh embodied the eternal life force, spirit, or **Ka** of Horus and that whosoever assumed the throne became divine. Although all mortals were believed to possess a Ka, the Ka of Horus resided only within the pharaoh and made him exclusively divine. Through the principle of sympathetic transference, the Ka of Horus was regenerated in each new monarch during the royal coronation ceremony. Although his divine status was not viewed in the same respect as that of other gods, his person nonetheless became sacrosanct and was believed to be dangerously potent. When he died, the pharaoh's remains would be carefully preserved in order to nurture the continued work of his spiritual Ka in defense of the Egyptian people. Each successive monarch underwent rituals of sympathetic transference, therefore, intended to renew the various facets of the origin of the ruler cult: the revival of the creation act (by virtue of the king's ascension to the throne of Egypt); the renewal of Ma'at through the incarnation of a new Horus; the reaffirmation of the dynasty's descent from Ptah, Min, Ra, Horus, and Osiris; and the reunification of the primordial kingdoms of Upper and Lower Egypt. This unique status of the pharaoh and the multifaceted and richly textured layers of religious dogma that it entailed formed the basis to the religious worldview of Old Kingdom Egypt. Nowhere is this better revealed than by the attention devoted to the cult of the Old Kingdom pharaoh in the afterlife.

BURIAL AND THE AFTERLIFE IN THE OLD KINGDOM

Pharaonic ideology insisted on the need to preserve the pharaoh's physical remains after death in order to bind his spirits and hence his divine power to the people of Egypt. According to Egyptian belief the pharaoh's spirit (Ka) depended on the physical remains of his body to survive and would return to earth periodically to visit them; it also needed

food and drink for nourishment. After death and with the aid of the proper rituals, the pharaoh's Ka would combine with his **Ba**, or his unique individual soul, to form the **Akh** (a glorified being of light) and climb a stairway to the sun to combat forces of evil and to protect the Egyptians from harm. The Ka and Ba represented two components of the multifaceted Egyptian concept of the soul. Represented in iconography as a human-headed bird, the Ba, like the Ka, could not survive without daily connection to its physical remains. The Egyptians believed that the reanimation of the Akh was achieved through the performance of necessary funeral rites and sustained through constant offerings thereafter. Important elements of the cult of the dead pharaoh included mummification to preserve the physical remains of the king, daily sacrifices to nourish the components of his soul, and tombs known as **mastabas** where the pharaoh's remains as well as those of members of the Egyptian royal family and hierarchy were interred. The process of mummification entailed the removal of vital organs (deposited in canopic jars) to eliminate moisture and to slow deterioration, and a thorough cleansing of the body's interior cavities with liniments such as natron, a natural salt found near Cairo. The entire process required 70 days to achieve, but with the benefit of Egypt's remarkable climate and careful interment of the body—wrapped in linen dressings and enclosed within a stone sarcophagus—a mummified corpse could last indefinitely.

Originally, mastaba tombs were rectangular structures with paneled facades intended to imitate the design of Egyptian royal palaces. Each mastaba had several rooms for the preservation of burial objects and was conceived as a house for eternity. At the beginning of the Old Kingdom, kings such as the Third Dynasty pharaoh Djoser (2650–2600 BC) sought to create more distinctive monuments to commemorate their status as gods. Djoser's vizier, Imhotep, a polymath of exceptional ability, adapted the design of the mastaba to invent the Stepped Pyramid, a raised monument of five step-like platforms some 60 m tall and 120 m at the base. The Stepped Pyramid was purposely located to rise above the necropolis at Saqqara and to be visible from the streets of Memphis. Around the monument Imhotep constructed an array of artificial structures with false doors to resemble the royal palace complex (and perhaps to fool ever-present grave robbers). With its pyramid visible from Memphis, the scale and size of this complex testified to the growing resources and laboring capacity of the Old Kingdom. The new complex with its monumental pyramid was essentially a grandiose version of a mastaba tomb, now translated into stone. Gradual modifications and technological breakthroughs in stone cutting, drafting, measurement, and architectural design culminated in the construction of the celebrated Great Pyramid of the Fourth Dynasty pharaoh Khufu (2589–2566 BC) at Giza, a few kilometers north of Saqqara. Until modern times the tallest man-made structure in the world, the **Great Pyramid of Khufu** stood 230 m at the base and 147 m tall. Capped with sloping walls of finely drafted limestone, the monument required use of some 2.3 million stone blocks weighing an average of 2.5 tons. Experts calculate that the pyramid required some 20,000 laborers 20 years to complete. The newly designed mastaba complex of the pharaoh thus extended from the banks of the Nile to the pyramid complex on the heights overlooking the valley.

Much like the spirituality of the Egyptian ruler cult itself, the pyramid incorporated complex symbolism in its monumental achievement. Religious spells inscribed in the mastaba complex of Khufu at Giza expressly record the pyramid's intended function as dead king's path to the sky. The pointed capstone and smooth sides of the pyramids represented—and by sympathetic transference was believed to create—a ramp furnished by the rays of the sun to enable the pharaoh's ascent. In addition, each true pyramid contained within it a stepped pyramid simultaneously functioning as a heavenly stairway. Moreover, by its very design and its placement on the heights above the city of Memphis, the pyramid furnished a perpetual reminder of the mound of creation. Finally, the priestly staff of the temple complex performed the necessary rituals to enable the pharaoh to achieve his divine status and to preserve his spiritual connection with his physical remains. The combination and layering of these relationships rendered each pyramid a source of great spiritual power for the Egyptians. By their very permanence and stature they enabled the magical experience of the deceased pharaoh to occur eternally before their eyes. The cult of the dead pharaoh thus furnishes the best example of the various ways that the Egyptian civilization combined and reformulated various strands of religious tradition to articulate a comprehensive, multifaceted worldview.

Mastaba complexes essentially were small cities devoted to the cult of dead pharaohs, constructed one after another in succession for nearly two centuries. On the one hand, this process of mastaba construction created a built landscape along the banks of the Nile so remarkable that its remains continue to inspire foreign visitors thousands of years after their disuse. On the other hand, the continual dedication of manpower, building material, agricultural terrain, and foodstuffs to the cults of long dead pharaohs must inevitably have diminished the authority of the pharaonic regime. By the Fifth Dynasty the size of pyramids diminished, suggesting that resources had become increasingly limited. The central importance of the cult of the dead pharaohs appears to have declined, and with it the fortunes of the Old Kingdom. Given this regime's sustained duration of 500 years, however, it is hazardous to pin the collapse of the Old Kingdom on any one causal factor.

TRANSITIONS IN POLITICAL AND SOCIAL ORGANIZATION (FIRST INTERMEDIATE PERIOD AND THE MIDDLE KINGDOM)

As the Old Kingdom pharaonic regime lost its grip on Egyptian society, power shifted from the royal household to the priestly hierarchies that dominated sanctuaries such as the temple of Re at Heliopolis. By the Fifth Dynasty many sanctuaries became financially independent of the crown, having benefited from repeated gifts of land, labor forces, and resources. The ministers and lower echelons of the bureaucracy likewise grew independent; in tomb autobiographies fewer ministers demonstrated blood ties to the king, and ministerial positions became increasingly hereditary. The long and inattentive reign of the last pharaoh, Pepi II (2278–2184 BC), initiated an era of societal collapse,

anarchy, and instability along the entire length of the Nile. By the time of the Seventh and Eighth Dynasties, power devolved back to the local level of the nomarchs. They declared themselves kings and warred incessantly among themselves. According to the baleful descriptions of life during the First Intermediate Period (2200–2040 BC), foreign trade collapsed, standards of living declined, and famine and disease became widespread. Since many of these texts were recorded later to justify the emergence of a stable regime during the Middle Kingdom (2040–1720 BC), they conceivably portrayed conditions during the Intermediate Period in the worst possible light. The complaints they raise do appear to be supported, however, by a number of contemporary indicators, including the absence of royal building projects, the lack of mining, quarrying, or trading expeditions, and a dearth of royal inscriptions.

Order was finally restored in the Eleventh Dynasty by pharaohs of the Middle Kingdom (2020–1780 BC). Pharaoh Mentuhotep II (ca. 2061–2010 BC), having reasserted the Egyptian frontier in Nubia, initiated necessary reforms and put an end to the autonomy of the nomarchs. A prison register listing Egyptians who were assigned to government farms and labor camps for refusing to comply with the demands of the new regime testifies to its renewed vigor. Although the pharaonic ideology of the Old Kingdom was revived, subtle changes became detectable. For the most part, the symbolism of the new regime followed on the traditions developed during the Old Kingdom at Memphis and Heliopolis in the north; however, the new pharaohs accentuated the fact of their origin at Thebes in Upper Egypt, both ideologically and materially. Originally a minor local deity of Thebes, Amon now assumed prominence as the chief deity of the Egyptian pantheon. He gradually became reformulated as Amon-Re, thus merging the local cult of Thebes with the traditional cult of Heliopolis to the north. Thebes became significant in other ways as well. Although the pharaoh and his court assumed residence at a newly constructed palace complex outside Memphis, there were regular royal visits to Thebes. The largest building programs, oftentimes combining the best of Lower and Upper Egyptian burial traditions, were conducted almost exclusively in Upper Egypt. In addition, Theban nobles assumed leadership positions throughout the bureaucracy. For the remainder of the Bronze Age, the leadership of this formerly insignificant nomitic capital would form the main spring to Egyptian imperial authority. Although the flowchart of the vizier and his echelon of ministers remained largely intact, the need to communicate more effectively with authorities along the Nile led to the reorganization of the kingdom into three provinces: the North (lower Egypt), the South (Upper Egypt), and the head of the South (Elephantine and Lower Nubia). Each of these provinces was administered by a senior official assisted by a council of advisers and a necessary complement of scribes. Communications with the Mediterranean world were likewise improved during the Middle Kingdom, particularly with coastal communities in Canaan and Phoenicia. Much like the Middle Bronze Age experience in Mesopotamia, therefore, the Egyptian Middle Kingdom represented an era of investment and reorganization that would lay the foundation for greater things to come.

Subtle changes are also detectable in the foundations of Egyptian religious belief. During the Middle Kingdom, pharaohs were no longer viewed as divine entities walking

The Temple of Amon-Re at Karnak was rebuilt during the New Kingdom and, like most temples from this period, was enclosed by a massive fortification wall. Pylons or gateways created an imposing facade along with the erection of towering obelisks (tall stone markers topped by pyramid-shaped points). Colossal statues of Thutmose I flanked the approach to the temple. The New Kingdom pharaoh Seti I (1291–1279 BC) added a large hypostyle hall at Karnak measuring 103 m wide by 53 m in length and supported by 124 gigantic columns. The central columns stood about 23 m tall and were designed with open papyrus flower capitals measuring over 15 m in circumference. Along the sides of the central colonnade stood 122 slightly shorter columns with closed bud capitals. The representation of stylized marsh plants in stone evokes the Egyptian story of creation—how the mound of creation emerged out of the watery swamp. The sheer size and number of columns were intended to fill the worshipper with a sense of awe, perhaps even insignificance when compared with the immensity of this ritualistic space. Throughout the temple complex, pylons and walls were covered with a uniquely Egyptian type of decoration called sunken relief. This type of relief (whose subject at Karnak was the king's relationship with the gods) required the sculptor to cut sharp outlines into the surface of the stone rather than carving it away using a reductive method. This technique allowed for the solid appearance of the wall to remain intact.

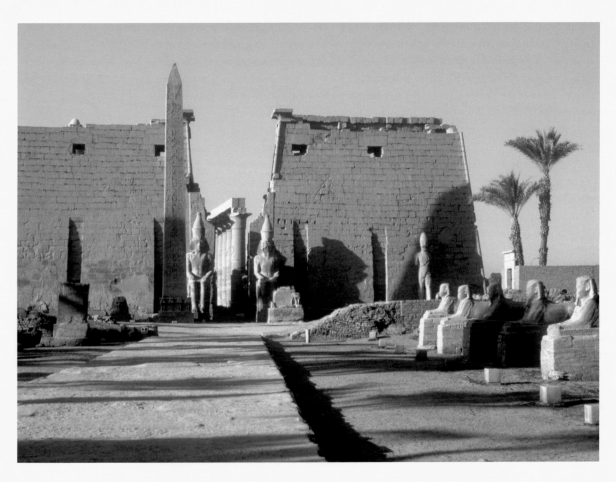

Figure 2.5 View of sphinxes, the first pylon, and central east-west aisle of the Temple of Amon-Re, Karnak in Luxor, Egypt, ca. 1290–1224 BC.

Illustrated funerary texts—like this scene from *The Book of the Dead of Hunefer*—contain incantations, or spells, derived from the Coffin Texts of the Middle Kingdom and traditional tomb paintings. Beginning in the Eighteenth Dynasty, funerary texts were copied by scribes onto papyrus-reed scrolls and read as continuous narratives. This rich illustration represents the weighing of the heart and judgment of the dead by Osiris. The jackal-faced guardian of the underworld, Anubis, is shown leading Hunefer by the hand into the Hall of Two Truths. The next scene shows Anubis weighing Hunefer's heart (contained in a small vase) against the ostrich feather of Ma'at, the goddess of truth and justice. Thoth, the ibis-headed scribe, records the outcome while the ferocious beast Ammut (the devourer of those judged unworthy of an afterlife) looks on with anticipation. Next, Horus (shown carrying an ostrich feather to represent the favorable judgment of Ma'at) presents the deceased to his father, Osiris, identifiable by his white shroud and the emblems of kingship. Behind the enthroned Osiris are two female figures: Isis and her sister, Nephthys, the mother of Anubis and protector of the dead.

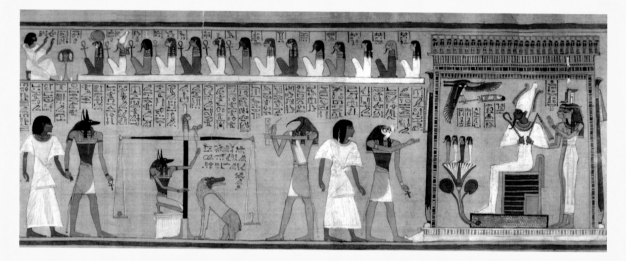

Figure 2.6 *The Weighing of the Heart and Judgment by Osiris*, from *The Book of the Dead of Hunefer*, 1285 BC. Painted papyrus, 39.5 cm high. The British Museum, London.

on the earth. Instead, the pharaohs presented themselves as paternalistic, task-worn administrators who bore the burden of rule for the benefit of Egypt. Instructional texts of the era openly acknowledged the king's fallibility and humanity, though the need to act in accordance with Ma'at remained implicit in all dealings. The exclusivity of the pharaoh's role in the afterlife likewise deteriorated during the independent days of the First Intermediate Period. Although the conceptualization of the afterworld remained largely intact, afterlife was now viewed as something attainable by the wider population of the Middle Kingdom. All citizens high and low needed to prepare themselves to face a final judgment. A council of gods, convened by Re but presided over by Osiris, who now assumed responsibility as the God of the Dead, would judge each person's deeds. As the accompanying illustration from the Egyptian *Book of the Dead* indicates, the gods weighed the heart of the deceased against that of a feather, the symbol of Ma'at. The heart had to be so free from sin that it

weighed less than the scale bearing the feather. To attain heavenly bliss one had to live one's life righteously in accordance with Ma'at; those who failed to do so would not survive their corporeal existence. So great was the fear of the final judgment that the relatives of the deceased would place a scarab—a large, elaborately carved stone image of a dung beetle with a human face—on the chest of the interred corpse to prevent the heart from testifying about the person's failings during the final judgment. As a further precaution the scarabs were frequently inscribed with declarations of innocence and negative confessions. Anyone who could afford the costs of mummification, a mastaba tomb, the sustained practice of the necessary rites—and, of course, the conviction of a blameless life—could expect to become god in the afterlife. Obviously, only a small portion of the Egyptian population could afford these requirements; nonetheless, the popularization of afterlife lore represented a significant departure from the previous era.

Much like conditions in Middle Bronze Age Mesopotamia, the pace of developments in Middle Kingdom Egypt eventually appear to have eclipsed the ability of the pharaonic regime to sustain authority. Heightened contact with Nubia and urban settlements in the eastern Mediterranean created new opportunities for trade and development. The agents responsible for this trade appear increasingly to have evaded the control of the Egyptian bureaucracy. At the same time the expansion of Egyptian interests abroad only served to advertise its wealth and prosperity to unwelcome neighbors. Ultimately, it became a target for migrating nomads. By the Thirteenth Dynasty, Egypt once again descended into an era of confusion, dissension, and political disintegration.

THE SECOND INTERMEDIATE PERIOD (1720–1550 BC)

The Second Intermediate Period endured considerably longer than the first. Chaos was induced primarily by the invasion and conquest of a large part of northern Egypt by a foreign element referred to by the Egyptians as the **Hyksos** ("the foreign rulers," Fifteenth Dynasty). Egyptian sources of the New Kingdom era were decidedly hostile to these invaders, rendering it difficult to arrive at an objective appraisal. As Manetho laments: "and unexpectedly from the regions to the east a people of unknown race brazenly marched against the land and captured it easily by force without a battle, and after consequently subduing its leaders, they savagely burned the cities and razed the shrines of the gods, and treated all the inhabitants in a most hostile manner, killing some and leading the wives and children of others into slavery."[1] The evidence suggests not so much a path of destruction, however, as one of technological and political accommodation. The invaders employed advanced weaponry—horse chariots, bronze helmets, scaled armor (bronze metal being previously unknown to the Egyptians), and compound bows—to overwhelm the native population. As with the Middle Bronze Age in Mesopotamia, the introduction of chariot

1 *Aegypticaca of Manetho*, Fragment 42, trans. Matthew Dillon.

warfare revolutionized Egyptian military science in the coming era. The infiltrating population settled first in the delta region of the Nile and then quickly assumed control over key transportation nodes along the river valley. Excavations at the site of the Hyksos capital of Avaris, modern Tell el-Dab'a at the eastern end of the delta, indicate the presence of large numbers of Semitic-speaking immigrants already by the late Middle Kingdom. The collapse of the Egyptian central government after 1720 BC appears to have opened the way to a second and even larger influx of immigrants from across the Sinai. Those who accept the Old Testament tradition of the Book of Genesis argue that the migration of the Hebrews into Egypt logically occurred with that of the Hyksos. By ca. 1650 BC Hyksos rulers extended their authority beyond the delta to the middle valley of the Nile, compelling the nomarchs of these regions to become their vassals. Even the kings of Thebes were compelled to pay tribute for a time. The startling discovery of Minoan frescoes in the palace complex at Avaris in 1992 as well as of Hyksos artifacts in Crete demonstrates that the invaders enjoyed trade and political relationships as far removed as the south Aegean.

The Hyksos thus appear to have successfully isolated the former hierarchy at Thebes and to have hijacked the trade routes of the Nile. Although the Hyksos kings bore Semitic names such as Sakir-han and Khan, they otherwise adopted the standard titles of the Egyptian kings and employed native Egyptians as high-ranking officials at their court. When Theban pharoahs Khamose (1554–1549 BC) and his brother Ahmose I (1550–1525 BC) conquered the Hyksos, they encountered as much resistance from native Egyptian elements in the Nile delta as they did from the Hyksos themselves. Led by these warrior kings the Theban hierarchy nonetheless reasserted control along the length of the Nile. The experience of the Hyksos interlude appears to have compelled the Theban hierarchy to adapt to the new realities of the wider Near East as well as to the quickening pace of international affairs during the Late Bronze Age. The result was a more aggressive policy of overseas intervention and imperial hegemony.

THE EGYPTIAN NEW KINGDOM (1550–1069 BC)

Through repeated military campaigns, Khamose and Ahmose I extended unified authority along the Nile Valley from the Third Cataract in Nubia to the Hyksos-dominated delta. The military campaigns against the Hyksos were particularly ferocious and ultimately cost Khamose his life. To suppress Hyksos resistance altogether, Ahmose had to extend military operations beyond the delta to Hyksos bastions in Canaan, setting the stage not only for Egyptian imperialism but also for the rise of an Egyptian military hierarchy. In what is unquestionably the best recorded era of Egyptian history, the remnants of an historical narrative for Late Bronze Age developments begin to emerge. Egyptian pharaohs conducted repeated razzias into Canaan and coastal Syria, culminating in the crossing of the Euphrates River by King Thutmose I (1506–1493 BC), who also marched to the Third Cataract in Nubia and constructed a canal there to suppress native resistance more

effectively. In less than a century the early kings of the New Kingdom acquired a vast empire extending nearly 2,500 km north–south and established themselves as the undisputed superpower of the Late Bronze Age. They compelled dozens of petty kings at maritime city-states in Canaan, Cyprus, and Cilicia to accept Egyptian suzerainty and in many instances they imposed permanent military garrisons. They amassed hauls of booty from their military campaigns as well as tribute collected annually from subject states. They established themselves as the political and military rivals of empires as far removed as the Hittites in Anatolia, the Mycenaeans and Arzawans in the Aegean, and the Marians, Assyrians, and Babylonians in Mesopotamia. The Egyptian pharaohs of the New Kingdom became the standard by which all other regional kings measured their worth. To be recognized by a New Kingdom pharaoh as a brother or to forge a marriage alliance with him was to establish a neighboring king as a member of the world's great powers. The international relations of the era will be discussed in greater detail in the next chapter; for now, it is essential to focus on the impact these developments had in Egypt.

The aggressive militarism of the New Kingdom had a profound effect on Egyptian domestic affairs. Unlike previous eras where military leaders rarely appeared in bureaucratic records, military professionals now occupied significant and high-ranking positions. In many ways Egyptian civilization adapted to a permanent war footing. As the examples of Khamose and Ahmose make clear, the pharaohs themselves assumed status as the New Kingdom's leading warriors. They were frequently portrayed fighting from their chariots, firing arrows and clubbing adversaries with maces. King Thutmose III (1479–1425) became the epitome of the warrior pharaoh, conducting 17 military campaigns during a 30-year reign. According to his *res gestae* inscribed on the walls of the Temple of Amon-Re at Karnak, Thutmose III captured 350 cities and extended the territory of the New Kingdom from the Orontes and Euphrates Rivers in northern Syria to the Fourth Cataract of the Nile. His son, Amonhotep II (1427–1401 BC), was equally successful. After one memorable campaign in Palestine, he reportedly returned to Egypt with more than 2,200 prisoners, 820 captured horses, 730 captured chariots, and shiploads of booty.

To manage the business of warfare, the New Kingdom pharaohs established a permanent military administration, typically directed by the crown prince who himself regularly served as a military commander. Standing garrisons were organized in Egypt and abroad, and the army was sustained by a continuous process of military recruitment and training. Recruiting officers toured villages along the Nile to press inhabitants into service, often times resorting to a perfunctory selection of one male out of every ten within the population. Scholars estimate that every Egyptian family had at least one relative in the army. Soldiers trained from youth at military camps and learned to fight with an array of weapons, including bows, spears, battle axes, sickle swords, and body armor, all manufactured and furnished by the state. Mercenaries were likewise recruited from nearby Bedouin populations of the Libyan Desert as well as from distant Mycenaean settlements in the Aegean. Mercenaries possibly accounted for as many as half the Egyptian forces under arms. The Egyptian army grew accordingly. Khamose and Ahmose combatted the Hyksos with one division of 5,000 warriors each; by the time of Ramses II (ca. 1279–1213 BC), there

were four divisions or 20,000 infantry. Additional forces included logistical and reconnaissance detachments, and most important of all dozens of squadrons of highly prized chariot warriors. These large, fast, mobile units demonstrated the capacity to outmaneuver infantry forces in the field, to inspire panic and confusion, and to pursue fleeing adversaries with devastating effect. Since the cost of acquiring war horses and chariots was beyond the reach of most Near Eastern principalities, these weapons furnished the great empires of the Egyptians and the Hittites with a distinct military advantage. The chariot corps quickly assumed status as an elite force from which leadership cadres were recruited, so much so that the Hurrian name for chariot warrior, *maryannu*, became universally recognized as a status designation, essentially the "top guns" of their day. To pursue their careers, young Egyptian nobles were likewise expected to train in chariot warfare from an early age, and to learn how to balance themselves while in motion, fire weapons while simultaneously driving the horses, and maneuver the vehicle at high speeds while hunting, fighting, or racing. Egyptian nobles were expected to volunteer to serve alongside the king's own chariot and to form his bodyguard during battle. As with the infantry the size of this force continually expanded. The greatest warrior pharaoh, Thutmose III, marched to the Euphrates with a corps of 20 squadrons, or a thousand chariots; by the time of Ramses II's campaign at Kadesh (1274 BC), the number of Egyptian war chariots surpassed 3,500. In addition, the Egyptian hierarchy developed a sizeable navy to transport, supply, and sustain the army in distant theaters of war. In the campaign of Thutmose III's on the Euphrates River, the army was actually transported by sea to Byblos in northern Syria. Sailors and marines then carried some of the smaller ships by oxcart across the Lebanese mountains to the Euphrates River. They simultaneously logged timber in the mountains and conveyed this to the Euphrates to construct additional galleys and barges. This enabled the pharaoh to penetrate across the river and deep into Hittite territory with devastating effect. Sailing triumphantly along the river, Thutmose III then erected a pillar to record his exploits directly beside the one erected decades earlier by his father, Thutmose II. In short, the era of the Egyptian New Kingdom was consumed by military conflict and overseas conquest. The experience of the Second Intermediate Period, particularly the impact of the invasion of the Hyksos from Canaan, convinced the Theban hierarchy that the world had become a small and dangerous place. The only way to insure the security of the unified kingdom was to restrict all likelihood of military confrontation to regions beyond the valley of the Nile.

Several additional aspects of bureaucratic reorganization were necessary to accommodate the needs of the New Kingdom Empire. Close proximity to military theaters in Syria and Canaan induced the hierarchy in Thebes to relocate to Memphis where a new royal palace and military headquarters were constructed. The vast territories of the empire now demanded the appointment of two viziers, one for the north and one for the south. These officials and their interior ministries remained responsible for civic order, for the assessment and collection of taxes, for the maintenance of royal archives and their documentary output, for the appointment and supervision of subordinate officials, and for the adjudication of land privileges and property rights. However, slave labor amassed during

foreign military campaigns also played an important role. Pharaoh Amenhotep II boasted, for example, of having hauled to Egypt 89,600 prisoners during one particular campaign in Canaan around 1420 BC.

Still another significant reorganization occurred within the administration of state supported temple complexes. Although not as impressive architecturally as the pyramids of the Old Kingdom, the construction of temples and burial monuments expanded at a bewildering rate during the New Kingdom, siphoning off an enormous percentage of Egyptian wealth. Many of the most famous surviving monuments of modern Egypt were constructed at this time, including several temples, the burial memorials of Hatshepsut and of Ramses II, and the massive palace complexes and military installations at Thebes, Memphis, Akhetaton, and Pi-Ramses. Thebes in particular became the kingdom's religious capital and was embellished with massive temple complexes dedicated to Amon-Re at Karnak and Luxor. The pharaohs of the early Eighteenth Dynasty regarded this god as their patron and protector and promoted his cult with lavish building projects and massive gifts of land and wealth. Since temple administrators were selected from within the hierarchy, the sanctuaries and their property essentially remained property of the realm, adding to the luster of the regime. As an example of their economic prowess, one can point to the holdings of the Temple of Amon-Re at Luxor. According to an Egyptian papyrus dated to the reign of Ramses III (1186–1155 BC), the sanctuary drew on the resources of 169 towns, 500 gardens, vineyards, and orchards, 88 cargo ships, and 500,000 head of cattle. Its wealth incorporated approximately one-fifth the available population and one-third the arable land of all Egypt. The warrior pharaohs of the New Kingdom appear to have delegated these responsibilities to the administrators of these temple complexes and to have employed them as surrogates for the expansion of agricultural terrain. The organization of the New Kingdom hierarchy accordingly grew in complexity.

Examples of the lavishness of royal life have emerged from the imperial cemeteries in the Valleys of the Kings and Queens. Beginning with the Eighteenth Dynasty in Thebes, pharaohs elected to disguise their tombs in the barren canyons opposite Thebes, probably because of the abundant evidence of tomb robbing during previous eras. The priceless artifacts recovered from the tomb of King Tutankhamen (1334–1325 BC) furnish an ample indication of the richness of Egypt's trade in exotic goods—fine woods from sub-Saharan Africa, precious metals from the desert mountains, lapis lazuli from Central Asia—as well as

TABLE 3. FLOWCHART OF THE NEW KINGDOM EGYPTIAN HIERARCHY		
PHARAOH		
Generals and Officers	**Two Viziers**	**Chief Priests of Luxor and Karnak**
Chariot Warriors	Ministers and Local Administrators	Subordinate Administrators
Scribes	Scribes	Scribes
Infantry Warriors	Servants	Servants and Artisans
Farmers and Slaves	Farmers and Slaves	Farmers and Slaves

proof of the existence of highly skilled labor necessary to manufacture the inlaid chairs, beds, sarcophagi, and gilded head dresses preserved within this tomb. These finds indicate the vigor of Egypt's commercial reach across continents and seas, with Egypt's own productive capacity furnishing the engine of the world system. Egypt's apparent monopoly of the gold trade originating from southern Egypt and sub-Saharan Africa put it at a distinct advantage vis-à-vis its neighbors. At a more mundane level one can point to the widespread distribution patterns of transport jars or amphoras, used to convey staple goods such as wine, olive oil, honey, and wax across the Mediterranean Sea. An important designator of tribute payments and trade, the Canaanite jar has been found in regions as distant as the Mycenaean Aegean and Nubia. Mycenaean stirrup jars (smaller in form and possibly used to convey perfumed oils) exhibit an even wider distribution pattern, having been identified in places such as Syria, Canaan, the Nile Delta, Italy, and Cornwall in Britain.

With so much international trade and political authority, it is not surprising that the status of the Egyptian pharaoh and the ideology of the Egyptian ruler cult underwent significant reinvention at this time, particularly during the Eighteenth Dynasty. The most novel departure for the Egyptian ruling cult was initiated by the female pharaoh **Hatshepsut** (1479–1458 BC). Hatshepsut was the daughter of King Thutmose I, who when he died was succeeded by his son, Hatshepsut's half brother Thutmose II. Thutmose II married Hatshepsut and recognized her as his chief wife and the divine wife of Amon. When Thutmose II died shortly thereafter, Hatshepsut decided to assume the throne herself. Presumably her initial purpose was to act as regent to the infant prince, Thutmose III, her late brother's son by a lesser wife. However, Hatshepsut proved unwilling to relinquish the throne when Thutmose III came of age. She assumed status as the king of Egypt and reigned ultimately for 21 years. As noted earlier, in her iconography she portrayed herself decidedly as a man. As the monarch she successfully maintained the New Kingdom's imperial status abroad, organizing raids into Nubia and Palestine and trading expeditions to Punt (Eritrea). Hatshepsut claimed to be the immediate progeny of the god Amon, who disguised himself as Hatsheptsut's father Thutmose I and impregnated her mother, and therefore divinely entitled to her position as pharaoh. She additionally claimed—quite falsely—that her father had declared her his co-regent and that he had publically designated her as his successor. The question is legitimately raised, therefore, as to whether this represented an attempt to reinvent the ideology of the ruler cult or merely an effort to mask her irregular ascent to the throne with divine justification. Later evidence suggests that her arguments failed to convince her intended audience. Despite the fact that her eventual successor, **Thutmosis III** (1479–1425 BC), shared her authority as co-regent for more than 20 years, he was compelled decades later to remove her name from inscribed monuments throughout the land (*damnatio memoriae*). Egyptians apparently interpreted her assumption of power, not to mention her outlandish claim of divine descent, as an affront to the balance and order of Ma'at.

Hatshepsut's innovation was later revisited by the pharaoh Amonhotep IV (1353– 1336 BC), who appears to have pursued a deliberate program of personal deification. Unlike Hatshepsut, Amonhotep did not wait until the end of his career to announce his divine

status. From the outset of his reign, he promoted the cult of a new deity—the Aton, or the dazzling sun disk. Evidence demonstrates that this cult was already cultivated by his father, Amonhotep III (Amonhotep the Magnificent, 1391–1353 BC), who constructed a lavish royal barge for his state festivals that he named the Aton. Amonhotep IV went further by initiating a program of exclusive devotion to this god at the expense of all other Egyptian deities. He changed his name from Amonhotep to **Akhenaton** (meaning *effective for Aton*) and refashioned all five of his official names to refer to the Aton in one manner or another. By the sixth year of his reign, he decided to relocate the palace hierarchy from Thebes to a newly established capital named **Akhetaton** (**Tel el Amarna**). Members of the Egyptian hierarchy had little choice but to relocate to Akhetaton with their king and to comply with his every wish. Located equidistant from the traditional centers of power, Thebes and Memphis, the site appears to have been deliberately selected as an alternative capital where Akhenaton could implement the Aton cult in relative seclusion.

Figure 2.7 *Akhenaton and His Family*, ca. 1355 BC. Limestone. 31.1 x 38.7 cm. Staatliche Museen zu Berlin, Preussischer Kulturbesitz, Ägyptisches Museum.

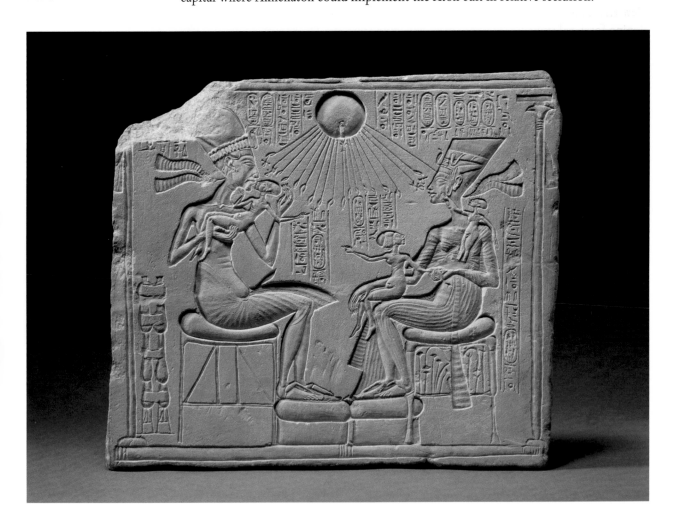

The ideology of the Aton cult has intrigued scholars for decades. Along with the change in his own name, Akhenaton attempted to suppress the name of Amon altogether: he ordered its removal from inscribed monuments throughout Egypt including the elimination of cartouches that recorded his father, Amonhotep III. By assuming his new name, Akhenaton proclaimed himself as the transfigured earthly representative of the solar orb. His wife Nefertiti was similarly recognized as a divine intermediary, completing a divine triad of the Aton, Akhenaton, and his wife. The new cult emphasized the bonds of family and child nurturing. A sunken relief on an altar stele recovered in Thebes displays the king attending to his family: the king and queen are shown fondling one another lovingly or playing dotingly with their daughters. In the relief illustrated in the accompanying image the rays of the Aton are visibly touching the nostrils of the two monarchs—as though they were breathing in its divine essence, as well as touching the inscribed cartouches that bear the names of their daughters. In marked contrast with the virile portraits of previous New Kingdom pharaohs, Akhenaton is portrayed with decidedly unflattering features: a sloping forehead and a long skinny neck, a flowing rounded outline, a protruding belly, narrow sloping shoulders, effeminate breasts, fleshy hips and thighs, spindly lower legs. Some have argued that the portrayals of the king were deliberately calculated to present the pharaoh as transgendered, ethereal, and other worldly. In this manner he sought to convey the notion that he was simultaneously a divine being and the androgynous parent figure of the state of Egypt. All aspects of the new ideology thus focused on the emerging relationship between the Aton, his domain at Akhetaton, and his two intermediaries in the royal family.

Ultimately, Akhenaton appears to have pushed his agenda to the limit, thereby jeopardizing the good will of the Egyptian populace. Reports of disturbing calamities that befell the royal household further heightened public alarm. Before the end of Akhenaton's reign, Nefertiti and several other relatives died (including at least three of their daughters, one of Akhenaton's lesser wives, and his mother). Although Akhenaton worked to maintain the appearance of normalcy, his efforts only added to the confusion. At first he elevated his eldest daughter Meritaton to his wife's former position as consort. Then he thought better of the idea and replaced her with one of his sons, Smenkhkare. Changing his mind a third time, he married off Smenkhkare and Meritaton and took his second-oldest daughter, Ankhesenpaaton, as his wife. Despite the fact that Ankhesenpaaton was only ten years old, she bore him a daughter prior to his death. With the passing of Akhenaton in 1335 BC, the Egyptian people concluded that the Amarna episode was a failure and had incurred the wrath of the true Egyptian gods. The young king Smenkhkare (1335–1334 BC) quickly attempted to restore popular favor by reopening the Temples of Luxor and Karnak, but he died suddenly. The throne then passed quickly to a queen named Neferneferuaten (1334–1332 BC) and finally to another adolescent member of the dynasty, King Tutankhamon (1334–1325 BC), who took as his chief wife Akhenaton's widow and daughter, Ankhesenpaaton. Tutankhamon continued Smenkhkare's policy of reconciliation with traditional beliefs. The young king and queen changed their names back to the Amon root and abandoned the palace at Akhetaton in favor of Memphis. In

addition, Tutankhamon embarked on a widespread initiative to repair temples damaged by Akhenaton. He reappointed nobles to the traditional priesthoods, refurbished several temples, and restored the resources that had been redirected to the Aton cult by Akhenaton. With Akhetaton a ghost town, the Aton heresy rapidly receded into the past.

Hittite advances in Syria and a mounting rebellion in Nubia eventually demanded Tutankhamon's attention elsewhere. Since the skull of his mummy exhibits injuries commensurate with a blow to the head, it is likely that he died during one of the military expeditions depicted on the walls of his celebrated tomb in the Valley of the Kings, discovered in 1922. After several unsuccessful marriage initiatives by his widow, Akhenaton's daughter Ankhesepaaton, Horemheb seized the throne (ca. 1319 BC to late 1292 BC) to establish the Nineteenth Dynasty. Instead of Ankhesepaaton, he married Nefertiti's sister, Mutnedjmet. To restore public confidence, he undertook a deliberate campaign to eradicate all vestiges of the Aton cult. He ordered the destruction of all monuments constructed by Akhenaton (including the Aton temple at Thebes) and razed the former capital of Akhetaton to the ground. Any and all inscribed references to the Aton or Akhenaton were eliminated along with the tombs of the dynasty itself. In his official records he dated his reign from the death of Amonhotep III (1353 BC), thus expunging the official memory of the Amarna pharaohs. In the one text he specifically referred to Akhenaton as the enemy from Akhetaton.

In hindsight, one can argue that the religious experiment of Akhenaton was misguided and costly. The Egyptian people apparently concluded that his actions were an affront to Ma'at and a direct challenge to the gods. Although the military hierarchy of New Kingdom Egypt managed to intervene politically and to avert a more serious crisis, in the long run the Akhenaton's innovations amounted to a distraction that the New Kingdom could ill afford.

THE DECLINE OF THE NEW KINGDOM, 1293–1050 BC

Although the New Kingdom Empire persisted for another two centuries, there is a tendency to see the demise of the Eighteenth Dynasty as its turning point. From here until the emergence of the Sea Peoples in 1186 BC, Egypt repeatedly lost ground against its rivals, the Hittites and the Assyrians, amid reports of growing instability throughout the region. In hindsight, it is easy to assume that the empire embarked on a downward spiral. The royal hierarchy appears to have weathered most of its challenges, nonetheless. Horemheb was able to restore significant credibility to the regime. He addressed widespread complaints of bureaucratic corruption (another likely consequence of Akhenaton's distraction) by establishing tribunals throughout all the major towns. He replenished the chief positions in the hierarchy, both religious and civil, with military officers loyal to himself. He divided legal authority between two viziers stationed at Memphis and Thebes and reorganized the military into armies of the north and the south. After 25 years as pharaoh, however, Horemheb failed to produce a male heir. Fearing likely disorder, he

elevated to the throne a vizier with significant military experience, Ramses I (ca. 1292–1290 BC; Nineteenth Dynasty). This pharaoh survived for less than two years, and he appointed his son Seti I (ca. 1290–1279 BC) as his successor. Seti managed to advance Egypt's position in Syria, but the legitimacy of the new Nineteenth Dynasty continued to be questioned. These concerns were allayed by the succession of Seti I's son, **Ramses II** (1279–1213 BC). Ramses II proved an extremely competent general and one of the greatest pharaohs in Egyptian history. Despite his reputation as one of the greatest builders in world history, however, even Ramses II's successes were viewed as seeming setbacks.

The new pharaoh was immediately confronted by an array of threats to the New Kingdom—including marauding pirates from the Aegean, the expanding influence of the Hittites and Assyrians in Syria, Bedouin invaders from neighboring deserts, and rebellions in Nubia. During his second year he successfully warded off a naval assault of the Sherden and Lukka pirates, forerunners of the later Sea Peoples. By his fourth year he campaigned against the Hittites, who were expanding their hegemony southward in Syria. As a preliminary he constructed a new forward capital at Pi-Ramesses, partly on the site of ancient Avaris, at the eastern end of the Nile Delta. This furnished him with an effective staging ground and weapons depot for his army. The following year he commanded the largest army Egypt had ever assembled, perhaps as many as 30,000 infantrymen and 3,500–5,000 chariots, in a pitched battle with the Hittite King Muwatallis at the Battle of Kadesh (1274 BC). Although his army suffered heavy losses, he was able to avoid a rout and to proclaim victory despite the appearance of a tactical retreat. In view of his reduced circumstances, Ramses II secured a negotiated peace with his rival that culminated in the celebrated **Treaty of Kadesh** in 1259 BC. The cessation of hostilities with the Hittites enabled the pharaoh to concentrate his energies elsewhere. Several of his most significant accomplishments concerned his building enterprises. Generally recognized as one of the three greatest builders of antiquity (alongside Pericles and Augustus), Ramses II erected a palace, several temples, and other structures at Pi-Ramesses. He also completed the hypostyle hall at the Temple of Karnak, the magnificent double temple of the Ramesseum near Qurna, and the renowned double temple at Abu Simbel in Nubia.

Following the death of Ramses II in 1213 BC, a steady drumbeat of conflicts and incursions engulfed not only the Egyptian New Kingdom but the entire eastern Mediterranean basin. Examples such as the Fall of Troy (ca. 1250–1220 BC), the destruction of Mycenaean palaces (1100 BC) in Greece, the collapse of the Hittite Empire (1160 BC), the movements of the Sea Peoples (1180 BC), and the conflagration of numerous coastal cities in Syria and Canaan all point to an episode of Late Bronze Age societal collapse. Egyptian society managed to survive these catastrophes, but it became increasingly isolated in the process and vulnerable to invasions from without. Following the assaults of the Sea Peoples (1204–1086 BC), Libyan nomads invaded the Nile basin from the neighboring desert (ca. 945–720 BC). The last of their incursions was accompanied by Kushites from Sudan (ca. 727 BC). The land was later conquered by the Assyrians (ca. 700 BC), by the Persians (ca. 525 BC), and by Alexander the Great (332 BC). It was then ruled by the descendants of one of Alexander's generals, Ptolemy I. The last Ptolemy, Queen

Cleopatra, died in 30 BC, leaving Egypt to become absorbed into the patrimony of the Julio-Claudian Dynasty of Rome. This string of setbacks obscures the fact that Egypt remained one of the critical junctures for food production and trade throughout the Classical Era. Despite its relatively small population, the Egyptian civilization achieved remarkable heights due to the unique qualities and resources of its riverine environment. Egyptian skills in architecture, stone cutting, agriculture, mathematics, medicine, and other disciplines catapulted them to the forefront of Bronze Age societal achievement. The worldview of the Egyptians remained distinctly optimistic: Egyptians seemed genuinely imbued by a belief in the rewards of afterlife. However, the inherent tendencies toward superstition and magic were simultaneously manipulated by the Egyptian hierarchy for its own purposes and culminated in what was possibly the most autocratic regime of the ancient world experience. The obsession of the New Kingdom Egyptian pharaohs with their godhead appears at times to have threatened the stability of their civilization. The historical record of the civilization, albeit one inordinately focused on the dynastic experience of its hierarchy, suggests that the Egyptian population acquiesced to the order and stability that was furnished by its hierarchy and its ruler cult.

FURTHER READING

Aldred, Cyril. *The Egyptians*. New York: Praeger, 1963.

Breasted, James Henry. *Development of Religion and Thought in Ancient Egypt*. New York: Harper, 1959.

Davies, Penelope J.E. *Janson's History of Art, The Western Tradition*. 7th ed. Vol. 1. Upper Saddle River, NJ: Prentice Hall, 2007.

Gillispie, Charles Coulston, and Michel Dewachter, eds. *Monuments of Egypt: The Napoleonic Edition; The Complete Archaeological Plates from "La Description de l'Egypte."* Princeton, NJ: Princeton Architectural Press, 1987.

Robins, Gay. *The Art of Ancient Egypt*. Cambridge, MA: Harvard University Press, 1997.

Shaw, Ian, ed. *The Oxford History of Ancient Egypt*. Oxford: Oxford University Press, 2000.

Van De Mieroop, Marc. *A History of Ancient Egypt*. Oxford: Wiley-Blackwell, 2010.

THREE

AEGEAN CIVILIZATIONS AND WIDER SOCIETAL COLLAPSE (2200–1100 BC)

WHAT HAVE WE LEARNED?

- ▶ The formidable natural barriers of desert, mountain, and sea caused the Egyptian population to remain highly isolated, secure in one respect from the threat of outside invasion but technologically backward and slow to change in another.
- ▶ Egyptian history was characterized by three sustained periods of centralized authority, stability, and order, when the kingdom of the Nile was unified: Old Kingdom (2700–2200 BC), Middle Kingdom (2040–1720 BC), New Kingdom (1550–1069 BC).
- ▶ Decipherment of the Egyptian hieroglyphic language system was made possible by the discovery of the Rosetta Stone in 1799 AD. The inscribed stele dates to the Ptolemaic era, ca. 196 BC, and was inscribed in hieroglyphic, demotic, and ancient Greek.
- ▶ During the Old Kingdom the pharaohs assumed status as the living embodiment of the god Osiris and protector of Ma'at, or the balance to the order of the universe.
- ▶ During the Middle Kingdom (2120–1780 BC), the pharaohs presented themselves as paternalistic, task-worn administrators who bore the burden of rule for the benefit of Egypt. They were no longer regarded as divine.
- ▶ New Kingdom Egypt (1550–1069 BC) was characterized by an Egyptian overseas empire. New Kingdom Pharaohs lead mercenary armies as far as Syria to the north and sub-Saharan Africa to the south, establishing an extensive empire and receiving annual tribute from subjected peoples.
- ▶ The consequences of Akhenaton's actions and the Amarna interlude marked a turning point in the New Kingdom experience, and pharaohs of the Eighteenth Dynasty attempted to restore the religious ideology of a divine ruler cult.
- ▶ New Kingdom Egypt was disturbed, like other eastern Mediterranean populations, by rising chaos at the close of the thirteenth century BC, an indicator of widespread Bronze Age societal collapse.

Many scholars believe that the sources of Bronze Age societal collapse can be traced to nearby populations in the Greek Aegean Sea, where ancient legend recorded the Sack of Troy as a defining moment in pre-Hellenic history. This was certainly what the inhabitants of Classical Greece themselves believed. Archaeological investigation has since demonstrated evidence not only of Bronze Age palace communities throughout southern Greece but also of fired destruction at nearly every palace. As with other civilizations in the Ancient Near East, this points to a period of widespread disturbances ca. 1250–1100 BC. In this chapter we will present brief summaries of what is reliably accepted about three influential Bronze Age Aegean civilizations: the Minoans, the Mycenaeans, and the Hittites. We will then discuss the available evidence for Late Bronze Age societal collapse and its likely causes.

THE INCEPTION OF BRONZE AGE AEGEAN ARCHAEOLOGY

Archaeological exploration of Bronze Age Greece has been profoundly influenced by Homeric traditions. A legendary bard who lived around 750 BC, Homer presumably traveled to the manor houses of early Iron Age Greek nobles to sing his version of an epic saga recounting the siege of Troy. The works attributed to him, the *Iliad* and the *Odyssey*, do not explain the entire story. Rather they relate short episodes—presumably the parts sung by Homer himself—from a much larger story about a great war that ushered in the end of the Bronze Age. Elements of the story include the judgment of Paris, the kidnapping of Helen, the Greek assault on Troy, the slaying of Patrocles, Hector, and Achilles, the use of the Trojan Horse to enter the city, and the tragic end that each and every surviving hero encountered when he returned to Greece. Despite its length the *Iliad* actually records only a few days in the tenth year of the siege and focuses mainly on a personal dispute that erupted between Agamemnon, the king of the Greeks, and his preeminent warrior, Achilles. The *Odyssey*, meanwhile, recounts the story of the traumatic return from Troy of the Bronze Age hero Odysseus (Ulysses) of Ithaca. The inhabitants of early Iron Age (Archaic) Greece (900–500 BC) firmly believed that this epic preserved an historical account of an earlier age of heroes. Archaeologists have long asked to what degree the saga of the Trojan War preserves recollections of actual events or, short of that, glimpses of Bronze Age Aegean civilization. When Classical sciences came into being in the 1800s, many European scholars openly dismissed the Homeric tradition as myth and focused instead on well-established Classical sites such as Delphi, Athens, and Olympia. Few scholars concerned themselves with the remains of Bronze Age Aegean civilization.

The person to change all this was an iconoclast named Heinrich Schliemann (1822–1890). A brilliant linguist who loved the works of Homer, Schliemann was utterly convinced that these preserved a record of genuine historical events. He excavated the mound of Hisarlik (Troy) in 1871, and followed this by excavating Mycenae in 1876. His excavations revealed the existence of rich prehistoric societies that clearly predated those of Classical

Greece. His discovery of these two Aegean sites set in motion the archaeological exploration of Bronze Age Aegean civilizations that continues today.

In contradistinction to Schliemann's work at Troy and Mycenae, the British archaeologist Sir Arthur Evans (1851–1941) pursued an alternate path of research on the south Aegean island of Crete. Evans came to reject the Homeric tradition that prehistoric Greek peoples ruled the Aegean in favor of a second mythological tradition that the Aegean was initially ruled by kings from overseas. Instead of Homer, he pointed to the myths recounting the feats of an earlier generation of Greek heroes, namely, Theseus of Athens. According to legend, Theseus slew the Minotaur in the labyrinth at Knossos in order to liberate Athens and the rest of Greece from the tyrannical rule of King Minos. In 1900 Evans conducted an excavation at the presumed site of Knossos and uncovered an elaborate palace complex that predated that of Mycenae by nearly a thousand years. Although similarities clearly existed and will be noted below, the architectural design of the palace at Knossos was decidedly Near Eastern (resembling the plan of Mari in northern Mesopotamia). Its associated written script, *Linear A*, now partially deciphered, is clearly non–Indo-European, as opposed to **Mycenaean Linear B** tablets, also found at Knossos, whose script is identified as a form of proto-Greek. Evans believed that advanced urban culture and bronze technology were imported to the Aegean by outsiders, perhaps refugees expelled from the Nile at the time of the formation of the Old Kingdom. According to this line of reasoning, these migrants settled on Crete and quickly imposed their authority on the less-sophisticated inhabitants of the Aegean. Conceivably, Minoan overlords dominated Aegean waters by means of a naval empire, or *thalassocracy*, much as the Classical Greek historian Thucydides recounts. According to this scenario, the Mycenaean Greeks were unsophisticated latecomers who assimilated Minoan culture and later replaced Cretan hegemony with one of their own. In essence, according to Evans everything the Greeks learned about civilization was taught to them by the Minoans, that is, by a non–Indo-European people originating from the Near East.

Concerns about possible connections to the Homeric tradition need to be borne in mind as we contemplate the evidence for world systems, macroregional interconnectivity, and cultural diffusion during the Late Bronze Age. Most recently, the argument that Greece, the so-called cradle of Western Civilization, was itself a product of Egyptian and Near Eastern cultural diffusion has been revived. According to scholars, the great empires of the Late Bronze Age Near East—New Kingdom Egypt, the Hittites, the Mitanni, the Assyrians, and the Babylonians—represented the core of a wider world system (ca. 1400–1100 BC) that extended its reach to remote regions of the world, including the Baltic, Central Asia, India, and possibly even China. Since interconnectivity and resilience theory represent crucial themes to this textbook, the sources of societal collapse at the end of the Bronze Age need to be evaluated within this wider frame of reference. Textual records preserved at Ancient Near Eastern societies refer repeatedly to seaborne renegades originating from the Aegean—the **Sea Peoples**—as the source and the cause of widespread societal collapse at the end of the twelfth century BC. Another menace warranting consideration, however, was a migrant population of Near Eastern renegades known as

the **Habiru**. A third contributing factor may have been **climate change**. After a brief summary of Bronze Age Aegean civilizations, we will consider each of these possibilities in turn.

INDO-EUROPEAN MIGRATIONS

As noted earlier, around 2200–2000 BC, possibly in conjunction with the unsettled period of Middle Bronze Age societal collapse, Indo-European migrants infiltrated the vicinity of the wider Near East. Language differences indicate that their origins and paths were complex. The earliest recorded presence of Indo-Europeans in the Near East occurred at Kanesh in the cuneiform tablets of Assyrian merchants ca. 2000–1900 BC, demonstrating that they already inhabited Anatolia by this time. Other Indo-European peoples moved in a number of directions, ca. 2200–1700 BC, to form populations elsewhere who spoke Celtic, Italic, Germanic, Baltic, Slavic, Greek, and Indo-Iranian. Elements of this second wave appear to have migrated through the Balkans to become the Mycenaeans, others crossed the Caucasus Mountains to become the Hurrians, and still others migrated eastward into Iran and the Indus by ca. 1700 BC. Some Iranian elements ultimately migrated into northern Mesopotamia to merge with Hurrian elements coming across the Caucasus. Hurrian-speaking elements assimilated Near Eastern cultural attributes such as Akkadian cuneiform while infusing aspects of their own culture into the ruling elements of the Mitanni and Kassite empires, possibly because they rose through the ranks as warriors. Hurrian words and the names of Indo-Iranian and Hurrian deities entered the international vocabulary of the Late Bronze Age.

The military success of the Indo-Europeans is typically attributed to their mastery of horse-drawn chariot warfare, as they were possibly the first to master horses and horse riding. Although a relief depicting a rider on horseback has been found dated to the eighth millennium BC in Iran, it is not clear that horse riding developed as a military technology prior to the Iron Age. Instead, the invention of light-weight, fast, spoke-wheeled chariot buggies and the metal horse bit took Late Bronze Age warfare in the direction of rolling assault vehicles. The chariot enabled military detachments to move faster than soldiers on foot and thus to preempt infantry movements, to arrive first at strategic positions (assuming that these were accessible by wheeled vehicles), and to outmaneuver infantry in the field. Chariot fighting required physical skill, balance, and extensive training, which rendered the chariot warrior the most highly recruited professional of his day. Although the advantages of chariot warfare would diminish with the advent of heavily armored infantry in the Iron Age, in the Bronze Age it became the cutting edge of military technology and furnished the large polities that could afford its cost a distinct tactical advantage. Cultural experience with horse breeding and horse-driven technology thus appear to have given in-migrating peoples such as the Mycenaeans, the Hittites, and the Indo-Iranian populations a decided military advantage during their journeys.

Like other Indo-European populations, early Mycenaean culture consisted of clan-based pastoral populations dominated by warrior bands. Warrior chieftains rode horse chariots and were buried in earthen mounds known as *tumuli*, sometimes together with the remains of their horses and female dependents. A Mycenaean king, such as Agamemnon, referred to in Linear B tablets as a *wanax*, was characterized by Homer as a "King among Kings." In Linear B a lesser king was referred to as *basileus* (the Classical Greek word for "king"). As Agamemnon's dispute with Achilles over a captured female prisoner indicates (Homer, *Iliad*, 2.1.160–99), rivalries between kings and nobles resulted in a highly unstable hierarchy. The nobles tended to defer to the royal line during times of emergency, such as periods of warfare or migration. The challenge for the Mycenaean *wanax*, much as it was for early German kings, was to preserve his heightened status once the emergency expired.

INFLUENTIAL BRONZE-AGE CIVILIZATIONS

Minoan Crete (ca. 3000–1500 BC; high period 2000–1500 BC)

By every indication, the inhabitants of Minoan Crete migrated to the island from the Near East. Their language was not Indo-European: their Linear A script has not been deciphered, but it appears to be a Near Eastern, West Semitic language. The Minoans brought Bronze Age technology to a Stone Age environment and established hegemony throughout the Aegean. They settled colonies on neighboring islands as well as the Greek mainland. They constructed large palace complexes. Several large, terrace-built palaces such as Knossos and Mallia have been excavated, revealing plans that resemble those in northern Mesopotamia. Their palaces were not fortified and were surrounded by storage complexes. Minoan art stood in a class of its own. Vividly painted frescoes recovered at Knossos reveal an emphasis on scenes of nature, gaiety, hedonism, as well as evidence of bull sports and bull sacrifices. Frescoes excavated at Akrotiri depicted communities of multistoried houses and vibrant sea traffic along the island. The hierarchy (kings) of these richly decorated palaces clearly controlled trade surpluses of locally produced wine and olive oil, shipping them throughout the Aegean and beyond. Their characteristic container, the **stirrup jar**, was adopted by the Mycenaeans and used later to ship expensive commodities, such as olive oil, overseas. This central control of production, storage, and maritime distribution is referred to as a **palace-based economy**.

Some cataclysmic event, perhaps the eruption of the volcano at nearby Thera, led to the civilization's decline, carbon dated to ca. 1600 BC. A layer of volcanic ash has been found in core sediments sampled throughout the Eastern Mediterranean, demonstrating that the volcanic plume of this eruption extended as far as the coast of Egypt. The eruption conceivably subjected Minoan settlements at Crete to tidal waves, hypocaustic clouds of poison gas, and earthquakes. The Minoan colony at Thera itself was indeed destroyed. In

The palace at Knossos was the largest constructed on Crete and, according to legend, was the home of King Minos. The Greek myth of the Cretan labyrinth inhabited by the Minotaur finds its origins in the palace's sprawling, mazelike plan. The complex was built across the top of a low hill and centers around a large central court. Two long corridors provided the main points of entrance and the palace consisted of multiple floors. Issues of lighting, ventilation, and water drainage were important considerations to the builders. Clay and fieldstones were used to construct the thick walls of the palace, many of which were covered with murals. These murals were brightly painted and, coupled with the palace's distinctive red tapered column shafts and black capitals, must have conveyed feelings of opulence and power.

The Minoans applied white lime plaster to the rough surface of the wall creating a true fresco (or wet fresco), a method by which pigments mix with water to become chemically bonded to the plaster upon drying. *The Toreador Fresco* depicts two young men bull-leaping—a ceremonial aspect of Minoan life that involved performers perilously vaulting over a bull's back. On the left of the composition, set against a light blue background, a young woman (with fair skin) clutches the horns of an elongated bull depicted in full charge. A male youth (with dark skin) performs a backwards somersault above the bull's back, while another fair-skinned woman stands at right with her arms outstretched. The use of skin color to distinguish between male and female was a widely held convention in ancient times. Aside from this distinctive use of color, the figures also are extremely stylized, that is, portrayed non-realistically with pinched waists and elongated features. While the Minoans adopted the convention of the profile pose from Egypt and Mesopotamia, their art is distinguishable by the use of elegant and curvilinear lines that connote feelings of life, movement, and elasticity.

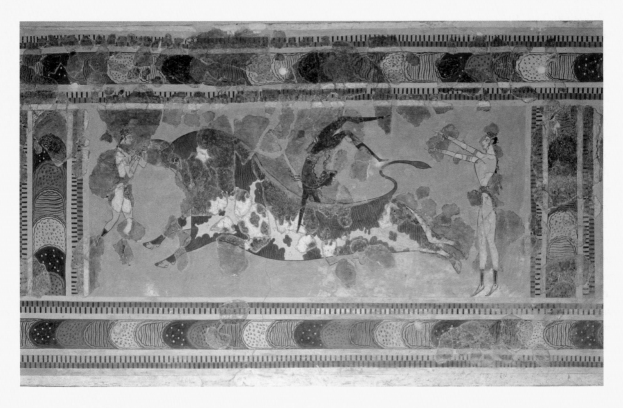

Figure 3.1 *The Toreador Fresco*, from the palace at Knossos (Crete), Greece, ca. 1450–1400 BC. Fresco, 78.2 cm x 104.5 cm, including border. Archaeological Museum, Herakleion.

the final phase of habitation at Knossos, Mycenaeans appear to have seized control of the palace complex. Finds include the discovery of a Mycenaean throne room and hundreds of Linear B tablets. In Homer's *Iliad*, the "Catalogue of Ships" records a king of Knossos among the Greek leaders who contributed warships to the armada that sailed against Troy.

Mycenaean Civilization (ca. 2000–1100 BC; high point 1600–1100 BC)

The Indo-European element that invaded the Greek mainland, known as the Mycenaeans, appears to have conquered the native population and to have reduced it to laboring status. They also came in contact with Minoan communities and assimilated their advanced building techniques. The Mycenaeans adapted to Minoan architectural design and the palace-based economic system, as the excavated palaces at Mycenae, Pylos, and Tiryns amply demonstrate. Given similarities in art and architectural design, not to mention the likeness of Linear A and B script, the Mycenaeans would appear to have relied on the immediate efforts of skilled Minoan artisans and scribes to make the transition. Palace-based bureaucracies appear to have supervised the

TABLE 4. FLOWCHART OF THE MYCENAEAN HIERARCHY		
KING AMONG KINGS (Wanax)		
Retine of Warriors		
Artisans and scribes		
Farmers and slaves		
Local King (Basileus)	Local King (Basileus)	Local King (Basileus)
Retinue of Warriors	Retinue of Warriors	Retinue of Warriors
Artisans and scribes	Artisans and scribes	Artisans and scribes
Farmers and slaves	Farmers and slaves	Farmers and slaves

administration of local resources while the Mycenaean warrior elites concentrated on warfare, gradually extending their raids into the Aegean and eastern Mediterranean Sea lanes. Mycenaean sea raiders marauded communities as far removed as Cyprus, Syria, and Egypt. Since the Mycenaean hierarchy left no written legacy, no Gilgamesh epic, no law code, no prose of any kind, one suspects that members of the Mycenaean warrior elites were illiterate, including the kings, and that they depended on educated subordinates to manage palace affairs. Their architectural remains prove stunning, nonetheless. Significant monuments at Mycenae include Grave Circle A (ca. 1650–1500 BC), Tholos tombs (1550–1200 BC), the **Megaron** (ca. 1350–1300 BC, a royal reception hall with a round central hearth), and **Cyclopean fortification walls** (1350–1200 BC). Linear B tablets themselves appear to have functioned as temporary archival records and survive only because they were fire hardened at the time of palace destruction. They record, therefore, the final phase of these palace-based communities (1250–1100 BC).

A useful indicator of Mycenaean commercial power arises in the form of colorfully painted ceramic stirrup jars used to export surplus commodities of wine and olive oil. Some 15 to 30 cm tall, these squat jars have been discovered throughout the Near Eastern coastal

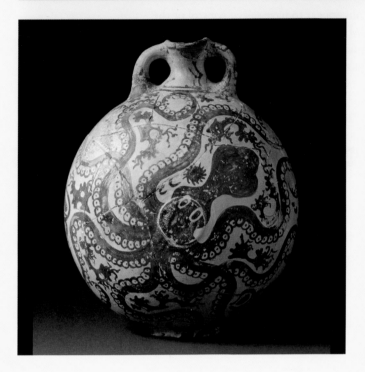

Minoan pottery, like Minoan painting, was inspired by a love of nature, movement, and organic forms. By the Middle and Late Minoan periods, pottery wheels were used to create a variety of forms and sizes. A realization by Minoan potters of the relationship between the vessel's decoration and shape is vividly apparent in the so-called Marine Style of the Late Minoan IB phase. The octopus stirrup jar from Palaikastro is an example of this style. Decorated with a large, wide-eyed black octopus with swirling tentacles— its dark decoration on a light, eggshell-colored background—reversed the light on dark format found on Kamares-ware jars produced earlier in Crete. This dark silhouette on a light ground that constituted the Marine Style was extremely influential, remaining the preferred manner in Greece for nearly a thousand years.

Figure 3.2 Octopus Vase, stirrup jar from Palaikastro, Crete, ca. 1500 BC. Height, 28 cm. Archaeological Museum, Iráklion, Crete.

region, including Egypt and serve to demonstrate the range of Mycenaean trade. Evidence of Mycenaean trade contacts has been identified in Italy, Spain, and in Cornwall, England, where Mycenaean traders traveled in search of metals such as lead and tin. Through maritime commerce the Mycenaeans were able to sustain large local populations. It is estimated that the wider community at Mycenae supported 180,000 people in the plain of Argos below. A population of this size is unthinkable under subsistence modes of production.

The peak era of Mycenaean Civilization was 1400–1200 BC. Excavated levels of 1200–1000 BC exhibit fire damage at several Mycenean palace complexes, indicative of widespread societal collapse. Not all the palace complexes collapsed: Tiryns, for example, continued as an urban settlement. It is undeniable, however, that the societies emerging in the following era were remarkably different. Equally significant is the fact that the Mycenaeans left no evidence of advanced literary culture despite the relative sophistication of neighboring Ancient Near Eastern hierarchies in their vicinity. Apart from their adaptation of Minoan-styled palace complexes with the likely accompaniment of palace bureaucracies and artisanal production, the ruling elites of the Mycenaean Aegean adhered to the warrior ethos that had enabled them successfully to conquer the Aegean region in the first place.

The Hittite Empire (ca. 1750–1180 BC)

The Hittites furnish a potential example of the manner in which the Mycenaeans might have developed had they enjoyed closer proximity to and greater cultural diffusion with neighboring Near Eastern civilizations. At the same time, they exhibit several societal characteristics in common with their Aegean neighbors. Although partly derived from legend like the Homeric tradition, the Hittites preserved a sometimes detailed account of their royal history. Since much of this archival information preserves contemporary events of the writers themselves, it is far more reliable than anything preserved in the Aegean. Hittite records present the impression of a royal hierarchy confronted by innumerable challenges, internal and external, political and military, divine and human.

The most remarkable thing about the Hittites was their hierarchy's ability to dominate the region for more than 400 years. After migrating into Anatolia by 1900 BC, the Hittites emerged as a regional power from settlements near Kanesh (Nesa). Legendary Hittite kings gradually conquered neighboring peoples, and by 1750 BC they extended their suzerainty throughout central Anatolia. Although their conquest was temporary, it promoted sufficient cultural and political assimilation to enable later kings such as Hattusilis I (1650–1620 BC) to assert a diverse, loosely regimented hegemony. Subject peoples included unruly neighbors such as the Kaska people on the Black Sea coast, the Arzawa on the Aegean, and the Luwian inhabitants of Kizzuwatna, and Tarhuntussa on the southern Mediterranean coast. Territorial gains were secured through the implementation of garrison posts known as royal seal houses and the imposition of Hititte weights and standards, including the production of highly polished Hittite ceramic forms. Like the Mycenaeans, the Hittites organized what proved to be an unstable hierarchy inordinately dependent on locally powerful subject kings. As with the Mycenaean political system, the Hittite king was recognized as the Great King, and his authority over subject kings was restricted in several respects. Hattusilis I's grandson and successor, Mursilis I (1620–1590 BC), extended Hittite authority beyond the Tauros Mountains into eastern Anatolia and northern Syria and conducted raids as far removed as Babylon. However, conspiracies emerged within the court, culminating in the assassination of Mursilis by his own brother-in-law. This crisis plunged the Hittite realm into an extended period of dynastic confusion and civil war. Neighboring states promptly took advantage of the situation, particularly the Mitanni who absorbed Hittite client states in Syria and embarked on repeated raids in Anatolia. Mitannian fortunes were reversed around 1420 BC by King Tudhaliyas I, who reestablished Hittite central authority in Anatolia. Tudhaliyas halted the advances of rival states and established what became known as the Hittite New Kingdom.

Given the recurring pattern of dynastic disputes that accompanied succession to the throne, the kings worked hard to establish a more stable means of transition. Following the period of anarchy that prevailed during the collapse of the Hittite Old Kingdom, King Telepinu, who himself acquired the throne through a violent act of usurpation, drew up an edict to formalize the rules for succession (ca. 1460 BC). As part of the process he required the convening of an assembly of nobles referred to as the *Panku*—presumably an

assembly of all high ranking military commanders and court officials. The Panku became entrusted by Telepinu to uphold the rules for succession: it could only be assembled at the order of the king and its function was merely to propose measures that the king was free to modify. In fact, Telepinu may only have intended to exploit the institution to prevent the formation of cabals against the throne. Nonetheless, according to the edict the king's authority became constrained by the requirement that he comply with the wishes of the gods and the Panku. This suggests that Hittite political institutions were chaotic much like those of the Mycenaeans, the main difference being that the Hittites preserved a much better record of their difficulties.

The Hittite king Suppiluliumas I (ca. 1344–1322 BC) expanded the territories of the Hittite Empire to its furthest extent. Resorting to a calculated blend of warfare and diplomacy, he retook Syrian client states from the Mitanni and New Kingdom Egypt and so weakened the first-mentioned state that it disintegrated shortly thereafter. While Suppiluliumas was campaigning successfully in Syria, he received a strange message from the Egyptian widow of Pharaoh Tutankhamon, requesting the hand of one of his sons in marriage. As he noted in the records preserved in the Royal Archive at Hattusa, he dispatched his youngest son, Zannzannza, to Egypt, only to learn that he was murdered en route. This and other accomplishments adequately demonstrate the status achieved by Suppiluliumas as a world leader, the only legitimate rival to the pharaoh of New Kingdom Egypt. Suppiluliumas returned to Hattusa from his campaigns in Syria bearing a plague that ultimately caused his own death and ravaged the inhabitants of Anatolia for more than a decade. His successors Mursilis II (1321–1295 BC) and Muwatallis II (1293–1271 BC) contended with repeated challenges to Hittite hegemony. Many of these were deliberately instigated by Near Eastern rivals and others seemingly arose from disturbed conditions in the Aegean. The Egyptian pharaohs persisted, for example, in their efforts to retake lost territory in Syria. Egyptian inroads in Syria became so serious that Muwatallis was ultimately compelled to invade the region with the largest military force ever assembled. He confronted Pharaoh Ramses II at the Battle of Kadesh in 1274 BC; at this battle, a combined host of 47,000 Hittite warriors and recruited mercenaries fought to a standstill against a similarly composed force of 41,000 Egyptians. Although the battle turned in both directions, the forces of Muwatallis ultimately prevailed and enabled him to retake most of Syria.

Following the death of Muwatallis, his son Urhi-Teshub was suddenly deposed by his uncle Hattusilis III (1267–1237 BC), inciting another dynastic crisis. By this point so many troubling developments were emerging in the Near East that both kings, Hattusilis III and Ramses II, decided to resolve their long-standing border war by contracting the Treaty of Kadesh (ca. 1258 BC). Although the treaty did little more than recognize the prevailing status quo, it freed the Hittites and the Egyptians to address other concerns. Around 1180 BC the Hittite state imploded, subject peoples such as the Ahhijawa, the Muski, and the Kaska overthrew the reigning hierarchy, and the capital of Hattusa itself was subjected to conflagration. Although the sudden break in record-keeping makes it difficult to determine what actually happened, the rapid disintegration of the Hittite Empire offers one of the first crucial signposts for the collapse of Late Bronze Age societies.

AGE OF EMPIRES: THE RISE OF INTERNATIONAL ELITES IN THE LATE BRONZE AGE NEAR EAST (1400–1100 BC)

The last three centuries of the Bronze Age (1400–1100 BC) represented a high watermark for the development of urban societies. Cities and capitals flourished across the Near East, and connectivity of trade and culture attained their highest levels of integration particularly among regional ruling elites. In many respects an international standard of culture and taste emerged among neighboring elites. International styles emerged in the fine arts, for example, representing a hybrid of local traditions blended with foreign influences. Akkadian became the universal standard of writing, and literate elites in all regions were expected to have read the classics of Mesopotamian literature. Education in international languages, traditions, trends, and culture enabled elite elements to identify with one another and thereby to distance themselves from their respective native populations.

Map 3 Late Bronze Age Empires of the Mediterranean ca. 1250 BC.

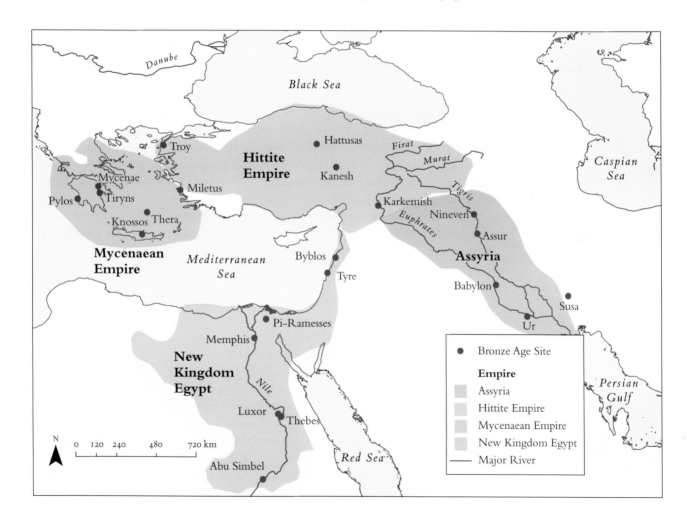

At the highest echelons of society, a network of royal dynasties became visibly linked through marriage alliances, treaties, commercial exchanges, shared values, and culture. One scholar describes this network as world of extended households.[1] In their communications the great kings of Egypt, Anatolia, Cyprus, Babylonia, and Assyria referred to each other as brothers and to lesser kings as servants. Although they sparred incessantly through border wars, they also engaged in extensive treaty and marriage alliances. Repeated intermarriages among royal dynasties enabled foreign dynasties to establish blood connections, to secure stable partnerships among neighbors, and even to play a role in neighboring dynastic succession (as demonstrated by the example of Tutankhamon's widow). This heightened the perception that the rulers of the Ancient Near East belonged to a common community, something resembling a large Near Eastern village. Gifts were the most frequent topic of correspondence between rulers. Gifts furnished a dual function as prestige goods and as emblems of mutual respect and brotherhood. These helped to reinforce the status of New Kingdom Egyptian rulers as the dominant players of the era, and the kings who received gifts of Egyptian gold regarded these as confirmation of their status in the wider community. Gift exchange also induced obligations of reciprocity, the repetitive nature of which helped to bind the kings in increasingly close circles of friendship. Gifts that accompanied treaty relations likewise had the potential to initiate better relationships between polities, by establishing mutually beneficial protocols such as trading rights and common weights and standards. Hence, gift giving helped to expand the world economy. In developed regions (the limited extent of which needs to be emphasized) specialization in agricultural and artisan production and wider commercial interconnectivity were increasingly visible. As we have seen, exchanges occurred with papyrus, gold, stone, and foodstuffs exported by Egypt; timber, oil, and wine from Canaan and Phoenicia; metals, horses, and military technology from Anatolia; perfumed oils, wine, slaves, and mercenaries from the Aegean. The end result, quite possibly, was a heightened era of interconnectivity, population growth, prosperity, interdependency, and cultural affinity across the region.

Rivalry and military competition was another essential component to the Late Bronze Age community of nations. Warfare was viewed as a legitimate way for a king to establish his status as a leading power and to join the fraternity of great kings. Neighboring kings engaged personally in incessant border wars; they conducted razzias to pick off one another's vassals and sometimes challenged one another through massive confrontations, such as the Battle of Kadesh in 1274 BC. Client states along border regions—particularly Cyprus, Syria, and Canaan—were lured back and forth or forcibly seized and garrisoned. Those states lacking adequate buffer zones, such as the Mitanni and Kassite Babylonia, had little choice but to expand their territories at the expense of their neighbors or see them reduced. Warfare was rarely viewed in absolute terms, however, and kings seldom embarked on campaigns with the intention of annihilating a rival party. Such a strategy would only have served to undermine the social fabric of the community and to destabilize

1 Marc Van De Mieroop, *A History of the Ancient Near East ca. 3000–323 BC*, 2nd ed. (Oxford: Blackwell, 2007), 136.

the existing status quo. Typically, warfare was used to readjust power relationships between rival kings and to acquire heightened status and the benefits this entailed. It was not until the late thirteenth century BC that this world system started to fall apart, prompting the rules of competition and warfare to change radically.

The bonds of the Late Bronze Age Near Eastern community were largely restricted to the limited elites that perceived themselves as an international hierarchy. Although expanded trade distributed material benefits to a diverse range of populations, most of the wealth of the international order of the Late Bronze Age remained squarely in the hands of the hierarchies. City-states large and small exhibited stout defenses and elaborate palaces for their local dynasties; many cities exhibited multiple palace complexes. Local ruling elites engaged in unprecedented accumulations and displays of wealth that enabled them to distance themselves from their local populations. They created palace communities that were built by foreign laborers rounded up as prisoners during military campaigns for the expressed purpose of constructing royal capitals. In fact, distant elites tended to identify more with one another than they did with their own host populations, and this may very well have contributed to the momentum of societal collapse. As conditions changed and wealth accumulated increasingly at the top, sizeable elements of disengaged and disenchanted populations began to challenge the stratified, interconnected system of the Late Bronze Age Near Eastern world. For whatever reason, the maintenance of the world system became unsustainable around 1250 BC, setting in motion two centuries of chaos and societal collapse. Much of the available information is fragmentary, and all the resulting explanations remain speculative. While attempting to outline this, we must be careful to stress the hypothetical nature of our conclusions. As we noted earlier, three phenomena are typically identified as causal to the societal collapse that occurred at the end of the Bronze Age—the Sea Peoples, the Habiru, and climate change.

MAIN CAUSES OF SOCIETAL COLLAPSE OF BRONZE AGE AEGEAN CIVILIZATIONS

The Rise of the Sea Peoples (1250–1178 BC)

Many believe that the Battle of Kadesh in 1274 BC marked a turning point for the political stability of the Late Bronze Age. Following this momentous confrontation the kings of the Hittites and New Kingdom Egypt agreed to the Treaty of Kadesh, marking the cessation of their century-long conflict. From this point onward the great powers turned their attention toward new more immediate threats to their security. One of these was the Sea Peoples, tribally organized groups of Aegean seaborne warriors with whom both the Hittites and the Egyptians had experienced numerous previous encounters. Although the Sea Peoples as a term emerges only toward the end of the Bronze Age, the constituent tribal groupings

listed in these records were mentioned by name in earlier military accounts. At the Battle of Kadesh itself the Egyptians name the *Dardany* and the *Lukka* among the various allies serving with the Hittite army. On their own side warriors known as the *Shardana* were mentioned. A notorious pirate population, the Shardana had launched seaborne raids on the coast of Egypt as early as the reign of Amonhotep II (1427–1401 BC). The Lukka were another notorious host of pirates. Reports of their raids on client states in Cyprus and Syria began as early as 1700 BC and recurred frequently in the texts of the Amarna archive. The rap sheet for the Dardany was less expansive, but specialists believe that the name was equivalent to the Dardanoi at Troy, that is, the Homeric name for the people who resided in that region at the time of the Trojan War. Since archaeological evidence points to the destruction of Troy Level VIIA occurring ca. 1250–1220 BC, their presence at Kadesh seems noteworthy.

In conjunction with Troy another element that could be mentioned was the *Ahhijawa*. For at least two centuries the Ahhijawa menaced the Aegean flank of the Hittite Empire. Like the Lukka people the Ahhijawa appear to have been skilled seafarers, for they too appear in the Egyptian list of Sea Peoples as the *Aqaiwasha*. In the Hittite archive their activities likewise intersected at Troy. Around 1280 BC the archival records of the Hittite king Muwatallis mention a treaty concluded by the Ahhijawa with a client king named "Alaksandus of Wilusa." Many scholars wish to identify this person with the Homeric hero Paris (Alexander) of Troy, particularly since the Classical city of Troy was known by the epithet *Ilios* or *Ilium*: the epithet sounds remarkably similar to *Wilusa*, particularly when one allows for the eventual loss of the *digamma*, or the "wha," sound in spoken Classical Greek. Although none of this data lines up squarely with the Homeric tradition for the Siege of Troy, they do exhibit a remarkable approximation to the archaeological record for the destruction of Troy Level VIIA. The assemblages of this layer at the site are clearly associated with Late Bronze Age contexts. Many scholars believe that the name and description of the *Ahhijawa/Aqaiwasha* share close affinity with Homer's description of the *Achaioi* or the Achaeans, that is, the Mycenaean tribe ruled by King Agamemnon himself. The Hittite archival records may contain actual references to the Siege of Troy, and the chronological overlap of these strands of information with those of the Sea Peoples who invaded Egypt remains uncanny. Another telling example of the Sea Peoples concerns the *Peleset* (or *Pulisati*). This particular Sea People bears linguistic association with the Philistines, a Bronze Age people who settled on the south coast of Canaan. They eventually became the inveterate foes of the Hebrews. Philistine pottery exhibits unquestionable continuity with Mycenaean forms such as stirrup jars. According to the Old Testament the Philistines originated from *Kaphtor*, the biblical word for Crete. The Peleset offer our most certain proof, therefore, that the Sea Peoples originated from the Aegean.

After the Battle of Kadesh the frequency and character of attacks by the Sea Peoples intensified. Together with the Arzawa and the Kaska, they appear to have been responsible for the destruction of the Hittite Empire. At the end of the thirteenth century BC they descended in waves on coastal communities along the eastern Mediterranean basin. No longer roving as isolated pirate bands, in this era the Sea Peoples arrived as massive hordes

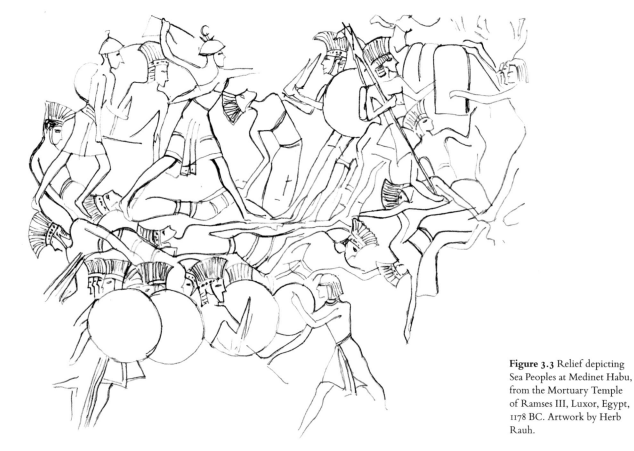

Figure 3.3 Relief depicting Sea Peoples at Medinet Habu, from the Mortuary Temple of Ramses III, Luxor, Egypt, 1178 BC. Artwork by Herb Rauh.

accompanied by large numbers of women and children desperate for food supplies. The archaeological evidence indicates that several Anatolian, Cilician, Syrian, and Canaanite settlements were destroyed at this time. After disrupting the infrastructure of this region, the Sea Peoples descended on the coastal territories of New Kingdom Egypt.

A preliminary assessment about the Sea Peoples posits, therefore, that they arose from tribal entities from across the seas, presumably from the Aegean or from along the southern shores of Anatolia, that they were competent seafarers, adept at naval warfare but equally proficient on land, and that they were well known to the hierarchies of the great powers who alternately confronted the Sea Peoples as pirates or recruited them as mercenaries. Most of the commentary about them is decidedly negative, but this may have resulted from the tendency of archival records to record mention of renegades only when they were doing something destructive. The essential point is that around 1200 BC, something— political instability, warfare, famine, climate change—seems to have set these peoples in motion and caused them to migrate as entire populations from the northern quadrant of the eastern Mediterranean (the Aegean, the islands of Crete and Cyprus, the south coast of Anatolia) to the east (Cilicia, Syria, Canaan) and the south (Egypt). Accordingly, the Sea Peoples are widely recognized as one of the fundamental contributors to the collapse

of Late Bronze Age Near Eastern societies. What needs to be determined is the nature of the problem that set them in motion in the first place.

The Habiru

The second element commonly blamed for the confused conditions at the end of the Bronze Age was the **Habiru** or **Hapiru**. Rulers at the end of the Bronze Age expressed repeated anxiety about these rootless, anti-social elements in their midst. The Habiru were an amalgam of pastoralists, renegades, runaway farmers, and refugees hiding in the deserts and neighboring mountains of the Near East. They resisted the authority of urban hierarchies and came to pose a significant menace to the security of Late Bronze Age polities, large and small. Like Maryannu and Sea Peoples, *Habiru* (originally Akkadian) is an international loan word employed in the documents of nearly every major empire of the region, particularly among the client states of Syria and Canaan for whom they posed the greatest menace. This suggests that much like the Sea Peoples the Habiru were a universally recognized threat. One Sumerian text refers to them as "soldiers from the West." This and their association with pastoralism suggest that their origins lay among amorphous Bedouin tribes that inhabited the north–south trending mountain ridges that demarcated Syria and Canaan. They spoke various languages, exhibited considerable military aptitude, and on occasion exerted significant political authority (regional kings signed treaties with Habiru, for example). Due to their ability to withdraw into the hills and the desert to evade the authority of more regimented societies, the Habiru acquired universal loathing. Despite their apparently limited resources, the mobility of the Habiru furnished a decided advantage when confronting Near Eastern hierarchies. The Habiru's reputation as bandits probably resulted from their tendency to infest strategic nodes of the overland trade routes in order to maraud passing caravan trains. Like the Sea Peoples the Habiru recur fairly often as mercenaries in Near Eastern military annals, with several texts referring to them as chariot warriors, the elite *maryannu*. In Egyptian reliefs depicting the Battle of Kadesh, for example, mounted Habiru are represented as reconnaissance soldiers serving with the Egyptian army. As warriors their numbers were occasionally quite large; some 3,600 Habiru were reportedly captured by the Egyptian pharaoh Amonhotep II during an expedition in Canaan ca. 1420 BC. Despite the ambiguity surrounding their ethnic identity, the Habiru threat to social stability seemed genuine.

At the close of the Bronze Age the main threat posed by the Habiru was their capacity to offer asylum to distressed elements fleeing autocratic oppression, particularly the imperiled city-states of Syria and Canaan. Not only did runaway laborers, criminals, and the destitute join the Habiru, but in times of mounting chaos even dissident princes of Syria and Canaan sought refuge among them. Peasant flight—widespread abandonment of agricultural terrain by peasants who could no longer endure the tax burden—possibly jeopardized the economic foundations of the Late Bronze Age world system, particularly given the close proximity of destabilizing Habiru encampments. A shortage of laborers would likely

have induced agricultural shortfalls, imposing greater demands on farmers who remained behind. Indebtedness and the risk of enslavement would likely have compounded peasant resentment and anxiety, encouraging additional flight and an eventual collapse of the rural infrastructure. Having lost confidence in the legitimacy of their hierarchies, the under-classes may have begun to fend for themselves. It may not be a coincidence, accordingly, that so many palace complexes exhibit signs of destruction. In the end the erosion of the rural social fabric as represented by the growing menace of the Habiru furnishes another likely component to the collapse of Late Bronze Age societies.

EVIDENCE OF CLIMATE CHANGE

The third scenario for causation of Late Bronze Age Societal collapse is climate change, an argument that we have seen raised for earlier downturns in Near Eastern urban develop-ment (the collapse of the Early and Middle Bronze Ages). As with the earlier events, the evidence for climate change in this instance is preliminary, limited, but suggestive. Tree ring data obtained from huge logs used to construct the royal tomb of the Phrygian king Midas at Gordium (ca. 715 BC) indicate a brief period of very dry weather ca. 1200–1150 BC. This evidence appears to overlap with repeated references to famine, declining agricultural production, and rising prices of grain throughout the region. Not only were the Sea Peoples reportedly driven southward by famine, but records show that the Hittite hierarchy at Hattusa appealed desperately for help with food imports at the time of their societal collapse (ca. 1212 BC). Throughout the wider Near East, bad harvests, drought, and famine are mentioned at least 14 times in texts dating from 1000 to 950 BC. In Egypt the price of grain rose 800 per cent during the twelfth century BC and remained at that high level for a century, provoking at least six recorded instances of labor protests by Egyptian artisans. In Assyria conditions grew so severe that rituals of food and drink offerings for many of the gods were indefinitely suspended. Archaeological survey indi-cates that populations declined perhaps by as much as 75 per cent on the Greek mainland, 75 per cent in Babylon, and 25 per cent at Susa. In the Aegean, surviving populations aban-doned previously well-populated coastal areas in Crete to develop new smaller villages in the mountains or at other easily defensible positions. Without palace bureaucracies to maintain recursive institutions, the knowledge of writing and other fine arts disappeared entirely in the Aegean, suspending historical reconstruction altogether and initiating a Dark Age. Even in Assyria, which survived relatively intact, there are no surviving records for the period 1050–935 BC. To be sure, not all areas were affected to the same degree. Egypt, Assyria, Babylon, and Elam endured, as did Carchemish and many of the cities along the coast of Syria and Canaan. Regardless of the relative degree of social and terri-torial decline during the Dark Age, the wider interconnected system of the Late Bronze Age Near East unmistakably collapsed. With confused conditions on all sides, Egypt, once the hub of the Late Bronze Age community of nations, returned to Early Bronze Age

levels of isolation. The Mediterranean and Canaanite trade links on which the Egyptians had depended for their hegemony broke down altogether, and the Egyptians ultimately succumbed to attacks by marauding Libyans and Nubians. The populations and trade links of Assyria, Babylonia, and Elam declined dramatically, leaving them an isolated pocket of interconnectivity. Wider trade links would not revive until after 950 BC.

Throughout the wider Mediterranean Sea some sort of universal cataclysm appears to have provoked political and social collapse and mass migrations around 1250 BC. It is interesting to observe that neighboring populations in more distant parts of Eurasia appear to have experienced similar patterns of rise and fall along the same chronological lines as those in the Bronze Age Near East. In Thy (Jutland), Denmark, for example, archaeologists have noted a decided rise in barrow settlements, extensive land clearance, and agricultural development between 2300 and 1700 BC. The discoveries of amber grave goods that ultimately originated from the Baltic in Grave Circle A at Mycenae demonstrate that exchanges between these distant regions, however minimal, had occurred at this time. The Indus Valley cultures in modern-day Pakistan were likewise dynamic urban societies during the Middle Bronze Age, though their development was likely interrupted prior to the invasions of Indo-European peoples around 1700 BC. Evidence of Mesopotamian seal stamps found in Mohenjo Daro demonstrates that these two civilizations were likewise in communication before this time. Recent archaeological investigations in Central Asia (particularly near the Pamir Mountains bordering China) have demonstrated similar patterns among the nomadic inhabitants in this vast steppe environment. A similar pattern of social fragmentation characterizes the transition from Bronze Age to Iron Age settlements in this region. Although it becomes hazardous to pursue the parallels further, one should probably note that in China the Xia Dynasty went through a similarly chronological curve of Bronze Age development and collapse, creating palace hierarchies, writing technology, and bronze metallurgy by 2000 BC. The military technology of horse chariot warfare reached East Asia at relatively the same time as it did the Near East, and the Xia civilization also underwent societal disintegration at approximately the same moment (1028 BC). In other words, the development of stored wealth at core urban civilizations appears to have generated an increasing radiation of exchange patterns with distant populations. The advanced civilizations of the Aegean/Ancient Near East extracted amber from the Baltic, lapis lazuli from Afghanistan, ivory from Africa, and tin from Britain. The patterns of this prestige trade demonstrate the emergence of a wider, potentially global world system that not only drew distant populations into its orbit but also synchronized the economic trajectories of everyone concerned.

Bronze Age societal collapse appears to have induced out migration by various Bronze Age populations, thus enabling the diffusion of advanced urban culture and technologies into untapped regions of the Mediterranean. Iron Age cultures became more widely dispersed than those of the Bronze Age and extended from Spain and North Africa to Syria, Egypt, Anatolia, and the Black Sea. This allowed for greater diversity and redundancy within the subsequent world system and helped to insure a broader, more sustainable foundation to urban growth. When relative calm returned to region in the tenth century

BC, the old empires were gone or reduced to impotence. In their place new technologies and new social formations would enable peoples such as the Phoenicians, the Greeks, and the Aramaeans to engage in fresh patterns of societal development.

FURTHER READING

Bernal, Martin. *Black Athena: The Afroasiatic Roots of Classical Civilization*. 3 vols. New Brunswick, NJ: Rutgers University Press, 1987–2006.

Betancourt, Philip P. *The History of Minoan Pottery*. Princeton, NJ: Princeton University Press, 1965.

Bryce, Trevor. *Life and Society in the Hittite World*. Oxford: Oxford University Press, 2002.

Davies, Penelope J.E. *Janson's History of Art, The Western Tradition*. 7th ed. Vol. 1. Upper Saddle River, NJ: Prentice Hall, 2007.

Drews, Robert. *The End of the Bronze Age: Changes in Warfare and the Catastrophe ca. 1200 BC*. Princeton, NJ: Princeton University Press, 1993.

Kleiner, Fred S. *Gardner's Art through the Ages: A Global History*. 13th ed. Boston: Cengage, 2011.

Preziosi, Donald, and Louise A. Hitchcock. *Aegean Art and Architecture*. Oxford: Oxford University Press, 1999.

Sandars, N.K. *The Sea Peoples: Warriors of the Ancient Mediterranean*. London: Thames and Hudson, 1985.

Vermeule, Emily. *Greece in the Bronze Age*. Chicago: University of Chicago Press, 1972.

PART II

CIVILIZATIONS IN FLUX: THE CLASSICAL/ EARLY IRON AGE

FOUR

IRON AGE NEAR EASTERN CIVILIZATIONS (1000–300 BC)

WHAT HAVE WE LEARNED?

► That many scholars believe that Bronze Age societal collapse began with disturbances in the Greek Aegean Sea, where ancient legend recorded the Sack of Troy as a defining moment in pre-Hellenic history.

► That the earliest Bronze Age urban civilization to emerge in the Aegean was Minoan Crete (ca. 3000–1500 BC).

► That around 2200–2000 BC, Indo-European migrations expanded into mainland Greece and Anatolia. From these emerged the Mycenaeans (ca. 2000–1100 BC) and the Hittites (ca. 2000–1200 BC).

► That the Hittites assimilated Anatolian native culture and established a royal hierarchy at Hattusa by 1700 BC. From Hattusa and other centrally located palaces, the Hittite warlords established supremacy over an array of Anatolian peoples.

► That a number of indicators including the Treaty of Kadesh, the destruction level at Troy VIIA (1250–1220 BC), the construction of Cyclopean defenses at Mycenaean palace complexes (ca. 1200–1100 BC), the invasions of the Sea Peoples, the unruliness of the Habiru, and evidence of climate change all point to heightened disturbances and political and social fragmentation in the eastern Mediterranean basin at the close of the Bronze Age (ca. 1100 BC).

► That a similar pattern of social fragmentation characterizes the transition from Bronze Age to Iron Age settlement in regions as far removed as northern Denmark, the Indus Valley, the Sub-Saharan Nile river basin, Central Asia (Tajikistan), and northern China.

IRON AGE TRANSITIONS

Societal collapse at the close of the Bronze Age was not uniform across space and time. Although societies at the center of world systems bore the brunt of the upheaval, they were also the first to rebound in the following era, most likely because they were situated in food-producing regions that straddled important arteries of trade. A few Bronze Age societies such as Assyria and Babylonia were able to reemerge relatively intact by 900 BC. Egypt likewise persisted, although by 945 BC Libyan Bedouins invaded the Nile valley and assumed local control. In other respects the complexion of the Near East changed dramatically. New peoples, notably the Aramaeans and the Chaldeans, migrated into Mesopotamia to establish an array of chiefdoms in the surrounding mountains and deserts. Their West Semitic cultural attributes, particularly their adaptation of the Canaanite writing system (Aramaic), would resonate as far away as Persia and the Indus. In the former region of Canaan, non-Aramaean polities emerged, including Phoenicia, Israel, Judah, Ammon, Moab, and Edom. Conditions in the Near East remained disturbed for a considerable time as newcomers reorganized political boundaries and control of local assets. Eventually, resurgent extraterritorial states (the Assyrians, the Babylonians, the Persians) renewed the process of consolidation and compelled smaller states to accept subservient roles in their hegemonies. Technological innovations in the post-Bronze Age centuries included the adaptation of iron as the cutting-edge technology for weapons and tools, the development of more accessible writing systems, and the introduction of horse- and camel-back transportation. The appearance of iron tools helped to designate the early Classical Era as the Iron Age. The collapse of Bronze Age trade routes appears to have restricted access to distant sources of copper and tin and compelled metallurgists to experiment with locally available iron ore. Iron was also more plentiful than copper or tin in all ancient regions of habitation. In the Mediterranean iron use developed more crudely; people most likely relied on charcoal to attain the necessary levels of heat. Primitive forms of charcoal production typically require seven units of wood to generate one unit of charcoal. Widespread production of charcoal placed far greater demand on regional forestry resources, accordingly, and may have played a significant role in landscape transformations at this time.

A second major development of the Early Iron Age was the appearance of the Phoenician alphabet. Drawing on previous experimentation with phonetic and syllabic scripts in Late Bronze Age Egypt, Canaan, and Ugarit, the Phoenicians created a simple writing system that was more accessible to everyday people. Although the extent of literacy in the Iron Age remains debatable, the new technology put stored knowledge and communications into the hands of a much wider swath of the population. This removed the advantage of (and need for) limited scribal elites that so dominated intellectual life during the previous era.

A third set of innovations entailed the harnessing of horses and camels for transportation. Innovations in the design of bridle and saddle equipment enabled pastoralists from the northern steppes (first recorded with the Cimmerians, the Scythians, and the Iranians) to adapt to large formations of horseback warriors as a new form of assault force. This

significantly expanded the range and effectiveness of cavalry warfare. The speed and mobility of mounted warriors revolutionized Iron Age battle tactics, with the result that emerging empires concentrated on recruiting these contingents in the same manner that Bronze Age polities had focused on chariot warriors. The domestication of the camel in the Arabian Peninsula, meanwhile, revolutionized long-distance trade and travel throughout the Near East, enabling voyagers to traverse vast expanses of desert. Camels, horses, and improved ship construction all contributed to the reassembling of interregional trading systems.

Initially, those states that sustained the greatest continuity with the Bronze Age—particularly the Assyrians, the Babylonians, and the Egyptians—did so by adhering to past technologies and social systems. These enabled them to weather the storm and to preserve crucial aspects of Bronze Age learning and technology. The infiltration of rural populations (Aramaeans, Chaldeans, and Cimmerians, etc.) generated highly unstable political conditions that prohibited interconnectivity. Gradually, the societies that bridged the Bronze and Iron Ages reasserted their military, economic, and cultural advantages. The leading societies of the Early Iron Age were the Phoenicians, the Assyrians, the Neo-Babylonians, the Iranians, and the United Kingdom of Israel. In this chapter we will discuss the impact of the first four mentioned civilizations. The cultural experience of the last mentioned society was so significant that we will reserve our discussion of it for later.

PHOENICIA (1100–600 BC; HIGH POINT CA. 1000–800 BC)

Phoenicia consisted of several West Semitic coastal cities that managed to survive the passage of the Sea Peoples at the end of the Bronze Age or alternatively were rebuilt following the period of disorder. Phoenician civilization emerged from a mixture of original Canaanite populations and newly settled Aramaeans and Sea Peoples. Their mastery of maritime trade and naval warfare and their ability to recruit the necessary skilled labor made them indispensable to the ruling hierarchies of Near Eastern empires. The Phoenicians are credited with the reconstruction of the Mediterranean trade routes, the first effective alphabet, the influence of the Baal cult, and innovations in creature comforts.

Together with the Aegean Greeks, the Phoenicians reconstructed the trade routes of the Mediterranean. By 1000 BC Phoenicians occupied several settlements on the island of Cyprus and extended their maritime reach westward. The Phoenicians continued to improve ship-building technologies to accommodate greater loading capacities and designed sleek, galley-oared warships to protect their convoys of merchant vessels. Sailing Mediterranean waters became more reliable. The greatest contribution of the Phoenicians was the reconstruction of maritime trade routes that connected raw natural resources (principally metals and grain) in the western Mediterranean (Sicily, Spain, North Africa, and beyond) to the finished goods increasingly generated by artisans in Phoenician cities. The Phoenicians devised relatively simple means of navigation. As they sailed they kept log

books exclusive to themselves. They relied on winds and currents for trans-Mediterranean navigation, but for the most part they explored coastal routes relying on hard-won knowledge of the locations of sheltered roadsteads and moorages, not to mention potable water and friendly inhabitants. Their position along the north–south trending coast of Syria-Palestine gave their harbors enormous advantage. Numerous harbors and roadsteads became established along this coast, even in the bleakest of desert environments, to accommodate and take advantage of this lumbering trade (particularly since it was hazardous to sail at night). Several Phoenician harbors, such as Tyre, Sidon, and Acre (Akko), were situated on off-shore islands furnished with ready-made harbors for passing sailing ships. Their populations developed agricultural terrain on the opposite mainland to create hinterlands. Much like Aegean Greek communities, this form of settlement pattern is referred to as *liminal* or coastal in character. Positioned as they were at the ends of the overland trade routes bearing exotic goods from the Middle East, the Phoenician states rapidly became wealthy, crucial nodes to interregional trade. Politically they were organized as independent, autonomous city-states, each of them ruled by powerful dynasties of merchant-warrior kings. As they developed skilled labor, large navies, and stored wealth, the Phoenicians quickly emerged as the leading maritime powers in the Mediterranean. Phoenician voyagers established colonies in Spain (investing in lucrative gold and silver mines), western Sicily, and North Africa. Although these colonies were for the most part limited to trading centers that drew on local native populations for laboring needs, they laid the foundations for the Carthaginian Empire in the West.

The Phoenicians also devised the first effective alphabet (22 letters) widely adapted by neighboring Greek and Aramaean populations. With the Phoenician alphabet, each symbol functioned as a combined mnemonic device and a designated phonetic sound, referred to as an *acrophonic* system. Thus the name for each letter represented something recognizable. The symbols could be assembled in any necessary order to sound out spoken communication, and their names and limited number made them relatively easy to learn and remember. It became possible for commoners to learn to read and write. Via Aramaic, the Phoenician writing system spread as far east as Iran and the Indus; via Greek, it spread to Italy (Latin) and the western Mediterranean. The simplicity of the system made it accessible to anyone with some minimal degree of education. In the Iron Age schools became available to most property-holding citizens, not only in Phoenicia but throughout the cultures that adapted to this writing system, particularly the Greeks and the Romans. Educational facilities, both public and private, became visible features of any urban landscape. This is not to say that everyone took advantage of the new literacy nor that it was furnished at no cost (typically schools were private and charged tuition). However, it does mean that a significantly higher percentage of Mediterranean and Near Eastern populations were functionally literate during the Iron Age.

The Phoenicians cultivated the Baal cult, which became widely revered and in Canaan in particular was a competitor of the Yahweh cult of the Israelites. Baal (*lord* or *master*) became syncretized with Hadad, the Mesopotamian storm god, and was eventually associated with Zeus by Aegean populations. Baal was killed by the god of the underworld

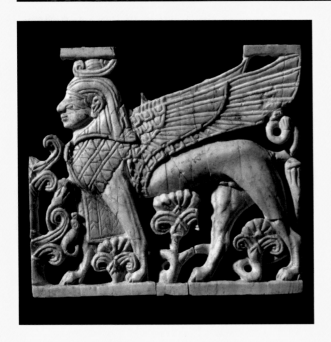

The Phoenicians made important contributions to Near Eastern art, specifically with regard to metalwork, ivory, and colored-glassmaking. In their art, the Phoenicians often incorporated eastern Mediterranean and Egyptian motifs—as is the case with this open-work ivory plaque from the eighth century BC. Many Phoenician ivories were originally covered with gold leaf and inlaid with semiprecious stones or colored glass. Found in Fort Shalmaneser at Nimrud (the Assyrian capital, where the plaque was likely confiscated by the conquering Assyrian kings), the plaque depicts an Egyptian winged spinx in profile. The work is a testament to the Egyptian influence on Phoenician art, its themes, and styles. Despite how "Eyptianized" the plaque appears—the wig, apron, and stylized plants—it is equally important to note its Mesopotamian characteristics, namely, the use of more rounded, organic forms.

Figure 4.1 Ivory plaque depicting a winged sphinx. Phoenician, ca. eighth century BC. Found at Fort Shalmaneser, Nimrud (ancient Kalhu), northern Iraq. The British Museum, London.

but restored to life by Anat, the goddess of love and war. His son, Melkart, avenged his death and made himself king of the earth's surface (his name literally meant *king*). Through syncretism Melkart became associated with the Greek god Herakles, especially at Tyre where natives and visitors came to offer tithed wealth and elaborate sacrifices at his altar. The Phoenicians were a prosperous, sophisticated, and highly materialistic people. Their hierarchies engaged in lavish, sometimes distasteful sacrifices, as well as temple prostitution. Evidence of infant sacrifice likewise survives. Elaborate orgiastic rituals earned the Phoenicians considerable bad press in the Hebrew Old Testament.

The Phoenicians were celebrated for the quality of their craftsmanship and luxury goods, producing the ancient equivalents of Armani suits and Lamborghini sports cars for wealthy consumers. Their engineers built high-rise buildings, massive fortification walls, sleek oared warships, ocean-going cargo vessels, and an array of large-scale weaponry (towers, catapults, and the like) capable of withstanding determined sieges. These and other skills demonstrate the presence of highly skilled and educated laboring populations. Ultimately the Phoenician city-states were defeated one by one by the Assyrians and then by the Persians. Every major Phoenician city was sacked at one point or another before the Roman era. The evidence suggests, however, that they worked more often as allies and partners of the great Near Eastern empires rather than as subjects. Even the Persian emperors concluded that accommodation with the Phoenician royal dynasties was the optimal way to proceed.

THE ASSYRIAN EMPIRE (1000–612 BC; HIGH POINT CA. 850–612)

The Assyrians rebounded relatively quickly from the chaos of the Bronze Age (by 935 BC) to assert renewed and unprecedented dominance in the Near East. In many respects their pattern of behavior reflected continuity with the strategies of the great empires of the previous era. Their conquest of Mesopotamia was achieved by 824 BC, only to be disrupted for a century by internal dissension and anarchy. Tiglathpileser III (745–727 BC) restored internal stability and expanded Assyrian hegemony by conquering Phoenicia, Israel, Babylon, and the Medes (western Iran). Sargon II (721–705 BC) destroyed Israel; Sennacherib (704–681 BC) sacked Babylon (689 BC); Esarhaddon (680–669 BC) invaded Egypt; and Assurbanipal (668–631 BC) so thoroughly crushed Elam that the people's long-standing threat to Mesopotamia came to a close. Many Assyrian policies recall the previous era. For example, they built multiple urban capitals, the most permanent being Assur, Nineveh, and Kalhu (Nimrud). These massive cities furnished visible markers of Assyrian prosperity. Their maintenance required transfers of resources from throughout the empire, particularly human populations, who were forcibly extracted from neighboring regions and relocated to Assyria to serve the imperial bureaucracy. British excavations recovered lively, remarkably detailed wall reliefs from palace remains at Nineveh and elsewhere. These furnish graphic detail of Assyrian military conquests. Also recovered at Nineveh was Assurbanipal's great library containing some 20,000 literary and scholarly texts, royal correspondence, and administrative documents. Our best-preserved text of the Gilgamesh epic, for example, surfaced at this library. To amass texts of all the extant classics of Near Eastern literature, King Assurbanipal dispatched military agents throughout Mesopotamia to rummage through temples and private houses of priests and scholars to confiscate tablets. A significant quantity of Mesopotamian textual data thus survived the chaotic end to the Bronze Age.

The Assyrian hierarchy also devised its own genre of records known as the *Assyrian Royal Annals*. These recorded chronologically detailed, well-organized accounts of military events, including regions where the kings campaigned, places that they conquered, and the kinds of booty they hauled back. Recorded on a variety of media, the abundance of detail they furnish about Assyrian military campaigns give the impression that the regime was inordinately warlike. The same implication arises from the wall reliefs, noted above, as well as from the Hebrew Old Testament. Reasons for Assyrian military aggression have been much debated. Some scholars argue that the Assyrians were no more bellicose than their competitors; they merely preserved a better record of their accomplishments. Others argue that the reasons for Assyrian military expansion evolved with changing conditions on the ground. Early on the Assyrians conquered neighboring territories in order to control threatening groups such as the Aramaeans and to acquire much needed farm land. After the political collapse of the late ninth century BC, the hierarchy reasserted itself with a renewed sense of purpose. The intent of the hierarchy was to convert Assyria into a political core by consolidating control over neighboring peoples, by harnessing and organizing their local resource capacities, and by employing its military forces to impose regional

order (and along with this, respect for their god Assur). Ideologically, they attempted to integrate the surrounding peoples into a support system for the cult of Assur and its hierarchy. Every province existed to supply basic foodstuffs to support the god's needs. The supremacy of the Assur cult thus served as an ideological expression of the Assyrians' desire to sustain its central bureaucracy and military apparatus by harnessing the potential resources of a wider region.

The Assyrian hierarchy maintained a clear distinction between native and territorial assets, referred to as those of the land of Assur and those under the yoke of Assur. The first population element represented Assyria proper. The four major cities of Assur, Kalhu (Nimrud), Nineveh and Arbil (Arbela) enjoyed special privileges such as exemptions from taxation and the military draft. The Assyrian king enjoyed supreme status. Although not deified, he embodied god-like attributes to make decisions in the best interest of Assyria and to fulfill the will of Assur and other gods. The king was essentially the state—an absolute ruler whose decisions could not be questioned and whose advisers and ministers worked as his servants. In practice his power was restricted by tradition, by the power of the Assyrian nobility, and by the need to obtain the approval of the gods for all decisions.

States that existed "under the Assyrian yoke" were nominally independent but their rulers functioned as Assyrian vassals, bound by treaties and subject to tribute. Their treaties included such requirements as obedience to the Assyrian king, support for his choice of crown prince, annual payment of tribute, fulfillment of military obligations, and the surrender of high-ranking hostages. Treaties were sworn in the names of the vassal's gods as well as those of Assyria, and foreign temples were just as likely to be sacked for their stored wealth as for their religious significance. Vassal states that failed to live up to their treaty obligations were punished with the utmost severity. Depending on the requirements or the example that needed to be set, the Assyrian kings employed their vast military superiority to destroy cities, to enslave populations, or to engage in mass deportations. The Assyrian kings viewed the application of swift and harsh punishment for rebellion not merely as a political tool, but as required to uphold the honor of Assur and to enforce his justice. Assyrian reliefs depict numerous instances of torture, mutilation, and other acts of calculated terror intended to suppress native sympathy. One of the most noteworthy Assyrian policies was the reliance on mass deportation of rebellious populations from the periphery to the core. Either during conquests or in response to rebellions the Assyrians captured and deported whole segments of native populations, typically skilled elements such as the nobility, merchants, and artisans. Over the course of three centuries an estimated 4.5 million people (including the Israelites, the Babylonians, and the Elamites) were forcibly relocated by the Assyrians. Although originally employed as manpower to resettle depopulated parts of the Assyrian heartland, by the height of the empire prisoners were exploited as war booty to furnish labor for state building projects or slave labor for temples, noble families, and Assyrian cities. In essence, the Assyrians developed a core population of urban communities by expropriating human resources from the periphery.

Numerous explanations have been raised to account for the sudden collapse of the Assyrian world system in 612 BC. Despite the risk of certain punishment neighboring

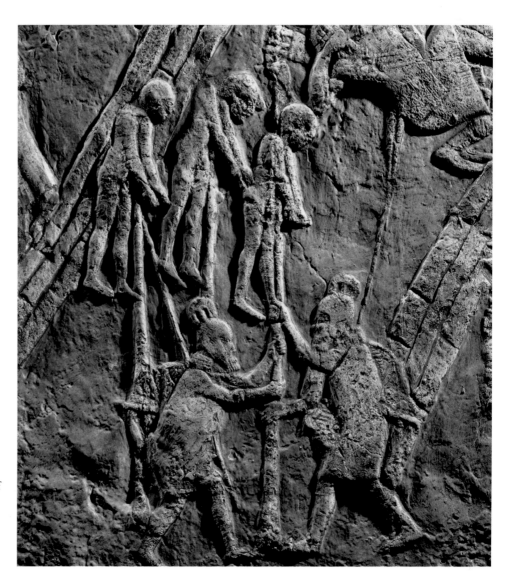

Figure 4.2 Assyrian warriors impaling Jewish prisoners after conquering the Jewish fortress of Lachish (battle 701 BC). Portion of a relief from the palace of Sennacherib at Nineveh, Mesopotamia (Iraq), ca. 700–681 BC. The British Museum, London.

peoples stubbornly resisted Assyrian authority. The resilience of these states suggests that the Assyrian hierarchy could not fully control the situation. In the final decades, simultaneous rebellions by tributary states may have successfully restricted the flow of resources to the core. Cut off from the empire's supply base the Assyrian hierarchy could no longer sustain its massive cities or the cost of its military establishment. Given the sizable population of deportees in their midst, the loyalty of the Assyrian core population was equally suspect. The combination of external pressure and internal conflict led to a sudden collapse of the entire regime. By the late 600s BC, rebellions were initiated by the Babylonians and the Medes who combined forces to crush the Assyrians, destroying Nineveh in 612 BC.

NEO-BABYLONIA OR CHALDEA (626–539 BC)

Neo-Babylonia marked a brief revival of the Babylonian Empire following the demise of Assyria. The Old Testament writers referred to the polity as Chaldea because of the pronounced Chaldean influence within its hierarchy. Like the Aramaeans, the Chaldeans migrated into the Euphrates valley ca. 1100 BC, provoking some 500 years of instability and lawlessness beyond the walled defenses of Mesopotamian cities. The Chaldeans struggled equally against the Elamites and the Assyrians until they successfully managed to impose a ruling dynasty in Babylon in 626 BC. After the collapse of the Assyrian Empire, the Chaldeans reconquered Mesopotamia for a time. Nebuchadnezzar (605–562 BC) invaded Egypt unsuccessfully then rebounded by sacking Jerusalem in 586 BC. He destroyed the Hebrew temple, enslaved the Israelite hierarchy, and brought the latter to Babylonia where its members were distributed among Babylonian cities to reside for 50 years (the **Babylonian Captivity**). Archaeologists working at the site of Babylon found cuneiform tablets recording ration measures assigned to Jehoiachin (the exiled king of Judah) and his family. For a time it appeared as though the Neo-Babylonian Empire would supplant that of the Assyrians. King Neriglissar (559–556 BC) conducted wars as far removed as Anatolian Rough Cilicia. However, the last king, Nabonidus (556–539 BC) proved to be somewhat of an iconoclast who antagonized the Babylonian hierarchy (particularly the priests of Marduk) by his singular devotion to the cult of the moon goddess, Sin. When a series of calamities beset the kingdom (including a plague, famine, and economic upheaval), he retired to an oasis in the desert, leaving his son Belshazzar (550–539) to rule as his regent. At this point the Babylonian hierarchy undermined the dynasty by supporting the invasion of Cyrus the Great of Persia (559–529). After confronting and defeating the army of Belshazzar, Cyrus entered Babylon to a hero's welcome in 539 BC. He allowed surviving Jews to return to Judah to rebuild their society, a process that would require repeated Persian assistance, as we shall see.

In contrast with the beneficence of Cyrus, the Old Testament view of the Neo-Babylonian Empire is decidedly negative and tends to understate the significance of this civilization to the emerging world system. Like Assyria, the Babylonian hierarchy relied on mass deportations to expand its population base, assembling thousands of urban artisans and rural farm laborers. The Chaldean administration was able to revive the agricultural foundation of southern Mesopotamia through a methodical process of internal colonization and canal building. This put the Babylonian economy on a solid footing for the rest of the ancient era. Babylonian cities remained self-governing communities directed by local temple hierarchies. Despite the tragedies entailed in mass deportations, these foreign elements, particularly the deported elites who resided typically at imperial courts, furnished Babylonia with important contacts to peripheral communities and to regions beyond the limits of the empire. Babylon's location along the central trade route of the ancient world system and its diverse population helped to restore its place as the hub of international trade and communications. From the Persian king Cyrus to the Macedonian king Alexander the Great to the Roman emperors Trajan and Septimius

Severus, numerous world leaders and abundant quantities of imported prestige goods passed through Babylon, restoring this city's status as an icon of urban amenities and architectural splendor (legendary for its hanging gardens). The Chaldean kings saw themselves very much as agents of a sustained tradition of Babylonian greatness and did their best to promote an awareness of the 1,000-year-old heritage of their city. These policies induced a cultural renaissance combining the best of archaic Akkadian-Sumerian traditions with the leading Iron Age innovations. Bronze Age texts were assiduously copied (some 15,000 tablets have been recovered and published from Babylon) and artworks rediscovered and preserved. Lively and vibrant at the moment that the Chaldean Dynasty was expelled by Cyrus, the city of Babylon secured its place among the ancient world's greatest cities.

THE PERSIAN EMPIRE (CA. 640–331 BC)

The Persian Empire emerged from the sustained infiltration of the Iranian plateau by Indo-Iranian elements at the end of the Middle Bronze Age (2000–1800 BC). In his Behistun inscription King Darius I referred to his people as *Aryans*, a Sanskrit word that originally meant "nobles" but could also have meant those who revered Vedic deities and ascribed to the Vedic way of life. Misuse of the term in recent times has rendered it distasteful to scholarly usage, so we must rely on the more ambiguous terms such as Iranian, Indo-Iranian, and even Indo-Aryan while recognizing that none of these terms adequately express the complexity of this vast civilization. In fact, the most remarkable aspect of the success of the Iranian peoples was the breadth of their political and cultural reach. The Persians represented the leadership cadre of an extensive hegemony of nomadic populations extending from the Iranian plateau across Afghanistan to the borders of China. By conquering the Near East, the Iranians succeeded for the first time at unifying nearly all the civilizations previously discussed in this book into a single, remarkably inclusive world system. Although the Persian Empire prevailed less than 300 years (ca. 640–331 BC), its capacity was extraordinary. As a land empire it extended more than 5,000 km east to west from the Aegean to the Tamir Mountains (a north-trending spur of the Himalayas). It incorporated an estimated population of 30 to 50 million inhabitants residing on three continents (Africa, Europe, and Asia). This ability to assemble and to organize disparate societies across vast distances made the Iranian hegemony pivotal to the development and maintenance of an interregional world system and assured its place in world affairs. Even as the Persian hierarchy assimilated the advanced culture of the Near East and infused it with their own attributes to create a uniquely hybrid form of expression, it never lost sight of its pastoral roots. The capacity of the Achaemenid and later dynasties to adapt to and to accommodate so many points of view explains greatly their success at statecraft and the longevity of Iranian civilization.

The Persians represented one of a dozen known tribes of Iranian peoples, along with the Medes, the Parthians, the Areians, the Arachosians, the Caramanians, the Gedrosians,

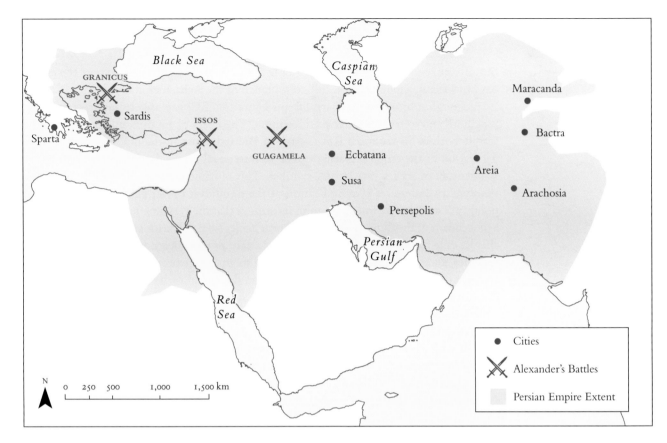

the Bactrians, and the Sogdians. These populations existed primarily as pastoralists and rural farmers with a nobility comprised of expert horsemen. Throughout Persian history these tribal entities furnished large cavalry contingents (40,000 allegedly at the Battle of Gaugamela in 331 BC) that lent the Iranian military remarkable speed and versatility. Recruitment of their horsemen by neighboring Iron Age empires in Mesopotamia probably drew the Iranians into the expanding orbit of Near Eastern affairs. The tribes in the west eventually became subject to the Assyrians. The Medean king Cyaxares (633–585 BC) consolidated authority within Iran itself and joined the Babylonians to defeat Assyria in 612 BC. According to various sources, the authority of his son Astyages was successfully challenged by Cyrus II (the Great) of Persia (559–529 BC), who deposed him and shifted the seat of political authority from Media to Persia. Cyrus was the epitome of a charismatic warrior king; he conquered Lydia (Croesus) ca. 547 BC (along with numerous East Greek city-states) and Babylon in 539. His son Cambyses (525–522 BC) conquered Egypt, but his prolonged stay in that country induced his brother Bardiya to mount a rebellion during his absence. Resentment was apparently mounting among Iranian noble houses concerning the growing authority of the Achaemenid Dynasty, and Bardiya attempted to placate this by abolishing taxes and suspending military levies. Rebellions soon erupted throughout Persia, Media, Elam, and Babylon. Cambyses attempted to return to Iran but both he and Bardiya were killed. The throne was then claimed by a number of pretenders, including a *magi* (a priest of Zoroaster) named Gautama. As the situation continued to veer

Map 4 The Persian Empire.

out of control, a number of leading noble houses joined together to support the candidacy of Darius, a member of a collateral branch of the Achaemenid Dynasty.

Although it took several years, Darius I (522–486 BC) was able to suppress scattered rebellions and to restore order to the empire. The effect of his difficult rise to power is visible both in his recorded **Res Gestae at Behistun** and in the blueprint to his reorganization of the empire. Darius agreed to restrict all future dynastic marriages to the womenfolk of six leading Iranian families. This remained the practice until the end of the dynasty and serves as an indication of the significant power enjoyed by the Iranian nobility. The Behistun inscription also informs us that the Persian king was expected to be a descendant of the dynasty's founder, Achaemenes (which Darius I was, albeit distantly), that his rule had to be blessed by the Zoroastrian supreme deity Ahura Mazda, and that together the god and the king were expected to guarantee order and furnish justice and truth to the Iranian people. As the first Iranian document of its kind, the inscribed text is remarkably illuminating.

The document also informs us that after crushing various elements of resistance, Darius regularized the imperial administration by replacing the original patchwork of subject polities with a uniform system of 20 to 30 provinces or **satrapies** to be ruled by **satraps** (governors). Within the Iranian network satrapies had existed for some time, and the satraps themselves were responsible for tribute payments and military contingents. Darius's innovation was to implement the system across the empire and to do so immediately. Relying in all likelihood on the Assyrian model, Darius imposed a system of overlapping jurisdiction between civil and military satraps to hold governors in check. Typically each satrap was a Persian nobleman, and his provincial administration resembled that of a local monarch, complete with a treasury, archive, and chancellery. He also established a system of roving inspectors, known as **the eyes and ears of the king**, who would descend on a provincial headquarters without warning to audit the satrap's accounts and to interrogate his staff, and he also established a far-flung network of paid informants, or spies, who reported suspicious activity directly to the king. To improve communications Darius constructed the **Royal Road**, a well-maintained roadway some 2,500 km long that connected the provincial headquarters at Sardis in Lydia (Anatolia) to his winter capital in Susa. (At its peak this was expanded into a vast road network connecting distant points throughout the empire.) "Pony Express" riders could reportedly convey messages along the length of this highway in seven days' time. A field army could reportedly march it in 90 days. This organization furnished the Persian Empire with sufficient coherency while allowing local satraps the necessary discretion to address the concerns of local populations with considerable flexibility. The Persian Empire was at same time highly centralized yet respectful of the multiplicity of the people it governed. It was the first empire to acknowledge that its inhabitants represented diverse cultures, spoke an array of languages, and were organized in different ways. Respect for local traditions, tolerance of local viewpoints, and openness to new ideas tended to achieve good relations with native inhabitants. The longevity of Persian authority in various regions ultimately achieved a unifying effect.

The complex of heavily fortified royal buildings at Persepolis serves as the most important source of information about Persian art and architecture. Begun by Darius I in 518 BC, the palace at Persepolis is a blend of materials and design traditions from all corners of the empire. At the center of the complex stood an enormous platform, 450 x 300 m wide and 15 m tall, where several palaces, audience halls, and a treasury were erected. The multicolumned audience hall, or apadana, with its soaring open interior supported by widely spaced columns appears to have been a Persian innovation. The terrace walls and staircases leading to the apadana are decorated with reliefs depicting the processions of royal guards, Persian nobles and dignitaries, and representatives from 23 subject nations bringing tribute to the Persian king. All the buildings were constructed of stone and supported by dozens of tall columns with capitals in the shape of griffins or bulls. The capitals are comprised of the front portions of two bulls or similar creatures that served as supports for the ceiling beams.

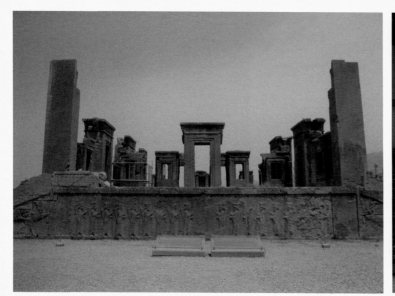

Figure 4.3 The Palace of Darius, ca. 500 BC. Persepolis, Iran. Photograph by Elizabeth Rauh.

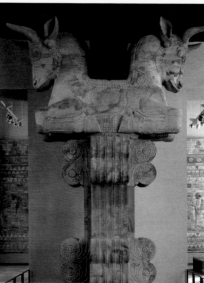

Figure 4.4 Bull capital, from Persepolis, ca. 500 BC. Musée du Louvre, Paris.

Much like the Assyrians the Persian Empire boasted multiple capitals, the three main ones being Persepolis in Persia, Susa in Elam (the eastern terminus of the Royal Road), and Ecbatana. The palace at Persepolis, constructed by Darius I and Xerxes I, exhibited two great, covered audience halls, or *apadanai*, surrounded by extensive botanical and zoological parks where imported examples of the flora and fauna found throughout the length of the empire were transplanted. Its central location along the trade routes enabled the Iranian hierarchy to transplant plant species from across the empire. Darius I, for example, transplanted rice from India to Mesopotamia and pistachio nuts from Anatolia to Syria. These pleasure gardens set world standards for royal capitals and were in many ways the source of ancient notions of "paradise," the word itself being derived from the Persian word *paradeisos*.

In 330 BC, despite its seemingly impenetrable fortifications, Alexander the Great leveled Persepolis—an act of retribution for the sacking of the Athenian Acropolis in the fifth century BC. The ancient historian Diodorus Siculus provides the story of the destruction of Persepolis:

Alexander held games in honor of his victories. He performed costly sacrifices to the gods and entertained his friends bountifully. While they were feasting and the drinking was far advanced, as they began to be drunken, a madness took possession of the minds of the intoxicated guests. At this point one of the women present, Thais by name and Athenian by origin, said that for Alexander it would be the finest of all his feats in Asia if he joined them in a triumphal procession, set fire to the palaces, and permitted women's hands in a minute to extinguish the famed accomplishments of the Persians. This was said to men who were still young and giddy with wine, and so, as would be expected, someone shouted out to form up and to light torches, and urged all to take vengeance for the destruction of the Greek temples (burned by the Persians when they invaded Athens in 480 BC). Others took up the cry and said that this was a deed worthy of Alexander alone. When the king had caught fire at their words, all leaped up from their couches and passed the word along to form a victory procession in honor of the god Dionysus. Promptly many torches were gathered. Female musicians were present at the banquet, so the king led them all out to the sound of voices and flutes and pipes, Thais the courtesan leading the whole performance. She was the first, after the king, to hurl her blazing torch into the palace. As the others all did the same, immediately the entire palace area was consumed, so great was the conflagration. It was most remarkable that the impious act of Xerxes, king of the Persians, against the acropolis at Athens should have been repaid in kind after many years by one woman, a citizen of the land which had suffered it, and in sport.[1]

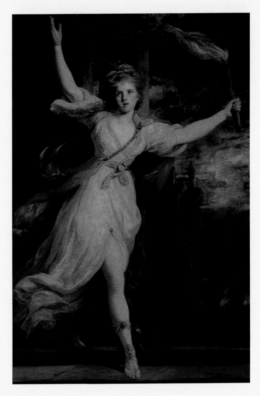

Figure 4.5 Sir Joshua Reynolds, *Thais*, 1781. Oil on canvas, 144 x 29 cm. Waddesdon Manor, Buckinghamshire, United Kingdom.

The goodwill of Persian authorities toward their subject populations was conditioned, of course, on political subservience, timely tribute payments, and a willingness to furnish military levies when summoned. Vast and cumbersome, the empire was often slow to react to emergencies. Xerxes I (486–465 BC) required three years to mobilize his invasion of Greece in 481 BC. The Persians were capable of putting large armies in the field, perhaps as many as 200,000 men at a time, but their armies lacked force cohesion. Ultimately Xerxes's forces were defeated by the Greeks, and Persian authorities yielded control of

1 Didorus Siculus, *Diodorus Siculus: Library of History*, vol. 2, *Books 2.35–4.58*, trans. C.H. Oldfather, Loeb Classical Library 303 (Cambridge, MA: Harvard University Press, 1935).

the Aegean theater to Athens. Nonetheless, the Persians exerted a powerful influence on eastern Mediterranean affairs until the reign of Alexander the Great. Alexander defeated the last Persian king, Darius III, in 331 BC, and absorbed the entire extent of the Persian Empire into his new realm. It was ultimately carved into lesser territories by his successors and rendered vulnerable to incursions from India, Central Asia, and the Mediterranean. Led by the Parthians, Iranian tribal hierarchies reasserted dominance in the Near East in the first century BC and remained a threat to Roman hegemony for three centuries. Parthian hegemony was succeeded by that of the Sassanid Persians (224–651 AD). Iranian hierarchies continued to play a determining role in Near Eastern politics until the time of the Mongol invasions (ca. 1000 AD).

ZOROASTRIAN RELIGION

The degree to which Darius I professed his devotion to the Zoroastrian deity, Ahura Mazda, warrants explanation. Zoroastrianism derives from Zoroaster (Zarathustra in Iranian), a prophet who probably lived at the end of the Bronze Age (ca. 1200 BC). Zoroaster propounded the belief in a cosmic dualism, and his sacred books survive as the Zend-Avesta. Unfortunately, little is known with certainty about the origins of Zoroastrianism or its founder. According to the *Gathas* ("Sayings" or "Verses"—a series of hymns and written in an ancient Iranian language known as Avestan, and purportedly inspired by Zoroaster himself), he was born somewhere in the steppe lands of Central Asia, perhaps in the eastern regions of Sogdiana/Bactria. The life of Zoroaster was highly mythologized in later legend. According to tradition, he was born laughing, at the central point in the history of the world; his house glowed for three days after the birth, and he survived numerous attempts on his life. Although he began his career as a *zaotar*, a sacrificial priest, at some point Zoroaster experienced a religious conversion and dedicated himself to spreading the word. At first his efforts were a failure: in 10 years' time he managed to convert only his cousin, and resistance to his teachings forced him to flee. Finally, he won over King Vishtaspa, who helped him spread his "good religion." He is said to have been assassinated while performing a fire sacrifice.

The most important theological innovations of Zoroastrianism were seemingly contradictory, since they included aspects that were both monotheistic and dualistic. As Supreme Being he recognized Ahura Mazda ("Wise Lord"), all-knowing and all-good. Other forces such as Truth and Good Mindedness were either created by him or emanated from this deity. But these positive forces were opposed by their opposites, and in particular the malign powers of Ahriman (Angra Mainyu, or "Evil Mind"). Ahriman was always and everywhere hostile to the forces of good. The entire universe was, accordingly, locked in a dualistic conflict between good and evil, more often expressed as Truth and the Lie, and the choice between them was the highest human responsibility. Those who fell fighting on the side of good would attain afterlife when Ahriman was defeated and the Day of

Judgment arrived. For this reason, Zoroastrianism posited an absolute freedom of the will; it was the least deterministic of all ancient religious systems.

Although dualism was common to many other religions and philosophies, Zoroastrian dualism differed from that of Platonic dualism, for example, in that the latter philosophy saw a divide between matter and spirit, body and soul. By contrast, the Zoroastrian dualism of good and evil did not align itself neatly with spirit and matter, only with truth and falsehood. Matter was not inherently evil, and the body was not inherently sinful. Since the cosmic elements of earth, air, water, and especially fire needed to remain pure, Zoroastrianism propounded a seemingly advanced expression of ecological balance. The acquisition of wealth (by honest means, of course) was welcomed; asceticism was rejected and sexuality was embraced (Zoroastrian priests had to be married).

As mentioned earlier, Zoroastrianism espoused an elaborate eschatology of heaven and hell, including a final judgment that would end the world. The physical bodies of devout believers would then be resurrected. Zoroastrian insistence on a form of monotheism that was inherently dualistic, and one that incorporated a complex system of abstract powers and angels and demons, naturally invites comparison with religions such as Christianity. Due to the confused nature of the chronology and the sources, however, it is impossible to identify the influence of the one worldview on the other. Prior to Christianity, an offshoot of Zoroastrianism known as the Mithras cult (named after the divine hero Mithras who died in defense of the good cause, and was destined to rise from death at the end time) likewise became an important mystery cult in Greco-Roman society.

THE IRANIAN HEGEMONY AND THE ANCIENT WORLD SYSTEM

Since the success of the Persian hierarchy depended highly on its skill at multiculturalism, the source of this ability probably lay with the Iranian people's roots in Central Asia. This was arguably the most diverse region of the ancient world. Extending from the northern shores of the Black and Caspian Seas to the mountain ranges that sealed off China from the West, this seemingly empty region of steppe lands and deserts formed a crucial nexus for communications across ancient Eurasia. Steppe pastoralists appear to have been responsible for technological advances such as the horse chariot (ca. 2500 BC) and the mastery of horse riding (ca. 8000 BC). In these and other respects their horse-driven mobility enabled them to function as conduits of cultural innovation, trade, and technologies between the distant world systems of the Mediterranean, India, and China. The fact remains that Central Asian cultures preserved little written record of themselves prior to the Hellenistic era (323–27 BC). This makes it exceedingly difficult to identify specific archaeological assemblages with historically recorded peoples.

Settled agricultural communities, known as the Oxus Civilization, took root in Central Asia by the Early Bronze Age along the east–west trending axis of the Oxus and Murgab

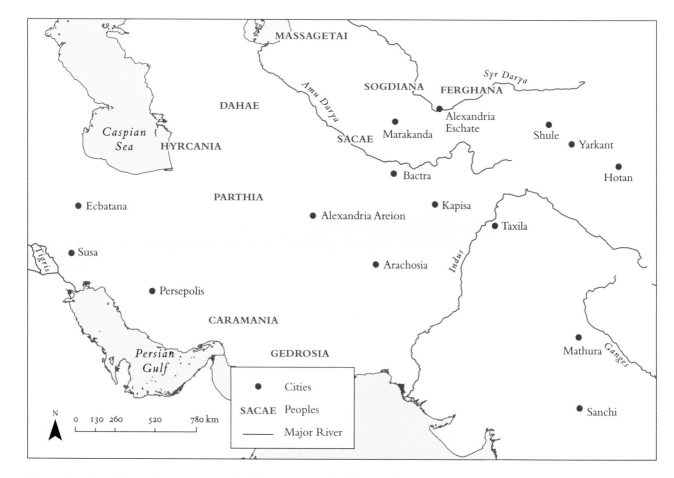

Rivers (modern-day Turkmenistan and Afghanistan north of the Hindu Kush Mountains). Later, during the Iron Age, these isolated settlements became known across the region as **kalas** (the Iranian loanword word for fortress), ruled by princes known as **khans** (a Mongolian loanword for military leader). Given the vast distances that separated these communities, it is presumed that their hierarchies were independent, though evidence of feudal systems of great kings and vassal kings is sometimes discernible. By 1900 BC migrating elements of this population began to penetrate into Iran, southern Afghanistan, and the Indus Valley. Around 1700 BC, the urban character of the Oxus Civilization collapsed, and the inhabitants reverted back to pastoralism. Explanations for this transition range from Indo-Iranian invasions, to climate change, to likely ecological damage provoked by the rise in population in so fragile an environment.

During the Iron Age the region of Central Asia was inhabited by three loosely identifiable populations: Indo-Europeans, Turkic elements (whose original homeland appears to have been in the northern steppes hemmed in by the intersection of the Altai and Tien Shan Mountains), and Mongolians (such as the Huns, or the Hsiung Nu, who filtered in from the northern steppes of East Asia). Naturally, this delineation is overly simplistic. Due to their highly mobile lifestyles, these groups repeatedly penetrated each other's cultural zones and merged to form hybrid populations. According to Chinese sources, for

Map 5 The Iranian Hegemony during the Iron Age. Designed by Lawrence Theller.

example, the Yuezhi were expelled from northwestern China by the Huns ca. 170 BC and were compelled to migrate westward across the Tarim Basin and the Pamir Mountains into the plains of the Jaxartes (Syr Darya) River. Eventually they invaded Afghanistan, and by the mid-first century BC the northern basin of the Indus Valley. Recombination enabled these chains of segmentary peoples to forge the **Kushan hegemony** that controlled the wider Central Asian region and its essential trade routes well into the Roman era.

The Kushan patchwork of nomadic groups furnished interconnected chains of communication and intercultural exchanges that linked Iran and the Indus with the Tarim Basin, the gateway to ancient China. Through these remote deserts and mountainous highlands passed caravans bearing valuable prestige goods, ambassadors, monks, and philosophers. Since Iranian and Indo-Iranian peoples inhabited the entire length of this journey, we may legitimately refer to this network as an Iranian hegemony. Iranian populations organized by the Persians into a loosely knit satrapal hierarchy furnished the necessary bridge to connect societies in distant continents. Iranian noble houses facilitated safety and supplies to travelers journeying from one end of the global world system to the other. Alexander the Great placed such importance on securing the loyalty of these houses that he married a Bactrian princess named Roxana (the daughter of the Persian ally, Oxyartes) in 327 BC. The extent to which cultures, technological innovations, and philosophical breakthroughs radiated along these routes cannot be stressed sufficiently. The cultural reach of the Persian Empire and the role it played in assembling the communications network of Eurasia were, therefore, crucial to the emergence of an ancient global world system. Although the volume of the long-distance trade that traversed the highways of Central Asia in this era remains to be determined, its conduct was due largely to the elasticity and diversity of the social formations that the Persians cultivated at its center.

FURTHER READING

Briant, Pierre. *From Cyrus to Alexander: A History of the Persian Empire*. Winona Lake, IN: Eisenbrauns, 2002.

Collon, Dominique. *Ancient Near Eastern Art*. Berkeley: University of California Press, 1995.

Davies, Penelope J.E. *Janson's History of Art, The Western Tradition*. 7th ed. Vol. 1. Upper Saddle River, NJ: Prentice Hall, 2007.

Esin, Emil. *A History of Pre-Islamic and Early-Islamic Turkish Culture. Supplement to the Handbook of Turkish Culture*. Series 2, Volume Ib. Istanbul: Ünal Matbaasī, 1980.

Fales, Frederick Mario. *War in the Assyrian Empire*. Oxford: Wiley-Blackwell, 2013.

Frachetti, Michael D. *Pastoralist Landscapes and Social Interaction in Bronze Age Eurasia*. Berkeley: University of California Press, 2008.

Fredrik, Hiebert, and Pierre Cambon, eds. *Afghanistan: Hidden Treasures from the National Museum, Kabul*. Washington, DC: National Geographic, 2008.

Kleiner, Fred S. *Gardner's Art through the Ages: A Global History*. 13th ed. Boston: Cengage, 2011.

Woolmer, Mark. *Ancient Phoenicia: An Introduction*. London: Bristol Classical Press, 2011.

FIVE

ANCIENT ISRAEL (THE UNITED AND DIVIDED KINGDOMS) (1850–539 BC)

WHAT HAVE WE LEARNED?

- ► That cultural development in the centuries immediately following the Bronze Age was characterized by the adaptation to iron as cutting-edge technology for weapons and tools.
- ► That the leading societies of the Early Iron Age were the Phoenicians, the Assyrians, the Neo-Babylonians, the Persians, and the United Kingdom of Israel.
- ► That the Phoenicians (1100–600 BC) are credited with the reconstruction of Mediterranean trade lines and with devising a workable alphabet of 22 letters, each combining a mnemonic device with a designated phonetic sound.
- ► That the armies of the Assyrian Empire (1000–612 BC) conquered the entire Near East by 660 BC. Assyrian culture furnished an important bridge between the Late Bronze and the Iron Ages.
- ► That the Persian Empire (ca. 640–331 BC) comprised an array of Iranian peoples in Iran, Afghanistan, and Central Asia. Drawing on this manpower, Darius I (521–486 BC) consolidated an empire extending from Thrace and the Danube River in the west to the Indus River and the borders of China in the east.
- ► That the Persian prophet Zoroaster founded a religion based on cosmic dualism; it was one of several worldviews verging on monotheism to emerge in the early Iron Age.
- ► That the Iranian peoples furnished a Central Asian hegemony linking distant world systems in the Near East, India, and China. This ultimately facilitated the construction of Iron Age interconnectivity on a macroregional scale.

CHRONOLOGY 4. ANCIENT ISRAEL

ca. 1850–1000 BC	Era of Patriarchs
1200–1000 BC	Period of Judges and the Settlement in Canaan
1000–922 BC	United Kingdom
922–721 BC	Divided Kingdom
721 BC	Assyrian Conquest of Israel
586 BC	Sack of Jerusalem
586–539 BC	Babylonian Captivity
538–424 BC	Restoration of Judah

Along with the reemergence of Iron Age hierarchies and complex societies came the restoration of literacy and recursive institutions throughout the Near East. Written testimony about the social experiences and evolving worldviews of inhabitants survives for a number of societies. While many Ancient Near Eastern societies labored to reconstitute and to remodel themselves according to the values of the previous era, the written testimony of one society, ancient Israel, challenged traditional concepts of political legitimacy, human rights, and polytheism. Unfortunately, our knowledge of the history of ancient Israel is based largely on one source, the Old Testament. From a historical perspective this massive work contains strands of information set to writing as early as the reign of King Solomon (961–922 BC). Most of it was probably compiled, however, during the Babylonian Captivity (586–539 BC) or later. In its eventual form the Old Testament contained an historical account of the rise and fall of the United Kingdom of Israel, a body of law received by Hebrew prophets (material that was ultimately formulated into a broad based code of ethical requirements or laws known as the Pentateuch or the Torah), and the poetry and prayers of various Hebrew prophets. Its contents were assembled first and foremost to teach the Israelites about the covenant between the god Yahweh and themselves. According to the Old Testament, Yahweh chose the Israelites to serve as human agents to his plan of salvation. The Old Testament stresses that Yahweh was consistently faithful to his promises to the Israelites, and that he expected them to remain faithful in their devotion to him in return. This much was believed and accepted as faith by the Israelites. Difficulties arise when we try to distinguish genuine historical information from matters of faith, particularly when there is little external information to corroborate the particulars of the Old Testament narrative. When external source material, such as the Stele of Merneptah, does surface it tends to confirm the general historical outline, however minimally. Additional inscriptions have surfaced in Dibon (Jordan) and Tel Dan. Each of these is contemporary with the Era of the Divided Kingdom (ninth century BC) and each refers to the polities of Judah and Israel as the House of David or the House of Omri, respectively. These demonstrate not only the names by which these polities were known to their neighbors, but also that the two kings, David and Omri, were historical. Both texts, in fact, recount plundering expeditions conducted by neighboring kings

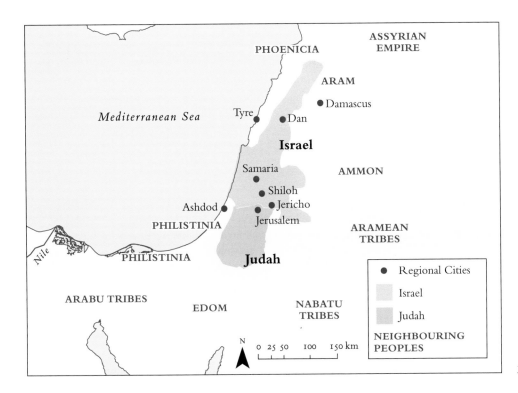

Map 6 Regional Map of Israel.

(Mesha, king of Moab, and an unnamed king of Aram, possibly Hazael) in the territories of Israel and Judah, respectively. Apart from furnishing external corroboration for their existence, therefore, the texts provide a decidedly contrasting perspective to the narrative presented by the Old Testament. In addition, Israel and Judah were both repeatedly mentioned as subjugated territories in the annals of the Assyrian Empire, including one inscribed relief that portrays King Jehu of Israel (ca. 841–814 BC) bowing before the Assyrian king Shalmaneser III.

These points need emphasis because they help to place ancient Israel within the context of wider Iron Age Near Eastern developments. Insofar as specific details about the history of Israel and Judah are concerned, we must rely almost exclusively on the narrative of the Old Testament itself. Without the benefit of the Old Testament, in other words, the place in history of Israel and Judah would be reduced to those of other tributary states that succumbed to the expansion of early Iron Age empires, alongside the Aramaeans, the Moabites, the Philistines, and the Edomites. We would know nothing, moreover, about earlier aspects of the Hebrew narrative, including the eras of the Patriarchs, the Exodus, or the Wanderings in the Wilderness.

In order to illuminate the historical path of the ancient Israelites we are compelled to parse the narrative of the Old Testament carefully. To do this, biblical historians rely on three competing strategies. Some insist, for example, that archaeological research in Palestine and the Near East has revealed and will continue to reveal material and textual evidence to confirm the fundamental historicity of the Old Testament. Opposing scholars are quick to observe that some of the emerging archaeological evidence actually contradicts the Old Testament narrative or is chronologically too imprecise to furnish suitable

In 1846, archaeologist Austen Henry Layard discovered this black limestone obelisk during his excavations of the ancient Assyrian capital of Kalhu (Nimrud). Erected as a public monument during a time of civil war, the obelisk contains relief scenes glorifying the achievements of King Shalmaneser III (reigned 858–824 BC) and his chief minister. The bas-relief sculpture (low or sunken relief) is believed to be the most complete Assyrian obelisk in existence and, furthermore, contains the earliest known representation of a biblical figure—Jehu, king of Israel. The obelisk both in text and image describes how Jehu brought or sent his tribute ca. 841 BC. The caption above the scene, translated from Assyrian cuneiform, reads: "The tribute of Jehu, son of Omri: I received from him silver, gold, a golden bowl, a golden vase with pointed bottom, golden tumblers, golden buckets, tin, a staff for a king [and] spears."

In addition to documenting Shalmaneser's military campaigns, the obelisk also contains a list of tribute offerings collected, including exotic plants and animals—both of which were viewed as demonstrations of power by Assyrian kings. The obelisk features twenty reliefs, five on each side, depicting five different vanquished kings bringing tributes and prostrating themselves before the Assyrian king. Each scene occupies four panels around the monument, accompanied by a cuneiform script. On the top and the bottom of the reliefs, a long cuneiform inscription lists the king's military campaigns over the course of his 31-year reign.

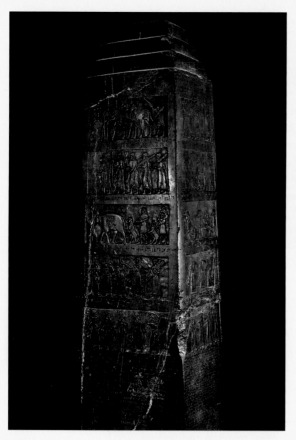

Figure 5.1 The Black Obelisk of Shalmaneser III. Neo-Assyrian, 858–824 BC. From Nimrud (ancient Kalhu), northern Iraq. The British Museum, London.

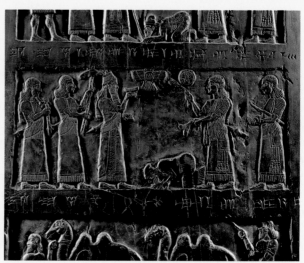

Figure 5.2 Detail of King Jehu of Israel bowing before the Assyrian King Shalmaneser III, from the Black Obelisk of Shalmaneser III. Neo-Assyrian, 858–824 BC. From Nimrud (ancient Kalhu), northern Iraq. The British Museum, London.

corroboration of recorded events. A second line of reasoning posits that the Old Testament was crafted exclusively as a religious and literary document. It neither furnishes nor was it ever intended to furnish accurate historical data prior to the time of the monarchy, at which time its compilers were sufficiently familiar with events to describe their state as a historically definable entity. According to this argument, the Old Testament tells us far more about the intellectual prism through which later Israelites viewed their origins and crafted their narrative than it does about history per se. A third perspective holds that some of the themes presented in the Pentateuch—the primeval history, the stories of the Patriarchs, the Exodus, the revelation to Moses at Mount Sinai, and the Wanderings in the Wilderness—resemble short credo-like recitations of recollected experience. These were probably organized within the framework of cult practices perhaps as early as the time of the Judges (1200–1000 BC). From this perspective, the purpose of the narrative was to reinforce belief in Yahweh's efficacy by emphasizing the need for sustained devotion. Apart from certain themes that were expressed in broadest possible terms—for example, that the Israelites eventually settled in Palestine, that their tribes became located in particular areas, and that the nascent society underwent a process of state formation—the Old Testament narrative preserves little that is historically recoverable or definable. While each of these perspectives holds merit, the main issues remain confused. Scholarly debate about these matters has significantly diminished our ability to rely on the Old Testament as a basis for historical reconstruction. Matters long taken for granted, such as when and how the Hebrews arrived in Canaan and where they originated, remain open questions. The Stele of Merneptah and its associated relief at Karnak indicate, for example, that the Israelites were a people (not a place) inhabiting Canaan, dwelling in tents and fighting on camel back ca. 1204 BC. However, they do not confirm the narrative of a flight from Egypt, the Wanderings in the Wilderness, or even the tradition that the Israelites invaded Canaan at this time (as opposed to having resided there all along).

Rather than attempt to sift through the narrative of the Old Testament for random kernels of historical authenticity, it seems wiser to explore its value as a general interpretation of Iron Age social and cultural transition, not only in Israel but throughout the wider region. In many ways the patterns discernible for the Israelites in the Old Testament narrative apply equally to neighboring societies such as the Ammonites, the Moabites, the Edomites, the Philistines, and the Canaanites. Many of these peoples exhibited common attributes, including associated languages and social origins and similar experiences during the process of state formation. In fact, the emergence of these states was to some degree a product of their immediate proximity to one another and the inevitable consequence of encroaching territorial claims. Another factor to consider was their common emergence from the upheaval provoked during the collapse of the Late Bronze Age. If we recall that the wider region of Late Bronze Age Canaan was overrun by such diverse elements as the Sea Peoples, the Habiru, the Israelites, and the Aramaeans, we should expect to see common patterns of societal development occurring across the landscape. The archaeological evidence indicates, for example, that Late Bronze Age Canaanite urban communities such as Hazor, Lachish, Debir, Bethel, Gezer, and Beth Shean were destroyed and replaced

by a pattern of dispersed rural settlements. As urban societies reemerged, it is safe to assume that they did so with populations representing an amalgam of previously settled and newly arrived inhabitants, again, not merely in Israel but throughout the region. Given the lack of recursive institutions during the interim, attempts to explain the complexity of these settlement origins would have been challenging for any of the emerging hierarchies. The idealization of so variegated a past required a process of simplification. However, to hold validity with its intended audience, the Old Testament narrative also needed a semblance of historical plausibility. In other words, the reliance on strategies for survival, such as pastoralism, farming, warfare, and the formation of centralized hierarchies needed to convey a sense of lived experience, as opposed to literary invention.

When examined from this perspective, the narrative of the Old Testament appears to reflect the challenges endured by a number of Iron Age societies that transited from pastoral roots to settled urban existence. Perhaps as a result of the time spent in the Babylonian Captivity, the compilers of the Old Testament reflected on this process more than others, closely examining its costs and its benefits. If so, the value of this reflection lies more in its interpretation of a fundamental change in lifestyle than in its account of any specific historical experience. Regardless of the complex origins of the Israelites, in other words, they as a people witnessed their society's transformation from a stateless population of dispersed, tribally based, rural elements to nucleated urban populations with a centralized hierarchy. They then witnessed the suppression and defeat of this hierarchy by those of larger, militarily stronger powers. In this textbook we have referred repeatedly to the acculturation of newly arrived migrant populations, such as the Akkadians, the Amorites, the Hurrians, the Kassites, the Hittites, and the Mycenaeans. However, the process by which cultural assimilation was achieved has never truly been explained. By devising a sense of trajectory for this experience and by subjecting it to the scrutiny of recalled memory, the writers of the Old Testament were able to articulate their experience as a process of gradual enlightenment. Apart from matters of faith, this explanation of the repeated Ancient Near Eastern transition from herding to farming, from rural to urban settlement, from tribal chieftains to centralized monarchies, is elucidated more effectively by the Old Testament narrative than by any other source.

HISTORICAL OUTLINE

The Era of the Patriarchs, ca. 1850–1000 BC

According to the Old Testament, the Hebrews began their history as a tribally based pastoral element migrating through Mesopotamia and surviving along the margins of urban societies such as Sumer, Akkadia, and Babylonia. Around 1850 BC, Abraham led his following from Ur in southern Mesopotamia to Haran in the northern Euphrates valley

and then to Hebron in Canaan. Sometime between 1700 and 1580 BC, Joseph led a migration into Egypt. According to the Hebrew tradition, not all the related tribal communities relocated to Egypt. The Benjaminites, for example, claimed to have remained in Canaan throughout the Egyptian experience and were viewed throughout the historical era as the keepers of ancestral law. In the period 1290–1224 BC, Moses conducted the Exodus from Egypt. On an inscribed stele recovered at Karnak, the Egyptian pharaoh Merneptah (1213–1203 BC) claims to have defeated a people identified as the Israelites during a military campaign in Canaan in 1204 BC. As noted above, an associated relief indicates that these particular inhabitants dwelled in tents and fought on camel back. Based on this testimony, and allowing forty years for the Wanderings in the Wilderness, the Exodus is presumed by many to have occurred during the reign of the New Kingdom Egyptian pharaoh Ramses II (1279–1203 BC). This would be consistent with other destabilizing developments of the Late Bronze Age, mentioned above. The Stele of Merneptah allows for the possibility that the Hebrews (referred to specifically as the Israelites) invaded Canaan. If so, during the next two centuries their populations gradually adapted to settled agricultural existence. They lived side by side with surviving elements of the native Canaanite population and in close proximity to competing, highly militaristic neighbors, such as the Philistines, the Aramaeans, and the Phoenicians.

The Period of Judges and the Settlement in Canaan (1200–1000 BC)

Hebrew society at this point was organized according to a loose confederacy of 12 tribes, 10 in the north, 2 (Judah, Benjamin) in the south. Each tribe was ruled by tribal warlords referred to as judges or **suffetes**. Their populations remained highly segmentary, with each regulating its own affairs. Within each tribal population there were also subtribes and smaller kinship-based communities. The Hebrew tribal confederacy was centered on a commonly held sanctuary (something referred to in Greek as an *amphyctyony*, or an association of neighboring states organized to defend a religious sanctuary). Although the sanctuary was relocated several times (Shechem, Bethel, Gilgal, and Shiloh), there was ever only one at any given time. According to the Book of Joshua, the confederate tribes first accepted the cult of Yahweh at Shechem and became united to each other and to Yahweh by a covenant. Some have interpreted this to mean that Shechem was where the Yahweh cult was initially conferred on the northern tribes by those who had migrated out of Egypt. The fact that it had to be conferred or accepted indicates, however, that the cult had many competitors, most particularly the Phoenician Baal cult, but others as well, including that of the love goddess Asherah. It is worth nothing, for example, that the names of several Israelite kings express variations of the name Baal.

The Period of Judges was one of deep internal dissension among the Hebrew tribes. The population was geographically scattered and lacked anything remotely resembling a unifying central hierarchy. This weakened the effectiveness of the Hebrew confederacy and exposed its constituent elements to attacks by neighboring peoples. Repeated military

Painted by Rembrandt and/or his pupils during the Dutch Golden Age, this scene depicts two figures set against a dark background. Saul, seen at left, is seated holding a spear and wiping his eye on a curtain. On the right of the composition, David kneels before him playing his harp. Interestingly, Rembrandt's painting depicts the moment before King Saul's rage, which caused him to throw his spear at David twice. I Samuel 18: 9–11 recounts the event:

9 And Saul eyed David from that day and forward.

10 And it came to pass on the morrow, that the evil spirit from God came upon Saul, and he prophesied in the midst of the house: and David played with his hand, as at other times: and there was a javelin in Saul's hand.

11 And Saul cast the javelin; for he said, I will smite David even to the wall with it. And David avoided out of his presence twice.

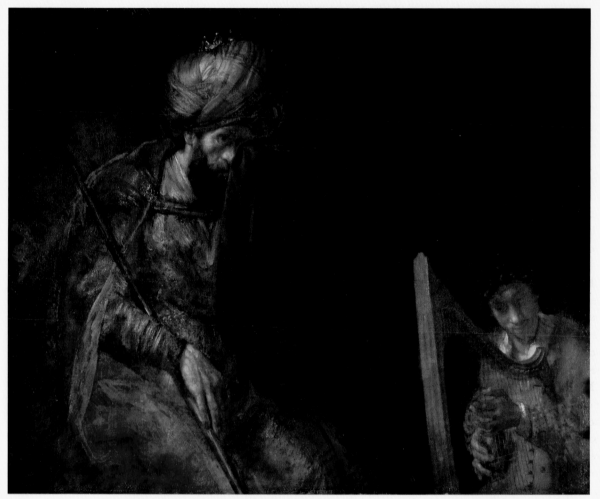

Figure 5.3 Rembrandt van Rijn and/or Studio of, *Saul and David*, ca. 1655. Oil on canvas, 130.5 x 164.5 cm (with additions). Royal Picture Gallery Mauritshuis, The Hague.

losses to the Philistines compelled reluctant tribal leaders to appoint a king named Saul (1020–1000 BC). According to the Old Testament, there was no precedent for kingship among the Hebrews, and the decision to create a central hierarchy was regarded as the option of last resort. As Saul's military success diminished, his authority was challenged by one of his officers, David of Judah. Saul eventually turned against the tribal leadership: he purged the standing priesthood (the one unifying institution prior to the creation of the monarchy), and otherwise provoked internal dissension and rebellion by his heavy-handed demeanor. Although Saul managed to expel David from Judah, he himself was defeated by the Philistines at Mount Gilboa and committed suicide. Resentful subjects then refused to recognize the legitimacy of his son and successor, Ishbaal, eliminating him as well. Having already been proclaimed king of Judah, David successfully obtained recognition of the northern tribes to emerge as the second king of all of Israel (ca. 1000–960 BC).

The United Kingdom (1000–922 BC)

David quickly defeated the Philistines and established the United Kingdom (1000–922 BC). As a military commander of remarkable ability, he conducted successful campaigns along the entire coastal strip from Gaza to Phoenicia. He ultimately extended his authority to the Euphrates River in the north and perhaps as far as the Red Sea to the south. His reign represented the greatest territorial extent of Israel and was later recalled as a "golden age." David established his capital at the former Canaanite citadel of Jerusalem, which lay conveniently on the northern border of Judah, close to the northern tribes. Using this fortress as his base, he successfully established a strong central authority. Among other things, he relocated the Yahweh cult to the capital, bringing it into closer association with his regime to enhance his own legitimacy. David was succeeded by his son Solomon (961–922 BC). Solomon was not as active militarily as David, but he was gifted in trade and diplomacy. He forged alliances with Phoenician kings, Egyptian pharaohs, and Arab sheikhs along the Red Sea. Solomon set about the construction of the palace and the temple in Jerusalem. He also extended the reach of the central hierarchy throughout Israel. He imposed taxes and established garrisoned fortresses or store cities at the center of each tax district. Along the frontiers and the trade routes of the kingdom the remains of fortified complexes (such as Megiddo) appear to date to this era. To construct his monuments, Solomon resorted to conscript labor, or the **prytany** system. Each tribe was compelled to send laborers one month per year to work for the king. Many scholars believe that Solomon imposed tax districts only in the north, and that the southern tribes of Judah and Benjamin were exempted from taxes as well as from conscript labor. If so, this would have fostered resentment among inhabitants of the northern tribes. Solomon also relied heavily on dynastic marriages to secure alliances with neighboring polities (allegedly amassing 700 wives and 200 concubines). Numerous foreign princesses settled in the palace at Jerusalem along with sizable entourages of priests, attendants, and dignitaries. These immigrants brought their native cults, particularly the Phoenician Baal cult, to the emerging temple/palace complex

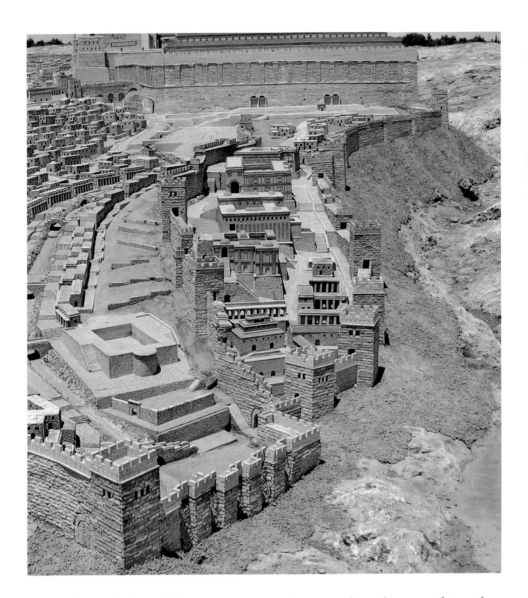

Figure 5.4 Depiction of the City of David with the palace complex in the background. Artwork by John Hill.

at Jerusalem. The forced labor requirements and cosmopolitan character of Jerusalem caused dissension among Israelite citizens, particularly among the northern tribes, and support for the dynasty soon eroded. At the demise of Solomon this resentment erupted into open civil warfare.

The Divided Kingdom (922–721 BC)

Within a matter of decades the United Kingdom dissolved into two separate kingdoms, Israel to the north and Judah to the south. Open conflict erupted ca. 922 BC when Jeroboam, the former supervisor of Solomon's forced labor gangs, challenged the authority of Solomon's son and successor, Rehoboam. The latter was attempting to impose arbitrary

labor levees on the northern populations while continuing to exempt the inhabitants of Judah. Aided by neighboring polities such as Aram (Damascus) and Edom, the northern tribes broke away to form their own separate kingdom. Jeroboam, who now assumed the throne as the king of Israel, not only established a new capital in the north (Samaria), but he installed new sanctuaries for the national cult of Yahweh at Ethen and Dan, cities that were situated on the southern and northern borders of his kingdom. These acts essentially rendered the secession irreversible. Of the two kingdoms Israel remained the more populous and urban and was more closely connected to the ruling houses of Phoenicia, Damascus, Moab, and Edom. Judah remained more rural and more isolated. Its people adhered to the legacy of rule by the ancestral House of David as well as to its claim to the temple built by Solomon in Jerusalem. Kingship remained charismatically based and dependent on evidence that the king personally enjoyed the support of Yahweh.

Under King Omri (885–874 BC) Israel became a significant regional power. Omri constructed the fortifications of Samaria and forged a crucial alliance with the king of Tyre by marrying his son Ahab to the Tyrian princess Jezebel. Ahab (873–852 BC) continued his father's work, establishing Israel as one of the strongest states in the region. He contributed the second-largest contingent of troops and chariots to the military coalition that confronted (unsuccessfully) the Assyrian forces of King Shalmaneser III at Kalkar in 853 BC. This and other defeats combined with Ahab's encouragement of Tyrian religious practices at Samaria (particularly the cults of the Phoenician deities El, Baal, and Asherah) incited a kingdom-wide rebellion instigated by the prophet Elijah. Elijah persuaded Ahab's general Jehu to overthrow the dynasty, eliminating the entire family of Omri in the process. Although set in motion by external developments, this struggle has often been interpreted as a religious dispute between more tolerant Israelites (such as the ruling class) who were willing to pursue a more inclusive form of Yahwism—one that did not prohibit the worship of outside gods—and others like Elijah who insisted on a more exclusive worship of the Hebrew deity. As we shall see, the pattern of this conflict appears to have repeatedly colored the perspective of the Old Testament narrative. From here on, the kingdoms of Israel and Judah became vulnerable to the advances of the expanding extraterritorial states to the east, including the Assyrians, the Neo-Babylonians, and the Persians. The kingdom of Israel joined in the repeated rebellions of its northern neighbors against the Assyrians and was punished with increasing harshness. The rapid succession of dynastic usurpations that occurred between 745 and 722 BC probably reflects the unhappiness of the Israelite population with the hierarchy's acquiescence to Assyrian authority. In 722–721 BC, the Assyrian kings Sargon II conquered Israel and deported the ruling hierarchy (the royal family, the nobility, and the warrior elite) to Urartu (ancient Armenia), replacing them with settlers from other regions. In Urartu the deported Israelites gradually merged with the native population to become the "lost tribes." In 601 BC the king of Judah, Jehoiakim, unwisely seized the opportunity of a momentary Chaldean setback in Egypt to stage a rebellion. When Jehoiakim died suddenly in 597 BC, the burden of resistance suddenly fell to his 17-year-old son, Jehoiachin. King Nebuchadnezzar quickly took Jerusalem, plundered its historic treasures, replaced King Jehoiachin with his uncle

Zedekiah, and carried off the rest of the royal family to Babylon, along with thousands of the kingdom's wealthiest residents. Most of the exiles including the prophet Ezekiel were settled near Nippur, but the former king was kept at Babylon itself. As noted earlier, archaeologists have recovered cuneiform tablets listing rations assigned to Jehoiachin and his family in the excavated remains of that site. Despite this tragic example, King Zedekiah mounted yet another rebellion in 587 BC. After an 18-month siege, King Nebuchadnezzar's forces successfully took the city, destroying its monuments and deporting King Zedekiah and thousands of other inhabitants to Babylon. This event is traditionally designated as the beginning of the **Babylonian Captivity** (586–539 BC), the period when the canonical Hebrew literature was presumably compiled.

The Restoration of Judah and the Emergence of Judaism

In 538 BC King Cyrus of Persia released the Babylonian captives and allowed their leaders to return to Jerusalem to restore Judah as a Persian client state. The process proved daunting, however, and required repeated Persian assistance over the next century. When Sheshbazzar (referred to as the Prince of Judah) was dispatched by Cyrus to serve as governor of Judah and to rebuild the temple of Yahweh, he encountered Jerusalem in ruins. Squatters were occupying the properties of the exiles, and his returning exile families lacked the necessary resources to restore the settlement. Various neighboring peoples such as the Idumaeans and the Samarians (many of whom were descended from foreigners settled there by the Assyrians) saw little advantage to the restoration of the polity of Judah in their midst. Internally, conflict emerged between those Judeans who had not been deported during the Babylonian Captivity and the returning descendants of the exiles. The latter tended to regard themselves as the legitimate worshipers of Yahweh and the non-deported inhabitants as heretics, much like the settlers in Samaria. Little progress was made during the initial wave of returnees, accordingly. In 520 BC, Zerubbabel, who was possibly the grandson of the former king Jehoiachin, was dispatched by King Darius I of Persia along with the high priest Jeshua to attempt a second program of resettlement. Although they managed to rebuild the temple, Jerusalem remained a ghost town. During the reign of King Artaxerxes I (465–424 BC) a third pair of leaders, Ezra (apparently a Jewish scribe) and Nehemiah (referred to as a cupbearer to the king), were commissioned to stabilize the province's social and religious situation. This time King Artaxerxes gave them the necessary funds and materials to restore the Yahweh cult, but more importantly they brought with them a copy of the Pentateuch or Torah. They used this document to legitimize their program to initiate a renewed covenant with Yahweh and to impose strict new religious prohibitions. Not only did they demand strict adherence to biblical law, observance of the Sabbath, and tithing to support the priests and the temple, but they also prohibited intermarriage between Jews and non-Jews and required proof of genealogical descent from exiled families as the basis for citizenship. These prohibitions arose naturally enough from concerns about the lingering effects of religious syncretism and

cultural assimilation that had occurred among the non-exiles. Many Judeans, for example, had married non-Hebrew spouses or had abandoned the Hebrew language altogether. The issue of foreign spouses, particularly among elite families, raised the prospect of veneration of foreign deities in the temple. Much like the stance taken by Elijah during his conflict with Ahab and Jezebel, in other words, these leaders pursued a more exclusive religious policy. While their measures insured the purity of both the Yahweh cult and the Jewish people, they initiated the formation of an ethnically and religiously closed society. Scholars point to the reforms of Ezra and Nehemiah as the inception of Judaism per se. The return from Babylonian Captivity and the restoration of Judah during the Persian Era also marked a transition from an earlier experience in which Israel was viewed as a Hebrew territorial state to a later phase in which cultural identity was based exclusively on Jewish religious ideology.

Judah was ultimately suppressed by Pompey the Great of Rome in 63 BC. From then on, the history of Judean dealings with the Romans proved decidedly uneven (friendly relations with Julius Caesar; however, the inhabitants were despised and terrorized by the emperor Caligula). Ultimately the remaining Jewish population in Palestine rebelled against Roman authority and was crushed violently by the Roman emperors Vespasian (64–73 AD), and Hadrian (132–136 AD). Their experience with Roman *imperium* proved disastrous and largely unavoidable.

CULTURAL ANALYSIS OF THE HEBREW EXPERIENCE

The cultural narrative of the Hebrew Old Testament clearly portrays the people's heritage as one firmly rooted in pastoralism. As such, the narrative could apply to the settlement pattern of any number of nonurban, agro-pastoral societies dwelling along the margins of Mesopotamian urban states. The Old Testament insists that the Hebrews were essentially a nomadic people, at least until the period in which they conquered and settled in Canaan (ca. 1200 BC). It is useful, therefore, to compare its description to that of other known pastoral societies.

Segmentary or pastoral societies in the Ancient Near East and the Mediterranean coastal regions exhibited certain recognizable traits. Most pastoralists did not wander long distances, for example. Most often they employed livestock grazing patterns known as *transhumance*. Typically herders rotated their animals between two or three points in a narrowly conscribed landscape (perhaps 150 km in extent) that combined highland summer pastures, lowland winter pastures, and springs, watering holes, or oases along the midland access routes. The most important component to transhumance was access to highland "top lawn" or *pelouse* meadows during the summer grazing season. For this reason, herders tended to drive their flocks into the mountains as soon as the snow melted and would keep them there for a considerable part of the year. This is where herds would be fattened and gleaned before returning to the coastal and desert lowlands for the winter. Lowland

pasturing was frequently furnished by field stubble outside the walls of cities. Seasonal proximity to cities enabled nomads to exchange livestock and by-produçts for tools and equipment that they could not manufacture themselves. Abraham, for example, began his experience outside the city of Ur. Pastoralism represented an alternative, complementary component to settled agricultural existence. It expanded the economic capacity of urban societies by utilizing the least productive terrain of the surrounding hinterland. In modern-day Afghanistan some 30 per cent of the population continues to engage in pastoralism in the rugged terrain of that country.

Living predominantly out of doors in tents pastoralists were and are more commonly exposed to the elements. In the Near East this meant exposure to harsh desert conditions where miscalculations could quickly result in death. The minimal character of existence and exposure to the elements profoundly influenced the trajectory of pastoral societies. In contrast with urban lifestyles, pastoral existence entailed the following:

The pastoral lifestyle was austere. Constant movement limited the quantity of material possessions that could be transported. Many possessions were shared in common, including wives, as the Old Testament repeatedly demonstrates. From the perspective of religious observances, nomads lacked the material wealth necessary to conduct large sacrifices to the gods like urban peoples.

Pastoralists were highly autonomous. The fact that nomads had to survive on their own reduced the need for hierarchy. Shepherds were frequently required to drive the herds in small bands, separating themselves for days from main camps. From the perspective of religious observances, these individuals maintained the capacity to pray to their gods as individuals. Pastoral cultures tended not to have priestly hierarchies, therefore; each person communicated with divine entities on his or her own. Religious practices needed to be accessible to all worshipers from one generation to the next. Accordingly, pastoral societies tended to construct an assemblage of rituals, rules, and laws, common to the entire community so that the devout could worship individually. As a society ancient Hebrews owned few material possessions, made minimal sacrifices, had no priestly hierarchy, and worshipped their tribal god, Yahweh, as individuals, families, or clans. The tendency of their culture to emphasize individual communication with their deity resulted in more immediate religious experiences for some, namely, the **prophets**, those perceived (and perceiving themselves) as divinely inspired by Yahweh. It is interesting to observe, for example, that neighboring pastoral peoples such as the Edomites similarly recognized the importance of prophecy. Something charismatic about prophets, such as the ability to speaking in tongues or the experience of epileptic seizures, convinced their contemporaries that they had been touched or "blessed" by a deity. Prophets could not be trained or appointed; rather, they were divinely inspired (revelational) and, therefore, represented the ascendancy of the individual in pastoral society.

If one can accept these basic tenets, then certain fundamental features seem evident about the Hebrews at the time of the Exodus and the migration into Canaan (again based on the narrative preserved in the Old Testament). Their society had no tradition for kingship, colleges of priests, or other urban forms of social hierarchy beyond clan or tribal leaders who frequently emerged as prophets. During the Period of Judges Israel existed as a loosely composed federation of tribal populations dominated by patriarchal councils of elders (**suffetes**) and little more. The existence of a college of priests purged by King Saul indicates, however, that collective hierarchies with recognized tribal authority were emerging in Hebrew society as it adapted to settled existence, possibly due to the unifying influence of the *amphictyony*. Resistance to the institution of kingship suggests that there was a potential conflict between those persisting in the austere traditions of pastoralism and those wishing to engage in the material benefits of more complex society. Historically, pastoralists were highly averse to the imposition of administrative procedures requiring census counts, property records, or tax assessments.

As we have seen, Ancient Near Eastern pastoral elements tended to venerate a particular warrior deity that warded over their tribal elements at the expense of all others. In this instance the Hebrews worshiped Yahweh. This does not mean that they denied the existence of other gods but rather that they saw their particular god as a savior deity who protected them against all opponents, human and divine. As a worldview the tendency to focus on one god at the expense of all others is called **henotheism**. Parallels can be drawn with the Babylonian emphasis on Marduk and Assyrian emphasis on Assur, not to mention the patron deities of numerous Mesopotamian city-states. Nevertheless, the Hebrews were able to sustain and to preserve a tradition, ultimately written, of a renewing covenant with their patron deity. There was the covenant of Abraham, that of Isaac, that of Joseph, and that again of Moses. This tradition enabled them to interpret their experience with Yahweh in explicitly historical terms. As they articulated it, Yahweh had a reason for leading them, for protecting them, and for using them to fulfill some larger purpose from which all humans would ultimately benefit.

Biblical scholars presume that the oral traditions of the Hebrews were first compiled and codified during the reign of King Solomon (961–922 BC). As such the Old Testament appears to contain numerous disparate particles of previous oral communication concerning Yahweh. One such example, the *Decalogue of J* (Exodus 34:14–28) appears to reflect a list of Ten Commandments consistent with the requirements of a pastoral community. Conceivably, this one more closely reflects the laws obtained by Moses on Mount Sinai.

The language of this code would appear to reflect moral requirements conceived for a pastoral people residing in a wasteland such as the "Wilderness," or migrating along the margins of settled agricultural communities such as Canaan. It exhibits henotheistic tendencies ("Thou shall worship no other god") and a profound emphasis on livestock as the economic basis of the community. Again, this seems very much in keeping with the narrative of the Old Testament.

With the conquest of Canaan, the Hebrews, now referred to as the Israelites, quickly adapted to settled agricultural existence. A yeoman stock of citizen-soldier-farmer came

THE *DECALOGUE OF J* (TENTH CENTURY BC; OLD TESTAMENT, *EXODUS* 34:14–28)

1. Thou shall worship no other god.
2. Thou shall make thee no molten gods.
3. The feast of the Passover thou shall keep.
4. The firstling of an ass thou shall redeem with a lamb; all the first born of thy sons thou shall redeem.
5. None shall appear before me empty.
6. Six days thou shall work, but on the seventh thou shall rest.
7. Thou shall observe the feast of in-gathering.
8. Thou shall not offer the blood of my sacrifice with leavened bread; neither shall the sacrifice of the Passover remain until morning.
9. The firstlings of thy flocks thou shall bring unto Yahweh, thy God.
10. Thou shall not seethe a kid in his mother's milk.

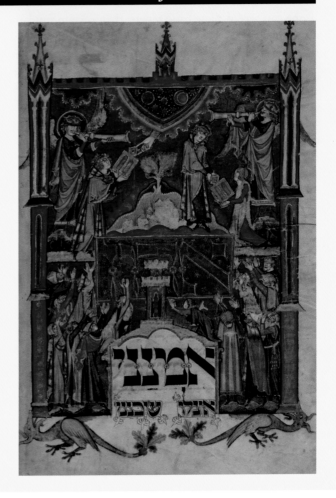

Figure 5.5 *Moses Receiving the Ten Commandments* from *Reuben Machsor mechol haschana (Jewish Holy Day Prayer Book for the Whole Year).* Germany, ca. 1290 AD. Vellum, leaves 59b, 50a. Sächsische Landesbibliothek, Dresden.

to furnish the backbone of King David's army as well as the conscript labor force used by the king to construct monuments at Jerusalem, not least of which the palace and the temple. Under David and Solomon, Israel experienced 80 years of powerful centralized authority. Along with territorial expansion through military conquest, the kings imposed a more sophisticated administrative and tax system. To assume its place as an emerging Near Eastern polity, they recruited talented outsiders, including skilled artisans, diplomats, courtiers, merchants, and financiers. As the flow chart below indicates, a stratified society gradually supplanted the traditional tribal system. At the top stood the king and his court (including wives and concubines, mercenary generals, and priests), officials dependent on royal favor stood just below these, and other people engaged in commerce and industry likewise resided in the cities. Presumably the largest proportion of the population consisted of ordinary Israelite peasant farmers who lived in the countryside. Wealthier landowners also employed slave agricultural labor.

TABLE 5. FLOWCHART OF THE ISRAELITE HIERARCHY		
	KING	
Mercenary Generals	**Foreign Princesses**	**Priests**
Officers and Administrators	Royal Attendants	Priestly Attendants
Foreign Financiers	Foreign Financiers	Foreign Financiers
Foreign Artisans and Traders	Foreign Artisans and Traders	Foreign Artisans and Traders
Citizens/Soldiers/Farmers	Citizens/Soldiers/Farmers	Citizens/Soldiers/Farmers
Slaves and Noncitizens	Slaves and Noncitizens	Slaves and Noncitizens

As urban centers developed, a considerable non-Israelite population is likely to have dominated their populations. At the head of David's army stood mercenary generals, such as his good friend Uriah the Hittite, presumably an émigré from the Neo-Hittite Empire in Cilicia. Numerous Phoenician artisans, merchants, and traders migrated to Jerusalem to fulfill skilled labor tasks and to fill voids in the emerging economy, with the inevitable result that they attained greater affluence and higher social status than the Israelite inhabitants themselves. In short, the attempts of Kings David and Solomon to construct an administrative hierarchy and to elevate the newly founded kingdom of Israel to the level of neighboring polities inevitably induced social and economic dislocations that placed ordinary Israelite citizens at a disadvantage. Such problems were not unique to Israel, to be sure, but they were clearly incorporated into a narrative that portrayed Hebrew society as one divided between a foreign urban hierarchy and a native rural peasantry. Conditions changed little during the Era of the Divided Kingdom. Both states, Israel and Judah, experienced prosperity until the late eighth century BC, although the gulf between rich and poor continued to widen with many independent farmers losing their land and falling into agricultural dependency. The literature of the reforming prophets refers repeatedly to economic difficulties characteristic of subsistence farmers trapped at the bottom of a transforming economy, such as land shortages, indebtedness (including debt bondage), and the abandonment of the poor. Indebtedness and heavy mortgages on land resulted in insolvency, not to mention legal proceedings initiated by wealthy creditors (particularly foreign moneylenders) against overburdened farmers. The resentment felt by Israelite citizens against these proceedings is demonstrated by the complaints preserved in Isaiah and elsewhere of "corrupt judgments" rendered by judges acting in the interest of the hierarchy. In the period of the United and Divided Kingdoms, in other words, a formerly pastoral society that viewed its destiny inextricably linked to the implementation of the will of its god Yahweh was confronted head on with the inevitable consequences of complex societies, including widening social disparities, tax burdens, and economic inequality.

To make matters worse, the kings themselves were viewed as the agents most responsible for having recruited these foreigners and for having elevated them to positions of importance. Since the hierarchy was essentially a product of the kings' own devices, it

effectively eliminated them as credible arbiters in disputes concerned with social justice or judicial redress. The pressures of so many converging forces culminated in a civil war at the end of Solomon's reign and in the dissolution of the United Kingdom into Israel to the north and Judah to the south. However, the process did not end there, because the ruling dynasties of both realms continued to pursue Near Eastern models of urban growth and centralized political hierarchy. Redress by Israelite citizens was obtained by turning instead to the leadership of the **reforming prophets**. Amos (ca. 760 BC) was allegedly a Judean sheep farmer who moved to Israel; Hosea (ca. 750–722 BC) was a baker likewise dwelling in Israel. Since the moral inspiration of the prophets was unquestionable and their role in Hebrew society dated back to its beginnings, their legitimacy was unassailable even before the kings. Visionaries such as Elijah and Elisha (ca. 860 BC), Amos and Hosea, and Isaiah elevated the complaints of Hebrew citizens to the level of religious redress. They pointed to the introduction of a monetary economy and to the recruitment of a foreign hierarchy as proof that the kings had deviated from the ancestral religion and the moral code of Yahweh. While this was certainly true, one could legitimately question the relevancy of the code mentioned above (the *Decalogue of J*) to contemporary needs of settled agricultural society in the Divided Kingdom. By focusing rather on the moral implications of the Hebrew covenant, the reforming prophets were able to adapt its expression to contemporary needs. This is indicated by the Ten Commandments recorded in their more familiar form in Exodus 20:1–17 and Deuteronomy 5:6–21 (presumably from the eighth to sixth centuries BC). Certain features to the more familiar code, such as property holding (houses), bearing false witness (as in testimony in lawsuits), and swearing oaths in vain (again as in testimony in legal proceedings) had little relevance to a pastoral society residing in a remote wasteland and appear much more to reflect the challenges confronting the Israelites at the time of the urbanized kingdoms.

As fresh components to the narrative, therefore, the prophets expressed the heightened pattern of alienation that emerged between the foreign dominated hierarchies of the cities and the rural peasantry in the countryside. In the process they redefined the moral requirements of the Yahweh cult insofar as these pertained to settled agricultural existence. The reforming prophets decried the social inequities and institutional corruption of the kingdoms by interpreting these as offences against Yahweh. They challenged the religious tolerance of the foreign dominated hierarchy by insisting on exclusive worship of Yahweh. Even at the time of the Divided Kingdom this idea was not as popular as one might think. Epigraphical data demonstrate, for example, that many inhabitants of Israel and Judah continued to venerate Yahweh in henotheistic terms, including the pursuit of cult practices that associated Yahweh and Asherah as divine consorts. In the Old Testament narrative the reforming prophets assumed an important role, therefore, in crystallizing religious thought in monotheistic terms. Since they lived and preached in an era in which the two kingdoms grew increasingly vulnerable to the threats of neighboring empires, the prophets employed the general sense of foreboding and anxiety with the kingdoms' declining political and military status as proof of the society's religious fall from grace. The narrative thus articulated a history of a pastoral society whose experience underwent

the long trajectory from the margins of urban society to the center, from periphery to core. The Hebrews' future was insured by a covenant with Yahweh so long as their veneration remained exclusive. By accepting this covenant, the Israelites' fortunes advanced and enabled them to become a world power. However, Yahweh's favor declined as the people adapted to settled urban existence and experienced the various complexities this transition required—cultural and religious diversity, social stratification, political and social inequality, monetized commercial practices, and the emergence of rich and poor. Having lost the favor of their deity, the Hebrews became vulnerable to conquest by the Assyrians, the Neo-Babylonians, and the Persians. The reforming prophets not only predicted these calamities, but they reinterpreted the moral code to make it applicable to the new conditions of settled urban existence. They insisted that the calamities themselves were the product of a failure in religious behavior.

In the post-exilic period the role and influence of Israelite prophets declined. Given the existence of a written testament bearing the word of Yahweh, the inhabitants of the restored kingdom of Judah no longer expected Yahweh to speak directly to them as in the past. Instead, the roots of a rabbinical tradition that reinterpreted the law and applied it to new situations came into being. Eschatological belief in a final judgment likewise appears to have germinated among Jews who remained in Babylon. In this regard they were probably influenced by exposure to Zoroastrian concepts that appeared to answer basic questions raised by monotheism. New strains of thought argued that a fallen angel similar to Ahriman was responsible for all evil and injustice in the universe. The divine forces of good and evil would confront each other in a cosmic battle to be won by a Messiah at the end of time. His victory would lead to the resurrection of the dead and a final judgment for all time. These ideas first appeared in Jewish writings in the Hellenistic era but they most probably were introduced during the Babylonian Captivity. For many centuries they were accepted by a small minority. However, following the success of the Maccabees the eschatological view became increasingly popular in Judaism and profoundly influenced both Christianity and Islam.

Despite the limitations of the Old Testament as a historical source, three clearly and consistently articulated concepts emerge from this distillation of the Hebrew experience. The first of these is **monotheism**. As the reforming prophets railed against the kings and their foreign hierarchies, they increasingly came to express their concerns in monotheistic terms. In doing so they drew on a cultural tradition of nomad austerity, of purity of religious observances, and hence of an indifference to and ultimately a rejection of materialism and polytheistic religious practices. By doing so at the expense of urban social hierarchies, they reasserted the primacy of the individual in the religious, moral, and social order. Equally important, the expressions recorded in the narrative of the Old Testament articulated a resounding denial of the divine right of kings. Ancient Israel represents the first culture on record to articulate such an opinion. Again, it was easier for the Israelites to assert this principle because their segmentary, tribally based origins lacked a tradition for kingship. Since kingship came relatively late in the development of Israelite society, it lacked the legitimacy of ancestral institutions such as prophecy. In addition, Israel was

a relatively small kingdom that placed a higher premium on preserving the security of its property-holding citizens. These citizens were able to rebel against the practice of forced labor in ways not possible elsewhere. When the kings attempted to secure their place in wider Near Eastern society by establishing foreign hierarchies, they furnished the reforming prophets with a xenophobic argument to challenge the authority of the social hierarchy in the interest of ordinary citizens. Accordingly, the narrative of the Old Testament articulated for the first time the principle of the dignity of humankind. Put simply, citizens of a given society possessed rights that were inalienable, even before the authority of a king. The problems incumbent to the emergence of subsistence agricultural society—land and debts, corrupt judicial proceedings, forced labor, care for the less fortunate—all reflect a wider demand for social reform as articulated by the reforming prophets. By confronting these developments as religious matters, and more specifically as the betrayal of the ancestral covenant with Yahweh, the reforming prophets were able to reassert authority in Israel, not only with respect to these questions but also with respect to religious reforms that rejected idolatry, sacrifice, and polytheism. In their place, they proposed a monotheistic moral order based ultimately in the responsibility of the individual. In this respect, they assumed their position alongside Zoroastrianism, Greek Rational Thought, Buddhism, and Confucianism as innovators of an Axial Age.

FURTHER READING

Barton, George A. *The Religion of Ancient Israel*. New York: Barnes, 1961.

Ben-Tor, Amnon, ed. *The Archaeology of Ancient Israel*. Trans. R. Greenberg. New Haven: Yale University Press, 1994.

Fine, Steven. *Art and Judaism in the Greco-Roman World: Toward a New Jewish Archaeology*. Cambridge: Cambridge University Press, 2005.

Finkelstein, Israel, and Amihai Mayar. *The Quest for the Historical Israel*. Ed. Brian B. Schmidt. Atlanta: Society of Biblical Literature, 2007.

Finkelstein, Israel, and Nadav Na'aman, eds. *From Nomadism to Monarchy: Archaeological and Historical Aspects of Early Israel*. Washington, DC: Biblical Archaeological Society, 1994.

Grabbe, Lester L. *Ancient Israel*. New York: T&T Clark, 2007.

SIX

ANCIENT CIVILIZATIONS IN THE INDIAN SUBCONTINENT (SOUTH ASIA) (2600 BC–500 AD)

WHAT HAVE WE LEARNED?

► That the Hebrews began as pastoral tribes migrating through and existing along the margins of Mesopotamian urban society.

► That repeated losses to the Philistines forced tribal leaders to appoint a king named Saul (1020–1000 BC), even though there was no precedent for kingship among the Hebrews. When he proved unpopular, they turned to a young charismatic renegade who assumed the throne as King David (1000–960 BC). David defeated the Philistines and established the United Kingdom (1000–922 BC).

► That David was succeeded by King Solomon (961–922), who was gifted in trade and diplomacy and forged alliances with neighboring Near Eastern dynasties.

► That the attempts of Kings David and Solomon to construct a ruling hierarchy largely of foreigners and to elevate the newly founded kingdom of Israel to the level of neighboring world powers inevitably created social and economic dislocations that left ordinary Israelite citizens disadvantaged.

► That the Divided Kingdom (922–721 BC) was represented by Israel in the north and Judah in the south. Both kingdoms became subject to Assyrian domination by 850 BC and were forced to pay tribute.

► That the experience of the Hebrews reflects the settlement pattern of numerous nonurban agro-pastoral cultures dwelling within the horizon of Ancient Near Eastern urban societies.

► That the tendency of Hebrew culture to emphasize individual communication with their deity resulted in the more immediate religious experiences of the Hebrew prophets, who were divinely inspired (revelational) and represented the ascendancy of the individual in pastoral society.

► That the recorded testimony of the reforming prophets was the first to articulate principles of monotheism, a denial of the divine right of kings, the dignity of humankind, and the moral responsibility of all humans as individuals.

INTRODUCTION TO ANCIENT INDIA (THE INDIAN SUBCONTINENT)

From the resurgence of ruling hierarchies in the Iron Age Near East to their intellectual and moral rejection by the reforming prophets in Israel, the role of governance was central to the rise of urban societies in the Ancient Near East. The opposite was true of contemporary societies in the subcontinent of India. Indian populations were less concerned with notions of political hegemony and historical record-keeping. Despite the inception of urban cultures in the Indus Valley by 2500 BC, there is no certain chronology of Indian history until the sixth century BC, and much of what we know derives from the writings of Greek visitors such as Skylax (ca. 500 BC) and Megasthenes (who was dispatched to India by King Seleucus I of Syria ca. 350–290 BC). One likely possibility is that organically based writing materials such as parchment or reed-paper failed to survive in the tropical environment of India. Another is that archaeological investigation in India simply has not kept pace with exploration elsewhere. Still another explanation arises from the fact that ancient cultures in southern Asia rarely developed a tradition of centralized authority with its commensurate need to compile data or to record accomplishments. During periods of political hegemony—the Mauryan Dynasty (324–184 BC), the Kushan Dynasty (40–176 AD), and

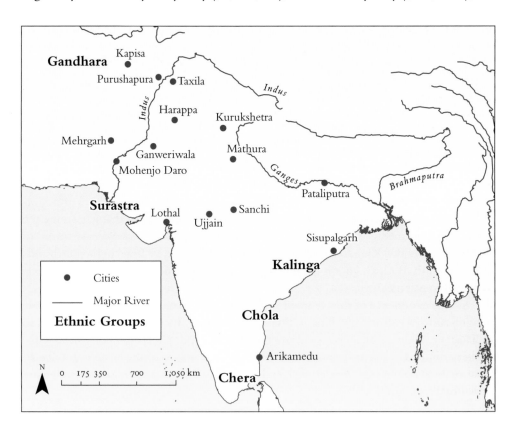

Map 7 Sites of Interest in Ancient India

the Gupta Dynasty (320–550 AD)—a minimum of records survives to illuminate political conditions in the region. The best examples in this respect are the inscribed pillars erected throughout the Mauryan Empire during the reign of the emperor Ashoka (304–232 BC). Some 19 of these pillars have been found inscribed with edicts of the king. Some 20 additional edicts have been found inscribed on exposed rock surfaces.

By and large, the decentralized, diverse, and highly autonomous settlement pattern in southern Asia prevented the emergence of a sustained historical narrative. More than 70 regional polities—some monarchies, some republics, some tribal chiefdoms—extended across the varied landscape until the formation of large territorial states in the Ganges river basin in the fourth century BC. At no point were the empires that emerged in northern India able to consolidate a single unified hegemony over the entire region. The large polities proved equally incapable of preventing repeated invasion and occupation of the subcontinent by outside peoples, be these the Persians, the Macedonians, the Scythians, the Kushan, or the Huns. Wave after wave of invaders simply added to the diverse mix of the population and polities. Indian civilization was characterized instead by the development of strong spiritual and social constructs that enabled their society to maintain stability and continuity in lieu of a strong centralized authority. Due to their strategic location between prosperous civilizations in the Mediterranean and East Asia, Indian populations played a crucial role as intermediaries in the formation of a global world system.

ENVIRONMENT

The Indian subcontinent furnishes an array of tightly clustered ecological zones ranging from alpine tundra at the base of the Himalaya Mountains to tropical rainforests in the south. The Himalayas form a barrier to the cold winds that arise in north Central Asia leaving the climate along the northern Indus and Ganges Valleys comparatively mild. The interior regions of the Indian subcontinent are extremely hot. The range of ecological diversity posed a significant challenge to the formation of urban societies. The Indus Valley in modern Pakistan sits primarily in an arid zone (the Thar Desert) but draws its water resources from snowmelt in the Himalayas, numerous fresh water springs in the surrounding mountains, and not least from the annual monsoons that bring prolonged downpours to the region between June and September. The Ganges River basin was more dramatically affected by the same influences of snowmelt, springs, and rainfall, but unlike the Indus it was humid and lushly forested. The Ganges also teemed with wild animals, reptiles, and disease bearing insects: in fact, land clearance was the single greatest challenge to urban development in the Ganges basin. The slow process of agricultural settlement along the length of the Ganges required nearly a thousand years (1700–700 BC). By the third century AD the river basins were largely deforested and converted into productive agricultural landscapes. Crops included cotton, wheat, barley, rice, sesame, and sugar cane. Along the east coast in the hills south of the Ganges Valley important sources of iron were

exploited. Settlement in these regions remained rural and Neolithic in character even at the time of the formation of the great Ganges empires (fourth century BC). Along both coasts trading settlements came to play pivotal roles in the maritime trade that crisscrossed the Indian Ocean. The southern regions generated spices such as pepper and cinnamon, various aromatic plants, precious metals in the Deccan hills, and other exotic goods such as pearls and gemstones.

CHRONOLOGY 5. ANCIENT INDIA	
2600–1900 BC	Indus Valley Civilization
ca. 1700 BC	Invasion of Indo-Iranians
1200–1000 BC	Vedic Era
1000–600 BC	Epic Era
500–300 BC	Magadha Empire
324–184 BC	Mauryan Dynasty
ca. 50 BC–200 AD	Kushan Empire
320–550 AD	Gupta Dynasty

FROM THE BRONZE AGE TO THE EPIC ERA

Emerging by 2600–2500 BC, Indus Valley riverine culture was highly urban, with more than a dozen cities, most particularly, Harappa, Mohenjo Daro, Ganweriwala, Mehrgarh, and Lothal. These cities dominated five of six posited regional populations referred to as *domains*. The wider settlement area encompassed approximately one million square kilometers, four times the area of Sumer and twice the size of the Egyptian Old Kingdom. Although these societies clearly interacted with one another through shared technologies, patterns of urban development, and trade, their populations were not homogenous. Urban design was sophisticated and employed a common code of planning principles. Excavations at Harappa and Mohenjo Daro have revealed that the two cities were built on a square grid pattern of streets divided by main roads into 12 precisely measured neighborhoods. Water and drainage systems were equally well organized. Domestic quarters were rectangular and arranged around central courtyards, with entrances opening onto side streets to reduce congestion on the main thoroughfares. For construction materials the inhabitants employed kiln-baked brick, the size of which was standardized throughout the region. Evidence of staircases and the significant thickness of walls in many structures indicate the existence of multiple stories. Each city exhibited a large fortified citadel (separated from the residential districts) offering sanctuary to the inhabitants in times of war and was also surrounded by extensive walls. Coordinated construction on such a massive scale

obviously required central governing institutions capable of organizing and supervising the daily efforts of large teams of laborers. However, the absence of palace complexes at these settlements has led scholars to classify them as *acephalous* or "headless" states. The hierarchy was possibly nonpolitical. For example, the citadels at Harappa and Mohenjo-Daro exhibit what are believed to have been audience and assembly halls or places of worship together with large public bathing tanks. Later Indian emphasis on spirituality and strictly organized social order may possibly trace its roots to these complexes. The grain storage silos and bathing structures at Mohenjo Daro, for example, point to hierarchical control of the food supply, perhaps by a body of priests. A complex resembling a monastery overlooked the brick constructed bathing tank and grain silos. Access to food distributions possibly required ritual purifying ablutions performed under priestly supervision. Similar ablutions, particularly along the banks of the Ganges River, remained a significant feature of Hindu ritual; stepped embankments known as *ghats* were common features to temples situated alongside the river.

Indus Civilization

By 1900 BC the Indus Valley civilization collapsed, major cities were abandoned, and writing, craft technologies, and other hallmarks quickly fell out of use. The suddenness of societal collapse suggests that some sort of cataclysmic event transpired. Explanations range from climate fluctuation, to a tectonic shift that diverted the course of the river, to resource depletion (deforestation) and the exhaustion of agricultural terrain. The currently assigned date for the infiltration of Indo-Iranian invaders (ca. 1700 BC) removes them as a potential factor in this calamity. More likely, population growth hit a ceiling or a tipping point.

The influx of Indo-Iranian pastoralists submerged the preexisting culture so thoroughly that it is impossible to determine the extent to which later Hindu culture was derived from the native (Dravidian) population or that of the invaders. Undoubtedly the likely answer was a combination of the two. The Indo-Iranian invaders (who referred to themselves as Aryans) brought with them a Vedic oral tradition that was eventually preserved in Sanskrit. This represented the sacred literature of the **Vedic Era** (1200–1000 BC). Sacred texts include the *Rg veda*, an assemblage of 1,028 hymns, prayers, and chants dedicated to various gods of the polytheistic Vedic pantheon. The main deities were Varuna (Vishnu) the god of the heavens, Surya the sun god, Agni the god of fire, Indra the god of war, and Yama the god of death. The *Rg Veda* furnished the definition of godhead and its various powers; expressed a sense that millions of gods existed, the true count being impossible to determine; and contained a great deal of mythological lore. The primary purpose of the *Rg Veda* was to facilitate religious procedures by the priestly class, the Brahmans, who memorized these prayers and recited them at rituals, typically for a fee. The hymns detailed a welter of intricate procedures required in sacrificial ritual. There were prayers and rituals for every occasion, including some intended to aid with crop production, others used to cure diseases such as leprosy and jaundice, others intended to harm rivals, and still others to

Little art from the Indus Civilization (which flourished from ca. 2600–1500 BC) is extant, and the art that has been discovered is small in scale. Two of the most noteworthy pieces include a robed male figure from Mohenjo Daro and a nude male torso from Harappa. Although created at approximately the same time, the two male representations are quite different in style. The robed male figure is represented with his eyes half-closed, a low forehead, and a beard. A headband with a circular emblem adorns his head, while a similar emblem and band decorate his arm. Originally precious metals and shell inlays were used as embellishments, suggesting the figure was an important individual. Decorated with trefoils (clover-like designs with three stylized leafs), a design motif that is also found in Sumerian sculpture, the robe likewise emphasizes the elite status of the figure. As in Sumerian culture, the trefoil motif denotes a sacred context, identifying the robed figure as a "priest-king." The nude male torso, however, emphasizes the sensuality of the body with its stylized curves, polished surface, and virility—all aspects that will come to characterize South Asian sculpture moving forward. The Indus artist was concerned primarily with representing the organic movement of the human body and its intrinsic sensuality.

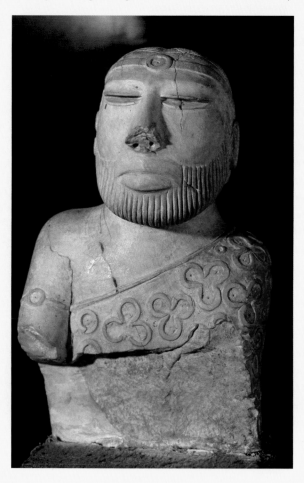

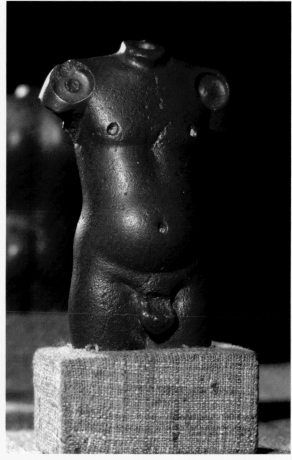

Figure 6.1 Robed male figure, from Mohenjo Daro, Pakistan, ca. 2000–1900 BC. Steatite, 17.5 cm x 11 cm. National Musuem of Pakistan, Karachi.

Figure 6.2 Nude male torso, from Harappa, Pakistan, ca. 2000–1900 BC. Red sandstone, 9.5 cm high. National Museum, New Delhi.

invoke as love charms. How one performed the sacrifice was very important; hence, ritual was emphasized and remained a dominant component of emerging Brahman culture. The closest linguistic match to Vedic was Avestan in Persian. Close affinities exist among the remnant particles of Vedic, Avestan, and Mitannian cultures (the last mentioned in northern Syria), indicating that the three populations lived and traveled together before pursuing divergent paths during the Middle Bronze Age. Written Sanskrit almost certainly existed in India by the sixth century BC and continued in use among the educated Brahman elite. It remained an exclusive language of that caste, however, and necessarily coexisted with the dozens of vernacular languages spoken by native populations throughout the subcontinent. A derivative writing system known as Brahmi eventually served as an umbrella script for numerous written and spoken languages at this time. The texts recorded on the pillars of Ashoka (see below) were inscribed in Brahmi.

Over time the Indo-Iranian invaders extended their dominance across the northern regions of the Indus River and the Ganges River basins. Particularly along the Ganges and further south, land clearance and irrigation were major challenges. Iron deposits along the southern flank of the Ganges attracted an expanding population, but the dense tropical rainforests were prohibitive, and manpower remained inadequate. Kings had to encourage colonization by granting enormous concessions to migrants who could tolerate living in remote, isolated villages. Brahman ascetics, or *yogis*, frequently led the way by migrating and essentially functioning as missionaries in isolated pockets of Dravidian population, most still existing as hunter-gatherers. Intermarrying with the native elements, the *yogis* syncretized their religious beliefs and opened the way for further expansion from the north. Later kings and emperors encouraged road building and offered armed escorts to travelers to connect remote regions with the principal cities. Dangers to travelers included attacks by bandits and hunter-gatherers (referred to as the *Nagas*), not to mention predation by wild animals attracted by the food and refuse of the camp.

Settlement in the Epic Era, 1000–600 BC

Although the tribal composition of Indo-Iranian invaders was inherently multiethnic, the newcomers appear to have found extreme difficulty assimilating to native culture as well as to the racially different (Dravidian) autochthonous populations. During the Epic Era, they organized a strictly ordered caste system of social hierarchy. The **caste system** originally recognized the supremacy of the warrior caste, the **Kshatriyas**, followed by priests or the **Brahman** caste (who served as teachers, judges, assessors, and ministers), merchants and farmers (**Vaisyas**), and subsistence laborers (**Sudras**). A fifth group, the **Dasyas** or untouchables, gradually evolved outside the recognized orders. The Dasyas consisted of Dravidian elements that failed to merge successfully with the Indo-Iranian invaders. They were not allowed to live in villages but rather resided principally as hunter-gathers on the periphery. Dasyas would enter villages only to perform "taboo" laboring tasks such as preparing the dead and hauling refuse. Tradition held that they would clack sticks together

to announce their approach so that the inhabitants could avoid direct contact. The caste system became a dominant component to the social order in later times.

During the Epic Era the political landscape evolved into a network of powerful regional states. More than 70 political entities are recorded in all, many of which remained viable for centuries. Many, if not most, were agriculturally based chiefdoms ruled by local kings known as *rajahs*. Several emerged into stratified tribal polities known as **mahajanapadas** (neighboring tribes subsumed under one tribal heading to forge a larger collective; literally, the "foothold of a great tribe"). Some 16 *mahajanapadas* extended across northern India at the time of the Buddha (sixth century BC). The western-most chiefdoms of the Kamboja and the Gandhara adhered most closely to their Indo-Iranian roots. Originally settled to either side of the Hindu Kush Mountains in Afghanistan, the Kambojas had gradually migrated to the upper highlands of the Punjab (the northern basin of the Indus River). Claiming always to have existed as a republic, they were more frequently exposed to the influences of Iranian hegemony. The Gandhara *Mahajanapada* possessed territories in eastern Afghanistan and northwestern Punjab. Its capital Takshasila, or **Taxila**, became a renowned center of learning in ancient times, attracting the attention of scholars and religious pilgrims from throughout the world. Young Indian nobles from the Ganges as well as the Indus journeyed to Taxila to study. In Gandhara educated elites employed a written form of Sanskrit known as Karosthi, which employed a different form of script than Brahmi, and it was probably influenced by the Aramaic script employed in Old Persian. During the era of the Kushan Dynasty (30–230 AD), use of Karosthi expanded northward along the Silk Road into north Central Asia (Bactria and Sogdiana) and the Tarim Basin (western China) as well as southward to the Ganges. Among Gandhara's most celebrated teachers were the Sanskrit grammarian Panini (ca. 400 BC) and the political thinker Kautiliya (also known as Chanakya or Vishnu Gupta). As a high-ranking minister in the Magadha court, Kautiliya enabled Chandragupta to usurp the throne and to found the Mauryan Dynasty (ca. 324 BC). Kautiliya also wrote a political treatise (the *Arthasastra*) that ruthlessly justified a monarch's right to absolute authority and thus helped to articulate an argument for centralized authority.

All the other *mahajanapadas* were settled along the Indus and Ganges river systems with the exception of Assaka, the only *mahajanapada* to settle south of the Vindhya Mountains. Most *mahajanapadas* were ruled by paramount kings (*maharajahs*) supported by resident courtiers. Several converted from chiefdoms to tribal republics, or oligarchies, governed by multiple tiers of councils, assemblies, and appointed executives. The Vriji, for example, convened its citizens in a *sangha* or tribal assembly organized according to districts (*khandas*). Its members arose from various subtribes (*janapadas*), villages (*gramas*), and professional groups (*gosthas*). The assembly was directed by a *Vriji gana parishad* (people's council of Vriji) with members likewise selected from each district. These in turn appointed a chairman of the council (*ganapramukh*). Other republics, such as the Kuru, preferred to be ruled by an executive known as a *korayvya*, or king consul; the Mallas, on the other hand, opted for a *sangha* administered by a council of constituent *rajahs*. As is evident, variations in republican forms of governance were manifold. Similarly fluid patterns prevailed among

the monarchies. When the king of the Avanti (one of four leading monarchies at the time of the Buddha) was defeated in battle by King Shishunaga of Magadha, his tribe was subsumed into the latter hegemony (ca. 400 BC). The Surasena *mahajanapada* was likewise annexed by the Magadha, enabling it to emerge as the leading polity of the region by the fourth century BC. Throughout the Epic Era, tribal polities came and went out of existence. This indicates that the institutions of state remained superficial, exposing tribal populations to the patterns of cultural recombination that occurred frequently among segmentary societies.

Although degrees of authority varied from one polity to the next, the power of most *maharajahs* was far from absolute. Typically, the ascension of a *rajah* or *maharajah* had to be approved in advance by the *Sangha* and its various ruling councils. The heir apparent would literally canvass his tribal constituencies for approval. The king's authority was further constrained by Vedic custom, which he was not only religiously obligated to uphold and to enforce but forbidden to transgress. The king was not so much a source of law, in other words, as he was the upholder and enforcer of the same. As the head of state, he vowed to protect his people (particularly the young and the elderly) and to preserve the caste system. The most powerful *maharajahs* were able to govern their populations through appointed viceroys, governors, and officers who would reside locally among towns and villages and derive support directly from the inhabitants. Taxes in kind ranged in value from the proceeds of as few as 10 to as many as a thousand villages. A king's authority to impose taxes was often disputed, however, and could significantly hinder the abilities of the *maharajah* to sustain his hierarchy or to provide for a common defense. This indicates once again that tribal affinities by and large trumped those of state. In many polities the kings had to sustain themselves from the proceeds of their own lands and assets, from profits taken in war booty, and from gifts obtained from his subjects on important occasions such as royal ascensions, marriages, and births. Gradually, through the influence of statesmen such as Kautiliya, Indian monarchs asserted claim to the assets of their respective kingdoms, especially the agricultural terrain and its essential water resources. In these instances the *maharajahs* imposed a 10 per cent tax on lands as well as other taxes on yields, livestock, produce, and merchandise, not to mention labor requirements from artisans (one day's work per month). Under Persian influence currency came into use in southern Asia by 400 BC.

THE *MAHABARATA*, THE *UPANISHADS*, AND THE *BHAGAVAD GITA*

As in other aristocratic cultures royal families of neighboring *mahajanapadas* engaged in extensive dynastic marriages and attempted otherwise to influence the diplomatic leanings and internal affairs of neighboring polities. The Kshatriya-led culture of the Epic Era is best represented by the epic poem the *Mahabharata*, which recounts the legend

Figure 6.3 Battle between Ghatotkacha and Karna from a manuscript of the *Mahabharata*, ca. 1670 BC. Mysore or Tanjore, Southern India. Ink, opaque watercolor, and gold on paper, 18 x 41.7 cm. Harvard Art Museums/Arthur M. Sackler Museum, The Stuart Cary Welch Collection.

of a dynastic conflict that erupted between the collateral lines of the royal dynasty of Kuru, the Kauravas and the Pandavas (the Kuru having settled near modern Delhi). Each side demonstrated a legitimate claim to the throne as well as justified complaints against the other, and each side employed its connections to muster allies from neighboring *mahajanapadas*, ultimately to converge in a decisive Battle at Kurukshetra near Delhi. According to the epic all the celebrated Vedic populations participated in this momentous conflict. Remarkably similar in form and substance to Homer's *Iliad*, the *Mahabharata* details the inherent conflicts that arose between kinship and friendship, loyalty and duty, honor and disgrace, victory and defeat. It particularly celebrates the supreme status of the warrior elite, or Kshatriya caste, in Epic Era society. Much of the poem emphasizes martial themes such as virility, weaponry, and preparation for death in battle. The description of the Battle of Kurukshetra is sweeping in its depictions of Indian combat. Thousands of warriors—the elite riding in chariots, on horseback, or atop elephants, the commoners on foot and brandishing swords, spears, and bows—clashed with violent ferocity. From a historical perspective, many scholars are struck by the remarkable continuity that existed between the locations and dynastic names of the *mahajanapadas* listed in the *Mahabharata* and those of later record, some insisting that the poem recounts an authentic historical event, a momentous conflict among the Vedic tribes that is alleged to have transpired during the Bronze Age or at the inception of the Iron Age (ca. 1000 BC). The parallel with scholarly attitudes toward the historical significance of the siege of Troy comes to mind. The source of each tradition in proto–Indo-European culture seems equally noteworthy.

The literature of the Epic Era otherwise reflects advances from early Vedic ritualism to a new threshold of genuine philosophical contemplation. Alongside the *Mahabharata* the

hymns or epic poems known as the *Upanishads* exhibit a highly mystical aura. There were no names associated with the hymns and, thus, no known prophets. The hymns arose from immense oral traditions borne by singers with prodigious memories who, despite being illiterate, were able to recite epic poems such as the *Mahabharata* for days on end. Many hymns existed in a dialogue format and thus formed the beginning of a dialectical tradition. The message of the *Upanishads* became sufficiently popularized that it reached beyond the exclusive control of the Brahmans. In the *Upanishads* there was open speculation as to what was god. The philosophy consisted in the belief in a grand cosmic essence, Brahman, or ultimate reality. The human individual was the *atman* (*mahatma* = great *atman*), which endured cycles of rebirth. This philosophical innovation, the belief in reincarnation, was totally absent in the earlier Vedas. Although formal Hinduism did not blossom until the era of the Gupta Dynasty (320–550 AD), the belief in the transmigration of the soul ultimately formed the basis to this and all subsequent Indian philosophy, with the *Upanishads* representing its formative texts. Its doctrine found its way into epics such as the *Bhagavad Gita*, a hymn devoted to the Hindu god Krishna. Krishna was one of the great gods of the Hindu pantheon very close to mankind, much like the Greek god Hermes. He was variously portrayed as a child-deity, a prankster, an ideal lover, a divine hero, or the supreme being. According to Hindu tradition he represented the eighth incarnation of the supreme god Vishnu, and thus demonstrated that the gods themselves endured phases of reincarnation. As Krishna asserts in the *Bhagavad Gita*: "Though I am unborn and of essence that knoweth no deterioration, though I am the lord of all creatures, still, relying on my own material nature I take birth by my own powers of illusion. Whenever loss of piety and the rise of impiety occurreth, on those occasions do I create myself. For the protection of the righteous and for the destruction of the evil doers, for the sake of establishing piety, I am born age after age."

As noted above, the *Mahabharata* recounts an epic struggle between two collateral branches of the Kuru clan, the Kauravas and the Pandavas, for the throne of Hastinapura. The struggle culminated in the Battle of Kurukshetra, in which the Pandavas ultimately prevailed. At the outset of the battle, the Pandava prince Arjuna was reluctant to initiate combat. Seeing himself opposed by his great-grandfather, by his teacher, and by numerous other relatives, he is confronted by the prospect of taking the lives of those he cherishes. In a famous passage of the *Bhagavad Gita*, Krishna, who serves as Arjuna's charioteer, convinces the prince to attack, furnishing the Kshatriya caste with divine justification for acts of violence. According to Upanishad philosophy, when immense consequences hung in the balance, it was morally imperative to resolve on a course of action and to fulfill one's destiny. The *Bhagavad Gita* offers a rejection of nonviolence, therefore, or at least a legitimization of the necessity to act. It furnished moral support to the rulers of various warring states during the Epic Era.

The ultimate statement of Upanishad philosophy (ca. 800–500 BC) was that Brahman equaled Atman, and Atman thus was at the same time Brahman; the great essence and the self were one. This view presupposed an entity that passed from one life to the next. The Atman thus was one of many possibilities through which an individual soul transmigrated.

Ultimately one became liberated after 84,000 or 100,000 reincarnations to achieve union with the divine essence. Hindu philosophy likewise entailed a meditative component. The *yogi*, or Hindu devotee, was required to look within himself to determine the causes of pain and suffering. He also relied on the recital of mantras or sounds and rhythms believed to control the etheric vibrations that permeated space and represented the first knowable source of creation. Personal synchronism with the harmonics of the universe was believed to produce beneficial effects on the persons or objects concerned. The self-discipline of the Yogi and his contemplation of an ultimate reality would eventually enable him to attain oneness with the divine essence. This proto-Hindu worldview gradually supplanted the minimalist worldview of the Vedic tradition while reinvigorating it at the same time with complex concepts filled with high spiritual content. Hinduism also furnished a moral system to legitimize the social caste system (that is, reincarnation implied that one could eventually advance to higher caste levels through rebirth). Moral ascendancy in Indian society derived from knowledge of Hindu philosophy and the essential Brahman rituals. The wisdom, philosophical confidence, and selfless demeanor of the ascetic eventually enabled members of the Brahman caste to supplant the Kshatriyas in Indian hierarchy. However, Brahman corruption and an obsession with ritual (typically accompanied by fees) caused the Kshatriyas to challenge Brahman ascendancy, particularly in the Ganges basin where it was customary for the ruling class to send its youths to be educated at Brahman seats of learning such as Taxila. Each element had their doubts about the other, in other words. Ultimately, the caste system and Hindu philosophy in general required centuries to attain their formally recognizable states.

INDIAN PHILOSOPHY

The prevailing levels of violence during the Epic Era also gave rise to ascetic or **shramana** philosophical movements such as Jainism and Buddhism. *Shramana* literally meant "to renounce." Scholars use *shramana* to refer to renunciate ascetic traditions that emerged around the middle of the first millennium BC. Shramana represented individual, experiential, and free-form traditions, divorced from society and opposed to the Brahmin hierarchy's inordinate emphasis on Vedic ritual. Many Shramanic traditions, such as Jainism, remained heterodox to Hindu belief because they rejected the authority of the Vedas and the *Upanishads*. Buddhism, however, blended and adapted these to form one of the world's most significant philosophical worldviews. By about 600 BC, an era of great doctrines inspired by noted individuals, the so-called Axial Age, came into being.

Shramanic or renouncing philosophers focused inordinately on death, as well as on the degree to which the link between birth and death was conditioned by an attachment to desire. **Jainism** appears to have represented a reaction to the rising threshold of violence in the Epic era. Jain philosophers imposed a standard of nonviolence that was quickly incorporated into Buddhism. Jainists drank only through nets and filters and carried brooms

to sweep the ground, partly because they believed that it felt pain when they walked on it and partly to protect crawling insects from harm. The rejection of worldly things and the acceptance of wisdom were both deeply rooted in this itinerant philosophical culture.

The most orthodox Jains went about completely naked. These were the celebrated **Gymnosophists** (a Greek term meaning *naked philosophers*) who accompanied Alexander's army back to the Mediterranean world. They claimed to be "sky clad," that is, dressed in the ether of the sky. Shramanic philosophers would gather in large assemblies to debate concepts of reality and wisdom, by this means perfecting skills in dialectical argumentation. One particular Buddhist *sutta*, or dialogue, rejects 61 points of view, offering a possible indication of just how many schools of thought existed at this time. Dozens of holy men traveled about in the company of thousands of followers. These religious leaders, known as *gurus*, would journey throughout the kingdoms of India in large tent cities, setting up on the outskirts of towns. According to one tradition, Parsvanath, the twenty-third prophet of Jainism who lived in the eighth century BC, possessed a following of 28,000 nuns, 164,000 men, and 327,000 women.

BUDDHISM

The identity of Gautama Buddha, or Siddhartha (ca. 567–487 BC), is equally shrouded in legend, but the tradition holds that he was a young prince of the Kshatriya or warrior caste. He was born under various omens to his father, Suddodhana: according to the canonical legend, Suddodhana was told that his son would either become the greatest ruler or the wisest philosopher in the world. To assure that his son would assume the throne, Suddodhana decided to keep him happy by shielding him from all horrible sights. He also took whatever steps necessary to divert Gautama from the pursuit of wisdom. Suddodhana went so far as to assign his son servants his own age and to replace them before they grew old. Eventually Gautama escaped from the palace to witness firsthand the horrors of sickness, infirmity, old age, poverty, and death. Appalled by these sights, he drew comfort from the wisdom of holy men. He came to the realization that he must search for answers to the various problems that afflicted humankind. Despite having a family of his own, he left the palace to become an ascetic and followed the leading philosophers of his day. Although his skills at argumentation seemed incomparable, he found little spiritual satisfaction in this, so he persisted in an ascetic way of life, gradually starving himself by reducing his food intake to the consumption of a single sesame seed a day. This left him emaciated and caused him one day to pass out. He awoke to find a cow girl offering him milk, and he gladly accepted her drink. The other ascetics in his presence grew disgusted at the sight of his indulgence and abandoned him. However, the Buddha recognized that by not tormenting himself he had found a solution, namely, a course he called the *middle way*. To the Buddha extreme asceticism was not required; like other gurus he continued to pursue an ascetic life by wandering, debating, and living off alms from the people. He

and his entourage of 1,200 devotees wandered throughout the Ganges basin gaining popularity among common people along their route. He was invited to live at various royal palaces, but he preferred to remain among the remote villagers of the rainforest, lending them guidance and listening to their complaints. Eventually somewhere in his meditations he fell into an ultimate trance under the bodhi tree (*bodhi* meant great tree of knowledge; the words *Buddha* and *bodhi* are related). In this prolonged trance he endured temptation by demons, four meditative states, and five transcendental experiences. Ultimately, he broke through to the divine essence, then awoke to become the Buddha.

The classic statement of Buddhism is that one does not talk about *atman*, but *anatman*, or no self.

Buddhism contains three basic doctrinal principles:

1. Self? No, there is no self, there is only anatta.
2. No self means that there is **dukkha**, that is, trouble, pain, and suffering.
3. There is impermanence to all life.

Buddhists wrote dialogues with numbers in them to furnish a mnemonic system of memorization. Thus there are the Four Noble Truths:

1. Life is dukkha, suffering, pain, trouble, toil;
2. The cause of dukkha is desire;
3. Cessation of desire results in the cessation of suffering;
4. The way to the cessation of suffering is the eight-fold path;

and the Eight-Fold Path:

1. Right View
2. Right Intention
3. Right Speech
4. Right Action
5. Right Living
6. Right Effort
7. Right Mindfulness
8. Right Concentration

The Buddha confirmed belief in the cycle of lives. In Buddhism moral actions add positive and/or negative values to one's existence and determine one's place in the next life. **Dharma** or **kharma** represents the law of moral consequences: too many negative actions sent one's soul to a lower state of existence in the next life (lower caste level, lower form of life altogether), while positive acts propelled one forward. The Buddha's conception of religion was purely ethical, with little attention to worship or rituals. He placed all his emphasis on conduct. He paid no attention to the caste system and was ready to welcome

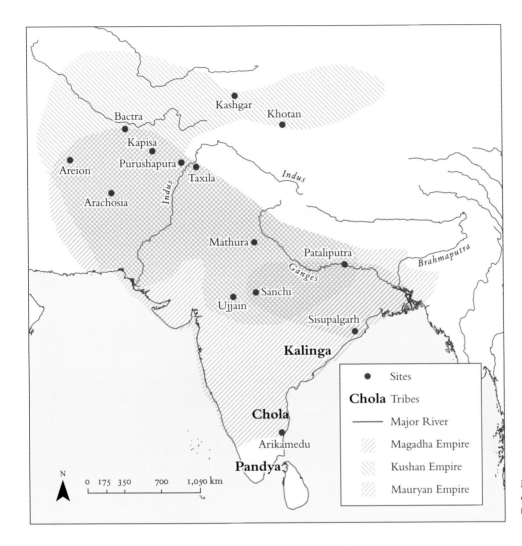

Kashgar

Khotan

Bactra

Kapisa

Purushapura

Areion

Taxila

Indus

Arachosia

Indus

Mathura

Pataliputra

Brahmaputra

Ganges

Sanchi

Ujjain

Sisupalgarh

Kalinga

	Sites
Chola	Tribes
—	Major River
	Magadha Empire
	Kushan Empire
	Mauryan Empire

Chola

Arikamedu

Pandya

N

0 175 350 700 1,050 km

Map 8 Territorial Extent of Three Indian Empires (300 BC–176 AD).

anyone into the Buddhist *sangha*, assembly, or monastic order, although he was uncomfortable with the idea of admitting women. His energy and charisma were unparalleled. He traveled widely, always on the move, spreading his teachings, and organizing *sanghas* of monks and nuns to help spread his philosophy, which were supported by the common people but also with donations from the wealthy. He urged his disciples to go out into the lands to proselytize that the rich and the poor were all one.

To a substantial degree, Buddhism and its competing worldviews provided a moral code and a spiritual basis for ordered society that eliminated the need for more complex political hierarchy. Indian society tended to rely on more intimate, localized forms of family and village organization. It relied on the moral systems of mainstream Hindu culture and various Shramanic strains, such as Jainism and Buddhism, to maintain social stability. Even kings found themselves accountable to the judgments of wandering holy men, and tribal

populations were encouraged by the same to develop assemblies and councils to hold kings to their promises. As we have noted, kings could not violate the traditional laws of their kingdoms. Prior to accession they had to obtain the approval of the tribal assembly, its councils, and its existing ministers of state.

CHRONOLOGY 6. THE DYNASTIES OF CLASSICAL INDIA	
324–300 BC	Chandragupta
324–184 BC	Mauyra Dynasty
273–236 BC	Ashoka
30–176 AD	Kushan Dynasty
78–101 AD	Kanishka
320–550 AD	Gupta Dynasty

POLITICAL DEVELOPMENTS IN THE CLASSICAL ERA (500 BC TO 300 AD)

At the same time that these philosophical and social transformations were underway, the process of state formation in both the Indus and the Ganges basins gradually reduced the number of tribal entities. The historical tradition points to heightened levels of violence during the Epic Era as local *rajahs* competed to consolidate territory. The Punjab region of the upper Indus Valley remained the seat of Vedic/Hindu learning and of ancient Vedic heritage. Polities along the Indus achieved urban status early in the Epic Era and by and large managed to retain local identity and autonomy. Since agricultural production in the arid Indus region could not be expanded beyond a certain threshold, and expansion southward was restricted by the Thar Desert, the natural direction for population growth trended eastward into the Ganges Valley. In the Ganges Valley incipient settlements extended in a chain-like pattern along the Himalayan foothills into southern Nepal and then southward along the banks of the Ganges. The challenges presented by land clearance, urban development, and communications in this region tended to favor the rise of more centralized authority. Three of the leading *Mahajanapadas* of the Epic Era (the Kosala, the Vatsa, and the Magadha) emerged in the Ganges basin, as did the large extra-territorial states of the Magadhas, the Mauryans, and the Guptas. The independence and deep-seated animosities that prevailed among polities in the Indus Valley, meanwhile, left that region exposed to repeated external invasion. The Persian emperor Darius I (522–486 BC) conquered the entire Indus Valley and, according to Herodotus, made it his most lucrative satrapy. The Persians were unable to sustain their authority in this distant region, however, and within a century conflict among the *rajahs* of the Punjab accelerated to new levels. A dispute between the kings Ombhi of Taxila and Puru of Purus enabled

the army of Alexander the Great to descend into the Punjab unopposed (328–326 BC). By the time of this invasion, meanwhile, the Magadha Empire had consolidated control along the Ganges: Dhana Nanda, its great emperor, allegedly commanded one million infantrymen, 300,000 cavalry, and 6,000 elephants. Although Alexander conquered the entire Indus Valley, his army refused to march against Dhana Nanda and instigated a mutiny on the Hyphasis River (an eastern tributary of the Indus) in 327 BC.

On his withdrawal Alexander left Macedonian officers and native client kings to govern satrapies along the upper Indus as well as in Afghanistan. But the shock of his invasion galvanized Indian resolve and led to the formation of "empires of reaction," or what is otherwise known as *secondary state formation*. In 324 BC Chandragupta seized power on the Ganges to establish the Mauryan Dynasty. He organized a massive empire throughout northern India and pushed his conquests as far as the borders of Iran. Although the details are lacking, he appears to have defeated the Hellenistic king Seleucus I during an attempt by the latter to reclaim the Indus sometime before 303 BC. In a subsequent treaty Seleucus was obliged to surrender to Chandragupta the former satrapies of Paropanisadai, Aria, Arachosia, and Gedrosia (all in modern-day Afghanistan). He also gave one of his daughters in marriage and dispatched one of his leading officers, Megasthenes, to serve as his representative to the Mauryan court in Pataliputra. Since Megasthenes was previously stationed at the satrapal headquarters in Arachosia, he was familiar with the region. In exchange, Seleucus I received 500 war elephants.

Under the influence of Kautiliya, Chandragupta organized the first genuine Indian organs of state. Megasthenes records the existence of a ministerial court or council at the capital city of Pataliputra, directing some 18 administrative departments. The military was organized according to a commissariat and six commissions (the boards of the navy, the infantry, the cavalry, the chariot corps, the elephant corps, and logistics). The city of Pataliputra itself was governed by a similar commission, and other officers were assigned to the duties of road maintenance and highway security, the management of irrigation works, and tax collection. Toll houses were established at city gates throughout the empire to obtain duties on imports and exports. Milestones were erected every two kilometers along the highways, and a great royal road was constructed from Pataliputra to the Iranian frontier. The foundations laid by Chandragupta and Kautiliya were expanded by his grandson, Ashoka (273–236 BC). As a viceroy serving his father Bindusara in the Indus region, Ashoka displayed early military prowess by successfully crushing rebellions at Taxila and Ujjain. In the thirteenth year of his reign he embarked on an extraordinarily violent campaign against the rival kingdom of Kalinga. During this campaign his army encountered unusually fierce resistance. According to Ashoka's own account, as many as 100,000 Kalingas died in combat, 150,000 others were enslaved, and an unknown number perished from famine, pestilence, and fortunes of war. Consumed by remorse, Ashoka turned for solace to Buddhist philosophy and grew increasingly devoted to its teachings during the course of his reign. Exploiting his unprecedented authority to full advantage, Ashoka began to promote the instruction, propagation, and enforcement of the ethical system of *dharma* (portrayed symbolically as the spoked wheel). In 249 BC he conducted a

The Maurya king Ashoka renounced violence and embraced the teachings of the Buddha following a bloody military conquest. To this end, Ashoka's legal code was inscribed on columns erected throughout the kingdom thereby marking the beginning of monumental art in India. An edict carved into a rock at Dhauli reflects the impact of Ashoka's conversion to Buddhism and his missionary fervor, spreading Buddhism far beyond his kingdom:

> The Beloved of the Gods [Ashoka], conqueror of the Kalingas, is moved to remorse now. For he has felt profound sorrow and regret because the conquest of a people previously unconquered involves slaughter, death, and deportation.... [King Ashoka] now thinks that even a person who wrongs him must be forgiven ... [and he] considers moral conquest [conquest by dharma] the most important conquest. He has achieved this moral conquest repeatedly both here and among the peoples living beyond the borders of his kingdom.... Even in countries which [King Ashoka's] envoys have not reached, people have heard about dharma and about [the king's] ordinances and instructions in dharma.... This edict on dharma has been inscribed so that my sons and great-grandsons who may come after me should not think new conquests worth achieving.... Let them consider moral conquest the only true conquest.[1]

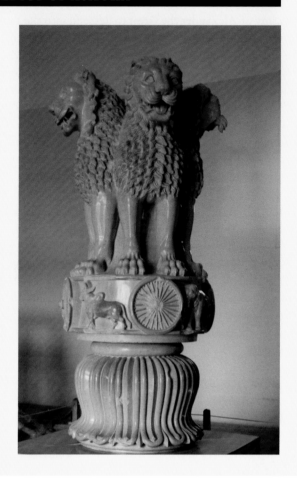

Figure 6.4 Lion capital of the column erected by Ashoka at Sarnath, India, ca. 250 BC. Polished sandstone, 2.14 m high. Archaeological Museum, Sarnath.

pilgrimage to all the most sacred Buddhist shrines in India. Ashoka erected inscribed stone pillars at each and every place. The texts on these and other pillars recorded measures he initiated for various ethical reforms. Several of his pillars record regulations concerning the slaughter and mutilation of animals, practices which he abhorred and punished with severity. Ultimately, Ashoka erected dozens of these monuments along the boundaries of his empire, more than 40 of which survive. Some 33 inscriptions, known as the **Edicts of Ashoka**, record laws and Buddhist teachings that were clearly written or inspired by Ashoka directly. To make them accessible to the general public, the texts were inscribed in the local dialects of the regions where they were erected (Karosthi to the north, Sanskrit along the Ganges, Prakrit to the south). These homilies represent the earliest surviving historical texts of India.

1 From Rock Edict XIII, in *The Edits of Ashoka*, trans. N.A. Nikam and Richard McKeon (Chicago: University of Chicago Press, 1959), 27–30.

The stupa represents the earliest surviving form of religious architecture in India. Derived from a funerary mount or heap ("stup"), the first stupa was built as a kind of reliquary to enshrine the cremated remains of the Buddha. As time passed, any holy relic associated with the religion—not to mention the remains of various Buddhist disciples—was buried under these structures. The monumental stupas can be understood as three-dimensional mandalas, or sacred diagrams of the universe; the hemispherical dome representing the world mountain. An integral component of Buddhist ritual was to walk clockwise around the stupa with one's right shoulder turned toward it as a mark of reverence. This process, called circumambulation, was intended to re-enact the rotational movement of celestial bodies. The Great Stupa at Sanchi, originally constructed in the first century BC, is the largest surving example of the stupa.

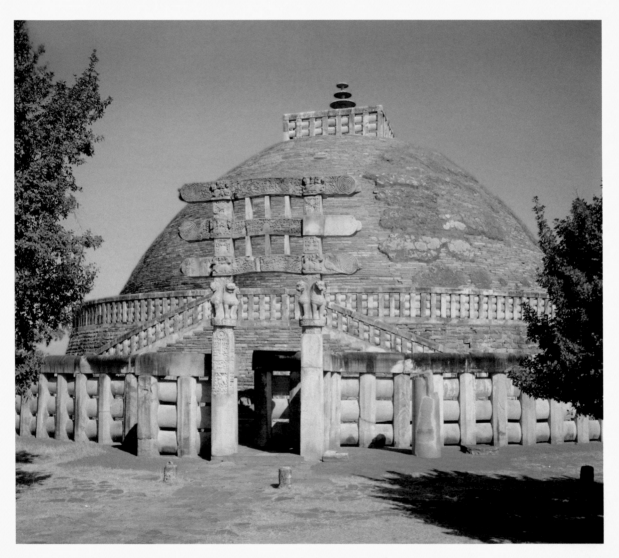

Figure 6.5 View from the south of the Great Stupa, Sanchi, India, third century BC to first century AD.

Ashoka likewise established several Buddhist monasteries and shrines, particularly dome-roofed reliquaries known as **stupas**. He erected more than a dozen of these at Taxila alone, though his most famous surviving example remains the Great Stupa at Sanchi. Ashoka demonstrated tolerance and support for communities of all Shramanic disciplines, not just Buddhism. Likewise, he ridiculed the ritualistic practices of the Brahmans and openly challenged the basic tenets of the caste system by treating people of all status with equal respect. Some have argued that he never formally became a Buddhist and merely exploited the teachings of this philosophy to display political and moral ascendancy over his highly diverse subject populations. However, the texts of his edicts, particularly those emphasizing nonviolence toward animals, appear to reveal a fervent interest in the philosophy. To spread its word and to enhance relations with neighboring societies, he dispatched embassies to distant monarchies in Sri Lanka (where he sent his brother, Mahendra, a Buddhist monk who helped to transplant Buddhism to that island), the Mediterranean (reportedly sending missions to each of the Macedonian successor kings), and China. Although the extent of his commitment to Buddhism and the motives of his altruism remain open to question, Ashoka appears to have used his power to modify patterns of behavior by institutionalizing the framework of ethical philosophy. His efforts reflect the first convincing attempt at centralized authority and cultural unification throughout India. As one scholar concludes, Ashoka "sought to combine the piety of the monk with the wisdom of the king."[2]

After Ashoka's death the empire plunged into chaos due to the infiltration of pastoral peoples to the north, particularly those of Iranian and Turkic-Hunnic tribes from Central Asia known as the **Kushan** (*Guishuang*, in Chinese). As noted earlier, the Kushan were nomads, referred to by Chinese sources as the Yuezhi or Yueh Chi, who originated from the Asian steppes beyond the Pamir Mountians. During their migration they incorporated strains of Indo-Iranian population to forge a pan–Central Asian hegemony that overturned existing polities as far removed as Iran. By the mid-first century BC, they invaded the northern basin of the Indus Valley. The end result was the arrival of yet another layer of nomadic peoples in the subcontinent, who unlike the Persians or the Macedonians before them came to stay. Eventually the king of one of the constituent Kushan tribes, Kujula Kadphises of Bactria (ca. 30–80 AD), was able forcibly to galvanize his rival warlords into a wider confederacy. His successors expanded their hegemony all the way to the Ganges, and from their capital at Purushapura (Peshawar in modern Pakistan) dominated central and southern Asia until 176 AD. Many of these newcomers likewise converted to Buddhism, particularly during the reign of their foremost king, Kanishka (78–101 AD). Like Ashoka, Kanishka founded a number of monasteries and stupas. He was even reputed to have convened councils of Buddhist monks to instill orthodoxy among divergent schools of the philosophy. One such significant dispute led to the schism of *Hinayana* and *Mahayana* Buddhism. The believers of the former recognized

2 From V.A. Smith, in *The Early History of India from 600 B.C. to the Muhammadan Conquest Including the Invasion of Alexander the Great*, 3rd edition, (Oxford: Clarendon, 1914), p. 190.

the Buddha alone as enlightened; those of the latter recognized the existence of later saints or *bodhisattvas*, and the potential in all believers to attain enlightenment through prayer, meditation, and the pursuit of the eightfold path. Kanishka's most striking military exploit was his assault on the caravan cities of the Tarim Basin, effectively retaking the region known to the Han Dynasty as the Western Protectorate. In this manner he gained control of the Silk Road and established trading networks that connected East Asia to the Roman Mediterranean world.

Because they controlled the passes through the Pamir Mountains and hence the Silk Road to China, the Kushan Dynasty also helped to disseminate Buddhism to East Asia, where it ultimately had a greater impact than it did in India. Buddhist colonies settled along the route to China in the Tarim Basin as well as in Tibet. From there the philosophy spread to China, Japan, and Southeast Asia. This marks the first example of the exportation of a significant worldview to neighboring civilizations. The collapse of the Kushan hegemony ca. 176 AD ushered in another century of decentralized confusion, followed by an era of stability under the Gupta Dynasty (320–550 AD). Like the earlier Magadha and Mauryan Dynasties, the Gupta Dynasty reestablished its capital in Pataliputra. Gupta rulers proved highly successful at organizing complex networks of alliances among local rajahs throughout India to maintain stability. Under their direction India attained unprecedented levels of prosperity and achieved a cultural renaissance through the revival of Sanskrit literature, mathematics, and science. Greek visitors claimed that the comforts furnished at Pataliputra surpassed those available at the Persian capitals of Susa or Ecbatana. Reliefs portray the bustling streets of Pataliputra lined by elegant buildings standing four stories tall. The Gupta emperors consolidated authority centrally and for the most part restored the Brahman-led Hindu establishment at the expense of Buddhist worshipers, sometimes violently. Even as Buddhism expanded in popularity in East Asia, its following waned in the Indian subcontinent. The Gupta Empire fell when overrun by the invasions of the (White) Huns, who entered the region in repeated waves between 455 and 480 AD.

INDIAN TRADE WITH ROME

Indians played a crucial role in the development of the ancient global world system, particularly the prominent maritime trading polities of south coastal India. Indian inhabitants generated cotton textiles, spices, pearls, and high quality steel, and traded these for goods from East Africa, the Persian Gulf, Southeast Asia (Thailand, Cambodia, Vietnam), and China. By the end of the second century BC at the latest, they were in commercial contact with the Mediterranean. Unquestionably, the most spectacular finds of Mediterranean trade with India arise from the excavations undertaken in 1941–50 and resumed in 1989–92 at Arikamedu near Pondicherry on the southeast Indian coast. Likely identified as the ancient port of Poduke, the site has revealed a Mediterranean

trading settlement of the late Hellenistic and early Roman eras. Significant finds of Hellenistic Greek transport amphoras indicate that the foreign trading presence at Arikamedu began around the mid-second century BC, at about the time that the Ptolemies discovered the importance of the monsoon winds of the Arabian Sea for outward voyages to India. Large quantities of Roman pottery, beads, intaglios, lamps, glass, and coins point to a continuous occupation by merchants of Mediterranean origin as well as to a healthy appetite for Mediterranean finished goods among Tamil inhabitants. The bulk of the excavated materials—transport amphoras weighing as much as 50 kilograms when filled and sealed, and large quantities of relatively heavy finewares— are the kinds of goods most frequently characterized as Mediterranean staple goods, not luxuries. Only a sea-going commerce of significant scale and sustained duration can explain such finds.

The remains of Roman artifacts at Arikamedu conform with and bring clarity to the archaeological evidence of south India generally. The barren terrain of the southern end of the peninsula and limited agricultural technology prohibited the development of large agrarian-based polities such as those of the great river valleys to the north. Instead, the Tamil *rajahs* who controlled the southern principalities of the peninsula exploited their maritime locations as settings for the development of long-distance trade. In his *Natural Histories* (6.101) Pliny reports that 120 cargo ships sailed annually from Egypt to India, and that the Roman Empire endured a significant drainage of its currency in a relentless effort to acquire exotic goods from the latter region: "In no year does India absorb less than fifty million sesterces [perhaps $1.5 billion] of our empire's wealth, sending back merchandise to be sold with us at a hundred times its original cost."[3] Pliny's comments remain highly controversial. Although more than 5,000 Roman silver denarii have been found in southern India, the amphora data from Arikamedu would seem to indicate that the true basis of Roman maritime trade with India lay with other commodities. The weight and size of exports, such as amphoras laden with wine and oil, ceramic finewares, glass wares, and finished metal wares, all but required that they be transported in large cargo vessels by sea.

Evidence for maritime commerce between India and China remains less substantial during the Classical Era. Documentation is scarce and largely dependent on anecdotal accounts of journeys to Central Asia and India by Chinese emissaries of the Han Dynasty or by Buddhist monks seeking manuscripts for Chinese monasteries. By and large, when journeying to south Central Asia Chinese travelers pursued the overland route through Central Asia at least until the fifth century AD. Only then do consistent reports of maritime voyages to and from China begin to occur. Although the more difficult northerly route of the Silk Road across the steppes of Central Asia remained the principal trading route to China, the bulk of the traffic between the Mediterranean and India would appear to have traveled by sea. Its volume and significance will be discussed in the final chapter of this book.

3 *Pliny Natural History in Ten Volumes*, trans. H. Rackham (Cambridge, MA: Harvard University Press; London: W. Heinemann, 1947, reprinted 1967), Vol. 2, p. 417.

OTHER ACCOMPLISHMENTS OF INDIAN CULTURE

Apart from religion and spirituality, classical Indian civilization accomplished a number of scientific breakthroughs. Indian scholars excelled in medicine, mathematics, and astronomy. They invented the number 0 and the 10-based number system. Arabic numbers, acquired by Europeans from Arabs, ultimately originated in India. Indian mathematicians also developed negative numbers, calculated square roots, the table of sines, and computed the value of *pi* more accurately than the Greeks. The great astronomer Aryabhata (476–550 AD) made significant advances in mathematics, algebra, trigonometry, and astronomy. He correctly insisted that the earth rotates about its axis daily, and that the apparent movement of the stars is a relative motion caused by the rotation of the earth. He also accurately calculated the length of the day (his estimate was 23 hours, 56 minutes, and 4.1 seconds; the modern estimate is 23:56:4.091) and the solar year (his estimate of 365 days, 6 hours, 12 minutes, and 30 seconds was off by less than 4 minutes). His trigonometric tables (Aryabhata is credited with determining the values of *sine* and *cosine*) and astronomical calculations profoundly influenced Islamic scientists during the Middle Ages. His calendric calculations continue in use with the Hindu religious calendar, and with the modern national calendars of Iran and Afghanistan. Another Indian scientist, Varahamihira (sixth century AD), wrote the encyclopedic *Brihat-Samhita*, or the "great compilation." This work in 106 chapters covered a wide range of subjects, including astrology, planetary movements, eclipses, rainfall, clouds, architecture, crop production, and numerous other topics. Read and copied by medieval Iranian scholars, Varahamihira's summaries of Greek, Egyptian, and Roman astronomical literature enabled elements of ancient learning to survive to modern times.

FURTHER READING

Craven, Roy C. *Indian Art: A Concise History*. Rev. ed. New York: Thames and Hudson, 1997.

Fisher, Robert E. *Buddhist Art and Architecture*. New York: Thames and Hudson, 1993.

Kleiner, Fred S. *Gardner's Art through the Ages: A Global History*. 13th ed. Boston: Cengage, 2011.

Kosambi, D.D. *Ancient India: A History of Its Culture and Civilization*. New York: Pantheon, 1965.

Mahajan, Vidya Dhar. *Ancient India*. New Delhi: Chand, 1983.

Manquin, Pierre-Yves, A. Mani, and Geoff Wade, eds. *Early Interaction between South and Southwest Asia: Reflections on Cross-Cultural Exchange*. Singapore: Institute of Southeast Asian Studies, 2011.

Possehl, Gregory R. *Harappan Civilization: A Contemporary Perspective*. Warminster, UK: Aris & Phillips, 1982.

Rapson, E.J., et al. *The Cambridge History of India*. 5 vols. Cambridge: Cambridge University Press, 1922–1937.

Ray, Himanshu P. *The Winds of Change: Buddhism and the Maritime Links of Early South Asia*. New Dehli: Oxford University Press, 1994.

Tomber, Roberta. *Indo-Roman Trade: From Pots to Pepper*. London: Duckworth, 2008.

Young, G.K. *Rome's Eastern Trade: International Commerce and Imperial Policy, 31 BC–AD 305*. London: Routledge, 2001.

SEVEN

CLASSICAL GREEK CIVILIZATION
(1000–27 BC)

WHAT HAVE WE LEARNED?

► That the broad range of ecological diversity in the Indian subcontinent posed a significant challenge to the formation of urban societies. Land clearance was the single greatest challenge to settlement in the Ganges basin.

► That Indus Valley riverine culture began by 3000–2500 BC. Societal collapse occurred here at the same time as that in the Early Bronze Age Near East (ca. 1900 BC).

► That Indo-Iranian invaders brought with them a Vedic oral tradition that was eventually preserved in Sanskrit, which evolved into the sacred literature of the Vedic Era (1200–1000 BC).

► That the Indo-Iranian newcomers had extreme difficulty assimilating to native culture as well as to the racially different (Dravidian) inhabitants. During the Epic Era (1000–600 BC), they organized a strictly ordered caste system of social hierarchy.

► That Hindu belief in the transmigration of the soul found its earliest record in the *Upanishads* or hymns of the Epic Era.

► That the prevailing levels of violence during the Epic Era induced the rise of Shramanic philosophical movements such as Jainism and Buddhism.

► That local autonomy and deep seated animosities left Indus Valley polities exposed to repeated external invasion. External invasions invariably proceeded from land routes that descended from the Afghan plateau.

► That by the first century BC India came to play an intermediary role in the development of an ancient global world system.

One thing that becomes evident from the history of India is the degree to which its culture was affected by external influences. A seemingly steady stream of foreigners invaded, governed, or otherwise came to study, pray, or trade in the polities of this land, making it a crucial lynchpin in the emerging Eurasian world system. The invasion by Alexander the Great in 327 BC, the recorded history of Megasthenes, and presence of Aegean amphoras identified at Arikamedu demonstrate the sustained role of Greek actors, some visible, most invisible, in this development. Before examining connections to East Asia, therefore, we need to return to events in the Aegean region following the social and political fragmentation and population decline during the Dark Age (1100–800 BC). Iron Age developments were more carefully recorded here than anywhere else in the ancient world, furnishing the earliest sustained narrative of its kind. Limited natural resources in the Aegean region induced regular out-migration among its inhabitants, while at the same time the permanence and success of its recursive institutions (the gymnastic educational system) produced generation after generation of talented Greek professionals, many of whom offered their services to foreign elites. Greek doctors, philosophers, historians, scientists, financiers, diplomats, warriors, and traders traveled extensively across the Ancient Near East and India, sometimes furnishing our best preserved records of these societies. Our repeated reliance on the Greek historian Herodotus (ca. 484 BC–ca. 425 BC) to describe societies as varied as Babylonia, Persia, Scythia, and Egypt serves as a case in point. Greek proximity to cultures east and west, an innate curiosity for things exotic, a facility with languages, and a seemingly effortless ability to assimilate foreign culture enabled this population to impose a pervasive cultural ingredient to the wider world system. Nearly every aspect of ancient world culture gets evaluated by scholars through a comparison with or according to its quotient of *Hellenism* or "Greekness." Ancient Mediterranean culture of the Roman era is generally referred to as Greco-Roman, and Ancient Near Eastern and even Indian art and architecture have been minutely evaluated according to their strands of Hellenic attributes. The degree to which Greek cultural attributes and institutions became recognized as norms for urban society is all the more remarkable given the relative smallness of

CHRONOLOGY 7. PERIODIZATION OF ANCIENT GREECE	
ca. 2000–1100 BC	Bronze Age
1100–800 BC	Dark Age
800–500 BC	Archaic Era
500–323 BC	Classical Era
323–27 BC	Hellenistic Era
IMPORTANT DATES	
499–478 BC	Persian Wars
431–404 BC	Peloponnesian War
336–323 BC	Reign of Alexander the Great

the Aegean as a place or a population. In this chapter we will investigate the contribution of Greek society to the ancient world system by proceeding through a number of topics. The wealth of available information allows for a more detailed investigation of several of the central themes in this textbook.

POLITICAL AND CULTURAL DEVELOPMENTS IN WIDER GREECE

Following the collapse of Mycenaean urban society at the end of the Bronze Age, our knowledge of political and social transformations in the Aegean becomes hindered by a lack of literary records. Considerable scholarly debate exists concerning the precise nature of regional developments during the Greek Dark Age (ca. 1100–800 BC). By the eighth century BC the reacquisition of literacy, borrowed from the Phoenicians, allowed for a resumption of Aegean record-keeping.

Regardless of the origins of the base population, similarities in dialect and cultural attributes do indicate a pattern of small-scale, gradual migration from the Greek mainland across the Aegean to central and south coastal Anatolia during the Dark Age. Evidence survives of traditions of refugee migrations from Greek mainland centers of Mycenaean

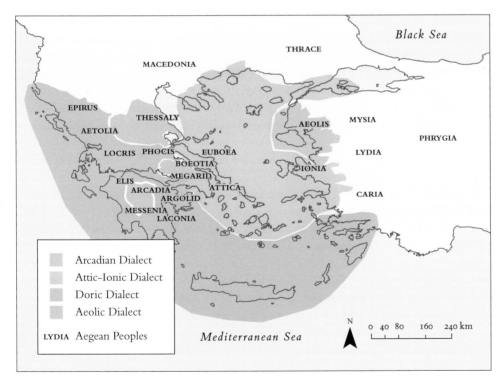

Map 9 Archaic Aegean Dialects.

civilization to new settlements overseas. Mycenaean populations dispersed across the Aegean, settled into self-sufficient rural communities in their new locales, and gradually expanded their populations. Of course, it is equally possible that these developments had their inception with Mycenaean cultural expansion during the Late Bronze Age and that they simply reestablished themselves once stability was achieved. Either way, it is important to recognize that until very recent times Greece and the Aegean were synonymous. Greek settlement existed all along the shores of the Aegean Sea, with no Greek settlement more than 80 km from the sea. Most settlements, new and old, remained isolated by the rugged topography of the Greek mainland (85 per cent of the Greek mainland is mountainous, and less that 15 per cent can sustain agriculture). Like the Phoenicians, the Greeks were a *liminal* people (dwelling along coasts) who depended on the sea for communication and food supplies. It is important to recognize that ancient Greece was neither a country nor a territory, but rather an assemblage of more than 300 **poleis**, or separate autonomous Greek city-states scattered along the shores of the Aegean and beyond. Because so many celebrated writers lived in Athens, the historical record of ancient Greece tends to exhibit an Atheno-centric point of view. The reality, of course, was that each and every separate Greek polis had its own historical tradition and its own unique perspective on wider developments.

Ecologically two additional points about the Aegean environment are noteworthy. For one thing, the limited carrying capacity of the Aegean landscape inevitably resulted in excess population growth with each historical phase of political and social development. Particularly in mainland Greece and the islands (which are all essentially a continuation of the Balkan massif) settlements gradually surpassed subsistence levels of production to induce an out-migration of excess population. For another, given the rocky terrain of the Aegean, local grain production was frequently inadequate to sustain the population. Together with wheat, olives and grapes formed the triad of Aegean (and wider Mediterranean) agricultural production, particularly when transformed into olive oil and wine. The multifunctional properties of olive oil made it indispensable to all Mediterranean societies, with the result that its production appears never to have equaled regional demand. Like olive oil, Aegean wines became celebrated both domestically and internationally; unlike olive oil, wine was consumed chiefly as a beverage with the result that any large scale production (viticulture) was by necessity intended for export purposes. The heavy daily consumption of wine in antiquity is sometimes lost on North American students. One needs to bear in mind the uncertain safety of the water supply and the fact that wine offered an optimal, uncontaminated substitute. Fish, meat, cheese, fruit, and vegetables were also readily produced and consumed in the Aegean, but these products possessed limited shelf life and were typically consumed locally, if not seasonally. From a commercial standpoint, therefore, the main contribution of Aegean populations to the wider Mediterranean economy was the export of wine and oil.

The twin dynamics of Greek historical development are expressed by the two terms **Particularism** and **Panhellenism**. Particularism embodies the notion of identity with one's immediate community, usually delineated by its mountainous topography. Separated

The collapse of the Bronze Age social order led to the ruin of great Mycenaean palaces such as Mycenae. As powerful kings and their courts began to crumble, knowledge of construction, masonry techniques, sculpture, and painting likewise disappeared. What resulted is the so-called Dark Age of Greece, a period characterized by poverty, overpopulation, and cultural isolation. As a result, art became largely nonfigural in the centuries that followed. By the eighth century, economic conditions began to improve, the population increased, and depictions of the human figure returned. During this period, the oldest known Greek style of art developed, known today as the *Geometric*.

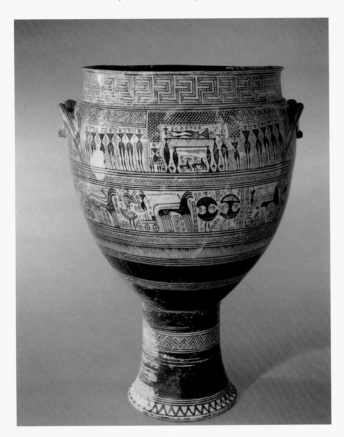

Figure 7.1 Geometric krater, from the Diplyon cemetery, Athens, Greece, ca. 740 BC. 108.3 cm high; diameter 72.4 cm. Metropolitan Museum of Art, New York.

The depiction of the human figure in monumental statuary was still quite rare at this time and, more often than not, the human figure was depicted in small bronze figurines or painted on ceramic vessels. A huge **krater** (a large bowl-like vase used to mix wine and water) that marked the grave of a man buried around 740 BC in the Diplyon cemetery of Athens is one of the earliest examples of Greek figure painting from the Geometric period. Much of the krater's surface is covered in horizontal bands containing carefully painted abstract motifs, including the **meander** (or key) pattern that decorates the rim. The widest part of the vase contains two bands of human figures and horse-drawn chariots—scenes depicting mourning for the deceased and a procession in his honor. The figures, animals, and furniture appear two-dimensional in the absence of shading.

It is important to note that not only is the imagery directly relating to the krater's function as a grave marker, the art is telling a story. Occasions for displaying imagery, as depicted on the Diplyon Krater, centered on the rituals surrounding birth, maturation, marriage, and death—with a deliberate emphasis on the establishment of social order at the household level. Group or community values were affirmed and encoded in the material culture of ancient Greece nuanced by figural representation. Figural art implies a message and social intent; here, some scholars suggest, is where Geometric art finds its value and meaning.

from neighboring communities by intervening ridge lines and the shore of the Aegean Sea, it was easy for inhabitants of a Greek polity to believe that nothing of consequence happened beyond the horizon of their immediate settlement. This sense of contentment finds expression in the relaxed, sometimes playful representations of local aristocrats in Greek plastic arts. Panhellenism, however, expresses those tendencies that induced Greek communities to recognize their place in wider Greek culture. Early Panhellenic

influences included the religious sanctuaries at Olympia, Delphi, Nemea, and Isthmia, which were important destinations for religious pilgrimages. Each of these sanctuaries hosted an international festival every four years, meaning that at least one Panhellenic festival, incorporating cultural as well as athletic competitions, occurred somewhere on the Greek mainland every year. The local hierarchy that ran the Olympic Games first recorded the names of the victors of their athletic competitions in 776 BC, the earliest surviving annalistic record of Greek society. It is interesting to note that most of the recorded victors at Olympia originated from Greek settlements in Italy and Sicily, not mainland Greece. Since visitors from beyond Greece regularly traveled to these sanctuaries, local administrators gained intelligence about the outside world that transcended that of everyday habitants. As the reputation of sanctuaries such as Delphi grew, they received emissaries from as far away as Lydia, Persia, and Egypt. Accordingly, Panhellenic sanctuaries played an important role in nurturing a common sense of identity among Aegean populations.

By the time that Greek society acquired literacy, proto–city-states existed in tribally based communities in which social structure was organized according to the priorities of aristocratic clan-based hierarchies. For governance, Greek oligarchic states relied on colleges or boards of annually elected magistrates. In Athens there were nine annually elected **archons**, with a preserved list of archons dating back to 684 BC. Next came a council of elders (in Athens the Areopagos) that typically consisted of all ex-magistrates who entered the council for life at the expiration of their year in office. Elections were conducted by an assembly of warriors (in Athens the Ekklesia) that consisted of all freeborn, property-holding male citizens able to bear arms (that is, those who were able to furnish a panoply of armor at their own expense). Issues of public concern tended to be restricted to two spheres: the common defense and the reduction of blood feuds that were commonplace among clans. Political identity remained firmly rooted in the clan-based *oikos* settlements in the countryside. An **oikos** was a large self-sufficient agricultural state that formed the basis of aristocratic wealth. By and large, power remained invested in the membership of the council of elders, since the council functioned as the repository of all political, military, financial, and judicial experience of the community.

In any Greek community cultural identity revolved around participation in the **polis**, another fundamental building block of Greek terminology (*politics*, *politician*). Topographically, a Greek polis exhibited the following characteristic features:

- ► **An acropolis**. The acropolis was the defensive heights of the city, not necessarily the tallest mountain in the vicinity, but rather the one most accessible.
- ► **An agora**. The agora served as a combined town square, meeting place, and market place, a central node where rural inhabitants could convene to learn about and to deliberate on current affairs.
- ► **A limen**. The limen was the municipal harbor; like the agora it was supervised by annually elected magistrates. Most Greek city-states existed within close proximity to the Aegean shore and relied on their harbors for communication with the outside world.

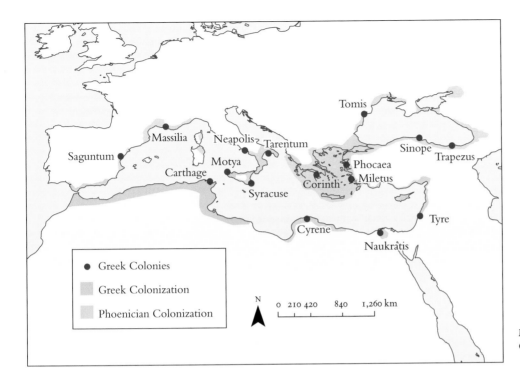

Map 10 Greek (and Phoenician) Colonization.

By the end of the Dark Age (800–750 BC), excess population posed a significant challenge to most archaic Greek communities. Put simply, subsistence food production failed to keep pace with the accelerating needs of local populations. Two basic strategies emerged to confront this problem: a community could fight for more land by expropriating neighboring territory (hence, increased warfare), or it could export excess population to distant undeveloped regions through colonization. These parallel solutions to Greek land hunger led the way to a transformative social and political institution known as *Greek tyranny*.

GREEK COLONIZATION

Between 800 and 500 BC, many Greek communities exported excess population by creating overseas colonies. Much like Phoenician colonization the locations of these settlements were largely determined by their proximity to resources in demand at the mother city, typically grain and metals. Unlike the Phoenicians, however, Greek colonizing enterprises were principally organized for the purpose of transplanting excess agricultural laborers overseas. Eventually Greek migrants colonized overseas regions ranging from the remote corners of the Black Sea to southern Italy, eastern Sicily, Sardinia, Gaul (Massilia, modern-day Marseille), and Spain. By 600 BC, it was possible for goods to move from Spain to the Black Sea entirely by means of Greek transport. At the same time, contact with native peoples tended to inspire in Greek-speaking travelers a greater appreciation of their own cultural identity.

The first life-size stone statues appear in Greece around 600 BC. Statues from this period, known as the Archaic, are characterized by frontal poses adopted from Egyptian statuary. A marked departure from the Egyptian prototype, Greek statues depict young men nude to reflect the way athletes competed at Olympia. One of the earliest examples of Archaic statuary is the marble Greek ***kouros*** (or "youth"; plural, kouroi) figure at the Metropolitan Museum of Art in New York. Although freed from its original block of stone (emphasizing the Greek preoccupation with representing movement), the New York kouros maintains the rigid frontal pose typical of Egyptian statuary, with his left foot slightly advanced, arms held parallel to the body, fists tightly clenched. The body and its generic features—including the eyes and hair—are highly geometric and stylized, linking the figure with artistic precedents found in the Geometric period. Archaic kouroi begin to replace the use of huge Geometric vases (like the Dipylon Krater) as grave markers and were also used as votive offerings in sanctuaries. Thus, both Greek kouroi and ancient Egyptian statues served religious purposes.

Over the course of the sixth century BC, Greek sculptors would exhibit a greater interest in naturalism, evident by the continual refinement of proportions and rounded forms. For example, in the Anavysos kouros the face, torso, hips, and limbs appear less stylized, more proportional, and lifelike. The rendering of the muscle tone in the torso and the rounded, suppleness of the hips (as opposed to the V-shaped ridges evident in the New York kouros) contribute to this sense of naturalism. Also present with the Anavysos kouros is the so-called Archaic smile, a defining characteristic of that period that evokes the life and vitality of the person being portrayed.

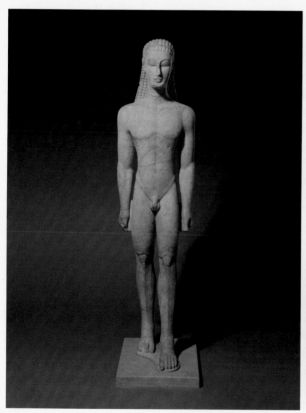

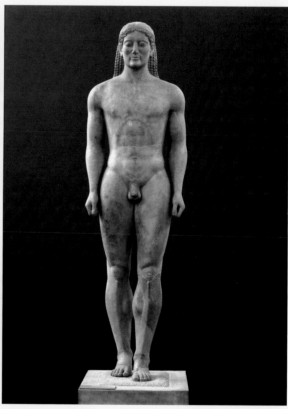

Figure 7.2 Kouros, ca. 600 BC. Marble. Height without plinth, 194.6 cm; height of head, 30.5 cm; length of face, 22.6 cm; shoulder width, 51.6 cm. Metropolitan Museum of Art, New York.

Figure 7.3 Kroisos Kouros, from Anavysos, Greece, ca. 530 BC. Marble, 1.9 m high. National Archaeological Museum, Athens.

Naturally, the transition from isolated subsistence economies to commercially engaged ones generated unanticipated consequences. One was the emergence of wealthy social elements, notably nonnative artisans and traders, who lacked commensurate political rights. Nonnatives settled in Greek city-states as *metoikoi* (literally, dwellers around the oikos), **metics**, or resident aliens. The other problem was that, much like the citizenry of Israel, the least advantaged inhabitants of Greek rural communities, ordinary subsistence farmers, failed to adapt as readily to specialized forms of surplus agricultural production. These inhabitants, in many instances full citizens, fell behind economically, even to the extent of indebted servitude. If allowed to continue, this trend, regardless of its true magnitude, had the potential to undermine the stability of the wider community.

INCREASED WARFARE

Greek land hunger also encouraged the rise of the **hoplite phalanx**, a large formation of heavily armored infantry. Participation and place in the phalanx was determined by one's possession of the necessary weaponry. Those who could afford full panoplies of armor stood in the front ranks and assumed higher status as heroes and military leaders. The mass propulsion of large formations of warriors became crucial to the outcome of all Greek battlefield engagements. As opposed to military establishments in other ancient societies, the use of heavy armor required that Greek warriors pursue rigorous training regimens to build the necessary body strength to engage in armored combat. Training occurred in an enclosed complex known as the **gymnasium**, eventually furnishing the setting for Hellenic schools. Military conflicts now had the capacity to determine territorial claims and even the survival of warring communities.

The hoplite phalanx has long been perceived as a leveling force, or democratizing influence on the Greek city-state. Manpower requirements were increasingly furnished by any and all male inhabitants who possessed their own armor, including wealthy artisans, traders, and small farmers. However, metics were increasingly frustrated by their lack of commensurate political rights, and small farmers were reportedly selling their armor to evade debt servitude. Within individual Greek city-states economic and social pressures ran directly contrary to the growing impetus of military security. In many instances opportunistic aristocrats who recognized the emerging importance and political potential of the national militia seized this opportunity to acquire power. By advocating for popular reforms, they used the weight of the emerging militia to establish themselves as tyrants.

The **Greek tyrant** was a nonhereditary ruler who acquired power through unconstitutional means, usually with widespread popular support—most typically the support of the hoplite phalanx. Tyranny was a frequent outcome of the common impetus toward colonization and increased warfare. Greek tyrants tended to address the economic and social problems of their communities by encouraging urban development, for example, by funding public works projects, by encouraging displaced rural farmers to relocate as

wage laborers in the emerging cities or to newly founded colonies, and by promoting the status of wealthy resident alien traders and artisans. Tyrants essentially "jump-started" their societies by converting them from dispersed, decentralized subsistence agricultural villages to outward-looking commercially active cities. They stayed in power only so long as they succeeded at delivering on promises made to their nonaristocratic supporters. Once their supporters turned against them, tyrannies inevitably collapsed. No tyranny survived beyond three generations. Some 17 states are known to have experienced tyranny, most particularly Athens. Others, such as Sparta, resisted the trend toward tyranny by expanding the ranks of their oligarchies. Since the socio-political experiences of Athens and Sparta are comparably well recorded, their histories may be taken as illustrative of these contrasting developments.

THE SPARTAN HOPLITE CASTE SOCIETY

Sparta existed as a settlement of four villages bordering the Eurotas River in the plain of Laconia or *Lacedaemonia*. It was protected on both sides by towering mountain ranges, particularly the Taygetos Range that separated Laconia from the neighboring plain of Messenia. Its early constitution to some degree resembled those of other archaic Greek states. There were two kings, each with the power to cancel the actions of the other. There was also a **gerousia**, literally, the council of elders, and an **apella**, or assembly of warriors. Evidence of accelerating local conflicts indicates as well that Sparta pursued a deliberate policy of expropriating land from its neighbors, particularly the neighboring Messenians. The Spartan warrior elite, the *Spartiatai*, successfully conquered the neighboring inhabitants of the Eurotas Valley and subordinated them to the status of ***perioikoi***, or the dwellers around the *oikoi*. These people preserved their autonomy but remained politically subordinate to the Spartans. Other elements captured in warfare were reduced to the level of field laborers, called **helots**, who farmed Spartan farmland for the warrior elite. Though Greek in origin, helots were essentially agricultural serfs, in that they could not be displaced from their lands nor sold into slavery. The largest concentration of helots could be found in the neighboring Greek region of Messenia, conquered and garrisoned by the Spartans in the eighth century BC. Repeated helot revolts in Messenia prompted a cry for political change.

CHANGES TO THE SPARTAN CONSTITUTION AND SOCIETY

Confronted by the threat of tyranny, the Spartans chose to expand the ranks of their oligarchy by co-opting all full-blooded Spartans. While the two kings persisted as military commanders-in-chief and religious heads of state, five annually elected magistrates, the

ephors, emerged as domestic administrative officials. The ephors were entrusted with the maintenance of the Spartan military establishment. According to tradition, the Spartans redistributed the land to level rich and poor, creating uniformity and equality among the warrior elite, referred to as the *homoioi*, or the equals. Suppression of rebel Messenians in the mountain fastness of Mount Ithome (ca. 650 BC) probably required many years of campaigning and the installment of a permanent garrison force. In essence, Sparta evolved into a totalitarian society in which all land and all souls were committed to the maintenance of a Spartan hoplite aristocracy. Even the purpose of its educational system was to generate perfect specimens as warriors.

The ephors' primary responsibility was the maintenance of the Spartan military caste, a hierarchical social order based on the institutions of the *kleros* and the *phiditia*. The **kleros** was a Spartan land allotment. Each allotment included attached helot families who did the actual farming to sustain the family of the Spartan warrior and themselves. The **phiditia** was the Spartan mess hall and barracks, representing 20 to 30 hoplites, or a detachment (*ila*) of the phalanx. Obtaining these privileges required a rigorous military training. To be a Spartan warrior required Spartan lineage on both sides of one's family. At age seven the youth entered the Spartan cadet corps where he would spend his next 13 years developing his skills as a Spartan warrior. Cadets trained for hours and learned to execute complex military maneuvers in rapid order. At the age of 20 the Spartan warrior was allowed to marry a bride selected for him by the ephors. At this time the warriors would also receive a *kleros*, but he continued to reside and work at the *phiditia* for another 10 years. At the age of 30, a warrior was allowed at last to live at the *kleros* with his family and to vote in the Apella, but he continued to eat his main meal at the *phiditia*. In essence, the *phiditia* was the key to building discipline and camaraderie among the Spartan warrior elite. State supervision rendered it the foundation of the national militia. Spartan soldiers remained eligible for military service until the age of 60, at which point they could retire and/or seek election into the Gerousia.

The implementation of this social system resulted in the development of a professional army, the greatest hoplite phalanx in Greece. Spartan soldiers demonstrated tremendous skill and stamina in battle. With an estimated force unit of 6,000 hoplites and 300 to 400 cavalry, the Spartan hoplite phalanx was not particularly large. However, their discipline and determination on the battlefield rendered them invincible. Expanding conquests led to the formation of a Spartan hegemonial alliance known as the **Peloponnesian League** or the Lacedaimonians and their allies. The Peloponnesian League became a permanent defensive alliance under Spartan leadership. By 500 BC nearly every state in the Peloponnesus, including the large commercial city of Corinth, had forcibly or otherwise joined the league. At the Battle of Plataea during the Persian wars in 479 BC, reportedly some 80,000 Greek hoplites opposed the Persian invaders, with three-fourths of this army represented by the Peloponnesian League.

Achieved through great sacrifice on the part of its citizens and its laboring population, the Spartan war machine emerged as the dominant land force in the Greek Aegean. Since the entire social system was sustained by a helot-based field economy that required constant

monitoring, the Spartan hierarchy could ill afford to dispatch its forces to distant theaters for extended periods of time. Another problem resulted from the closed character of the Spartan hoplite aristocracy. To be a Spartan warrior required Spartan lineage on both sides of one's family. Legitimate marriages were thus restricted to a limited number of families that probably totaled no more than a few dozen. The impact of continuous inbreeding, of high rates of infant mortality, and of the inevitable loss of manpower on the battlefield culminated in declining numbers of Spartan males eligible for service. Spartan land holdings fell gradually into the hands of fewer and fewer families. Unwilling to open their ranks to non-Spartans such as the *perioikoi* or Spartans of mixed heritage, the Spartan establishment never found a solution to its dwindling numbers of warriors.

POLITICAL TRANSFORMATION IN ATHENS: FROM TYRANNY TO RADICAL DEMOCRACY (621–429 BC)

Athens came late to the problem of land hunger and tyranny, probably because its ethnic territory, Attica, possessed greater carrying capacity and was able to sustain a larger subsistence population than most regions of Greece. When it did arrive at the tipping point, the community endured repeated instances of internal meddling by outside powers, including neighboring tyrants and the kings of Sparta and Persia. Political development in Athens was greatly influenced by public reaction to such perceived threats. Unlike Sparta, Athens underwent the tyrannical experience and emerged by 500 BC as the leading commercially oriented city-state in the Aegean. Four principal phases of political development warrant mention: the social reforms of Solon (ca. 573/72 BC), the tyranny of Peisistratus (546–527 BC), the political reforms of Cleisthenes (510–ca. 500), and the democratic leadership of Pericles (ca. 465–429 BC).

At its earliest recognition, Athens was dominated by a cluster of aristocratic families, such as the Alcmeonidae and the Philaidae. With the emergence in the seventh century BC of an element of indentured citizenry known as the *hektemoroi*, impoverished agricultural conditions threatened stability and challenged the supremacy of the aristocracy. To resolve the growing debt crisis and to appease those favoring tyranny, Solon (638–558 BC) was appointed *lawgiver* and was assigned wide-reaching powers in ca. 573/72 BC. According to his own lyric poetry, Solon engaged in debt reform, but he refused to redistribute land (as in Sparta) and did his utmost to avoid the emergence of tyranny, an option opposed by aristocrats generally. Since he lacked the resources necessary to stimulate genuine economic improvement, his reforms merely delayed rather than deterred its rise. A decade after his reforms one of Solon's own relatives, Peisistratus, openly pursued tyranny in Athens. Peisistratus's first attempt to seize power in 561/60 BC ended in failure, resulting in his exile, but he returned to Athens to establish his tyranny through force in 546 BC.

THE PEISISTRATID TYRANNY (546–510 BC)

Peisistratus's main objective appears to have been to render farming sustainable at the hoplite level by restoring the largest possible segment of the population to the land. He did this in part by redistributing land that he confiscated from aristocratic opponents. He also imposed a 5 per cent income tax on all citizens and used this revenue to secure loans for farmers. This enabled many small farmers to make the transition from subsistence to surplus agricultural production. He used similar tactics to undermine aristocratic authority at the local level. He instituted a body of circuit court judges who journeyed about the countryside to hear local grievances on appeal; he also forced the relocation of several prominent religious cults to Athens, thereby, awarding them national focus. Composers developed a technique for advancing individual singers from the chorus to recite poetic soliloquies and dialogues. This marked the beginning of Athenian dramatic performances and the birth of Greek tragedy and comedy.

In other respects Peisistratus worked to transform Athens from its subsistence origins to newfound status as an Aegean maritime power. He utilized relationships with fellow tyrants and kings at Naxos, Samos, Argos, Thessaly, and Macedonia to improve the city's commercial footing in the wider Aegean. He further enhanced trade by establishing colonial settlements at Sigeon and the Chersonessos on the Hellespont, the gateway to the grain trade in the Black Sea. Domestically, he implemented a number of measures to foster the rise of the Athenian polis. For example, he undertook public building enterprises paid for by his own silver revenues. In this manner he created wage laboring opportunities for the *thetes*, or landless poor citizens of Athens. Displaced agricultural laborers quickly migrated from the countryside to the urban center of Athens to seek new opportunities for employment. In Athens he constructed a number of public monuments such as the Temple of Olympian Zeus, and the Temple of Athena (the so-called Hekatompedon). His efforts helped to advance Athenian reputation in crafts production, by encouraging the settlement of skilled foreigners as metics. During his tyranny, a highly polished ceramic fineware, known as Attic Red Figure, came into being and quickly attained international reputation and Mediterranean-wide demand. Peisistratus also invented the Attic *tetradrachma*, or four drachma coin. Equaling roughly 12 grams of silver, the consistent weight and purity of this coin secured its place as the most common medium of international exchange in the Classical period.

Peisistratus converted Athens into a prosperous urban community of perhaps 100,000 inhabitants known internationally for its crafts production, its building enterprises, and its agricultural exports. The city promptly assumed preeminence as a trading power in the Aegean world. Its harbor in the Piraeus attracted merchants and sailors from throughout the eastern Mediterranean. Economic progress was possibly slowed by the conquest of Thrace and Macedonia by King Darius I of Persia in 514 BC, which may have separated Peisistratus's successors, Hippias and Hipparchus, from the proceeds of their silver mines in the north. When the Peisistratids could no longer fund public works programs, the Athenian public lost its enthusiasm for the regime. An aristocratic conspiracy successfully

attempted the assassination of Hipparchus, provoking a violent political purge by his brother Hippias. This only served to accelerate popular distaste for the tyranny. Driven from Athens by an array of political factions, Hippias fled to the palace of the Persian satrap at Sardis (Lydia) where he was welcomed as an exile and maintained as a tool for future use.

Despite the expulsion of Hippias, Athenian society remained divided after some 35 years of tyrannical rule. Long suppressed sentiments quickly boiled to the surface. More moderate aristocrats, led by Cleisthenes the Alcmeonid, preferred to continue with the Peisistratid reforms. Civil war ensued, and despite the unsuccessful intervention of the Peloponnesian League, the faction of Cleisthenes prevailed. Just as Peisistratus had successfully reformed the economic order, Cleisthenes now tackled the Athenian constitution. He resolved to impose dramatic political reforms to prevent a return to aristocratic rule.

CLEISTHENIC POLITICAL REFORMS, CA. 510–500 BC

In essence, Cleisthenic democracy meant **hoplite democracy**. All citizens who furnished arms in defense of the state were expected to participate in the assembly. Cleisthenes instituted a new political system organized according to 174 *demes* (voting wards), 30 *tritteis* or thirds of tribes, combined to form 10 new voting tribes. Collective organization within the Ekklesia (the assembly), and hence within the Athenian army, now consisted of citizens drawn from a cross-section of the Attic population. Instead of identifying with localized clan-based warrior bands, in other words, soldiers participating in the Athenian phalanx now came from various districts throughout Attica. Artificially, this diminished an individual citizen's tendency to identify with his immediate origin and to view his place in wider societal terms.

The reorganization of his government likewise required Cleisthenes to invent new offices. One of the innovations of the Cleisthenic reforms was the Council of 500, which consisted of 500 representatives: 50 per each of the 10 tribes, selected by lot from all eligible citizens for a period of a year. The Ekklesia, or Athenian voting assembly, which was reorganized according to the 10 voting tribes, emerged as the principal organ of governance and determined all official policy through open public debate. All crucial matters, such as votes of war and peace, treaties, citizenship, and taxation, were decided by the assembled citizenry, convened at least four times per month. Cleisthenic democracy was essentially participatory democracy exercised by all those who could afford to attend

TABLE 6. CLEISTHENIC CONSTITUTIONAL REFORMS		
Cleisthenic Institution	Formerly	Procedure
10 Generals	None	Election
10 Archons	9 Archons	Sortition
Council of 500	Areopagus	Sortition
Assembly: 10 Tribes	4 Tribes	One Man, One Vote
Popular Courts (6,000)	4 Tribes	Sortition

the once-weekly meetings. In conjunction with the revamped assembly, Cleisthenes also appears to have reorganized the *Helaia* or popular courts to manage the city's burgeoning legal business and to serve as the final arbiter of disputes arising from the assembly.

Instances of political gridlock, a frequent outcome to participatory democracy, inevitably arose when antagonistic politicians proved singularly incapable of achieving a majority in the assembly, but all too capable of thwarting popular sentiment. Both to prevent such gridlock from occurring and to insure the effective maintenance of the democracy, Cleisthenes appears to have invented a procedure known as **ostracism**, first successfully utilized in 486 BC. Ostracism was essentially a national unpopularity contest. When warrented, during springtime voting would transpire in the Sacred Pit at the Agora, with citizens casting their votes inscribed on broken pieces of pottery (*ostraka*). A quorum of 6,000 votes was necessary for the vote to be official. If that number was achieved, the politician receiving the most votes would have to leave Attica forthwith for 10 years' exile, without option of appeal but without personal loss of citizenship or property. He simply had to get out of town.

Political developments in Athens thus required a century-long process of adaptation that included transiting through full blown tyranny into participatory democracy. Solon had opened the door to popular participation; Peisistratus had converted Attica into a commercially robust landscape centered on the city of Athens; Cleisthenes now introduced political reforms to impose *isonomia* (equality before the law) throughout the citizenry. Despite these significant advances, however, the democratizing process remained incomplete. Since regular participation in the democracy required financial means and free time, only those who could afford to attend the assembly or to hold office would typically do so. Since the landless poor of the city, the *thetes*, had to labor whenever the opportunity presented itself, they could rarely be counted on to attend public meetings.

RADICAL DEMOCRACY IN THE AGE OF PERICLES (465–429 BC)

The last phase in the political development of Athenian democracy occurred simultaneous with the political rise of the democratic leader Pericles. Pericles emerged as a public figure at the end of the 460s BC and died during the plague that struck Athens in 429 at the outset of the Peloponnesian War. At that time we are told that he had held the office of general for 17 consecutive years, typically as *strategos autokrator*, or commander-in-chief of the Athenian military. A gifted statesman, orator, and politician, Pericles simultaneously guided Athenian foreign policy through the development of an Aegean naval empire and its domestic policy through the implementation of **radical democracy**, or pay-for-service. By encouraging Athenian citizens to participate in public affairs through payment, Pericles enabled thousands of landless, poor Athenian males (specifically, the *thetes*) to obtain some portion of their earnings through participation in governing institutions, such as the Ekklesia and the popular courts. In some respects, what Pericles created was an

urban political machine. Poorer citizens voted in massive numbers to support his political agendas because they stood to benefit directly from the results. Nonetheless, the decision to pay citizens for service, and thereby elicit broader participation in the Athenian political life, marked an important transition from the earlier, Cleisthenic phase of democracy. In essence, radical democracy induced a dramatic transformation in the character of Athenian society, its population, and its social structure.

Pericles used the benefits of empire to create additional state-funded laboring opportunities to keep citizens employed throughout the year. As Plutarch observes, "Pericles created allowances for public festivals, fees for jury service and other grants and gratuities. He succeeded in bribing the masses wholesale and enlisting their support against the Areopagus." Despite the disapproving tone of Plutarch's testimony, it underscores the possibility that an Athenian citizen could obtain a day's wage for a day's service in the military (particularly rowing for the Athenian navy), in the courts, in the officialdom of the Athenian empire, or on various state boards of magistrates and the council. Estimates suggest that some 8,000 Athenian citizens were supported by the state in any given year. In addition, Pericles embarked on the most ambitious building program in Greek history. Several similarly designed, Doric-style temples and monuments found their inception during this building program. These include the Temple of Athena Parthenos (the Parthenon), the Propylaea (the monumental entrance gates to the Acropolis), and the Erechtheion (a temple sacred to Athena, Poseidon, and the Bronze Age royal dynasty of Athens) on the Acropolis, and several additional monuments constructed elsewhere in Attica. Naturally, the opportunity to obtain remuneration from service with any of these activities carried with it an obligation to participate in the assembly and to vote in favor of Pericles's democratic political agenda.

Much of the cost of this activity was defrayed by public-spirited citizens of the wealthiest census class, who voluntarily assumed the burden of **liturgies**, or the performance of state duties at private expense. Liturgies included activities as varied as the production costs of Greek tragedies and comedies and the maintenance of a trireme (the cost of maintaining a warship and its crew for an entire campaign season). Thus, opportunities created by Pericles for Athenian citizens placed a premium on citizen status itself. Citizenship opened the way for potential remuneration by the state, and Athenians remained inordinately protective of this privilege. Much like Sparta, the Athenian assembly passed laws restricting citizenship to those who could demonstrate direct Athenian descent on both sides of their family. Access to the benefits of radical democracy by metics (resident aliens) remained limited, accordingly, despite their commensurate obligations of military service and tax payments. Several prominent figures in Athenian political life owed their fortunes to the bustling urban landscape of the democracy: artists, intellectuals, teachers, entertainers, weapons-makers, and warriors all migrated to the chief city of the Mediterranean in search of fortunes and fresh beginnings that were otherwise unattainable in their home communities.

Such were the foundations that Pericles and other democratic leaders created for Athens. Following a century and a half of unremitting growth, the city became the hub of the

The works of Perikles are even more admired—though built in a short time they have lasted for a very long time. For, in its beauty, each work was, even at that time, ancient, and yet, in its perfection, each looks even at the present time as if it were fresh and newly built. Thus there is a certain bloom of newness in each building and an appearance of being untouched by the wear of time. It is as if some ever-flowering life and unaging spirit had been fused into the creation of these works.[1]

The reconstruction of the Athenian Acropolis took place following the Persian sack of 480 BC and was financed by the Delian League. Under the patronage of Pericles and the artistic directorship of Pheidias, the reconstruction was one of the most ambitious building projects ever undertaken. Four main buildings were built on the Acropolis during the fifth century BC: the Parthenon, Propylaia, Erechtheion, and Temple of Athena Nike. The greatest Athenian architects and sculptors of the Classical period completed the construction and decoration of these four buildings in which the sculptural programs and architecture are intertwined.

The Parthenon survives as the centerpiece of the Periclean building program on the Acropolis despite significant damage incurred from both time and conquest. Dedicated to the goddess Athena Parthenos, the Parthenon serves as a sophisticated example of temple architecture from the Classical period. The architects of the Parthenon—Iktinos and Kallikrates—believed in the mathematical harmony and precision described as *symmetria* (or "commensurability of parts"), professed by the sixth-century BC Greek philosopher Polykelitos in his *Canon*. Polykleitos argued that by applying harmonic proportions to the human figure, perfect beauty could be achieved. With the Parthenon, we see this idea of *symmetria* applied to architecture through the employment of a mathematical formula—a proportional scheme first used in the Temple of Zeus at Olympia. Despite this formulaic predisposition that largely governed the Parthenon's design, subtle variations from the imposed mathematical regularity are evident. Scholars suggest that these intentional variations in the Parthenon (such as the curvature of the building's assumingly straight lines, for example) reveal man's experience and real life—in essence, his humanity.

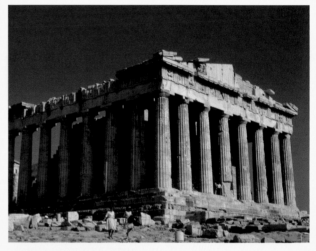

Figure 7.4 Iktinos and Kallikrates, Parthenon (Temple of Athena Parthenos, looking southeast), Acropolis, Athens, Greece, 447–438 BC.

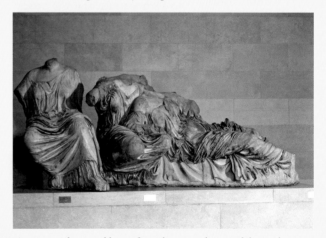

Figure 7.5 Three Goddesses, from the east pediment of the Parthenon, ca. 438–432 BC.

1 Plutarch, *Life of Perikles*, trans. J.J. Pollitt in *The Art of Rome, c. 753 BC–AD 337: Sources and Documents* (Englewood Cliffs, NJ: Prentice Hall, 1966), 13.

entire Mediterranean world, a great commercial center, a military power of enormous reach, and the world's leading cultural inspiration. Not only did the presence of so many talented people generate a unsurpassed burst of intellectual achievement, but (Athens being a relatively small place) most of the celebrated figures of this era also knew one another and saw their lives overlap. However, the fact that this city, its culture, and its empire was constructed with the labor of subjugated Greek allied states and enslaved inhabitants who had no say whatsoever in the Athenian democracy must also be borne in mind. The surviving monuments on the Athenian Acropolis serve as a careful reminder that the benefits obtained by any ancient civilization were unattainable without the unwilling efforts of invisible, unsung masses.

THE RISE AND FALL OF GREEK HEGEMONY (499–27 BC)

Political developments in mainland Greece did not occur in a vacuum; the socio-political transformations that transpired in Sparta, Athens, and neighboring communities were heavily influenced by external pressure both real and perceived. Around 500 BC the Greek world plunged into a prolonged era of warfare, sometimes fierce, oftentimes desultory. During the interval 499–27 BC a succession of empires (Persian, Athenian, Spartan, Macedonian) expanded rapidly across the eastern Mediterranean world, only to experience political setbacks or military defeat by neighboring polities. Their examples seem to demonstrate that the model of military conquest as an engine of economic growth was flawed, that for every deliberate initiative toward expansion there was unforeseen feedback.

FROM THE PERSIAN WARS TO THE ATHENIAN EMPIRE (499–404 BC)

CHRONOLOGY 8. THE PERSIAN WARS (499–478 BC)	
522–486 BC	Reign of Darius I, emperor of Persia
499–494 BC	Ionian Revolt
490 BC	Battle of Marathon
486–465 BC	Reign of Xerxes I, emperor of Persia
490 BC	Battle of Thermopylae
480 BC	Battle of Salamis
479 BC	Battle of Plataea

Persian domination of the Greek settlements in Ionia (the Aegean coast of Anatolia) led inevitably to conflict with those on the Greek mainland. Athenian interference in a revolt that erupted in Ionia in 499 BC provoked a Persian counterattack that was unexpectedly but resoundingly defeated by the Athenian hoplite phalanx on the Attic shore at Marathon in 490 BC. King Darius I of Persia died before he could prepare a suitable response, and his son, Xerxes I (486–465 BC), had to spend several years suppressing rebellions throughout the empire before he could attend to the matter. Ultimately Xerxes decided to conduct a full-scale invasion and conquest of mainland Greece. In 483 BC Xerxes announced the mustering of a great army to be recruited from all his satrapies at Sardis. Modern estimates suggest that 200,000 combatants and 1,200 triremes (state-of-the-art war galleys with three banks of oars) assembled for the invasion in 481 BC. In the face of this emergency, numerous Greek states on the mainland suppressed their habitual squabbling to form a defensive alliance known today as the Hellenic League. At its core was Sparta as hegemon assisted by its allied Peloponnesian League forces. Initial setbacks at Tempe and Thermopylae culminated in the Persian seizure of Athens and the destruction of the Peisistratid monuments on the Acropolis. However, the Persian fleet was outmaneuvered and destroyed by the Greek fleet at the Battle of Salamis (480 BC). Unexpectedly deprived of naval security, Xerxes had no choice but to withdraw from Greece altogether. This was a stunning defeat, a check on Persian expansionism, but not necessarily a turning point for Persian authority in the Aegean. Additional successes on the part of the Hellenic League only served to encourage further undertakings. Subject states throughout the Aegean hastened to urge the leaders of the league to secure their liberation militarily. However, the Spartans, who were not a naval power, decided to recall their forces to the Peloponnesus and to leave the liberation movement to the Athenians, whose citizenry had recently voted to construct a navy of 200 triremes. With the blessings of Sparta, the Athenians convened a congress of Greek maritime states at the Sanctuary of Apollo at Delos in 478 BC, to forge a second hegemonial alliance known as the Delian League.

Modeled on the example of the Peloponnesian League, the **Delian League** was founded as a voluntary alliance in 478 BC. Athens assumed the lead as hegemon, while each allied state received a vote on league policies. The ambassadors of the assembled states vowed to abide by the league forever, pledging to liberate the Greek world from Persian oppression and to avenge the destruction of various Greek sanctuaries by the Persians. Athenian authorities attempted to apportion the league contributions to each member state fairly, according to its size and military capacity. Delian League forces slowly rooted out Persian garrisons in the northern and eastern Aegean, ultimately liberating dozens of Greek cities in Ionia. By 470 BC they managed to extend their reach beyond the Aegean to the south coast of Asia Minor. A major confrontation with Persian naval forces at the Battle of the Eurymedon River in Pamphylia (ca. 469 BC) resulted once again in a resounding victory that left Persian territories throughout the eastern Mediterranean seaboard vulnerable to Delian League assaults. By 460 BC league forces landed in Egypt, provoking a rebellion that pinned down Persian military resources for several years. Following a string of

setbacks Persian authorities now had to confront the possibility of territorial losses that were crucial to the maintenance of the empire.

Athenian successes at the command of the Delian League were offset by growing resentment on the part of league allies, many of whom resented the Athenian insistence on annual military contributions to fight in places as remote to allied interests as Cyprus and Egypt. Athenian attempts to mitigate this complaint by allowing allied states to furnish cash payments in place of material contributions only made matters worse. Athens amassed a sizeable treasury and used the funds to expand their naval capacity while the allies essentially abandoned their role in the war effort. This development culminated in the near total demilitarization of Delian League allies by 431 BC. As the conflict with Persia dragged on, mounting hostility prompted the Athenians, now led by the democratic leader Pericles, to negotiate an end to the war that left Athens in control of the Aegean in 449 BC. Realizing that Delian League member states would immediately call into question the continuing need for the alliance, Pericles purposely summoned a Hellenic League congress to address its future and wider Greek affairs. Although all Greek states, including Sparta, were invited to attend the conference in Athens, none outside the Delian League ultimately chose to do so. With no representatives from independent Greek states present to raise objections, Pericles announced at the congress that the Delian League and its cash contributions must continue and that the 5,000 talents that had accumulated in the league treasury would now be used to reconstruct the monuments destroyed by the Persians, beginning with the temples on the Athenian acropolis.

With this pronouncement Pericles dispelled the illusion of the Delian League as a joint, voluntary alliance of free and equal member states and replaced it with the cold, hard reality of an empire ruled by Athens. Rebellions by league members were frequent and suppressed with alacrity. In addition, by projecting Athenian naval influence to western Greek settlements in Sicily, Pericles threatened the commercial interests of Sparta's ally, Corinth. Since the Spartans lacked the necessary naval resources to oppose the Athenians, they were reluctant to confront this growing threat. Despite this intransigence the entire Greek world looked increasingly to Spartan leadership as the only viable deterrent to Athenian naval supremacy. Continued Athenian military expansion ultimately provoked the outbreak of the Peloponnesian War (431–404 BC). This long, drawn-out war culminated in the defeat of Athens by Sparta and its allies, but only after tremendous losses on both sides. Since the outcome merely replaced Athenian domination by a renewed one of Sparta, the seeming pointless character of this conflict became evident to all participants and elicited a profound sense of despair among Greek intellectuals in the coming era.

As destructive as the Peloponnesian War was, the threshold of violence in the Greek world seemed only to accelerate in the following century. Greek city-states aligned themselves according to a bewildering array of shifting alliances to combat the military ascendancy first of Sparta (404–371 BC), then of Thebes (371–362 BC), and then Athens (362–357 BC). The rapidly changing character of these alliances appears to reflect a resurgent swing toward **particularism** and a rejection of hegemonial authority throughout Greece. By switching sides in successive military conflicts, Greek city-states were able

to regain their autonomy by undermining whichever state (Sparta, Thebes, or Athens) appeared to be aspiring toward ascendancy. The inevitable result of this tendency was to leave the city-states of the Greek mainland sharply divided and resentful of one another at the very moment that external military powers capable of threatening their autonomy appeared once again on their horizon.

THE RISE OF MACEDONIA UNDER KING PHILIP II (359–336 BC)

The Macedonians were a neighboring people in the northern Aegean who spoke a language that was similar to Greek yet apparently unintelligible to Greek speakers. After long existence as an Aegean backwater, Macedonia emerged in the mid-fourth century BC to become the most powerful state in the region and eventually the entire eastern Mediterranean world. Over time Greek colonization and military hegemony in the wider Aegean resulted in Hellenic cultural diffusion: the process of assimilation was slow, but by the early fourth century BC the Macedonian royal court had made several significant advances. With its dispersed rural population Macedonia also possessed a greater capacity for military manpower than any individual Greek city-state. Were these resources ever harnessed by an effective king, Macedonia's potential as an Aegean power was considerable.

Philip II or Philip the Great (ca. 390–336 BC) proved to be the first of two such kings. During his brother's reign, Macedonia had succumbed temporarily to Theban domination. By inflicting a stinging defeat on the Spartan army at the Battle of Leuctra in 371 BC, the Thebans had assumed a brief period of military ascendancy on the Greek mainland (371–362 BC). Sent to Thebes as a teenage hostage, Philip studied new techniques in Greek phalanx maneuvers (what is specifically known as the **oblique phalanx**) firsthand as a guest of the Theban commanders. When his brother perished while battling the Illyrians in 359 BC, Philip quickly returned to Macedonia to act as regent to his infant nephew. He reorganized the Macedonian army according to Theban innovations and soon won a decisive victory over the Illyrians. Riding on this success, he immediately supplanted his nephew as king. While in the highlands, he used the emergency to seize control of the aristocratic warrior bands of the Macedonian interior. To keep the nobles in check, he recruited their sons to live and to study at his royal court in Pella. There they were exposed to Greek culture and learning and grew to exhibit greater loyalty to the throne than to their ancestral families. By relocating soldiers to garrison colonies on the frontiers or to military camps in lowland areas near the capital, Philip acquired similar leverage over the Macedonian rural population. Through these measures he incentivized the Macedonian army, rewarding its members with land, agricultural laborers, military honors, and cash. His need for skilled warriors led Philip to reach beyond his kingdom to recruit the best and the brightest warriors from throughout the Greek world, particularly horsemen. The Macedonian cavalry (estimated at 5,100 riders) quickly attained unsurpassed tactical abilities. Instituting an ethos of meritocracy, Philip extended Macedonian status to his foreign

warriors, settling them on land and elevating them to high-ranking positions based entirely on their military accomplishments. Although the pace and direction of his innovations angered many of the traditional Macedonian nobles, it was hard to argue with success.

Philip soon molded the Macedonian army into an effective fighting force of 34,000, which far exceeded that of any individual Greek city-state. When utilized in combination with Philip's deft diplomatic ability and his lavish use of bribery, the Macedonian army sliced its way through every Greek army sent to oppose it, ultimately defeating the combined forces of Athens and Thebes at the Battle of Chaeronea in 338 BC. Confronting a seemingly ungovernable array of city-states, Philip recognized that his ascendancy in Greece would at best be temporary unless he devised some alternate direction in which to channel their aggressive tendencies. Convening a Hellenic congress at Corinth in 337 BC, he announced his intention to conduct a crusade against the Persians to punish them for all the troubles they had caused the Greek people through the years. Leaders of Greek city-states readily supported the expedition, hoping, of course, that Philip would depart, never to return. However, on the eve of his expedition in 336 BC, Philip II was murdered in an apparent palace coup at Pella, leaving his 20-year-old son, Alexander, as his successor. Philip's surviving generals assumed at first that they could manipulate the young king as a puppet; however, in this they proved profoundly mistaken. As fate would have it, Alexander's raw ambition and innate military genius exceeded those even of his father.

THE CAMPAIGNS OF ALEXANDER THE GREAT (336–323 BC)

It seems unlikely that Philip II intended to march directly into the heart of the Persian Empire as his son, Alexander II, ultimately did. With swift battles and forced marches Alexander quickly overran Persian resistance along the Mediterranean, marching as far as the desert oasis of Siwah in Libya to visit a renowned oracle of Zeus Amun (the Ammonium) in 331 BC. He then assaulted Persian positions in Mesopotamia. Defeating the Persian king, Darius III, at the Battle of Gaugamela, Alexander seized Babylon and advanced toward Persia unopposed. After successfully capturing the Iranian palaces at Persepolis and Ecbatana in 330 BC, he announced that all the allied forces were free to return to Greece, but that those who agreed to remain with the expedition would receive enormous cash bounties from the bullion expropriated from Persian royal treasuries. At this point he abandoned distinctions between Macedonians and foreign mercenaries and recognized the assembled fighting force as the Macedonian people, regardless of origin. To maintain morale on such a perilous campaign, he lavishly dispensed the Persian reserves of silver and gold and extended his soldiers unlimited financial credit. The campaigns in Afghanistan and India between 329 and 324 BC proved extraordinarily difficult; Plutarch claims that of the 40,000 men that departed with Alexander from Ecbatana in 329 BC, only one in four returned to Babylon six years later. The others either died on the march or were left behind at a number of remote colonies, all named Alexandria after their king.

Map II Hellenistic Successor States, ca. 180 BC.

Conspiracies within the ranks abounded, and numerous high-level generals and nobles of the Macedonian aristocracy were executed for real or suspected treason. But Alexander successfully drove his forces to the mouth of the Indus River and would have penetrated to the Ganges, had his army not openly mutinied at the Hyphasis River in 326 BC, refusing to go any further.

Returning to Babylon while still in his early thirties, Alexander died mysteriously in 323 BC, probably as a result of infections derived from his numerous war wounds. Gathered around his deathbed at the palace in Babylon, his generals asked him who among them he would choose to command his newly conquered empire. "The fittest," were reportedly his final words. Alexander's example, his conquests, and his newly acquired wealth set in motion two generations of conflict among the Macedonian generals who vied to succeed him as the emperor of a vast new empire. By 306 BC, most of the surviving Macedonian commanders came to recognize the impracticality of this ambition and resorted instead to a second phase of conflict intended to carve out individual territories for themselves. These ultimately devolved into Antigonid Macedonia (279–167 BC), Attalid Pergamum (270–133 BC), Seleucid Syria (305–66 BC), and Ptolemaic Egypt (305–27 BC).

HELLENISTIC SUCCESSOR STATES TO ALEXANDER THE GREAT (305–27 BC)

Antigonid Macedonia (279–167 BC): Capital at Pella

Following an era of considerable political confusion, Antigonus Gonatas, the grandson of one of Alexander's leading generals, was able to secure control of the Macedonian heartland. In comparison with the competing Hellenistic dynasties, Macedonia remained a cultural backwater, but this appraisal belies the strengths furnished by its topography, its resources, and its manpower. Unlike rival Hellenistic states, Macedonia presented itself as a compact, easily defensible state ringed by mountains that permitted few means of access. Its timber resources and silver mines furnished it with the revenues necessary to sustain the leading military establishment of the Greek world. Macedonia was, after all, the homeland of the armies used by Philip and Alexander to conquer the Persian Empire. It remained the chief recruiting ground for the armies of the Hellenistic dynasties, the most effective of which remained that of the Antigonids themselves. The skillfulness of the Antigonid army posed a serious threat to all Greek states of the Aegean. Those most threatened ultimately invited the armies of the Roman Republic to come to their aid. The Romans confronted the Antigonids on three separate occasions and found them exceedingly difficult adversaries. They ultimately defeated the last Antigonid king, Perseus, at the Battle of Pydna in 168 BC. When this failed to deter rebellions in 148 BC, Roman forces again intervened to suppress uprisings throughout the Greek mainland (including the suppression of Corinth in 146 BC). This time the Romans reduced Macedonia to provincial status, the first such Roman territory in the Aegean.

Attalid Pergamum (270–133 BC): Capital at Pergamum

This kingdom was the only one founded by a non-Macedonian dynasty. Originally the Greek secretary of a Macedonian general, Philetairos gained dynastic recognition through his successful efforts at repulsing the Gallic invasion of western Anatolia in 270–269 BC. For this accomplishment he was recognized by the Greek cities of the western Anatolian coast as a liberator and savior, and he established his royal hegemony with widespread approval. Sustained friendship with Rome enabled his Attalid successors to enjoy continued success during the early second century BC. At their peak under Eumenes II (ca. 190–168 BC), they controlled the entire western seaboard of Anatolia and much of the Phrygian highland. The Attalids also succeeded at establishing Pergamum as a leading cultural center of the Mediterranean world. Its library was second only to that of Alexandria; its sculptures, woven tapestries, and ceramics were prized throughout the Mediterranean. An expressive, highly baroque style of sculpture known as the Asian School set important trends

The Great Altar of Zeus at Pergamum was built by Eumenes II, the son of Attalos I, and commemorates territorial victories and the establishment of *Nikephoria* (a grand victory festival). Excavated by German archeologists in the late nineteenth century, the Great Altar—which consists of both the altar and a large rectangular enclosure—was removed from its original location on the Pergamene Acropolis and reconstructed in Berlin.

The emotional and dramatic frieze that decorates the base of the massive altar (extending over 122 m in length and over 2 m in height) reveals the **Hellenistic style** at its pinnacle. With the battle of gods and giants as its subject, the frieze symbolically alludes to the victory of King Attalos I over the Gauls of Asia Minor. The eastern frieze depicts the Olympian gods juxtaposed with divinities of the earth and sea at west; deities of the night are represented on the northern frieze, while heavenly lights are depicted on the south. Details of the *gigantomachy* frieze, such as *Athena Battling Alkyoneos* from the east side, convey a profound sense of theatricality in the deeply carved and overlapping figures, carefully rendered textures, and muscular bodies revealed beneath twisted garments—the scene seemingly frozen in constant motion.

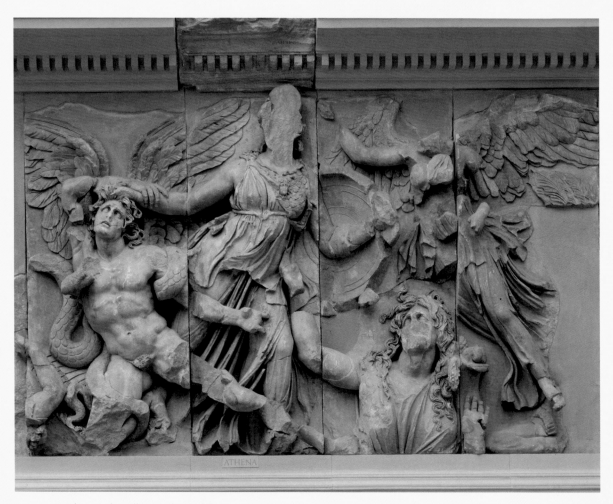

Figure 7.6 *Athena Battling Alkyoneos*, detail of the gigantomachy frieze, from the Altar of Zeus, Pergamum, Turkey, ca. 175 BC. Marble, 2.29 m high. Staatliche Museen, Berlin.

in Greek plastic arts and profoundly influenced artistic endeavor at Rome. The Attalids likewise competed for control of the eastern luxury trade, relying on the overland route of the ancient Royal Road across Anatolia.

When a dynastic dispute threatened to undermine the stability of the Pergamene realm at the end of the second century BC, King Attalus III (138–133 BC), in an unprecedented move, left his domain to the people of the Roman Republic. Following his death in 133 BC, the Romans accepted this inheritance and secured it through military intervention. By 126 BC, the royal territories of Pergamum were transformed into the Roman province of Asia, the richest of all Roman territories. The merger of Greco-Roman culture was probably most successfully achieved here. In the Roman imperial era, cities such as Pergamum, Ephesus, Sardis, and Miletus ranked among the leading cultural centers of the Mediterranean world.

Seleucid Syria (305–66 BC): Capital at Antioch

Founded by Seleucus, who like Ptolemy was one of a handful of Macedonian officers to survive Alexander's campaigns in India, the Seleucid Empire had its capital at Antioch but established numerous neighboring Greek settlements, including Syrian Alexandria, Laodicea, Beroea, and Edessa. Although the core of the Seleucid Empire was situated in coastal Syria, its territories typically included the neighboring regions of Cilicia and Mesopotamia. As late as 205 BC, the Seleucid king Antiochus III conducted a military expedition to restore his authority as far away as the Indus Valley in the east and the Aegean in the west. However, his defeat by the army of the Roman Republic at the Battle of Magnesia in 189 BC compelled him to restrict his claims to the heartland of northern Syria. On the whole, Seleucid foreign policy focused on the consolidation of its Mediterranean territories. Afghanistan was abandoned to the Mauryans and the Kushans; Iran and Mesopotamia were ultimately ceded to the Parthians.

Through methodical efforts at colonization, the cultivation of high quality crafts production in Syria, and fierce competition with the Ptolemies for control of the eastern luxury trade, the Seleucids secured tremendous wealth. Their production centers generated expensive perfumes, incense, purple-dyed clothing, tapestries, and a highly polished, red-slipped fineware known as Eastern Sigillata A. Much like the Phoenicians before them, the artisans of the Seleucid Empire established a number of trends in material comfort for Greco-Roman civilization. Through a sustained program of colonization, the Seleucids encouraged out-migration by Aegean Greek inhabitants to newly founded settlements in non-Greek regions of the Mediterranean, helping to create a Hellenistic *koine* (common or universal) culture. Seleucid weakness arose primarily from the diverse array and inveterate animosities of its subject peoples. Internal disputes caused the dynasty to implode ca. 150–96 BC. Long decades of civil war and chaos ensued until ultimately the Roman general Pompey the Great absorbed the remaining vestiges of the Seleucid Empire into the Republican provincial administration in 66 BC.

Ptolemaic Egypt (305–27 BC): Capital at Alexandria

Founded by Ptolemy, who was one of the youngest Macedonian nobles to accompany Alexander to India, Ptolemaic Egypt rose to become the most spectacular of the Macedonian successor states. Its capital, Alexandria, reportedly attained a population of one million at the height of the Roman era. Ptolemy and his successors successfully harnessed and even maximized grain production in the Nile Valley, converting Egypt once again into the breadbasket of the Mediterranean. By collaborating with Rhodian traders, the Ptolemies assumed near monopolistic control of trade in grain and wine throughout the shores of the Mediterranean and Black Seas, while establishing a similarly lucrative maritime trade with Arabia and India. Although coastal traffic in the Indian Ocean had clearly endured for centuries, with the discovery of the monsoon winds by Ptolemaic mariners at the end of the second century BC, direct passages (approximately 1,800 km) from the western shores of the Arabian Sea became possible. The Ptolemies constructed roads connecting the Upper Nile basin with the Red Sea and ports such as Berenike on the Red Sea to facilitate maritime voyages to the Indian Ocean. Forward-situated islands such as Charax Spanisou (near the Shatt al Arab) and Socottra (approximately 320 km east of the Horn of Africa) offered advantageous points of departure for ocean crossings. With the development of the sea route, the Ptolemies were able to bypass Seleucid and Parthian domination of the overland routes to India and to forge their own trade links with the subcontinent by means of large, ocean-going cargo ships. Archaeological finds of materials such as Indian sail cloth at Berenike and Aegean amphoras at Arikamedu help to confirm the patterns of this trade. Bolstered by the profits of the luxury trade, Alexandria quickly supplanted Athens as the most cosmopolitan city of the world. Its spacious protected harbors, resort-lined canals, and broad avenues designed by Alexander the Great himself made the city an attractive destination for talented Greeks seeking better opportunities abroad. The museum, the great library, the mausoleum of Alexander and the Ptolemies, and the great lighthouse all ranked among the most splendid monuments of the era.

During the third century BC, the Ptolemies commanded an extensive eastern Mediterranean naval empire, drawing on Hellenized population centers for manpower. Dynastic disputes and military losses to their rivals and closest neighbors, the Seleucids, resulted in gradual but unmistakable political and military decline shortly thereafter. An astute diplomatic relationship with the Roman Republic prevented Seleucid incursions on more than one occasion and was probably the only reason for Ptolemaic survival. The last member of the dynasty, Queen Cleopatra (52–30 BC), actually attempted to exploit her personal relationships with Julius Caesar (by whom she had a son) and Mark Antony (begetting more children) to revitalize the realm and perhaps even to establish herself as a Ptolemaic consort at Rome. However, Octavian's defeat of Antony and Cleopatra in 31 BC put an end to these ambitions. As will be noted in Chapter 10, Octavian seized Egypt for himself, making the kingdom part of the Julio-Claudian patrimony to be governed by private procurators. Egypt continued to generate food exports during the Roman Empire, furnishing grain for the burgeoning population at Rome.

HELLENISTIC GREECE

Confronted on all sides by empires of significant capacity, traditional Greek city-states had little choice but to organize themselves into wider federations, if only to resist the threat posed by neighboring Hellenistic dynasts. The Aetolian League emerged in central mainland Greece and the Achaean League in the Peloponnesus (including Corinth, but not Sparta). Certain states, such as Rhodes, Athens, and Sparta, remained independent: Rhodes because of its importance to Mediterranean trade and its naval power, Athens because of its status as an international cultural center and university town, and Sparta because of its secure borders and its sustained reputation as a society of indomitable warriors. The trend had definitely shifted, however, in the direction of the new Macedonian successor states. Greek mercenaries, citizens down at their luck, and/or nobles with higher ambitions migrated eastward to join the Greek-speaking intelligentsia at the Hellenistic capitals of the Mediterranean, to serve in Hellenistic armies, or to participate in colonizing enterprises. Regardless of one's ethnic origin, the common denominator to membership in any Hellenistic hierarchy was training in Greek language and Greek culture, obtained exclusively through education in Greek gymnastic institutions of learning.

By exporting the means to replicate Hellenic culture overseas, Greek hierarchies successfully imposed their values on neighboring Mediterranean peoples while at the same time tapping into beneficial attributes of native cultures. Many Hellenistic kings continued to employ the meritocratic policies of Philip and Alexander the Great, recruiting the best and the brightest citizens from throughout the Hellenistic world to command their armies and to serve as governors, courtiers, financiers, and ambassadors. The emerging international community that governed the Hellenistic world system exuded an air of worldly confidence, one that transcended the particularism of the previous era. Hellenistic elites perceived of themselves as *kosmopolitai*, or citizens of the world. They were people so adept at the practices, customs, and institutions of the new order that they found themselves at home nearly anywhere in the Mediterranean world. This new attitude had a profound effect on society, arts, and philosophy in the Greco-Roman era.

THE INTELLECTUAL REVOLUTION OF GREEK RATIONAL THOUGHT

In light of the significant political transformations that occurred during the Hellenistic era, we need to consider the importance of the cultural beliefs that the emerging world system came to represent. More enduring than the material, military, or political accomplishments of this civilization were the ideas it successfully advanced. These have outlived Aegean civilization to form the cornerstone of Western intellectual thought.

During the Archaic Age (800–500 BC) Greek thinkers in Ionia (the Aegean coast of Anatolia) began to question the viability of their traditions and the Olympic deities. Partly

In 1509, Raphael Sanzio (1483–1520 AD) began one of the most important commissions awarded by Pope Julius II: the decoration of the papal apartments in the Apostolic Palace of the Vatican. One of the rooms (or *stanze*) painted by Raphael was the Room of the Signature, or *Stanza della Segnatura*, a study where Julius signed important documents. In this room, Raphael decorated each of the four walls with imagery that encapsulated Renaissance thought and culture: theology, law (justice), poetry, and philosophy.

Great philosophers and scientists conversing and explaining their various theories and ideas serve as the setting for Raphael's *Philosophy* fresco. More commonly known as *School of Athens*, the mural focuses on the central figures of Plato and Aristotle. Plato, pointing heavenward, holds his text *Timaeus*; Aristotle gestures toward the earth while carrying his *Nicomachaen Ethics*. The writings of Plato and Aristotle caused debate during the Italian Renaissance over man's place in the universe, the immortality of the soul, and the ability to improve oneself through virtue.

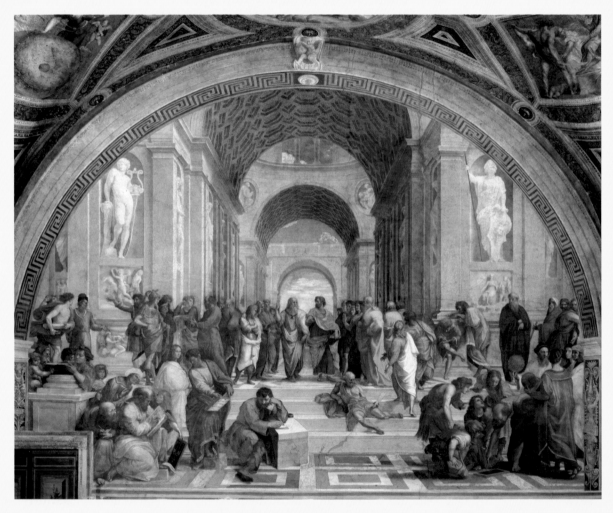

Figure 7.7 Raphael, *(Philosophy) School of Athens*, Stanza della Segnatura, Vatican Palace, Rome, 1509–1511 AD. Fresco, 500 cm x 770 cm.

this resulted from contact with older civilizations that revealed the naiveté of Greek folk traditions; partly it arose from the moral ambiguity of mythical traditions about deities who raped, stole, and otherwise behaved like children. Ionian thinkers in particular exhibited a love for collecting facts and for systematizing phenomena on a rational basis. In a rudimentary manner they devised an empirical method of inquiry by insisting on the need to ignore the myths and to trust nothing other than what they could observe with their own senses. This insistence on individual inquiry and self-awareness naturally compelled many to question the traditions of Greek religion, placing Greek thinkers on a collision course with political and religious hierarchies, and in the case of Socrates, with the religious attitudes of the community as a whole. The inevitable result was conflict between the individual and the state. Another consequence was a highly articulated investigation of ethics. The overriding question raised by intellectuals throughout Greco-Roman antiquity was, to put it simply, *how could an honorable person live a just life in an unjust world*? A third innovation, again very similar to one that emerged in Indian culture, was the development of the **dialectic**, or intellectual inquiry, through reasoned debate. In its simplest form the dialectic was a means by which a teacher would direct a student to a rational outcome by posing questions intended to reveal this to the student through the logic of his or her own answers. The Athenian citizen and thinker **Socrates** (470–399 BC) was generally recognized as the greatest practitioner of the dialectic.

Several early Greek thinkers (referred to collectively as the pre-Socratics) are renowned for their notable contributions to science, mathematics, healing, and philosophy. For example, Milesian Thales (ca. 624–ca. 546 BC) made significant breakthroughs in the natural sciences, in the practice of rational criticism and debate, and with the distinctions between natural and supernatural phenomena. Although Thales was not an atheist, he argued that the supernatural played no part in the explanation of natural phenomena observed by humans. His conclusion—that there was unity to everything and that the unifying substance was water—demonstrates the scientific limitations of Greek rational inquiry. Celebrated for his breakthroughs in mathematics and geometry as well as for his exactness in science, Pythagoras of Samos (ca. 570–495 BC) argued that principles of mathematics lay at the foundation of everything, because all things were ultimately modeled on numbers. He is credited for the Pythagorean Theorem ($a^2 + b^2 = c^2$), though evidence suggests that this was already known to the Babylonians. Hippocrates of Cos (ca. 460–ca. 370 BC) was reportedly a priest of Asclepius, the Greek god of healing, and descended from a long line of such priests. Prior to the development of Greek rational thought, treatment generally entailed dream therapy and suitable chants and incantations prescribed to expel bad humors from the patient. Through rational observation and deductive reasoning, superstition gave way to medicine, founded according to tradition by Hippocrates. Greek doctors became recognized throughout the world as uniquely skilled in medicine. They made significant breakthroughs in hygiene, diet, and in the use of drugs to reduce fever, and they determined that cauterization of wounds could prevent infections along with cleanliness and a regular change of dressings. They were particularly proficient at setting athletic injuries, such as sprains, dislocations, and broken limbs. Other scientific breakthroughs

were achieved by Democritus of Abdera in Thrace (ca. 460–ca. 370 BC). Democritus argued that all matter was composed of tiny particles called *atoms*, and that the differences that appear in natural phenomena resulted from the infinitely varying arrangement of these particles. This was remarkable reasoning for scientists devoid of the technological means to support their arguments with concrete data.

The greatest contribution of pre-Socratic thinkers was undoubtedly metaphysical. Heracleitus of Ephesus (ca. 535–ca. 475 BC) proposed that a divine entity, which he referred to as the *nous* or "the mind," had organized the universe in a logical manner and that the expression of this divine reason was embodied in the many proofs of natural law, proofs he referred to as the *logos*, or "the demonstration." Belief in the existence of a divine, quasi-monotheistic intelligence laid the foundation for Greek ethical and metaphysical development. Xenophanes of Colophon (ca. 570–475 BC) pointed to the existence of the laws of nature as proof that there could only be one god, eternal, unchangeable, and spiritual: "One god is greatest among gods and men, not at all like mortals in body or in thought." The great sophist **Anaxagoras** of Clazomenae (ca. 500–428 BC) likewise explained that the divine intellect or the *nous* was infinite, omniscient, and the source of order in all things. Not only was Anaxagoras the tutor of young Pericles, but he reportedly had significant influence on the intellectual development of Euripides and Socrates. He also serves as a useful bridge to explain how ideas emanating from Ionia made their way to mainland Greece. Many trained by the pre-Socratics in Ionia migrated westward, lured by opportunities such as those provided by the burgeoning metropolis of Athens. They taught at gymnasia for a fee, and thus became known as **sophists**, or "wisdom-dealers." What they tried to offer was the dialectic itself, that is, the means to rational deductive inquiry. The dialectic became a standard means of political debate as well as of intellectual reasoning, and its patterns of speech are readily recognizable in Greek literature.

The infusion of this new way of thinking coincided with Greek success during the Persian Wars (499–478 BC). The resulting fusion manifested itself as an expression of Greek Positivism during the fifth century BC. Greek thinkers and politicians alike became convinced that they owed their success against the Persians to the superiority of the Greek way of life, its reasoning power, its polis system, and its patron deities. A love of reasoning took hold in the democracy in Athens, convincing many citizens that all ailments of the world could ultimately be solved through reason. As the **empirical method** became applied to various intellectual pursuits, breakthroughs occurred in fields such as the plastic arts (sculpture), architecture, as well as in philosophy, science, and medicine. The new ideas gradually rippled through society to reach the masses. The progressive impact of Greek rational thought in mainstream Athenian society reveals itself through the evolving expression of its tragedians, Aeschylus, Sophocles, and Euripides. Similar use of intellectual reasoning can be seen in the works of writers, such as the comic playwright, Aristophanes and the historians Herodotus, Thucydides, and Xenophon. Unquestionably, the turning point in this development was marked by Socrates, an ordinary Athenian citizen who became recognized as the greatest philosopher of his day.

SOCRATES AND THE FORMATION OF GREEK PHILOSOPHICAL SCHOOLS

Although Socrates was a relatively poor Athenian citizen, he served with distinction in the hoplite phalanx. He owned a pottery kiln and a small farm, but he gradually abandoned his trade to pursue truth. Socrates emphasized ethics and the dialectic and became recognized as the greatest arguer of his day. According to Socrates, true knowledge was not simply the source but the very substance of virtue. He sought a kind of truth capable of determining the conduct of men by posing questions such as, "What is piety? What is impiety? What is beauty? What is ugliness? What is noble? What is base? ... Just/unjust? ... Courageous/cowardly?" and so on. Socrates's method of research was to single out people in the crowd at the Athenian Agora and lure them into debate. He would then employ his ability as the most formidable reasoner of his age to argue his point, typically at the embarrassment of his antagonist.

Socrates engaged in inductive reasoning (from the particular to the general) and universal definitions, that is, principles representing the very foundations of knowledge. While professing ignorance in all things, he tried to construct a body of ethical science that might serve as a guide to himself and to others. In questioning all things, he stood on sophistic ground; but he stressed reason rather than the senses as the universal and eternal element in humankind. Since an intellectual education could increase a man's power to do evil, Socrates tried first to instruct his associates in self control and to inspire in them an informed reverence for the gods. Many of his teachings were as much religious as they were philosophical. Ultimately, by challenging the status quo and by encouraging his students to think for themselves, his loyalty to Athens was called into question, particularly during the dark days at the close of the Peloponnesian War. Many of his followers were wealthy young aristocrats whose ambitions were more political than philosophical. Several of these despised the democracy of Athens and used violent measures to suppress it. When the democracy was restored in 399 BC, Socrates was tried and condemned to death for denying the established gods (apparently due to his repeated allusions to the *nous*) and for corrupting the youth. This travesty of justice had a disheartening effect on his followers.

One such student, **Plato** (428–347 BC), arguably surpassed his teacher by devising a comprehensive system of ethics, dialectic, physics, and a theory of ideas. Plato was a noble Athenian intending to pursue a political career, but he was deterred by the political excesses during the last years of the Peloponnesian War, culminating in the prosecution and execution of Socrates. Abandoning public life Plato founded a school at the gymnasium of the Academy outside Athens, the first great university of the Mediterranean world. The Academy continued as a place of learning until it was closed by the Roman emperor Justinian in the sixth century AD. Plato wrote 26 dialogues, all of them framed through the voice of his teacher Socrates. To Plato, knowledge was a body of true and unchanging wisdom open only to a few philosophers whose training, character, and intellect enabled

them to grasp reality. According to Plato, only those with enlightened philosophical awareness were qualified to rule. Naturally, as philosophers they themselves would prefer a life of genuine contemplation, but in the interest of humanity they would accept this responsibility and rule as philosopher kings. Following this precept Plato argued that each and every individual should perform the societal role that he was naturally fit to assume. Some should be leaders, others should be warrior-guardians of the state, while most should toil as laborers.

Plato also taught that ideals equaled abstract forms and that the world of sensation was in large part an illusion. Plato expounded on the existence of ideal truths or forms. To Plato an ideal form of beauty exists apart; things that were called beautiful were so only because they exhibited some essential particle or quality of the truth or ideal form of beauty. The same went for wisdom, restraint, courage, justice, and so on. As Anaxagoras had argued, all such forms were the expression, the *logos*, of an infinite divine wisdom, the *nous*. Plato's divine intellect nearly took on the appearance of a monotheistic deity. Plato's aspirations, accordingly, were spiritual as well as metaphysical; he clearly believed in the immortality of the soul. His texts furnished the first genuine evidence of a *comprehensive* philosophical system, one that argued positions in all of the branches of philosophy (in the modern sense of the term), including:

Metaphysics: a view of the nature of reality as a whole
Epistemology: the nature and means of human knowledge
Ethics: the explanation of the nature of right and wrong, morality and immorality
Aesthetics: the nature and use of art in human life
Politics: the ethical organization of society

Aristotle (384–322 BC) was a student of Plato who studied at the Academy for 20 years after moving to Athens at the age of 17. Aristotle's father had been the physician of Amyntas II, the father of Philip II of Macedonia, and Aristotle himself became the tutor of Alexander the Great for a few years beginning in 343/342 BC. Alexander reportedly sent Aristotle biological specimens from his decade-long journey to the East. While in Athens, Aristotle founded a second university at the gymnasium known as the Lyceum. Here he directed his students to collect data on all aspects of science, ethics, and government. He wrote on a wide range of subjects, including logic, physics, astronomy, biology, ethics, rhetoric, literary criticism, and politics. Aristotle was a pioneer and innovator in numerous fields of knowledge. He is credited with organizing and forming bodies of knowledge into specific disciplines, including zoology, botany, biology, psychology, physics, astronomy, logic, ethics, literary criticism, and more. Aristotle was less inclined to pursue the metaphysical inquiries of Plato and far more interested in the organization of knowledge per se. He possessed a keen ability to analyze and to classify things with exhaustive thoroughness. He began with empirical observations by collecting data and then applied reason to discover inconsistencies or difficulties with the results.

In 399 BC, Socrates (then 70 years old) was sentenced to death for corrupting the youth of Athens both through his anti-democratic ideals and rumored atheism. Through the narrative voice of his fictional character, Phaedo, Plato describes his teacher's suicide by drinking poison hemlock:

> He took it perfectly calmly, Echecrates, without a tremor, or any chance of color or countenance; but looking up at the man, and fixing him with his customary stare, he said: "What do you say to pouring someone a libation from this drink? Is it allowed or not?"

> "We only prepare as much as we judge the proper dose, Socrates," he said.

> "I understand," he said; "but at least one may pray to the gods, and so one should, that the removal from this world to the next will be a happy one; that is my own prayer: so may it be." With these words he pressed the cup to his lips, and drank it off with good humor and without the least distaste.

> Till then most of us had been fairly well able to restrain our tears, but when we saw he was drinking, that he'd actually drunk it, we could do so no longer. In my own case, the tears came pouring out in spite of myself, so that I covered my face and wept for myself—not for him, no, but for my own misfortune and being deprived of such a man for a companion. Even before me, Crito has moved away, when he was unable to restrain his tears. And Apollodorus, who even earlier had been continuously in tears, now burst forth into such a storm of weeping and grieving, that he made everyone present break down except Socrates himself.

> But Socrates said: "What a way to behave, my strange friends! Why, it was mainly for this reason that I sent the women away, so that they shouldn't make this sort of trouble; in fact, I've heard one should die in silence. Come now, calm yourselves and have strength."[2]

The most famous interpretation of the above scene is by the French neoclassical painter-ideologist Jacques-Louis David (1748–1825), who championed a return to Greek style and the depiction of the heroic, noble, and patriotic.

In David's painting, time has seemingly stopped. The poses and gesticulation of his figures signal emotions rather than enact them, calling instead for a logical, psychological response to the painting—the same response Socrates is calling for in *Phaedo*, one of Plato's most famous dialogues. There is a restrained elegance in David's composition as well as his chosen color palate; the uniformly dispersed light places equal emphasis on the figures and prison interior. It is an awe-inspiring scene, one that calls the viewer to consider Socrates's courage, loyalty, and sacrifice.

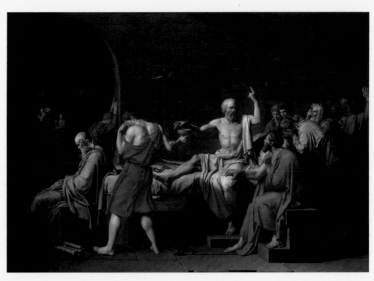

Figure 7.8 Jacques-Louis David, *The Death of Socrates*, 1787 AD. Oil on canvas, 1.33 m x 1.99 m. Metropolitan Museum of Art, New York.

2 Plato, *Phaedo*, trans. David Gallop (Oxford: Oxford University Press, 1975), 117b–e.

PHILOSOPHICAL DEVELOPMENTS IN THE HELLENISTIC ERA

From its free-form origins in Ionia, Greek philosophy and modes of empirical inquiry gradually evolved into formal schools of thought. The application of reasoning and scientific discipline inevitably had a profound effect on intellectuals beyond Athens. Philosophically, as well, the precedents of Socrates and Plato found resonance in the new age. The age-old question, *how to live a just life in an unjust world*, found even greater urgency in an era when leading minds voluntarily accepted employment with Macedonian dynasties and Roman emperors. For example, how did one justify working for a murderous tyrant such as the Roman emperor Caligula? By and large, Hellenistic philosophers emphasized private virtues, contemplation, and self-discipline rather than a commitment to notions of the greater good. This was best expressed by three schools of thought: **Stoicism**, **Epicureanism**, and **Cynicism**.

Zeno the Stoic (390–310 BC) came to Athens from Cyprus and founded the school of Stoic philosophy. Not only did he believe in the existence of the divine intellect and divine law, but he also thought that it was possible for human intellect to merge with the *nous*. To Zeno the laws of the universe bound all humans as brothers; in essence, all men were equal. The key tenets of Stoicism were to accept one's fate, to bear it with equanimity, and to fulfill one's assigned role in life to the best of one's ability. If one were a slave, one should not question why this was so, for it was not one's purpose to question the workings of the universe: one should accept one's fate and be the best slave possible. The same was true for kings, although their duties required vastly more responsible behavior. Stoics also recognized the brotherhood of humankind and the need to exhibit compassion toward slaves and social inferiors. To a large degree Stoic notions of human equality were a reflection of the experience of Greek intellectuals living in non-Greek regions such as Egypt and Syria and coming to terms with native cultures. In any event, Stoic philosophy became extremely popular with the Roman aristocracy because it espoused a proactive rationale for engaging in public life. No longer viewed simply as a noble aspiration, a political life could now be justified as the duty of any enlightened citizen.

Epicurus (342–268 BC) took an opposing view when addressing the role of human existence. However much the world may have been designed as a machine by the *nous*, Epicurus argued that the gods had abandoned humankind eons ago and harbored no further interest in human affairs. Humanity was essentially on its own with few guidelines apart from the inherent order furnished by the laws of nature. Epicurus taught lessons of right conduct, serenity of mind, and moderation in all things. He argued that a truly wise person should seek pleasure, by which he meant absence of pain. In essence, his message was to avoid harmful, immoral experience. An Epicurean was expected to withdraw from society and to spend his life more usefully by contemplating the existence of the divine intellect and the harmonious order of nature. One can see how Epicureans took a distinctly contrasting point of view to that of the Stoics. Among the intellectuals to espouse Epicurean attitudes were the Roman poet Lucretius whose treatise *On the Nature of Things* survives as the most

complete explication of Epicurus's philosophy. Julius Caesar, and Cicero's good friend and correspondent T. Pomponius Atticus, were allegedly Epicureans as well.

Diogenes (ca. 412–323 BC) founded the **Cynic** school. Diogenes was a contemporary of Alexander the Great who ultimately settled in Corinth and became something of a curiosity and a tourist attraction. Diogenes doubted the likelihood that the human intellect could ever truly obtain enlightenment. At the same time he saw no sense in trying to save a world mired in hopeless ignorance. He argued that an enlightened person should not concern himself with wealth or power; he should find peace of mind by withdrawing from worldly affairs. The only thing that mattered was virtue, and virtue was unattainable to anyone who pursued worldly ambitions such as material wealth or political power. Cynics went about dressed in rags, living off the hand-outs of sympathetic people, much like itinerant Shramanic monks in India. Diogenes wisely observed the behavior of the Corinthian people and commented on the failings of society with incisive wit. Cynics and other philosophers known as the *peripatetics* (descendants of the school of Aristotle) traveled about the Greek world, offering up important instances of social criticism. They lent the Greco-Roman public an iconoclastic way of looking at things.

All three schools of Greek philosophy possessed limitations that were repeatedly exposed by their rivals. Only aristocrats could find real purpose as Stoics (slaves would hardly have cared); one had to be wealthy to enjoy the leisure time necessary to "cultivate one's own garden" like the Epicureans. Ultimately one had to abandon all material pleasures to be a Cynic (who at least accepted female philosophers into their midst, in part because by their way of thinking, doing so barely mattered). The impact these ideas had on the lives of everyday people in the Hellenistic world seems accordingly very minimal. Instead, the wider masses of the Greco-Roman era increasingly drew personal meaning from mystery cults originating from non-Greek regions of the eastern Mediterranean world. The cult of **Isis** obtained huge followings in places such as Athens and Rome by offering ceremonial purification from earthly sins, the comfort of an intimate, loving goddess, and the promise of immortality. Likewise, the cult of Mithras with its high ascetic requirements and its commitment to a virtuous role in the cosmic battle between forces of good and evil found tremendous appeal among warriors such as the Cilician Pirates, and by means of these, the humble legionaries of the Roman Empire. The message of these cults did not so much convey a summons to reform the world as it did an alternative call to ignore it. Mystery cults invited the initiates to transcend their daily miseries by offering them hope of greater compensation in a future life. It was precisely at this juncture that Christianity came into being. It is important to recognize the strains of various contemporary worldviews that survive in the teachings of Jesus Christ (ca. 6 BC–30 AD). As a rabbi, Jesus was trained in Hebraic law and the belief in one all-knowing, infinitely just god. As a philosopher, however, he clearly studied broadly and was versed in the vernacular language of competing philosophical and spiritual doctrines. Like the proponents of mystery cults, he offered hope to the downtrodden by promise of a better existence in the next life. Like the Platonic schools he insisted that the existence of god could and ultimately had to be proven through reason, that the process of enlightenment was never-ending, and that the

need for reflection and contemplation was crucial to one's spiritual development. And like the Buddhists and Cynics, he argued that the benefits of the material world were of negligible importance other than to reduce the misery of the poor. Because the teachings of Christianity operated on so many levels, it offered broad appeal to people in all strata of society and became the dominant way of thinking in the Mediterranean world by the fourth and fifth centuries AD. In the Gospel according to John, Jesus' disciple deliberately recalls the language of the pre-Socratics by employing the term *logos*: "In the beginning was *logos*, and *logos* was *theos*."

Much like developments in Judaism, Buddhism, and Confucianism (to be discussed below), the expression of Greek philosophy became increasingly monotheistic as its proponents worked to devise useful systems, or bodies of law, to guide human conduct in the material world. Given the ease with which travelers voyaged between world systems in this era, the likelihood of intellectual cross-fertilization cannot be excluded. Something about the cultural platforms, lines of communication, and the sustainability of recursive institutions in the emerging world systems of the Hellenistic and Roman eras facilitated the occurrence of intellectual breakthroughs of the highest order simultaneously on several continents.

GENDER RELATIONS AND SEXUAL BEHAVIOR IN ANCIENT GREECE

Along with intellectual accomplishments, those of creature comforts represent a second significant benchmark for Greek civilization. By the end of the Hellenistic era, Greek or Greco-Roman households attained a standard of comfort and permanence that was unsurpassed until modern times. Solid insulated walls, ceramic roofs, paved floors, interior kitchens, cisterns, and sewerage disposal all made living more tolerable. Every facet of household sanitation and food preparation was done by hand, however, and required significant hours of human labor energy to complete. The evidence indicates that the primary labor contributions to these endeavors, most particularly in the maintenance and development of domestic quarters in Greek society, were performed by women.

In an earlier chapter we attempted to outline a paradigm for the status of women in Bronze Age Mesopotamia and the ancient world in general. As with so many other aspects of the Greek experience, the surviving literature for Greek gender relations furnishes greater detail on these matters. The literary record demonstrates many patterns that were similar to behavior elsewhere but other aspects that appear to have been unique. By and large, Greek society exhibited the all-too-common dominance of patriarchal hierarchy. Due to the ascendancy of hoplite aristocracies in Greek city-states, male society possibly displayed a more overt double standard than that found elsewhere. The elite caste of freeborn, landholding, citizen-soldier-warriors tended not only to dominate the narrative of Greek history but also to impose its norms on all subordinate elements of the population.

That is why consideration of the material remains of the Greek household becomes useful. More than any evidence furnished by extant literary sources the remains of Greek households furnish the most reliable data about the day-to-day existence of Greek females.

Besides their function as domiciles for family nurturing, Greek houses were also the settings for the Greek male drinking party or *symposium*. Symposia occurred during festivals that coincided with Greek religious events approximately once a month. During these celebrations the Greek polis would suspend all public work, and men would congregate in taverns and private houses to drink, to converse, and to amuse themselves. Symposia were intended to promote patterns of male bonding that formed the underpinnings of Greek hoplite society. Sustained bonds of family unity, school-age camaraderie, shared political and military experiences, and repeated instances of personal loyalty helped male members of the Greek polis to forge bonds of collective identity. These frequently determined the outcome of military conflicts as well as political contests. Even the least advantaged citizens found ways to celebrate symposia typically by arranging potluck dinners that would rotate, month by month, among the households of the associated participants. Popular figures such as Themistocles, Aristophanes, Alcibiades, and Socrates were expected to make the rounds of dozens of symposia during the festival season, dropping in on one dinner party after another in an ancient form of table hopping. In a word, the symposium was arguably the most central social practice to the formation of cultural identity in the Greek polis.

Regarding sexual behavior in Greek society, the best we can do is to utilize the available information to identify the widest possible range of sexual behavior while recognizing that the behavioral pattern of most inhabitants fell somewhere in between. Repeatedly we find ourselves confronted by the following question: was the behavior represented on the vases or in the textual source literature "closet behavior" of a privileged and limited aristocratic elite, or was it something symptomatic of mainstream society? A useful presentation of this question has been framed by Eva Keuls in her book *The Reign of the Phallus*. Put baldly, Keuls claims that ancient Greek men were pigs. As the dominant element in society, Greek males imposed their will on all beneath them, including women, both free and slave; children, male and female; and other men, through domineering homosexual relationships associated with symposia. It was almost as if the hoplite warrior element exerted its authority sexually as one of several ways to demonstrate its virility, thereby objectifying all subordinate elements of society. However, it is equally possible to view this development within the context of broader social mores and patterns of childhood development. First, we need to recognize that the purpose of marriage in Greek society was to generate the necessary conditions for the maintenance of the Greek household. This included not only the procreation of children necessary to sustain the family line, but, equally and perhaps more importantly, it entailed the handing down of a given family's assets from one generation to the next. All marriages were arranged by parents, usually neighbors or interrelated aristocratic families, at the time when prospective spouses were still children.

To insure the sanctity of the marriage relationship and the purity of the family line, freeborn Greek children underwent a highly restricted, segregated upbringing, at least

insofar as sexual interaction with the opposing gender was concerned. Within the social stratum of freeborn landholding citizen elites, young people of opposite genders remained rigidly segregated. As with other ancient cultures, the freeborn daughters of respectable landholding families entered into contractually arranged marriages with males from neighboring families for purposes of procreation and to maintain the economic foundations of both families. Dowries and gifts of land parcels accompanied the coming of age in Greek society. Religious stipulations, such as the need to produce a male heir to preserve the ancestor cult, added the additional requirement that the Greek bride be a virgin at the time of her marriage. Young females would be kept carefully cloistered in the private recesses of the family household and even more carefully chaperoned in public. They were generally required after puberty to hide their features whenever they were in public, donning clothes similar to those worn by females in contemporary Islamic society. Virginity prior to marriage was a requirement of the marriage contract, and chastity and modesty after marriage were norms not only expected of but imposed on respectable Greek females. Married women were expected to maintain the household; to spin and weave clothing for the family (as well as for retail sale); to direct household servants; and to attend to the highly demanding tasks of cooking, cleaning, and domestic hygiene; not to mention the raising of the family's young. In view of the limited technologies available for these tasks, the number of laboring hours devoted to them was considerable. These requirements inevitably induced families to arrange marriages for female children early on in life. On the whole, young freeborn women of property-holding families would be married as soon as they reached puberty to begin the process of childbearing and to maintain the domestic quarters of the newly formed family.

The male's decision to marry was determined by the availability of property assets necessary to sustain a family. Normally, this occurred through inheritance, for example, when the eldest surviving male of the family died and the estate was divided among his sons and grandsons. Sometimes a Greek male would have to wait until fairly advanced in age before he acquired his portion of the family patrimony. Accordingly, marriage patterns in Greek citizen communities tended to combine extremely young females (early teens) with mature adult males (twenties to thirties). Prior to sexual relations by marriage, Greek males resorted to alternative outlets of sexual activity. Given the inordinate length of bachelorhood in ancient Greek society, a man's reliance on these outlets tended to develop into habits that carried over into married life. These outlets, in addition to household servants, included professional courtesans and homosexual relationships.

Those males who could afford the expense purchased the services of prostitutes, particularly highly gifted, attractive, oftentimes articulate **hetairai**. Typically of slave or foreign origin, hetairai were call women, the ancient Greek equivalent to Japanese geisha or medieval European courtesans, who were trained in music, dance, and poetry to entertain men at the symposia. In other words, they furnished entertainment and sophisticated conversation as well as sexual favors; they appealed to the minds of their male clients as well as to their sexual desires. In addition, hetairai tended to be more sophisticated and more mature than freeborn wives and inordinately capable of competing for the affections of

adult Greek males. Nonetheless, they remained recognized socially as unchaste or "beyond the pale." Hetairai were also extremely expensive and were notorious for their tendency to exploit their lovers financially before their attraction wore off. Although Greek male experience with hetairai would begin prior to marriage, the character of these relations was such that the male's participation in sex-laboring culture would continue long afterward. The host of a Greek symposium was expected, for example, to recruit hetairai and young flute girls to entertain his guests during the banquet. At least three Greek writers wrote books recording the lives of celebrated hetairai and their lovers; the fragments of these works, preserved in Athenaeus's *Deipnosophistae*, indicate that nearly every famous Athenian politician, sculptor, dramatist, and philosopher possessed a courtesan mistress at some point in his career. These relationships were simply that commonplace, hence, the centrality of this figure in Greek society and her potentially destabilizing influence on Greek family life. It is important to recognize as well that for women originating from non-respectable, impoverished families and/or slave origins, life as a hetaira offered the only potential avenue for upward social mobility. One could go from being an abandoned fondling collected by a pimp in the streets to becoming, like **Aspasia of Miletos**, the mistress and eventually the wife of one of the leading political figures of the day, namely, Pericles. The potential of these women to influence the political decisions of their lovers angered freeborn elements of society, particularly since any and all female involvement in politics was regarded with distaste.

Pederastic homosexual relationships were also encouraged to some degree by the social elite of the ancient Greek polis. These relationships occurred very early in life as Greek males participated in the athletic regimen and education of the **gymnasium**. Here in this enclosed, semiprivate environment, adult Greek males tended to exploit younger males for sexual favors and emotional relationships. Since young males had no monetary resources, could not afford hetairai, or other, more common forms of prostitution, and could not expect to date respectable females in any manner whatsoever, their outlets for sexual experimentation were inevitably restricted to relations with household servants, if available, and to other males. Evidence of fairly elaborate courting rituals among older Greek males and their younger lovers indicate the likely commonplace character of these relationships. A meticulous etiquette evolved establishing norms of behavior within these relationships, which sexual activities were deemed acceptable and which were debased or degrading. For some, homosexual relations possibly served as a rite of passage, something experienced in lieu of heterosexual dating until such time as marriage or dating with hetairai became feasible. Others clearly continued with this behavior after marriage, oftentimes in combination with the exploitation of hetairai. This would seem to indicate that wider Greek male society was not so much homosexually inclined as it was bisexual. At the extreme end of the spectrum stood the elite fighting forces, such as the Spartan cadet corps at the phiditia or the Theban Sacred Band of 400 elite warriors. Among these groups, homosexual relations were openly encouraged as a means to reinforce the intense levels of emotional bonding that were believed necessary to sustain military ardor on the battlefield. A seemingly ascetic quality was assigned to this lifestyle by wider society, given

that it was admired and emulated by military elites throughout the Greek world. This in turn places emphasis on the centrality of the military experience, what is referred to here as the "hoplite mystique," in Greek sexual mores.

Modern students invariably question how young Greek males who were not homosexually inclined could be drawn into pederastic relationships in the first place. There is some evidence that ancient Greek families worried similarly; many attempted to protect their sons from these relationships, going so far as to assign slaves known as *pedagogues* to chaperone their sons' trips to and from the gymnasium. To some degree, one can argue that the dominant role played by the warrior-hoplite in all Greek societies enabled them to impose their norms on their respective societies and to serve as the models of male cultural behavior. Given the degree to which young Greek males aspired to emulate these role models, they would have been hard-pressed to view activities such as pederasty and prostitution in a negative light. In addition, the prevalence of homosexual and bisexual orientation generally in human societies all too often gets ignored in this context. Modern research has demonstrated that tendencies of homosexual or bisexual orientation are far more commonplace than generally recognized. Since most of this research is based on less reliable forms of sampling, scholars assume that these numbers and percentages are in fact underreported. It is entirely likely that the percentages of homosexual and bisexual orientation in ancient Greece were similar, therefore, and that the inhabitants of Greek polis communities were simply more open and tolerant of this behavior than contemporary societies.

Either way, the inhabitants of ancient Greece appear to have been far more comfortable with these tendencies than some elements of contemporary society, and it is worth noting that the patriarchy of the Roman Republic expressed similar revulsion for homosexuality—despite evidence of its practice—at Rome. Roman male sources also tend to display a greater awareness for the role of females in society (however much chagrined to admit it). Greek male writers rarely make mention of women, almost as if they were invisible. Exceptions can always be forwarded—arguably the greatest of all lyric poets, Sappho of Lesbos, was a lesbian, and several Greek aristocratic females, such as Elpinice, the sister of the Athenian general Cimon, used the autonomy afforded by their high stations in society to engage in sexually liberated lifestyles. Apart from these, however, we know far more about the lives of Greek hetairai, including their professional names and the names of their lovers, than we do about the long-suffering Greek matrons who day-in and day-out managed Greek households and nurtured Greek families. This suggests that the Greek patriarchy was more tolerant of alternative sexual orientations than its contemporaries.

In conclusion, it seems wisest to turn to the evidence furnished by the archaeological remains of the Greek household as the best preserved testimony for the experience of ancient Greek females—the pots and pans, dinner plates, small braziers used for cooking and heating, evidence of refined wall painting, richly woven textiles, and serene gardens situated within the interior courtyards of Greek households. These as well as the remains of children's toys and family pets combine to furnish the most telling elements of their world. By creating and maintaining tranquil domestic environments—house by house,

block by block—across the urban landscape, women worked to weave together the social fabric of ancient Greece.

FURTHER READING

Andrewes, A. *Greek Tyrants*. London: Hutchinson, 1966.

Cartledge, Paul. *Sparta and Lakonia: A Regional History, 1300–362 BC*. London: Routledge, 1979. https://doi.org/10.4324/9780203472231.

Cassirer, Ernst, Paul Oskar Kristeller, and John Herman Randall, eds. *The Renaissance Philosophy of Man*. Chicago: University of Chicago Press, 1956.

Errington, R. Malcolm. *A History of the Hellenistic World, 323–30 BC*. Oxford: Blackwell, 2008.

Fullerton, Mark. *Greek Art*. Cambridge: Cambridge University Press, 1999.

Guthrie, W.K.C. *History of Greek Philosophy*. 6 vols. Cambridge: Cambridge University Press, 1962–1981.

Hammond, N.G.L. *A History of Macedonia*. Oxford: Clarendon Press, 1972.

Hankins, James. *Plato in the Italian Renaissance*. Leiden: Brill, 1990.

Honour, Hugh. *Neo-Classicism*. New York: Penguin, 1975.

Keuls, Eva C. *The Reign of the Phallus: Sexual Politics in Ancient Athens*. Berkeley: University of California Press, 1985.

Meiggs, Russell. *The Athenian Empire*. Oxford: Clarendon Press, 1979.

Ober, Josiah. *Mass Elite in Democratic Athens: Rhetoric, Ideology, and the Power of the People*. Princeton, NJ: Princeton University Press, 1989.

Pollitt, J.J. *Art and Experience in Classical Greece*. Cambridge: Cambridge University Press, 1972.

Rhodes, Robin Francis. *Architecture and Meaning on the Athenian Acropolis*. Cambridge: Cambridge University Press, 1995.

Ridgway, Brunilde Sismondo. *The Archaic Style in Greek Sculpture*. 2nd ed. Chicago: Ares, 1993.

Smith, R.R.R. *Hellenistic Sculpture*. New York: Thames and Hudson, 1991.

EIGHT

ANCIENT CHINESE CIVILIZATION
(2000 BC–200 AD)

WHAT HAVE WE LEARNED?

- ► That the Greek tyrant was a nonhereditary ruler who acquired power through unconstitutional means, usually with widespread popular support.
- ► That the Spartan hierarchy avoided tyranny by expanding its aristocracy to include all freeborn, full-blooded Spartans as state-supported warriors. Athens contrastingly endured tyranny to emerge as a democratic society, the largest polis and greatest maritime power of the Aegean.
- ► That the external threat of Persian invasion compelled states in western Greece to suppress their particularistic tendencies and to combine efforts as Panhellenic Hegemonial Leagues. Continued internecine Greek warfare opened the way for Macedonian intervention and conquest.
- ► That following the death of Alexander the Great (323 BC), Macedonian generals endured 60 years of civil war in a struggle for succession. The survivors ultimately achieved a balance of power among four dominant successor states: Antigonid Macedonia, Attalid Pergamum, Seleucid Syria, and Ptolemaic Egypt.
- ► That Greek philosophers—of which Socrates, Plato, and Aristotle are the most well known—developed the dialectic or a process of intellectual inquiry through open debate.
- ► That the Greek male's decision to marry was determined more by the availability of resources necessary to sustain a family. Marriage patterns in Greek citizen communities tended to mate younger females (early teens) with mature adult males (twenties to thirties), forcing unattached Greek males to seek alternative sexual outlets such as hetairai and homosexual partnerships.

Having considered the development of Greek civilization through the formation of a wider Hellenistic world, we must now turn to consider the cultural development of the easternmost civilization of ancient China. The expansion of Greek patterns of urban society across the eastern Mediterranean raised productivity and standards of living throughout this basin. Together with the conquests of Alexander the Great, these stimulated contacts with producers in India and China. Furthest removed by distance and topography, China appears to have been the last of the three great world systems to join the global community. By the time of the Han Dynasty's expansion into Central Asia (202 BC–220 AD), interconnectivity with India and the Mediterranean became a reality. Although the sinuous link furnished by pastoral peoples played an important and sustained role in the development of Chinese civilization, Chinese society emerged largely in isolation. Apart from the persistent marauding of the Hsiung Nu (the Huns), no armies from distant empires ever invaded China. On several occasions, however, armies of the Han Empire invaded Central Asia. One commanded by the Han general Pan Chao in 97 AD penetrated 4,000 km across the region, advancing as far as Iran. This indicates that the Chinese became aware of the importance of the land route across the continents (later known as the Silk Road) and worked to control it. In other respects, China remained predominantly an agrarian society with few neighboring trading partners. Those populations that did exist in neighboring waters—Japan, Taiwan, and Indochina—were essentially satellite societies that developed in response to Chinese expansion and largely assimilated urban culture from China. Apart from the threat posed by nomads to the north (the Hsiung Nu), China remained an entity to itself. Unlike urban forms of development in the West, Chinese society, its governmental system, its material culture, its architectural forms, and its written language all emerged in the Early Bronze Age. These forms evolved at their own pace and sustained themselves for millennia. Consistency is possibly the defining term for Chinese civilization. The core of its culture evolved on the Huanghe or Yellow River by 1500 BC and expanded and evolved slowly and incrementally.

CHRONOLOGY 9. ANCIENT CHINESE DYNASTIES	
1994–1523 BC	Xia (Hsia) Dynasty (Legendary)
1523–1028 BC	Shang Dynasty
1027–221 BC	Zhou (Chou) Dynasty
771–481 BC	Spring and Autumn Period
480–222 BC	Warring States Period
221–202 BC	Qin (Ch'in) Dynasty
202 BC–220 AD	Han Dynasty
220–589 AD	Era of Disunity

China was connected to other early civilizations by means of a dispersed chain of pastoral peoples that transmitted ideas, material goods, and technologies across the vast steppes of Eurasia. The Chinese probably acquired some technologies, such as iron smelting, horse chariots, and horseback riding, from without. Others technologies, such as grain and rice production, bronze manufacture, the horse harness and stirrups, were native inventions, developed better and earlier in many respects than they were in the West.

THE ECOLOGICAL SETTING OF CHINA

The landscape of the Chinese mainland embraced coastal lowlands, piedmont tablelands, and highland prairies and mountains extending approximately 9,000 km north to south and 5,000 km east to west. Given this vast extent of terrain wide variations in climate and environment are only to be expected. The heartland was bounded by the Huanghe (Yellow) River in the north and the Yangtze in the south. This region represents a great plain extending more than 300,000 square kilometers. To the north lay the steppes and desert wastelands of Mongolia; to the west, mountain ranges and piedmont plateaus rise from

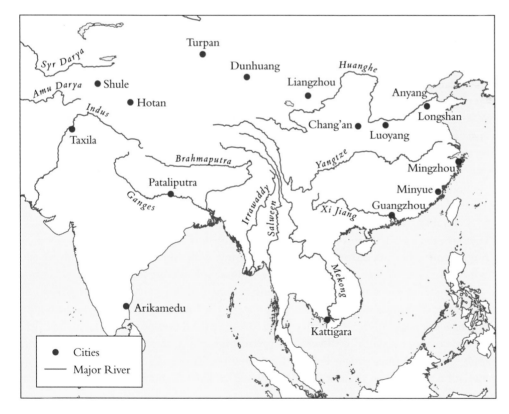

Map 12 Sites of Interest in Ancient China.

the river valleys to the distant base of the Himalaya Mountains. To the south the environment turns humidly subtropical and in antiquity was covered with dense rainforests. Between China and the Indian Ocean (southwest) lay numerous impenetrable mountain ridges, the result of repeated folding of the crust of Asia following collision with the Indian subcontinent millions of years ago. To the east, the shoreline of China was immense (ca. 3,670 km), with several deep-water ports such as Guangzhou (Canton) along the southern shore and with neighboring landmasses such as Korea, Japan, and Taiwan within navigable reach. The Huanghe River was navigable far upstream. As a transportation route it was enhanced by the construction of large canals and adjoining road networks. Grain and millet were produced successfully in the deep loess soil and remained the staple food products not only for most Chinese cities in the north but also for the pastoralists who lived in the highland steppes beyond the Huanghe basin. These depended inordinately on the Chinese for foodstuffs and finished goods.

Further south, with the Yangtze River marking the approximate border, the climate turns warm and humid. Along the Yangtze and further south at the Xi Jiang (the Red River), rice technology was harnessed by Neolithic farmers; rice farming has been confirmed as early as 5000 BC at Hemudu (near Minyue). Precisely where the technology of wet rice agriculture originated is unknown: it appears to have extended from modern-day Bangladesh to Vietnam, and it probably arrived in China through cultural transmission. Rice production entailed a multi-step process demanding abundant water and sustained human labor energy. The plants were ordinarily grown for their first month in seed beds, while subsidiary crops were raised and harvested in dry fields. The fields were then irrigated, fertilized, and plowed in preparation for the transplanting of rice seedlings. Diligent human labor was required to transplant, weed, and water the seedlings. Once the crop was ripe, the field was drained and harvested. Due to the intensive labor requirements, the size of an individual rice paddy was relatively small. However, wet rice agriculture typically yielded two and in some regions three crops per year, and was capable of generating eight times the food mass of a similar sized plot of land devoted to wheat or millet. Rice farming was able to sustain very large populations per square kilometer, accordingly. The high labor requirements of rice production all but depended on a dense settlement pattern. No one community could marshal the labor and resources necessary to perform and maintain so deliberate an agricultural system. Living in close proximity to family and neighbors, the early farmers of China grew accustomed to a collectivized lifestyle in which group identity prevailed over individual autonomy. The unquestioned hierarchy of the traditional family system tended to prepare Chinese inhabitants to accept status distinctions at higher levels of society. Family identity remained the basis of social organization throughout Chinese history, provoking the sociologist Max Weber to characterize China as a *familialistic state*. Political authority inevitably gravitated toward those who could organize and control neighboring clusters of agricultural communities and maintain the food supply. Land clearance proceeded rapidly during the Bronze Age. Eventually the rising population reduced the amount of land available for pasture and with it the potential for livestock production.

Shang artists created some of the finest bronzes of the second millennium BC, revealing their mastery in casting, the likely existence of well-organized workshops, as well as the power and vitality of the period. Bronze ritual vessels—highly decorated with abstract animal motifs—were made for the purpose of offering food and wine to ancestral spirits. As such, these often-elaborate vessels lay at the heart of sacrificial rites performed by the ruler and aristocracy (including funeral ceremonies), with the shape of each vessel matching its intended purpose. At least 30 main types of ritual vessels are known, ranging in size from several centimeters tall to gigantic *ding* measuring almost 2 meters high and weighing nearly 2,000 pounds. This *you* vessel—a covered vase or jar with a swinging handle—was used to hold fluids, mainly wine. The vessel is decorated with a zoomorphic *taotie* mask motif in bold relief.

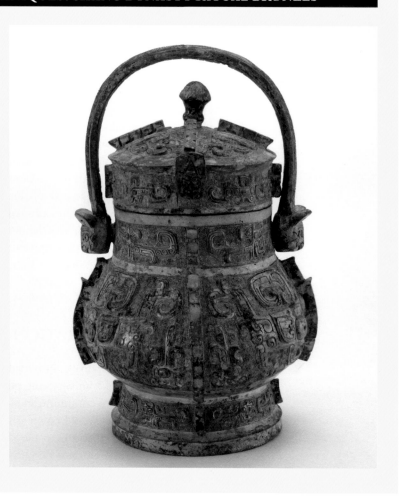

Figure 8.1 *You* ritual vessel. Bronze, 36.5 cm high. Late Shang period. Freer Gallery of Art, Smithsonian Institution, Washington, DC.

Further south, much like southern India, malarial forests became an impediment to the expansion of urban settlement. Populations remained tribal and dispersed. The density of the rainforests along the coast of Southeast Asia and the vast and remote expanse of this shoreline appear to have obstructed maritime travel between India and China during the Classical Era (a voyage from Guangzhou [Canton] on the Xi Jiang River to the mouth of the Ganges was at least 6,400 km). Given the limited progress of shipwreck archaeology in this region, the true extent of ancient maritime travel in Southeast Asia remains unknown. Explicit Chinese textual references to sea voyages between India and China remain few prior to the fifth century AD, when they begin to rise in frequency. Possibly by this date the disparate populations inhabiting these coasts became sufficiently stable and interconnected to furnish nodes along this crucial maritime trunk route. This question will be discussed in the final chapter.

To the west, the rich agricultural plains of China narrow and rise through gaps into upland valleys enclosed by mountains. One region, Shensi (Shaanxi), "the land within the two passes," played a recurring role in Classical Chinese warfare and state formation, most probably because of its proximity to pastoral populations to the north and west, which enabled Shensi leaders to recruit intimidating military manpower. Beyond this region one passed into the vast desert steppes of Mongolia to the north or the equally arid highland basin of the Tarim or Taklamakan Desert to the west. In this broad oval wasteland ringed by high mountains, snowmelt from the mountains furnished the potential for a dozen isolated oases settlements along its margin, including Shule (Kashgar) and Hotan (Khotan). These oases communities, with populations recorded by Chinese officials ranging from a few hundred to as many as 30,000 inhabitants, served as important nodes for Chinese communication with the West. Difficult passes through the Pamir Mountains, reportedly enhanced by the construction of wooden suspension bridges, enabled caravan traders and migrants to cross this divide to the opposite steppes of Sogdiana and Bactria, and from there across Afghanistan (Gandhara) to India, Iran, and the distant Mediterranean world.

CHINESE STATE FORMATION

The early history of China remains shrouded in legend. According to Chinese mythology, the deity Pangu created the universe and placed upon earth a dynasty of sage-emperors who taught the Chinese to communicate, feed, cloth, and build shelter for themselves. These legendary emperors were known as the Xia or Hsia Dynasty; in historical terms they ruled from roughly 2000 BC to 1600 BC. Archaeological investigation at the late Neolithic/early Bronze Age site of Longshan indicates that by the time of this dynasty, several crucial cultural attributes of later Chinese society had emerged. Prestige goods included jade instruments (imported from western mountains and believed to have life-extending properties), lacquered ceramics, **ritual vessels** (first of ceramic, then of bronze), and silk textile produced from the cocoons of caterpillars that thrived on the leaves of native mulberry trees. High-firing pottery kilns led to a superior form of bronze casting by 2000 BC as well as to the development of porcelain or enameled ceramic wares. Although the quality of Chinese fired bronze was vastly superior to the metals produced contemporaneously in the West, cultural isolation meant that bronze continued in use as the principle technology for tools and weapons until the era of the Warring States (480 BC). Also at Longshan, oracular responses were obtained from the fired bones of sacrificial animals. Diviners (soothsayers) attending the kings would apply heated metal to the shoulder blades of sacrificed cattle (as well as to tortoise shells) to obtain oracular messages from the gods. The omens would then be inscribed in proto-Chinese characters directly on the animal remains. The recording of oracular responses appears to have occurred as early as 2500 BC, with evidence of a fully developed writing system by 2000 BC. Aspects of this proto-Chinese script appear to have emerged from the process of prognostication itself as well

as from the belief that oracular activities enabled the king (and others) to communicate with the dead.

Chinese writing technology employed complex systems of characters, or glyphs, that were at one and the same time pictographic and *logographic* (symbols designating actual spoken sounds). Most Chinese characters combined two or more glyphs to form more complex words. Besides pictographs, logographs, and ideographs, the language employed some unique features such as logical aggregates (the combination of two or more glyphs to form a new meaning), phonetic complexes (glyphs known as radicals that serve to indicate a general semantic category), transference (simple characters expressing an extended, abstract meaning), and borrowing (characters used to mean something other than its original sense). The vast majority of Chinese characters were constructed, in fact, of complex forms such as these. By the late Bronze Age some 2,000 characters were in use. By the beginning of the Han Dynasty (202 BC), a variety of writing materials was being used, including clay tablets, silk cloth, and rolled scrolls made from bamboo strips sewn together with hempen string; by the first century AD Chinese artisans invented a form of paper. A Han Dynasty exposition of Chinese characters (the *Shuowen Jiezi*, 120 AD) lists some 10,516 Chinese characters in use at that time. The sheer volume of characters required would seem to have significantly limited the extent of literacy in Classical-Era China. However, language scholars observe that modern Chinese university students typically master some 3,000 to 5,000 characters used in 40,000 to 60,000 Chinese words. This potentially challenges the prevailing skepticism that ordinary people in China, or Mesopotamia, or Egypt for that matter could not have mastered the complex scripts of their respective civilizations. In any event, the Bronze Age script of the Shang Dynasty gradually evolved to form the basis of the ancient as well as modern Chinese writing system.

Unlike urban settlement patterns in the West, in Bronze Age China settlements were organized according to **urban clusters**, elite enclosures (fortified precincts) surrounded by a scattering of workshops and artisan-supported farm villages. The remains of the enclosures demonstrate that they were constructed typically of pounded earth through the use of wood framing. Archaeologists estimate that the Shang capital's earthen walls would have required an estimated 10,000 workers 18 years of labor to complete. The monumental precincts contained both residential palaces and ritual complexes. From the time of the earliest urban settlements, accordingly, Chinese elites appear to have distanced themselves from the common people by dwelling within these precincts. By the time of the Shang

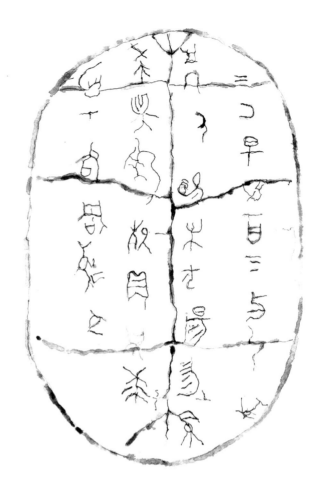

Figure 8.2 Tortoise shell bearing inscribed oracular response. Artwork by Herb Rauh.

Dynasty (1523–1028 BC) more than a thousand such nucleated settlements existed along the lower reaches of the Huanghe River, with many specifically named by inscribed oracle bones. The settlement pattern of Longshan culture indicates the existence of neighboring warring elites, therefore, with each noble house struggling to maintain its position or to gain ascendancy over its rivals. The archaeological record also indicates that ritual vessels, the 50-odd forms of which became canonical over time, represented important emblems of elite status.

According to the Chinese textual tradition, the Xia Dynasty was deposed by the Shang family. At this point we are much better informed, not only by surviving historical texts but by the recovery of more than 100,000 inscribed oracle bones at the capital of Anyang (Nanyang). The king, who spent most of his energy fighting nomads and invaders from the north, ruled from his capital as the religious and secular head of society. He functioned as the head of a patrimonial state that was as much theocratic as secular in its political responsibilities. The king was not merely the earthly sovereign but the deputy of T'ien, the chief god of the Chinese pantheon, also known Shang Ti, "the Supreme Ancestor." By his oracular responses, the king was recognized by the heavens as an adopted son entrusted by the **Mandate of Heaven** to rule over earth. As ruler of China the king served as the sole mediator between this deity and the inhabitants of the realm, T'ien's direct descendant, as it were. Excavation has revealed the remains of a multi-stepped, pounded earth platform that served as an altar, the so-called **Altar of Heaven**, where the king would perform sacrifices to T'ien. Ritual vessels, as noted above, demonstrate the pivotal place of ancestor cult in Shang society. Chinese aristocrats believed that the spirits of deceased relatives embarked on a long and tortuous journey into the heavens with no guarantee of success. Those who arrived at the ultimate destination were allowed to sit at the court of T'ien. It was the duty of Chinese descendants, particularly the eldest male of a given family, to assist these spirits in their journey by feeding them through ritual sacrifices. Only this would enable them to attain their place in the heavens and to assist their descendants on earth. Not only the canonical ritual vessels themselves but even the pictographic forms of early Chinese characters are believed to have been fashioned from this worldview. By practicing this pronounced ancestor cult, the Shang rulers were able to legitimize their authority. They not only monopolized use of the Altar of Heaven, but they also controlled the production and distribution of prestige goods, such as bronze ritual vessels, jade ornaments, and silk.

All three of the early dynasties—Xia, Shang, and Zhou—succeeded one another without evidence of cultural interruption or external interference. Each dynasty probably overthrew its predecessor by military means, something historically confirmed in the case of the Zhou. Having ejected the Shang, the Zhou (1027–221 BC) undertook a number of political and symbolic measures to assert their authority over neighboring states. The Zhou organized a feudal network of vassal states by dispatching sons and relatives to preside over conquered principalities. Each local king had to swear allegiance to the Zhou emperor before being dispatched to govern an assigned territory. In addition, whole communities descended from common lineage groups would accompany each new

vassal king to govern the local population as garrison forces. Perhaps as many as 1,800 such feudatory states were established in this manner. To dispel religious concerns regarding the legitimacy of their ascent to power, the Zhou proclaimed that the Shang had lost the confidence of T'ien through their corruption and incompetence and that they could no longer guarantee the religious safety of the Chinese people. In other words, the Shang's spiritual fall from grace all but required that the Zhou assume this responsibility. By arguing this principle, the Zhou modified the concept of the Mandate of Heaven to allow for the transference of religious authority to another morally worthy dynasty. Royal power in China was, therefore, commutable under the appropriate circumstances. Diviners educated in the required rituals would guide the Zhou and later kings through their sacrifices at the Altar of Heaven and monitor the resulting omens. A clustering of bad omens might very well indicate that a given king's mandate had expired. This development not only placed inordinate emphasis on ritual procedures among the ruling class, but it also introduced the concept of royal accountability to a higher moral authority. In essence, the religious rationalization for the Zhou's rise to ascendancy initiated a set of moral criteria for the assumption of power itself. Throughout Classical Chinese history, once a dynasty was shown to have lost its moral ascendancy (in part through negative prognostication), it became impossible to preserve its authority.

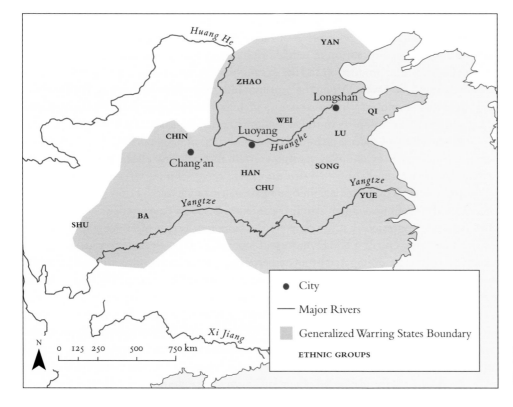

Map 13 Chinese Polities at the Time of the Warring States (480–222 BC).

The power and legitimacy of the Zhou were weakened gradually by their inability to confront mounting raids by Turkic and Mongolian marauders from the north. Roving bands of horse-mounted warriors repeatedly pillaged and plundered the settlements of exposed feudal states. The burden of incessant warfare forced the Zhou emperors to impose greater demands on their vassals for military manpower and supplies even as their legitimacy waned. In 771 BC an alliance of frustrated feudal lords attacked the Zhou emperor at his capital, sacking the city and eliminating the king. One prince of the realm managed to escape eastward to Luoyang to reconstitute the dynasty, hereafter known as the Eastern Zhou Dynasty. However, the Eastern Zhou emperors lacked the necessary resources to rebuild the empire and were obliged to accept status as religious figureheads. In essence, the kings of the Eastern Zhou Dynasty were relegated to the status of sanctified overlords whose primary role was to perform the sacrifices necessary to preserve the equilibrium between heaven and earth. This enabled former vassal states to expand on their own, typically at the expense of neighboring polities.

Internecine warfare became a widespread problem. During the era known as the **Spring and Autumn** period (771–481 BC) as well as during the subsequent, significantly more violent era of the **Warring States** period (480–222 BC), a number of conflicting developments arose. Success in military conflicts enabled some states to absorb their defeated neighbors into larger regional polities. The number of existing states declined from approximately a thousand states in 1026 BC to a hundred states in 771 BC; fourteen states by 480 BC; and finally one state, the Qin or Ch'in of Shensi, in 226 BC. Despite the rising threshold of violence, the population of the surviving states actually grew in size—not only through the incorporation of neighboring territories but also through the intensification of agricultural production and the expansion of territory into non-Chinese lands to the north, south, and west. Along the northern hills of the Huanghe River, for example, local dynasties employed various strategies such as tax exemptions, land sales, and land allotments to settle colonists in forest and grazing lands previously occupied by non-Chinese nomads. This process disrupted the equilibrium of neighboring nomadic societies while expanding the extent of agricultural terrain through land clearance.

Scholars have recently observed that the expansion of Chinese territory into nomadic territories actually compelled neighboring pastoralists, such as the Hsiung Nu (Huns), to organize themselves into larger, stronger confederacies. The development of Hsiung Nu confederacies progressed at approximately the same rate as that of Chinese urban states. By the time of the Qin or Ch'in Dynasty (221–206 BC), the amalgamated confederacies of the Hsiung Nu were dominated by an emperor (*shanyu*) and supreme council and posed a serious threat to neighboring Chinese polities. As Hsiung Nu raiding of Chinese border states accelerated, the exposed principalities responded by constructing extensive perimeters of earth-constructed barriers along the newly claimed frontiers. These defenses would eventually evolve into the **Great Wall** of the Qin and Han Dynasties. The purpose of the Great Wall appears to have been not so much to keep mounted bands of Hsiung Nu warriors out of China as it was to restrict points of access and thereby to reduce their mobility. The walls also eliminated the likelihood of reinforcement and random escape. Along the western

highlands of the Huanghe River, captured Hunnic warriors were frequently settled inside the walls by Chinese warlords as a means to complement their infantries with skilled cavalry contingents. Eventually this practice furnished border states such as the Qin of Shensi with a decided military advantage over their rivals in the eastern plains. At one and the same time it earned them dubious reputations as semi-barbarous polities. The historical record indicates, nonetheless, that non-Chinese pastoralists quickly assimilated to mainstream culture and became indistinguishable from native Chinese inhabitants.

The rising emphasis on mounted warfare created an equally large demand for war horses. Since horse trading and horse breeding became crucial to the success of Chinese military expansion, horses came to assume nearly mythical status in Chinese lore. To address the tactical advantage of cavalry, meanwhile, rival polities abandoned now obsolete forms of aristocratic chariot warfare in favor of large formations of infantry armed with powerful crossbows (another Chinese invention). The need to furnish large armies with armor and weaponry also placed heightened demand on mining and metallurgy, particularly in the eastern states where iron ore was accessible by sea from mountainous regions to the south. Once effectively introduced, Chinese iron smelting achieved higher levels of proficiency than it did in the West. By devising technologies such as hand-pumped bellows and coal-processed charcoal, Chinese metallurgists were able to obtain the high firing temperatures necessary to generate carbonized steel. The deadly combination of Hunnic cavalry formations and heavily armed mass infantry ultimately revolutionized Chinese warfare during the violent era of the Warring States and rendered the outcome of military conflicts increasingly decisive.

The political and social instability that accompanied the ineffectual leadership of the Zhou thus set in motion a number of dramatic changes. As accelerated warfare displaced local dynasties and their hierarchies, leadership cadres abandoned the old ways of feudal hierarchy to seek new forms of employment. Scholars and former officials with skills acquired through years of service with unsuccessful vassal states migrated throughout China to offer their talents to competing dynasts. Ancestral ties of obligation were soon replaced by contractual arrangements. Those finding employment with new realms typically received payment in the form of rents drawn from clusters of agricultural communities assigned to their control. Despite the fact that wealth remained solidly based on agricultural production, in other words, land ownership underwent a significant transformation. This forcible redistribution of landed wealth gradually replaced the ancient Chinese aristocracy with a newly emerging **gentry-based ruling class**. To succeed in this dynamic environment, aristocratic descent was no longer a priority; a candidate needed to be educated, cunning, and ruthless. One notorious adviser, Lu Pu-Wei, rose from humble beginnings as a merchant (possibly as a horse trader) to become the chancellor to the duke of Qin and regent to the eventual emperor, Qin Shih Huangdi.

In an era of widespread social upheaval and uncertainty, people invariably question the legitimacy of traditional mores. Intellectual debate in China flourished among *One Hundred Schools of Thought*. From this ferment, three competing worldviews came to dominate imperial Chinese ideology: **Confucianism**, **Taoism**, and **Legalism**.

CLASSICAL CHINESE PHILOSOPHIES

Confucianism

According to tradition, Confucius or Kung Fu Tzu (551–479 BC) was a typical example of a displaced learned official. Raised and educated in the feudal state of Lu (modern Shantung), Confucius acquired the reputation of a scholar and made a living teaching young aristocrats and assisting with the administration of noble estates. After failing in numerous attempts to secure political advancement at Lu, he abandoned his home state in search of opportunities elsewhere, accompanied by a few young men who were most probably the sons of destitute scholars like himself. After a series of short-term posts that invariably ended in dismissal, Confucius abandoned his hopes of obtaining a career as a professional courtier and returned to Lu, where he taught until his death. His teachings were heavily influenced by his origins (Lu was a stronghold of Shang traditionalism), his background as an aristocratic outsider, and his experience as an unsuccessful courtier in these greatly disturbed times.

Confucius's teachings furnished a code for the emerging gentry-based ruling class. Much like Buddhism, Confucius did not challenge the essential construct of the traditional Chinese religious worldview. Instead, he offered moral instruction for the conduct of human affairs on earth. In many ways Confucius was a traditionalist, committed to Shang-era beliefs in the ancestor cult and the Mandate of Heaven. He insisted, however, that rather than functioning solely as the arbitrary king of the heavens, the god T'ien represented the embodiment of a universal system of order and legality, the so-called principle of **Tao**. Humans needed likewise to conduct their earthly affairs in accordance with Tao. To insure the safety of the Chinese people, for example, the emperor needed faithfully to observe the established ceremonies and to offer prescribed sacrifices in accordance with the law. Lesser individuals likewise needed to conduct their lives in such a way that harmony was preserved between the cosmic realm and human society. This harmony presupposed the subordination of the individual to the community according to clearly defined principles of rank. In Confucian philosophy each individual enjoyed a defined place in the social order that could be referenced according to its superiority and/or subservience to other members of society. The status of each individual carried with it an obligation to maintain the social fabric through proper behavior. According to this philosophy, rank was ordered according to *Five Confucian Relationships*:

1. Ruler to subject
2. Husband to wife
3. Parent to child
4. Older sibling to younger sibling
5. Friend to friend

The five relations displayed two fundamental assumptions about Chinese social relations: first, that no two persons were equal; and second, that inequality was expressed according to the three basic criteria of age, gender, and social rank. At the core of Confucianism stood the individual. "It is man that can make Tao great," observed Confucius. Although he taught numerous virtues, his cardinal virtue was *jen*, which is variously translated as "humanity," "love," or "human kindness." To Confucius, *jen* defined the very essence of a virtuous person. Significantly, the Chinese character for the word consisted of two parts, one representing the individual and the other human relations or society. The ideal virtue, therefore, involved both the perfect individual and the perfect society. This was the goal not only of Confucianism but of all Chinese philosophy.

For Confucius the ideal citizen was the superior individual, or the *chun-tzu*—literally, the son of a ruler. Until the era of the Warring States, a *chun-tzu* was manifestly someone of aristocratic upbringing. However, to Confucius the superior individual achieved *jen* not through bloodlines but through moral excellence. Such a person was wise, benevolent, and courageous; he was motivated by righteousness instead of by profit. He studied the Way, or Tao, and loved humanity. Confucianism thus emphasized a code of human behavior. Self-perfection, family harmony, social order, and world peace could all be attained so long as balance and harmony were maintained between the individual and society. Only in such a state could Tao, the moral law of the universe rooted in the Mandate of Heaven, prevail. Confucianism, therefore, encapsulated both the complaints and the aspirations of the gentry class that would eventually govern Han-era China. The new elite would be educated in Confucian schools and fulfill the requirements of literacy, courtesy, and refined behavior. Around 100 BC, officials working under the imperial Han Dynasty initiated a system of state examinations to identify and to recruit officials like themselves from students who were educated in the *Five Chinese Classics* (collected texts in poetry, history, ritual, divination, and the annals of Confucius's home state of Lu). While in practice state officials tended to be recruited from within the gentry class, in theory the Han bureaucracy became accessible to any educated, respectful, well-bred citizen. The Confucian system of regularized education and examination helped to generate a sustained, educated elite capable of governing the vast uneducated agricultural population of the Chinese countryside. These leaders tended to be generalists rather than specialists, gentlemen, rather than professionals. When extended across the breadth of the Chinese society, this system enabled the ruling class to withstand repeated crises and political and social turmoil by replenishing and reconstituting itself time and again with talented leadership cadres. Confucian notions of enlightenment, of devotion to public service, and of proactive participation in and maintenance of the social order bear obvious comparison with Stoicism in the Greco-Roman West.

TAOISM

In the same manner that Epicureanism challenged Stoic philosophy in the West, Taoism framed a popular response to Confucianism in China. According to tradition Taoism was articulated by an elder contemporary of Confucius named Lao-Tzu (now dated ca. 350 BC). However, in accordance with the tenets of the philosophy itself, it is supposed to have evolved and matured anonymously through the work of numerous intellectuals, simply known as "the masters." Like Epicureanism, Taoism expressed a sense of futility in so far as the efforts of humankind to improve the natural order were concerned. Even though Taoists denounced conventional morality, they cherished love, wisdom, peace, and harmony no less than the Confucianists. Unlike Confucianism, however, their Tao was not the Way of humans but the *Way of Nature*. According to Lao-Tzu, Tao was the standard of all things to which all humans must conform. Tao was eternal, absolute, and existed beyond space and time; in its operation it was spontaneous, omnipresent, constant, and unceasing. It existed in a perpetual state of transformation and proceeded through a multitude of cycles before ultimately returning to its source. At the core of this philosophy was the duality of opposites, *yin* and *yang*, Male and Female, Light and Darkness, Being and Nonbeing, all revolving in a state of perpetual dynamic. According to Lao Tzu, all things carried the *yin* and embraced the *yang*. Through the blending of their opposite material forces *yin* and *yang* achieved a sense of harmony. The *yin-yang* ideal dictated that in marriage there should be harmony between the male and female; in landscape painting harmony between mountain and water; and in spiritual life harmony between humanity and wisdom. It was futile for humans to attempt to oppose nature, to improve it, or to overcome it. Much like the Epicureans, the principal objective of the Taoist was to become a sage, or a person of "sageliness within and kingliness without."[1] Also like Epicureanism, Taoist sageliness demanded withdrawal from society and the abandonment of political ambition for a life devoted to the contemplation of Tao. This was more than a metaphysical argument, in other words. Like the Cynics in Greece, Taoism insisted on passivity, frugality, and simplicity as the necessary prerequisites of enlightened behavior. It was only through the realization that everything pursued its own independent course and yet came around to form one harmonious whole that happiness and freedom could be attained.

Confucianism and Taoism became countervailing philosophical schools as China emerged as a world system. They flourished in part because their proponents successfully incorporated the tenets of competing philosophies over time. Taoism shared many attributes in common with Buddhism, for example, particularly its doctrinal insistence on a renunciation of material possessions and worldly desires. This commonality opened the way for the transmission of Buddhism throughout China. Taoism's oppositional character

1 *The Sacred Books of the East, The Texts of Taoism*, ed. F. Max Müller, trans. James Legge, Part 2: *The Writings of Kwang-ze: Books XVIII–XXXIII* (Oxford: Clarendon Press, 1891), 217, translated by Legge as, "and thus it was that the Tao, which inwardly forms the sage, and externally the king became obscured and lost its clearness."

to the formalistic, increasingly elitist culture of Confucianism also made it enormously popular with the Chinese masses. By the time of the Later Han Dynasty (9–202 AD), Taoism absorbed aspects of popular mysticism, shamanism, and witchcraft. Taoist magicians beguiled everyday people and Han emperors alike with alchemy and medicines supposedly capable of furnishing material wealth and immortality. Charlatanism and quackery inevitably diminished popular sentiment for the philosophy. One Taoist sage, Liu Ling (221–300 AD), used to declare that to an enlightened man the "affairs of the world amount to so much duckweed in a river." Allegedly, Liu Ling rode about the capital city of Chang'an in a small cart drawn by a deer, accompanied at all times by a servant bearing a large pot of wine and a shovel. The servant was instructed to furnish Liu Ling wine at a moment's notice and to bury him in the event that he should keel over dead. Much like the iconoclastic lifestyles of the Cynic philosophers in Greece, it is easy to interpret the eccentric, drunken behavior of the Taoists as a deliberate protest against the formalism, ritualism, and elitism employed by Confucian scholars to distance themselves from the everyday people of China.

Legalism, the third major intellectual development of the Era of the Warring States, was more a political ideology than a philosophical school per se. In fact, Legalism rejected any and all forms of philosophical disputation, Confucian or Taoist, as futile and contrary to the interests of the state. To Legalist scholars such as Hsun Tzu (Xunzi, ca. 250 BC), humans were inherently evil, corrupt, rebellious, disorderly, and undisciplined. The job of the king and his officials was to steer the flawed masses to correct behavior through the use of codified law, main force, and severe forms of punishment. Like Confucianism, Legalism emerged among unemployed statesmen who peddled their knowledge and political experience to competing Chinese warlords toward the end of the Warring States Era. However, the Legalists abandoned faith in the moral tenets of Confucianism in order to secure a more powerful place in the emerging social hierarchy. By insisting on the exclusive authority of the ruler and his ministers, the Legalists furnished competing warlords with the necessary arguments to legitimize the establishment of a centralized, autocratic state. According to Legalist dogma, the power of the emperor was restricted only by his responsibility toward heaven. To preserve his Mandate with Heaven, the ruler needed to remove himself from the day-to-day management of government in order to devote his attention to the complicated requirements of daily religious rituals. This also meant that the ruler needed to abide by and to enforce recognized principles of morality lest the appearance of ominous portents furnished evidence that his mandate was expired. With the king's role as divine mediator firmly established, the king's chancellery assumed responsibility as the true engine of authoritarian will. The chancellery's job was to draft measures intended to propel the Chinese people on an optimal course. Legalist authorities codified a bewildering array of rules and regulations and applied this body of law indiscriminately to Chinese inhabitants at all levels of society. By 200 AD the Han Dynasty penal code grew to 26,272 paragraphs in 960 volumes. Everyone existing outside the imperial court was viewed as a potential criminal and a commoner. From the Legalist perspective, the sole duty of the Chinese people was to labor for the benefit of the ruler and to obey without

question the orders that emanated from his chancellery. Infused with the authority thus obtained through Legalist dogma, the ministries of the Qin and Han imperial dynasties exerted absolute control over their subjects. In the proper hands the use of such totalitarian authority could achieve massive undertakings in the arena of public works and galvanize the Chinese state to withstand crises. In the wrong hands, it amounted to an arbitrary form of tyranny.

Not surprisingly, Legalism was first adopted by the rulers of the western principality of Qin, where traditional Chinese influences were less rooted. It left its most profound legacy in the historical record of imperial beheadings, the ultimate punishment imposed not only on murderers and thieves, but on ministers, generals, and even chancellors accused of malfeasance and treason against the realm. Beheadings form a recurring backdrop to the narrative of the Han Dynasty, leading one to believe that the dispensation of capital punishment was swift, capricious, and arbitrary. No one in Chinese society was so lofty as to assume that he could escape the ultimate penalty for capital crimes. Even China's greatest historian, Ssu-ma Ch'ien (Sima Qian, ca. 100 BC), was forced to endure a "lesser" penalty of castration when charged with duplicity against the throne. To justify these instances of severe punishment and humiliation, the Legalists reasoned that the Han emperors were as duty bound to execute the penal code as their subjects were to abide by it. As the adopted sons of heaven, the emperors had no choice but to follow and to enforce basic rules of morality. Much like failure to perform the necessary rituals, a failure to punish malefactors could result in the withdrawal of the Mandate of Heaven. As the representatives of heavenly justice, therefore, the emperors had a religious obligation to inflict punishment, however severe, on criminals in order to preserve the essential harmony between heaven and humankind. As one Legalist commented:

> In ancient times the Sage-Kings knew that man's nature was evil, selfish, vicious, unrighteous, rebellious, and of itself did not bring about good government. For this reason they created the rules of proper conduct (*Li*) and justice (*Yi*); they established laws and ordinances to force and beautify the natural feelings of man, thus rectifying them. They trained to obedience and civilized men's natural feelings, thus guiding them. Then good government arose and men followed the right Way (*Tao*).[2]

Autocratic resort to Legalism thus furnished a salient contradiction to Chinese moral philosophy. On the one hand, the soon-to-be imperial state of China became a society based on the rule of moral authority: it came to value learning above birth or wealth, and it administered an empire through a bureaucracy composed of dedicated, highly educated officials. On the other hand, it imposed a legal system that employed fear as its primary

2 Xun Kuang (Xun Zi, ca. 300 BC), *Xunzi*, book 23: *The Nature of Man Is Evil*, in *The Works of Hsüntze*, trans. Homer H. Dubs (London: Probsthain, 1928; repr. New York: Paragon Book Gallery, 1966), 302.

deterrent and one that exacted punishments of cruel and barbarous severity. However convincingly Confucian ideals of justice and benevolence were articulated in the theory of government, they were woefully absent from the exactions rendered by its tribunals.

QIN (CH'IN) SHIH HUANGDI AND THE FORMATION OF THE CHINESE WORLD SYSTEM (221–210 BC)

The autocratic ideals articulated by Legalism saw their culmination with the emergence of the Qin Dynasty as East Asia's first extraterritorial state. Through reliance on brute force and cold administrative efficiency, the duke of Qin (259–210 BC) successfully transformed China from a cluster of squabbling feudal states into a unified bureaucratic empire. Although Qin's dynasty did not manage to survive his death, it left an enduring legacy to China, including the name China itself. Situated in the western Shensi (Shaanxi), "the land between the two passes," the state of Qin was more practicably defensible than its rival states in the east; it was also more vulnerable to nomadic incursions. The early dukes of Qin pursued a successful policy of recruiting Hsiung Nu cavalry contingents and mobilizing the local peasantry into the infantry. Duke Qin Shih used these military advantages to overwhelm his rivals on the battlefield. He then assumed the title, Qin Shih Huangdi, or Qin Shih the Supreme Ruler. Formerly a term reserved exclusively for legendary, semidivine heroes, Qin's assumption of this title furnishes one of several indications of his megalomania.

Everything else about the emperor Qin Shih suggests that he was a cruel and ruthless tyrant, determined to exploit the full laboring potential of the Chinese population in pursuit of his grandiose scheme of world domination. As the duke of Qin, he assembled around himself a chancellery of foreign generals of nomadic origin and revolutionary ministers and officials of decidedly Legalistic mindset. As noted above, Qin Shih's regent, Lu Pu-Wei, began his career as a successful merchant. He and his fellow ministers conferred patronage on similarly minded refugees from the displaced hierarchies of the collapsing feudal states. A great military organizer, Qin Shih successfully crushed his rival aristocratic polities and eradicated their leadership by forcibly evacuating their surviving numbers to his capital, Xianyang (Hsien Yang) in Shensi (Shaanxi). Allegedly some 120,000 aristocratic families from throughout the region were forcibly relocated and compelled to sever ties with their ancestral domains. The surviving nobles were compelled to serve as Qin Shih's personal courtiers, to appear regularly at court, and otherwise to submit to his supremacy. This instant infusion of aristocratic inhabitants converted what had formerly been a western barracks town into a city of wealthy consumers, who in turn attracted an in-migration of craftsmen, laborers, and merchants. In practically no time Qin Shih and his ministers transformed Xianyang into a world capital. They then implemented the highly unpopular decision to confiscate and burn all books, particularly the annals, the poetry, and the accumulated records of rival noble houses. Only nonpolitical books treating subjects

In 1975, 6,000 life-size clay figures (including men, horses, and chariots) were discovered in a pit to the east of the immense burial mound of Qin Shih Huangdi. Arranged in battle formation, the statues were apparently manufactured to guard Qin's soul in the afterlife. Remarkably, the face of each terracotta warrior is unique, evincing the efforts of numerous sketch artists to draw representative members (if not each and every member) of the army before molding and firing the statues. The construction of each figure centered on a hollow body supported by solid legs. The body, head, and separate arms were formed of coiled clay strips over which a smoother, skin-like layer was applied. Individual features were then applied to the figure or worked with a tool.

The terracotta army was undoubtedly crafted and erected in situ and reveals the high level of organization required to achieve such a display—and the considerable public expense. Crude stone sculptures produced during the Western Han Dynasty suggest that craftsman had not yet mastered carving in-the-round, instead preferring to work in clay. The custom of placing clay figures (called *yong*) in tombs as stand-ins for the living was fairly widespread in the Han with the number of *yong* dependent upon the importance of the deceased. Qin's clay army, only a fraction of which has thus far been revealed, rank among the archaeological wonders of the world.

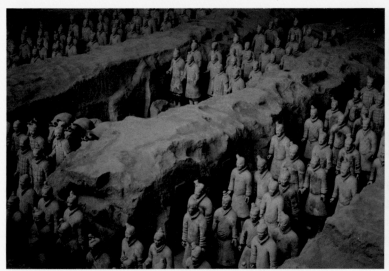 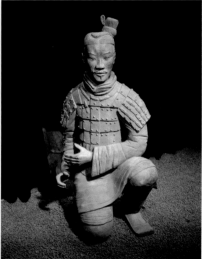

Figure 8.3 Army of the First Emperor of Qin in pits next to his burial mound, Lintong, China. Qin Dynasty, ca. 210 BC. Painted terracotta, average figure 183–195 cm high.

Figure 8.4 Kneeling archer. Life-size pottery figure from Pit no. 1, east of the tomb of Qin Shih Huangdi at Lintong, China. Qin Dynasty.

such as medicine, divination, agriculture, and arboriculture were spared destruction. Much like the relocation of the Chinese aristocracy itself, the presumed purpose of this unfortunate policy was to eradicate the memory of the Warring States aristocracy for all time. The decision provoked widespread opposition. Reportedly some 460 scholars were executed for attempting to conceal books. However much these policies were intended to put an end to the feudal nobility, they only served to harden sentiment against the Qin Dynasty and to hasten its demise. Apart from the Legalist hierarchy that had successfully imposed the new regime, the rest of the Chinese population became united in its hatred.

In place of the feudal aristocracy, the Qin Dynasty's administration dispatched military officers to the defeated states in the east to rule them as conquered terrain. Now devoid of aristocratic leadership, the tax-burdened rural peasantry rebelled repeatedly and was forcibly suppressed. Once this threat was eliminated, Qin Shih's ministers devised a uniform system of administration that divided the newly assembled realm into provinces, with each province divided further into prefectures. Newly conquered non-Chinese territories were organized into *commanderies* ruled by military governors, which enabled officials dispatched from the central administration to monitor activities all the way to the grassroots level. Ultimately, the Qin Dynasty adopted a system similar to that of the Achaemenid Dynasty of Persia. Civil and military governors were assigned overlapping fiscal and military jurisdictions within the same provinces, and the affairs of each official were in turn scrutinized by a comptroller dispatched from Xianyang by the emperor himself. The balance of power achieved between these three officials prevented any one of them from organizing a powerbase capable of threatening the dynasty's central authority. The usefulness of this system of checks and balances was recognized by rulers of the Han and later dynasties who perpetuated it.

Having more or less successfully secured control of the countryside and its resources, the Qin administration next embarked on massive public-works programs, ostensibly in the interest of wider Chinese society. As noted above, in 214 BC Qin Shih's administrators set to work rebuilding the system of the fortifications that had previously been constructed piecemeal by various warring states in the north. When finished, the refurbished and reorganized Great Wall (5,000 km long) extended all the way from Manchuria in the east to Dunhuang (Tun Huang) in the west. (To achieve its present state, the Great Wall was rebuilt under the Ming dynasty between 1368 and 1644 AD.) The construction of the Great Wall not only combated the threat of the Hsiung Nu to the north, but it also positioned Chinese military forces to investigate, and if necessary to conquer, distant trading centers to the west. Hundreds of thousands of laborers and convicted criminals were forcibly conscripted and dispatched to the remote and dangerous western regions to build and defend these walls. Other public works closer to home, such as the dredging of new canals along the great rivers, the design of connecting road networks, the construction of new administrative centers in the prefectures, and, not least, the building of the tomb and palace of Qin Shih himself near Xianyang, were likewise initiated as laboring projects for the regime's mounting population of "criminals."

Driven paranoid by the extent of his unpopularity, Qin Shih lived and worked in closely guarded secrecy. Knowledge of his everyday movements in the vast palaces at Xianyang was restricted to a handful of trusted eunuchs. The emperor's innate megalomania also left him increasingly vulnerable to magic and superstition. He repeatedly consulted magicians who promised him means to immortality. Convinced by reports of the existence of a distant overseas island where the inhabitants were immortal, he commissioned a naval expedition to set sail in search of it. Like the thousands of laborers dispatched to the Great Wall, these sailors never returned. While journeying through the eastern provinces in 210 BC, Qin Shih suddenly died. The hundreds of soldiers and officials that attended his imperial cortege

returned to Xianyang completely unaware of his demise. The chief minister who accompanied him on this journey went so far as to place a cart of rotting fish directly behind the emperor's wagon in an effort to disguise the scent. Heavy-handed tyranny, mounting requisitions, incessant warfare along the frontiers, mass forced-labor camps, and the brutal repression of a restive population eliminated any likelihood that the dynasty could survive. On the news of his death, the empire was wracked by a series of uprisings. Some six pretenders to the throne were eliminated in rapid succession. After several years of chaos, the general Liu Bang successfully removed the nominal head of the Qin Dynasty. Assuming the imperial name Kao Tsu, Liu Bang founded the Han Dynasty—believed by many scholars to have been the largest civilization of the ancient world—and restored political stability to China.

THE HAN DYNASTY (202 BC–220 AD)

Kao Tsu's first task was to find a way to reassemble the tattered bureaucracy of the Qin regime. He had risen through the ranks as a military officer and had attained power by assembling around him a cadre of similarly rebellious-minded warlords. As rewards for their support, he assigned them territories in the form of artificially created feudal states. He also restored many of the former polities of the Warring States Era, though in greatly diminished size. This placated his two most troublesome constituencies (the new generals and the old aristocracy) and convinced them to accept his authority. Once secured with the Mandate of Heaven, Kao Tsu made certain that succession to the imperial throne would remain restricted to his family. In the countryside he maintained the Qin Dynasty governing system of provinces, commanderies, and prefectures, and personally selected the officials assigned to govern them. Although he posed as a traditionalist, Kao Tsu allowed this two-tiered governing system (the imperial state and its various client states) to pursue its natural course. Inevitably the smooth efficiency of the central administration outpaced the poorly organized, decentralized governments of the client states. At the same time Kao Tsu and his successors carefully monitored the kings of the client polities. Client kings were summoned repeatedly to court and were removed (and beheaded) at the slightest provocation. Many of the generals who had helped Kao Tzu rise to power were likewise executed for real or imagined conspiracies. As the Han administration grew more confident of its authority, it imposed laws that intentionally diminished the authority of the traditional aristocracy. For example, a decree of 144 BC mandated that inheritance within feudal states must be divided equally among all sons of a given king. This essentially guaranteed that vassal principalities would diminish in size even as they multiplied in number. In the event that a feudal line failed to produce an heir, the client state was summarily confiscated by the Han Dynasty and assigned to an official in the provincial administration. Generation after generation the feudal states declined in stature. When Kao Tsu first established his administration, there were some 143 officially sanctioned client states; by the end of the Han Dynasty, there were 241.

Archaeologists excavated the tomb of the Marquise of Dai in 1972. Located at Mawangdui in Hunan Province, the tomb contained a wide variety of burial goods, including decorated lacquer utensils, textiles, and a nested sarcophagus that contained the well-preserved remains of the marquise herself. Most remarkable of the objects found in the tomb—objects that were used during the funeral ceremonies and to accompany the deceased into the afterlife—is a painted, T-shaped silk banner that was draped over the marquise's coffin. The funerary banner (called a "flying garment" in the tomb inventory) was believed to carry the soul of the dead upward into the sky. The Marquise of Dai is depicted in the center of the pictorial narrative where she is awaiting her ascent to Heaven and immortality, represented by the red sun and silvery moon; the funeral of the deceased is viewable toward the bottom of the banner, followed further down by the Underworld. The funerary banner is remarkable because of its complex narrative, unified composition, preservation, and its depiction of one of the first known portraits in Chinese art.

The extravagance of Han tombs can likewise be seen in jade shrouds, like the burial suit of Prince Liu Sheng—a member of the Han imperial family. Comprised of 2,500 thin jade plaques sewn together with gold wire, the suit took an estimated 10 years to complete. The Chinese strongly believed in the preserving, protective power of jade (or nephrite, more precisely), first using the heavy, hard stone for artworks and ritual objects during the Neolithic period.

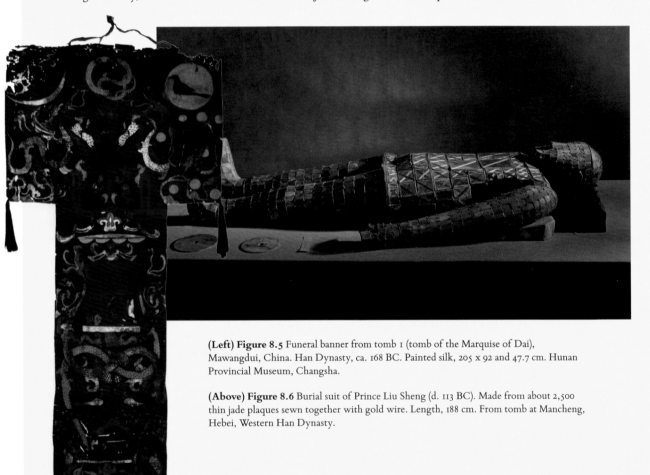

(Left) Figure 8.5 Funeral banner from tomb 1 (tomb of the Marquise of Dai), Mawangdui, China. Han Dynasty, ca. 168 BC. Painted silk, 205 x 92 and 47.7 cm. Hunan Provincial Museum, Changsha.

(Above) Figure 8.6 Burial suit of Prince Liu Sheng (d. 113 BC). Made from about 2,500 thin jade plaques sewn together with gold wire. Length, 188 cm. From tomb at Mancheng, Hebei, Western Han Dynasty.

In place of the aristocracy, the Han Dynasty turned for leadership to Confucian scholars recruited from the emerging gentry class. Like the traditional aristocracy, the gentry class had relied on the support of lineage groups to survive the turbulent times of the Warring States. As gentry clans gradually accumulated property, they carefully distributed the estates to subordinate branches of the family. Subordinate branches of the gentry clan invested in the hierarchy by combining resources to assist high-ranking relatives with their political careers. The politicians typically forged marriage alliances and engaged in political combines at various levels of the bureaucracy to advance their careers. They then shared the resulting benefits with their wider families. If a politician from a gentry clan fell out of favor at the court or was convicted or perhaps executed for an alleged crime, the entire lineage group would inevitably suffer the consequences. Within a generation or two, however, the same family would invariably return to prominence under the leadership of a new crop of political leaders. Gentry clans thus remained relatively secure in their wealth and status. The financial support of the wider clan guaranteed the production of educated candidates to serve with the imperial bureaucracy and, once positioned at Chang'an, successful bureaucrats dispensed rewards back to family subordinates. Despite the revolutionary character of the gentry class, therefore, its emergence in Chinese society was essentially a conservative development. Its dependency on networks within the imperial government for political patronage and economic advancement gave the gentry a vested interest in preserving the status quo. Instead of noble versus commoner, social distinctions under the Han Dynasty became decidedly that of the educated elites versus the uneducated laboring population.

To recruit gentry scholars into the government, the Han Dynasty successfully promoted principles of Confucianism as the entry requirements to the regime. Naturally the emperor emphasized first and foremost the Confucian relationship of *ruler to subject* and its implicit subservience. The implementation of state-sponsored examinations guaranteed a steady stream of Confucian *Chun tzu* or educated gentlemen into the ranks of the imperial bureaucracy. The emperor surrounded himself with an array of court officials, including three imperial counselors, nine ministers of state, eight generals, and scores of palace attendants. Following the model of the Qin Dynasty, the secretariat of the court chancellor dispatched inspectors throughout the ministries and the various branches of the provincial administration to insure accountability at the bureaucratic periphery. Since statistics were crucial to central planning, officials at the local level worked diligently to collect and to transmit accurate information to their superiors. As a result, surviving Chinese records furnish detailed, fairly reliable census figures, not only for the provincial populations of China but even for the non-Chinese inhabitants of distant protectorates. In 1 AD, for example, the census recorded 12,400,000 households and 57,000,000 inhabitants dwelling within the boundaries of the Han world system.

Throughout the era of the Early Han Dynasty (202 BC–6 AD), the Chinese military establishment focused its attention on the enduring threat of the Hsiung Nu empire to the north (estimated at two million in population). After years of attempts to placate the Hunnic hierarchy with gifts, marriages, and treaties, the Han administration came to the

realization that the *shanyu* (king) and the ruling council of the Hsiung Nu were incapable of controlling the warlords on their periphery. Regardless of the agreements contracted with that hierarchy, local Hsiung Nu raided and plundered Chinese settlements along the frontiers with impunity. Eventually sentiment at Chang'an shifted in favor of the militarists, and a succession of powerful generals was dispatched to the western and northern boundaries of the empire to crush the Hsiung Nu. After a series of difficult campaigns, several of which ended in disaster, the Han Dynasty successfully broke the unity of the Hsiung Nu confederacy in 51 BC and purchased itself a brief era of frontier security.

The logistical requirements of these military operations presented a substantial challenge to the Han Dynasty and ultimately facilitated its reach as a global power. To confront the transient Hsiung Nu, Han officials had to organize long-distance, overland transport with the capacity to project deep into steppe regions beyond Chinese frontiers. Food supplies would necessarily have to be transported from the eastern agricultural provinces to the remote desert protectorates of the steppe. As a preliminary step the Han administration completed the construction initiated by the Qin Dynasty of a vast network of canals and roads capable of transporting supplies to the centrally located capital at Chang'an. To encourage the necessary movement of supplies to the western war zones, the Han administration offered further incentives such as official rank to merchants capable of arranging these activities as well as land allotments to impoverished citizens and reduced sentences to criminals, all in an effort to encourage subjects to serve on the frontiers. When necessary, the Han bureaucracy also resorted to direct intervention in the private economy. When complaints arose about the manipulation of prices of essential commodities such as salt and iron, for example, the government seized control of these industries by imposing imperial monopolies. This raft of policies enabled the Han bureaucracy to harness the potential manpower and resource production of the entire Chinese world system and to project force into distant theaters of war. Campaigns such as those of Pan Chao in Central Asia (ca. 97 AD; mentioned below) required years of advanced preparation. Merchant caravans employing thousands of porters would assemble the necessary stockpiles of food and supplies at garrison towns such as Dunhuang at the eastern end of the Tarim Basin. Agricultural colonists would settle in the vicinity to improve local production. From these bases Chinese generals successfully launched protracted campaigns into the desert. By prepositioning supplies along the intended path of the campaign, Chinese armies penetrated northward at considerable expense into Inner Mongolia to crush the Hsiung Nu confederacy between 119 and 51 BC. This bought about a century of peace along the northern frontier. They also advanced across the Pamir Mountains against the Kushan in Central Asia. In the Han Era, peoples living in remote regions of Mongolia, Central Asia, and Afghanistan began to witness the sight of advancing Chinese armies.

Chinese diplomats and explorers simultaneously traveled along the caravan routes to investigate neighboring polities and civilizations. One particular diplomat, Zhang Qian (Chang Ch'ien), was sent by the Han emperor Wu Ti (141–86 BC) in 138 BC to negotiate an alliance with a break-away element of the Hsiung Nu known as the Yuezhi (Yueh Chih). Zhang Qian pursued his diplomatic travels as far as the Indus Valley and returned

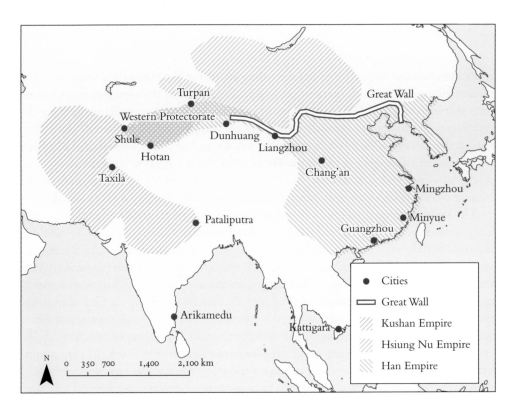

Map 14 The Han Dynasty Empire (first century AD).

to the court at Chang'an in 133 BC with detailed information about the urban societies that existed in India, Iran, and beyond, not to mention the exotic prestige goods that emanated from these locations. Zhang Qian and other Chinese emissaries began to furnish reliable information about the outside world to replace the exaggerated accounts of traders and travelers. Zhang Qian's mission also helped to sway Han administrative opinion toward a policy of direct intervention on the western frontier, culminating in the conquest of the oases states of the Tarim Basin by the Chinese general Li Guang (Li Kuang). Sometime before his death in 119 BC, this general mounted a preemptive attack on Kushan elements in Ferghana beyond the Pamir Mountains. In 97 AD, Pan Chao, a commander of the Western Protectorate for the later or Eastern Han Dynasty, led a second Chinese army of 70,000 men across the Pamir Mountains. This army advanced unopposed all the way to the shores of the Caspian Sea. In short, the energy required to defeat the Hsiung Nu and to control the remote western regions resulted in repeated efforts by the Han administration to harness the movement of men and material beyond the horizons of the Chinese world system. Indeed, Wu Ti also attempted to construct a road network through the rugged, densely forested terrain of Southeast Asia to India, attempting yet failing to complete the ancient equivalent of the Burma Road. This enterprise demonstrates that the foreign ventures of the Han Dynasty were not motivated solely by the threat of the Hsiung Nu. However minimally the Chinese engaged in international trade during previous periods, there can be little doubt that the administrators of the Han Dynasty successfully removed China from its cultural isolation. Ultimately, the cost of these endeavors taxed the Chinese population exorbitantly. In the short term, the projection of force westward, northward,

and southward enabled the Han Dynasty to secure its borders, to achieve domestic tranquility, and to connect its population to a globally expanding trading system.

COLLAPSE OF THE HAN EMPIRE

The cost of so many far-reaching enterprises eventually proved prohibitive to Han society, provoking internal dissension at various levels. At the top of the hierarchy, the death of a Han emperor invariably set in motion power struggles among the leading gentry families at the imperial court. The faction of the most powerful queen (known as the dowager empress) typically attempted to consolidate power by manipulating royal succession to its advantage. At the very least its members would attempt to stack the new administration in its favor by assigning allied bureaucrats to important positions of state. Eventually these destructive conflicts within the gentry class exposed the Han Dynasty at its core. Court rivalries, frequently dominated by highly placed females and imperial eunuchs, gradually undermined its legitimacy. The Liang were one of several gentry families jockeying for position at this time. During the Later or Eastern Han Dynasty (25–202 AD) the Liang generated no less than six princes, three empresses, six imperial concubines, three grand generals, and fifty-seven ministers and provincial governors in a span of 20 years. After decades serving in the chancellery, elements of a second gentry family, the Wang, usurped the throne in 9 AD and set in motion a violent civil war between themselves and collateral branches of the Han Dynasty. By the time that a Han pretender, Kuang-Wu Ti (5 BC–57 AD), managed to restore order in 25 AD, his capital in Chang'an and the logistical network necessary to maintain it had been destroyed. Palace intrigues inspired by rival gentry families continued to plague the regime, along with repeated mutinies in the army, and widespread peasant rebellions. The fury of popular uprisings, including the rebellion of the Red Eyebrows at the time of the Wang usurpation (7–25 AD) and that of the Yellow Turbans in 184 AD, provoked long-term, widespread chaos and gradual erosion of public confidence. Enraged by famine, exorbitant taxes, and the harshness of the penal code, the Chinese agricultural population turned to the leadership of charismatic popular leaders who claimed to possess magical powers. Populist rebels were able to seize control of urban centers and to resist the onslaught of armies dispatched by the central government sometimes for decades.

Distracted by such internal dissensions, the Han administration lost its grip on the frontiers, as well as on the agricultural countryside in the provinces. The cost of maintaining so extensive a land-based empire ultimately proved overly burdensome. The collapse of the Han Dynasty in 202 AD ushered in four centuries of civil war known as the Era of Disunity (220–588 AD). This era was characterized by repeated attempts of powerful warlords to reconsolidate China, only to provoke further chaos. Meanwhile, newly organized nomadic confederacies of the Hsiung Nu and the Toba people in Korea emerged as threats in the northwest and the northeast respectively. In the fourth century AD

these peoples invaded the Chinese heartland with decisive effect. They settled along the Huanghe River as overlord populations, destroying settlements and driving many of the elite families of the gentry southward beyond the Yangtze River. There the refugees of former Han society reconstituted Chinese hierarchy into newly formed kingdoms in the south. As a political entity China would remain divided until the era of the Tang Dynasty (618–907 AD). However, nomadic ruling houses in the north assimilated Chinese culture even as the reconstituted aristocracies harnessed the laboring capacity of the non-Chinese populations in the south. Despite the collapse of imperial authority, in other words, the Chinese managed to maintain their recursive institutions at the regional level and to preserve the memory of their culture through to modern times.

CONCLUSION

Despite its vast geographical separation from urban civilizations in the west, China became connected to the emerging system of the Classical world, and for better or worse it hitched its trajectory to the outcome of this global relationship. From the Mediterranean to the Indian subcontinent and all the way to East Asia, urban societies busily developed networks of roads, sea lanes, and trading centers to enhance interconnectivity during the Classical Era (ca. 300 BC to 200 AD). Turning now to the development of the Roman Empire at the Mediterranean end of this global world system, we will attempt to understand how the existence of interconnectivity raised productivity within regional boundaries at the same time that it placed distant civilizations on a common economic course.

FURTHER READING

Chang, Kwang-chih. *Art, Myth, and Ritual*. Cambridge, MA: Harvard University Press, 1983.

Di Cosmo, Nicola. *Ancient China and Its Enemies: The Rise of Nomadic Power in East Asian History*. Cambridge: Cambridge University Press, 2002. https://doi.org/10.1017/CBO9780511511967.

Ebrey, Patricia Buckley. *Women and the Family in Chinese History*. New York: Routledge, 2007.

Fairbank, John King. *China: A New History*. Cambridge, MA: Harvard University Press, 1998.

Fitzgerald, C.P. *China: A Short Cultural History*. New York: Praeger, 1954.

Lewis, Mark Edward. *The Early Chinese Empires: Qin and Han*. Cambridge, MA: Harvard University Press, 2007.

Loewe, Michael. *Everyday Life in Early Imperial China during the Han Period, 202 B.C.–A.D. 220*. New York: Putnam, 1970.

Sullivan, Michael. *The Arts of China*. 5th ed. Berkeley: University of California Press, 2008.

Wood, Frances. *The Silk Road: Two Thousand Years in the Heart of Asia*. Berkeley: University of California Press, 2002.

PART III
THE ROMAN ERA AND WIDER SOCIETAL COLLAPSE

NINE

STATE FORMATION IN ANCIENT ROME (753–275 BC)

WHAT HAVE WE LEARNED?

► That Chinese society, its governmental system, its material culture, its architectural forms, and its written language all emerged early in the Bronze Age.

► That rice farming was able to sustain very large populations per square kilometer in China. The high labor requirements of rice production all but depended on a dense settlement pattern: the early farmers of China grew accustomed to a collective lifestyle in which group identity dominated individual autonomy.

► That Bronze Age Chinese settlements were organized according to urban clusters, elite enclosures (fortified precincts) surrounded by a scattering of workshops and artisan-supported farm villages.

► That the Shang kings of China (1523–1028 BC) served as the sole mediators between the deity T'ien and the inhabitants of the realm.

► That the Zhou Dynasty (1027–221 BC) introduced the concept of the Mandate of Heaven, that is, that royal power in China was transferable under the appropriate religious circumstances.

► That the power and legitimacy of the Zhou were weakened gradually by their inability to confront mounting raids by Turkic and Mongolian marauders from the north.

► That three competing Chinese schools of philosophy—Confucianism, Taoism, and Legalism— arose from this ferment to dominate imperial ideology of the following era.

► That Qin Shih Huangdi, the duke of Qin (221–207 BC), successfully transformed China from a cluster of squabbling feudal states into a unified bureaucratic empire. He in turn was succeeded by the Han Dynasty (202 BC–220 AD).

► That throughout the era of the Han Dynasty, the main focus of the Chinese military establishment remained the enduring threat of the Hsiung Nu (Hun) empire to the north.

► That ultimately the expense of these endeavors taxed the Chinese population beyond its abilities. The collapse of the Han Dynasty in 202 AD ushered in four centuries of civil war known as the Era of Disunity (220–588 AD).

From the eastern Mediterranean to East Asia, human populations managed to organize urban societies that furnished high standards of creature comfort across vast stretches of geographical terrain. The civilization ultimately to capitalize on these developments was the Roman Empire (27 BC–476 AD). In many respects the Romans inherited the benefits of the groundwork prepared by the Macedonian successor states of Alexander's conquest. Roman trade with India and China appears to have been one crucial result. To understand this, we must now turn to an examination of the building blocks of Roman society and the ultimate reasons for their military and political success.

CHRONOLOGY 10. ANCIENT ROME	
753–510 BC	Royal Rome
510–27 BC	Roman Republic
510–281 BC	Early Republic
484–287 BC	Struggle of the Orders
281–133 BC	Middle Republic
281–276 BC	War with King Pyrrhus of Epirus
264–241 BC	First Punic War
218–201 BC	Second Punic War (Hannibalic War)
201–146 BC	Wars in the Hellenistic East
133–27 BC	Late Republic
133–121 BC	The Gracchi
88–82 BC	Civil War between Marius and Sulla
81–78 BC	Dictatorship of Sulla
59–53 BC	First Triumvirate
49–46 BC	Civil War between Caesar and Pompey
46–44 BC	Caesar's Dictatorship
42–32 BC	Second Triumvirate
32–31 BC	Civil War between Octavian and M. Antonius
27 BC	Augustan Settlement
27–476 AD	**Roman Empire**
27 BC–180 AD	Early Empire
27 BC–68 AD	Julio-Claudian Dynasty
70–96 AD	Flavian Dynasty
96–180 AD	Antonine Dynasty
180–476 AD	Late Empire
312–336 AD	Constantine

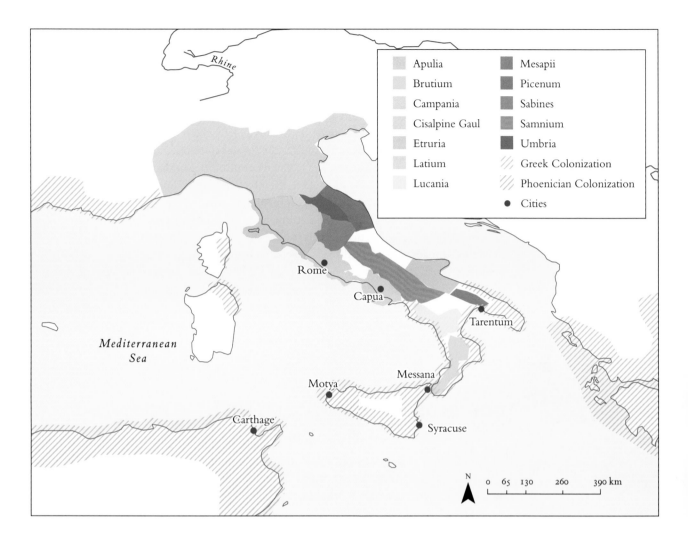

Map 15

Legend:
- Apulia
- Brutium
- Campania
- Cisalpine Gaul
- Etruria
- Latium
- Lucania
- Mesapii
- Picenum
- Sabines
- Samnium
- Umbria
- Greek Colonization
- Phoenician Colonization
- ● Cities

Rhine

Mediterranean Sea

Rome
Capua
Tarentum
Messana
Motya
Carthage
Syracuse

N

0 65 130 260 390 km

ENVIRONMENT

The peninsula of Italy extends some 1,100 km north to south and 320 km across. It was protected from migrations from the north by the barrier of the Alps Mountains; the Apennines likewise form a long central spine that separates the east coast of Italy from the west. The eastern or Adriatic coast tends to be less mountainous, marsh bound, and malarial. During antiquity, it was exposed to attacks by Illyrian pirates from across the sea. Accordingly, urban society developed later there than it did along the west coast. The western or Tyrrhenian coast is more mountainous, with several natural harbors, and tended to develop faster. The region is highly volcanic, with several active cones (Mount Vesuvius, for example), areas of hot springs, and porous tufa soils. Combined with the mild Mediterranean climate, the region was well suited for the production of wine and oil. In Campania and along the flanks of Mount Etna in Sicily, for example, the porous soil retains water during the dry season, enabling the inhabitants to harvest three crops per year. The climate of Italy varies significantly from north to south. Along the broad flat

Map 15 Population Elements in Archaic Italy.

plain of the Po River Valley north of the Apennine Mountains, the climate is continental, with significant accumulations of snow and rain during winter. The midsection is lush with rolling alluvial plains but subject to the Mediterranean drought; the southern heel and toe of Italy becomes extremely dry, but even here the mountains harbored rich pine forests suitable for timber. Rivers, such as the Po and the Tiber, allowed for communication between coastal populations and isolated communities in the mountains. Both rivers are perennial and allow navigation along their extent (approximately 40 km inland in the case of the Tiber). Again, coastal development and urban centers emerged more quickly along the western coasts of Etruria, Latium, and Campania (not to mention the opposing eastern coast of Sicily, particularly Syracuse) than they did along the Adriatic; however, once the Romans constructed roads across the mountains, communities throughout the peninsula began to develop at the same pace. Unlike Greece some 60 per cent of the land of Italy is arable. This meant that the region allowed for more cities and a larger overall population. Whereas in Greece the average hoplite army held about 3,000 to 5,000 men, in Italy the average hoplite army contained 15,000 to 20,000 men. Larger armies meant that the political situation took longer to resolve.

ETHNIC DIVERSITY AND SETTLEMENT PATTERNS IN IRON-AGE ITALY

The population of Italy was extremely diverse. Earliest on record, the Etruscans migrated to Italy at the end of the Bronze Age, possibly as a component of the Sea Peoples. They established a significant empire that extended by 600 BC along the entire west coast from the Po River Valley in the north to Campania in the south. More than a dozen Etruscan cities formed a confederacy that was often as divided within as it was hostile to outside elements. Etruscan ruling elements at one point or another controlled nearly every major settlement in Italy, including Rome, which was seized (according to tradition) by an Etruscan dynasty in 619 BC. The last Etruscan king, L. Tarquinius Superbus (Tarquin the Proud), was expelled by the Roman aristocracy in 510 BC. Although their language was not Indo-European and has still not been fully deciphered, it is clear that the Etruscans lent the Romans a number of cultural attributes. These included bronze and iron technology, urban planning, and several religious customs, such as augury and funereal games that featured gladiatorial combat. Along the central mountainous spine Indo-European peoples speaking Italian dialects (Oscan, Umbrian, Latin) migrated into Italy sometime after 1000 BC. Regions such as Latium, Umbria, and Samnium reflect the gradual agricultural settlement of these pastoralists. Along the southwest and south coasts of Italy and the eastern half of Sicily, Greek colonists settled ca. 800–600 BC, founding places such as Syracuse, Neapolis, and Tarentum (Taras). Over time Greek and Italian settlers made important contributions to a common culture, most notably in Campania where centuries of interaction, often violent, resulted in a mixed population at communities such as

Capua. Greek innovations such as the hoplite phalanx were readily imported by Greek colonists and adapted by Italian neighbors. In addition to the Etruscans, the Italians, and the Greeks, in western Sicily and across the seas in Carthage a significant Phoenician (Punic) presence took root by 800–700 BC. By 500 BC the Carthaginians had extended the reach of their maritime empire across the sea to Sicily, Sardinia, Corsica, and coastal Spain. They controlled the Straits of Gibraltar and sailed as far as the Canary Islands and southern Britain. Several cultural attributes, including Punic language and political organization (councils of *suffetes*, or judges), not to mention material remains such as Punic transport amphoras, display an unbroken continuum with their Phoenician origins in the eastern Mediterranean. Finally, to the north in the broad valley of the Po River, Gallic tribes traversed the Alps and settled the region by 600 BC, appearing in the historical record through their sack of Rome in 390 BC. The Gauls adapted slowly to an urban lifestyle; they are described by Roman writers as physically large and extremely fierce. The combination of so many populations within close proximity helps to explain the pattern of delayed political development in Italy. Whereas in Greece the political map became apparent ca. 600–500 BC, in Italy the course of political development did not become evident until 275 BC, when the Roman Confederacy emerged as the dominant power on the peninsula.

ARCHAIC OR ROYAL ROME (753–510 BC)

The Latin pastoralists who settled Rome chose the location because of its defensible heights (seven hills) above the navigable river of the Tiber. The Tiber offers the most accessible means from the coast to the central Italian hinterland, and the Tiber Island at Rome is the closest point to the coast where the river was fordable. Hence the position was strategic for traffic in fish and salt from the coast to the hinterland, as well as for movement north–south along the coast. No contemporary records of Royal Rome have survived, whether due to the destruction caused by the Gauls in 390 BC or otherwise. One can report only what was essentially stated as a tradition by later sources. The early kings of Rome were legendary but claimed descent from the Trojan hero Aeneas. Apart from the historically long survival of kingship, political organization at Rome resembled that in Greece. The king was the commander-in-chief in war, the chief priest, and the chief executive of the state (i.e., judicial authority). He was advised by a council of elders called the Senate (derived literally from *senex*, or old man).

The Senate consisted of the heads of all the great landholding households, or the *patres*, who were probably selected for life by the king. Beneath the Senate stood an assembly of freeborn, land-holding citizen warriors as in Greece. The assembly tended to be consulted for issues of war and peace; it may possibly have elected each king. As noted above, political development progressed more slowly in Italy. The transition to a national militia (hoplite phalanx) did not arrive in Rome until the alleged reforms of King Servius Tullius (578–535 BC), which is to say that social organization remained based on kinship much longer

According to legend, the twins Romulus and Remus founded Rome in 753 BC. Born to a human mother (a direct descendent of Aeneas) and the god Mars, the twins' uncle—King Amulius—feared the boys would someday overthrow him. To this end, Amulius ordered the boys be hurled into the Tiber River. The ancient Roman historian Livy tells the story of how the twins were saved:

> The story persists that when the floating basket in which the children had been exposed was left high and dry by the receding water, a she-wolf, coming down out of the surrounding hills to slake her thirst, turned her steps towards the cry of the infants, and with her teats gave them suck so gently, that the keeper of the royal flock found her licking them with her tongue. Tradition assigns to this man the name of Faustulus, and adds that he carried the twins to his hut and gave them to his wife Larentia to rear. Some think that Larentia, having been free with her favours, had got the name of "she-wolf" among the shepherds, and that this gave rise to this marvelous story.[1]

The so-called Capitoline Wolf, cast in bronze, was long believed to be an Etruscan work dating to the fifth century BC (the figures of the twins were added much later during the Italian Renaissance). However, recent testing confirms the she-wolf portion of the statue was likely cast between 1012 and 1153 AD. The Capitoline She-Wolf has been housed in the Palazzo dei Conservatori on the ancient Capitoline Hill in Rome since 1471, and persists as a symbol of Rome to this day.

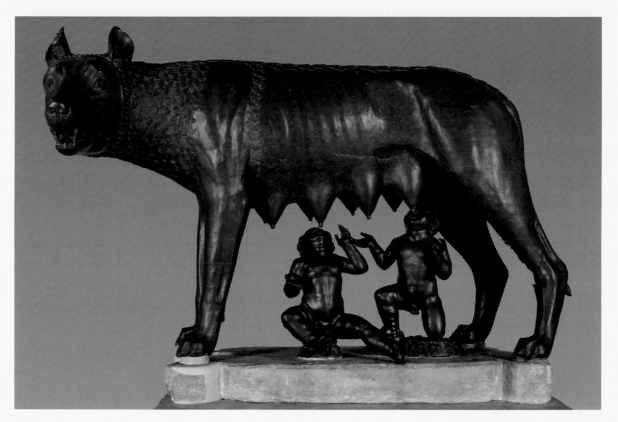

Figure 9.1 Capitoline Wolf, thirteenth and late fifteenth centuries AD. Bronze, 75 cm x 114 cm. Musei Capitolini, Rome, Italy.

1 Livy, *History of Rome: Books I and II* (Cambridge, MA: Harvard University Press, 1919), I. 4.

in Rome. As late as 479 BC aristocratic clans, such as that of the patrician Fabii, could still mobilize 306 warriors and operate independently on the battlefield. Family arguably remained the predominant building block of Roman social structure until the Late Republic (133–27 BC), when, like many traditional Roman institutions, it fell into decline.

THE ROMAN FAMILY STRUCTURE

The patriarchal family remained the basis of social organization in Rome throughout most of its history. In the archaic period all land was held in common and controlled by the eldest surviving male, the **paterfamilias**, or head of the Roman household. The *paterfamilias* enjoyed absolute power over everyone and everything on his estate. As late as 140 BC we are informed of an aged Roman senator, T. Manlius Torquatus, whose son committed abuses as a military commander in the provinces. Although popular magistrates had indicted the son for malfeasance, his aged father asked leave of the Senate to try his son before the council of his extended clan or *gens* (the *gens* consisted of all those who claimed descent from a common ancestor, usually a hero descended from the gods). Although surprised by the request, the Roman Senate had a penchant for respecting ancestral traditions, or custom, what the Romans called the *mos maiorum* ("the ways of the ancestors"), and acceded to the senator's request. Torquatus assembled a council of his family elders, tried his own son, and finding him guilty, banished him from his sight. The son reportedly hanged himself the following night. As strange as the story sounds today, it was preserved by Roman sources precisely because it reinforced notions of traditional values in a period when such values stood in decline. It demonstrates as well that as late as the end of the Republican Era, the dominance of family structure remained paramount in Roman society.

This dominance is best exemplified by Roman nomenclature. Generally, the family or *gens* took its *gentilicium* or family name from some hero ancestor, such as Julius (Iulus), the descendent of Aeneas. Each *paterfamilias* would assign to his children first names or *praenomina* to distinguish one from another, about 10 to 12 of which, typically abbreviated, became commonplace (Caius or Gaius, Gnaeus, Lucius, Marcus, Quintus, Sextus, etc.). Several *praenomina* were based quite simply on numbers: Quintus, Sextus, Decimus, and female names such as Tertia. Such numerical names not only reflect the cold authority of the *paterfamilias* but also the likelihood of high infant mortality rates. When the *paterfamilias* died, each male member of the succeeding generation assumed his place as the *paterfamilias* of a separate nuclear family. Inheritance was divided accordingly. Particularly among patrician families (those claiming descent from members of the Senate during the era of the kings, that is, before 510 BC), it became common for these branching-off elements of the *gens* to distinguish their identity through the acquisition of third names known as *cognomina*. *Cognomina* frequently took the form of heraldic badges such as L. Tarquinius Superbus, or Tarquin the Proud. C. Julius Caesar, the future dictator, for example, took

Roman artists working in the first century BC continued the tradition of making portraits—a practice that was already firmly established in Italy by this time. Yet it was the development of *naturalistic* portrait sculpture that remains one of the most characteristic achievements of Roman art. Rooted in Hellenistic Greece, this taste for realism—or **verism** (from the Latin *verus*, meaning "truth")—included the careful depiction by the artist of the smallest details, including skin imperfections like warts and wrinkles, as well as an interest in well-defined musculature and bone structure. Often the subjects for these portrait busts were older statesmen, prominent leaders who were well respected for their political influence. These portraits are brutally honest in what the twenty-first-century viewer would call less than idealized representations. In this portrait of an anonymous Roman politician (second century BC), his determination and vigor is evident in his expression and agile cocking of his head. Yet his face is worn. Bags hang under his eyes, and the soft, inward curve of the mouth suggests he is toothless. Here the sitter's physiognomy serves as evidence of his wisdom, responsibility, and experience—characteristics strongly respected by the ancient Romans.

Likewise, profound respect for family and ancestry played a huge role in Roman cultural identity. A principle funerary practice involved publically displaying portraits of prominent ancestors at the funerals of family members. Such a demonstration was both a show of pride and a source of inspiration for future generations. Polybius, a Greek historian (second century BC), explains the ceremony:

> The portrait [of the deceased] is a mask which is wrought with the utmost attention being paid to preserving a likeness in regard to both its shape and its contour. Displaying these portraits at public sacrifices, they honor them in a spirit of emulation, and when a prominent member of the family dies, they carry them in the funeral procession, putting them on those who seem most like [the deceased] in size and build.[2]

A statue dated to the first century BC depicts a toga-clad man carrying two Republican-era busts. Based on the descriptions by Polybius and Pliny, scholars are largely in agreement that the man is taking part in a funerary event. While the sculpture is likely commemorative, the portraits being held by the male figure are, in this case, three-dimensional busts and not masks as Polybius describes. Regardless, what seems indisputable is the importance portraiture—specifically veristic portraiture—played during this period both within the family and to society at large.

2 Polybius VI, trans. J. J. Pollitt, in *The Art of Rome, c. 753 BC–AD 337: Sources and Documents* (Englewood Cliffs, NJ: Prentice Hall, 1966), 53.

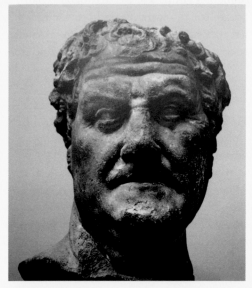

Figure 9.2 Portrait of an anonymous Roman politician. Second century BC. Marble. Musée du Louvre, Paris.

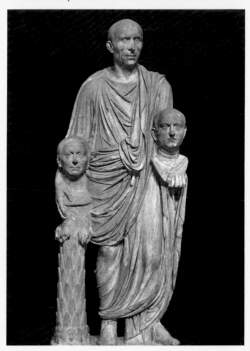

Figure 9.3 Togate male portrait with busts. Late first century BC. Marble, life-size. Museo Montemartini, Rome.

his cognomen from an ancestor who was reportedly born by caesarian section (*caedo, caedere*, meaning "to cut"). Many *cognomina* were acquired through valor in battle or conquest. Others were apparently awarded to Roman politicians by the voters, whether they wanted them or not, and were often based on distinctive personal features. For example, there was M. Licinius *Crassus* (the Fat), L. Cornelius *Balbus* (the Bald), Q. Sulpicius *Rufus* (red-haired or red-bearded). Q. Fabius *Maximus* (i.e., the Greatest of the Fabii), the celebrated dictator who opposed Hannibal, acquired the *cognomen Verricosus* because of his warts, as well as that of *Cunctator*, the Delayer, because he wisely resisted the impulse to confront Hannibal in battle with unseasoned Roman troops. Heraldic or pejorative, *cognomina* were useful to Roman politicians in an electoral environment because they offered invaluable name recognition with the voting public.

Following the census reforms of King Servius Tullius (ca. 550 BC), the formal names of all male Roman citizens were registered with the censors as follows: C. Julius C. f. C. n. Caesar, or Caius Julius, son of Caius, grandson of Caius, Caesar. Survival of this nomenclature enables historians to trace back family lineages over hundreds of years during the Republican era, in part because the aristocratic families themselves preserved the memory of their lineages so carefully that their record survives to the current day. Census registration also reveals the dominance of the *paterfamilias* over others within the *familia*, including dependents such as slaves. The Romans perceived their *familia* as a fluid entity capable of absorbing outsiders on an expanding basis. One could rise into the family through adoption, through marriage, and through manumission. Whether the result of death, divorce, or remarriage, blended families became commonplace, particularly among the aristocracy. Ex-slaves awarded their freedom by their masters would obtain Roman citizenship at the next census with their new status designated, for example, as C. Julius C. l. Epagathus, or Caius Julius, freedman of Caius, Epagathus. The abbreviation for *libertus* clearly designated the person's manumitted status and his cognomen his native (in this instance, Greek) origin. Roman nomenclature serves as a useful reminder of the centrality of family organization in Roman society.

The so-called Etruscan Kings (619–510 BC) were credited with a number of developments at Rome, including the constitution. King Servius Tullius (ca. 550 BC) introduced census reforms similar to those of Solon in Athens. According to tradition, Servius reorganized the military assembly into five classes based on property qualifications. Within each class, soldiers were organized according to centuries of 100, and for each level of wealth a century of older and a century of younger citizens existed. Hence, the Military Assembly became known as the Centuriate Assembly (*comitia centuriata*).

The Military (Centuriate) Assembly was organized according to some 193 centuries in all, 18 in the equestrian or Knights' class (i.e., those whose worth enabled them to own horses) and 80 in the First Class. Votes would be cast according to centuries (the majority vote within a century carried that century as one vote). The highest-ranked centuries (those whose members possessed the highest property worth) voted first, and their votes counted most. As soon as the vote of a majority of centuries (97) was secured, the election for that office was completed. Since the wealthier citizens tended to see things

similarly, centuries of the *Equites* (the Knights) and the First Class typically voted alike. This gave a candidate or a pending legislative measure potentially 98 centuries, or the necessary majority, at which point the voting would cease and the assembly disbanded. Typically, the lower classes would rarely be called on to vote. In short, the Military (Centuriate) Assembly was organized conservatively so that the votes of the wealthiest citizens came first and counted most. King Servius Tullius's logic in organizing such an assembly was to enable wealthy *plebeians*, that is, Roman citizens not related to any of the senatorial families of the kings, to be enrolled in the highest class on the basis of wealth, as opposed to birth. This reflects the growing importance of the national militia (the phalanx) at Rome, not to mention the need of the king to draw on greater reserves of manpower than otherwise available within the aristocracy. As in Sparta, Roman kings appear to have enjoyed strong support among the element of farmers-citizens-soldiers and to have incurred the animosity of the aristocracy. The development of the Roman Republican constitution was a fluid process, requiring experimentation with trial and error over several centuries.

THE DEVELOPMENT OF REPUBLICAN INSTITUTIONS (510–287 BC)

In 510 BC the aristocracy rebelled and expelled the last Etruscan king of Rome, Tarquin the Proud. Patrician aristocrats declared themselves a republic and carefully transferred the power of the king to new annually elected magistrates eventually known as **consuls** (two elected annually). These annually elected chief executive officers were elected by the Centuriate Assembly. The religious authority of the king was transferred to a chief priest known as the *Pontifex Maximus*. The members of the Senate, the *patres* or *patricians* (all those who claimed descent from members of the Senate at the time of the kings), informed the citizenry that since they were descended from the gods, it was necessary that patricians exclusively hold these high offices. The power of the consuls, their *imperium*, was ultimately based on the consul's authority to consult the auspices, that is, to consult with the gods about the appropriateness of a public action (be this electoral, judicial, or military). This religious authority gave the consuls the right to command armies, the power to hold assemblies and to convene the Senate, and more broadly the royal power of life and death over everyone and everything in the army's path. This power was designated by the presence of 12 consular bodyguards, or crowd-control attendants known as *lictors*. The *lictors* preceded the consul everywhere he went to clear a path. They carried bundles of rods known as the *fasces* to beat people who failed to respect his authority. When the consul left the city at the command of the army, the *lictors* placed an ax in their bundle of rods to signify the consul's authority to conduct the sacrifices. The emblems of *imperium*, the *fasces*, thus, served as a symbol of the consul's power of life and death. Once entrusted with *imperium* outside the walls of Rome, the consul could execute captured enemies and

his own mutineers with impunity. A religious ceremony conducted by the priests known as the augurs would deliver the *imperium* into his hands as he prepared to leave the city. Hence, an aura of religious magic, the power to consult the gods through augury, lay at the very foundation of *imperium*. Roman officials entrusted with this authority (consuls, dictators, and praetors) had the power to consult the gods before conducting any public action, be it a battle or an electoral assembly. Patricians insisted that this power would evaporate if the authority were entrusted to someone who was not, like themselves, descended from the gods, thus relying on religious taboo to secure their authority in the political arena. Plebeians could vote in the assembly, but only patricians could hold office or enter the Senate for life.

By the time of the founding of the Roman Republic in 510 BC, Rome was the largest city in all Italy. The efforts of the Etruscan kings had enabled the community to develop into a complex society with numerous wealthy plebeian, or non-senatorial, families. The latter were unwilling to accept the logic of patrician exclusivity in governance, particularly since the kings had recently encouraged plebeian participation in leadership by electing many leading plebeians into their Senate. Plebeian leaders exploited popular discontent arising from crises concerned with land and debts (recall the similar circumstances in Israel and Greece) to mount protests against the patrician hierarchy. According to tradition these culminated in 494 BC in the Great Secession. The hoplite army of the Romans withdrew from the aristocratic contingents of the consuls just prior to a battle with the army of the expelled King Tarquin. While dressed in their full panoplies of armor, the soldiers staged a sit-down strike on what became known as the Sacred Mount. The plebeian soldiers bound themselves together religiously by swearing a most fearsome oath to protect the persons of representatives chosen at that moment to speak on their behalf. These annually elected representatives of the *plebeian assembly* became known as the **plebeian tribunes**. Because of the oaths sworn on the Sacred Mount, their persons were sacrosanct or inviolable, that is, they could not be touched without inciting all plebeians to rush to their protection. *Sacrosanctitas* gave the plebeian tribunes the religious authority necessary to withstand the *imperium* of the consuls, with the potential to incite a constitutional crisis. Through personal inviolability tribunes could extend their protection to ordinary Roman citizens merely by placing their hand on them and asserting their *auxilium* or self-help. No Roman magistrate could impose his authority on a citizen once a tribune's *auxilium* was extended to him. Tribunes also learned to veto the acts of all other magistrates simply by appearing at a convened assembly or Senate meeting and using their *sacrosanctitas* to block any and all public activity (*intercessio*). Ultimately they obtained the authority to pass legislation in the Plebeian Assembly. By virtue of the *Lex Hortensia* in 287 BC, all legislation passed in the Plebeian Assembly became binding on the state. All these powers evolved intrinsically from the religious authority furnished by tribunician *sacrosanctitas*. Over time, ambitious tribunes learned to explore the full scope of their religious power to effect political reform and innovation on the Republic.

As the plebeian assembly became permanent, it evolved into a *Tribal (Popular, Plebeian) Assembly* of 35 voting tribes, arranged geographically according to one's residence. The

votes casted by the majority of voters in a given tribe determined the vote of that tribe. Out of 35 tribes, a majority of 18 would carry an election or a legislative assembly. Although the Tribal Assembly appeared to be more democratically organized, evidence shows that it was blatantly jerry-rigged to insure that the voting even of this assembly was weighted toward the property-holding classes. For example, when enrolled in the Roman census all manumitted slaves were placed in the four urban tribes of Rome rather than in the 31 rural tribes of their former owners. This insured that the vote of the burgeoning urban population was offset by a smaller number of votes cast by rural farmers living in tribal districts in the outskirts of the city. In short, Rome remained a conservative society through and through. At the outset the work of the plebeian tribunes was really to insure the political rights of wealthy non-patrician citizen soldiers, and until the era of the Late Republic the main purpose of the plebeian assembly was to address the concerns of freeborn, property-holding citizens.

Ultimately what plebeian leaders wanted was access to the magistracies and membership in the Roman Senate. For centuries this conflict—referred to as the *Struggle of the Orders* (494–287 BC)—raged domestically even as Rome conducted wars against its expelled king, his sons, and various neighboring polities. Every time the plebeians appeared to be on the verge of gaining full political equality with the patricians, the patricians would devise some innovation. For example, they would invent a new electoral office and relegate some former component of royal power to that office in order to restrict eligibility exclusively to patricians. In this manner, an array of magistracies gradually came into being, including: *praetors*, or chief judicial officers; *curule aediles*, or magistrates responsible for public safety; *quaestors*, or chief financial officers; and *censors*, who conducted the census, determined membership in the Senate, and leased public contracts at auction to contractors known as *publicani* (these offices will be discussed in greater detail below).

Another very important office arose from this conflict, namely, that of the Roman **dictatorship**. A dictator was appointed by the Roman Senate and People in the event that the consuls became incapacitated through death on the battlefield, for example. The dictator enjoyed *imperium* inside the city, not just without, and was designated by appointment of 24 *lictors* as opposed to the 12 entrusted to each consul. The *lictors* bore axes in their *fasces* inside the city because the dictator enjoyed absolute power at all times. However, the appointment lasted only six months, at which time it was expected that the political crisis would be resolved and normal governing procedures and institutions could resume. In essence, the dictatorship represented the temporary imposition of martial law, with all Roman citizens placed on an emergency war footing. The tenure of all other *curule* magistracies was suspended, and the dictator ruled the city through the appointment of archaic, royal subordinates known as the Master of the Horse (*magister equitum*) and the Prefect of the City (*praefectus urbanus*). The appointment of the dictator was accordingly an extreme measure rarely resorted to because the freedom of all Romans, including patricians, became subject to the authority of a single individual. Later, during the Hannibalic War, dictators such as Q. Fabius Maximus were appointed after several Roman consuls were defeated or killed in the field, creating a genuine military emergency.

Ultimately, in 287 BC the Plebeian Assembly passed a law known as the *Lex Hortensia* that recognized the legally binding character of all legislation passed by the Plebeian or Tribal Assembly. By this time plebeian legislation insured that at least one elected consul and one elected censor must be plebeian. Plebeians attained full and equal status in the body politic, assumed the highest magistracies, and entered the Senate for life. The Roman aristocracy thus became a mixed aristocracy and was majority plebeian, in fact. Since patrician status could only be sustained through blood relations (both of one's parents had to be patrician), by the end of the Republic fewer than 20 patrician families survived. The conflict between plebeians and patricians essentially disappeared by the time of the Middle Republic (287 BC), but it left the Roman Republican state in the unique position of operating two governments at the same time in the same place. The Centuriate Assembly was convened by the consuls to elect those magistracies concerned with *imperium*, the military,

TABLE 7. FLOWCHART OF THE ROMAN REPUBLICAN GOVERNMENT		
Curule **Magistrates**	**ROMAN SENATE**	**Plebeian or Popular Magistrates**
2 Consuls (chief executives, age 42, presided over Senate and assemblies, commanded armies in the field through *imperium*)	*Auctoritas* (combined influence and experience of its members)	10 Plebeian Tribunes (civil liberties defenders, veto power, legislation, *auxilium*)
8 Praetors (judges of state tribunals, age 39, wielded imperium as provincial governors)	*Senatus consultum* (sense of the senate resolutions, legally nonbinding but having the weight of law)	
2 *Curule Aediles* (public works, public games)	All ex-magistrates entered the Senate for life.	2 Plebeian *Aediles* (public works of the people)
10 Quaestors (financial officers, age 30)	Senate determined foreign affairs (appointments to military and provincial commands) and finance (the amount of funds to be disbursed for warfare, festivals, and public works)	
(*cursus honorum*)		

the judiciary, and the treasury (what were known as the curule magistracies); its elections were conducted in a way that favored the wealthiest citizens and its acts were binding on the entire Roman state. The Plebeian Assembly meanwhile relied on the more democratically organized assembly of 35 tribes to elect the plebeian magistrates (tribunes and *aediles*) and to pass any legislation that the assembly deemed necessary. The point to be emphasized is that the same citizens did the voting in either assembly, the difference was how the voting was organized and its results. Such a political system is referred to as *dual polity*, that is, the potentiality of two governments operating in the same place at the same time. What held these governments (*curule* and plebeian) together and prevented the risk of political gridlock was the intermediating influence of the Senate.

THE ARISTOCRATIC ETHOS AT ROME

The results of constitutional developments at Rome were best expressed by the Republican acronym, *SPQR*, *Senatus Populusque Romani*, "the Senate and the People of Rome." What held the Republic together for five centuries was the stabilizing influence of the Senate itself and the reliance on Roman family structure as an extralegal source of political and social redress. Roman citizens consented to rule by an oligarchic regime in large part because the competitive nature of the electoral process allowed for some measure of public scrutiny. To become a Roman senator, an aristocrat had to compete repeatedly for election to an ascending hierarchy of political offices. This kept them accountable to the voters. In addition, as Roman senators pursued election to higher office, they endured a winnowing process whereby each office proved more competitive than the last and demanded a new and more challenging skill set. The Romans devised an expression for this process, the **cursus honorum**, or "the race for the offices." Senators perceived their political careers in highly public and decidedly competitive terms. They pursued *gloria et honos*, that is, glory on the battlefield or through political success in the assemblies or the Senate, and honor, or the acquisition of elected office at home. Political success required that individual aristocrats commit themselves to a public career essentially from the time they first became prescient of mind.

Dual polity at Rome entailed the distinct possibility of a constitutional crisis whenever the curule magistrates of the aristocratic wing of the government disagreed with the plebeian magistrates of the democratic wing. What prevented such conflicts was the mediating influence of the Senate. The Senate consisted of all ex-magistrates of Rome. As such, its membership represented the sum total of all wisdom and experience available to the Republican state. Although the Senate enjoyed no legally binding authority, it ruled by virtue of its *auctoritas*, that is, the sum total of influence and experience possessed by its members. Its members passed *Sense of the Senate* resolutions known as **senatus consulta**. Since few standing magistrates were willing to challenge these resolutions and risk open

conflict with the senatorial aristocracy as a whole, a *senatus consultum* possessed the de facto weight of law.

Rank within the Senate itself was determined by the highest offices a member had obtained. To be a decision maker, one had to hold the highest offices, particularly the consulship, which ennobled oneself and one's family by making one a member of the *consular nobility* at Rome. These men sat in the front rows of the Senate and were asked by presiding magistrates to address their colleagues publically on the issues of the day. Customarily, the consul or tribune presiding over a Senate meeting would call on two highly distinguished ex-consuls known to hold opposing points of view. There was no time limit to discussion, and a chosen senator, once given the floor, might proceed to rant about current affairs for hours. M. Porcius Cato the Elder (234–149 BC), for example, was known to conclude each and every speech he made before the Senate (regardless of the issue being addressed) with the recommendation that Carthage be destroyed (*Carthago delenda est*). Typically any and all ex-consuls would get their chance to speak; however, most other senators would merely sit and listen, while exhorting the orators with shouts of encouragement or derision. At the end of the day, the presiding magistrate would call for a vote by division or *divisio*. He would announce that all those senators who agreed with the distinguished ex-consul so-and-so walk to one side of the hall and that all those who agreed with the opposing ex-consul's opinion walk to the other. Few senators actually got to speak, in other words, and most expressed their votes by walking from one side to the other. These were known derisively as *pedarii*, those who voted with their *feet* (as opposed to their voices). To obtain office, a young aristocrat had to assemble an expanding base of constituents and to display competency in military science, law, rhetoric, and finance.

Competing for office was so challenging that Roman aristocratic families typically determined early on which of their male children would be prepared to seek political office. Parents would select their most talented sons, not necessarily the eldest. Aristocratic children learned from watching their fathers just how public a senator's life was meant to be. On days when Rome conducted public business, the senator would sit in his office, the *tablinum*, inside the atrium of the Roman house in full view of constituents or clients waiting out in the street to greet him. Once the doors to the house were open, it was possible to gaze directly in from the street to see the aristocrat ready to greet his clients. The latter typically queued at the door waiting to salute him and to ask for assistance in some matter, be it political, financial, legal, or personal. He would welcome as many relatives, friends, and clients as he had time for, greeting them by name (frequently whispered into his ear by a slave known as a *nomenclator*, who would also remind the senator of significant details to the client's life, such as the name of his wife, the number of his children, their dates of birth, any and all past dealings including loans outstanding or services rendered). The senator would never be alone. If public business required his presence downtown, he would leave his house and walk to the Roman Forum surrounded by an entourage of clients. At the end of the day these same people would accompany him back to his house.

The size of a senator's entourage testified to his importance in the Roman *patron/client relationship*. Senators and their constituents engaged in relationships of mutual dependency

The burial of the cities of Pompeii and Herculaneum following the eruption of Mount Vesuvius in 79 AD led to the remarkable preservation of Roman domestic art and architecture. The typical patrician Roman house or **domus** at Pompeii was symmetrical with an emphasis on the interior space and decoration rather than on the exterior. Upon entering the house, one would be led through a vestibule to the *atrium*, a large hall with a square or oblong opening in the roof that revealed the sky. The atrium traditionally displayed the portraits of ancestors. Surrounded by living rooms and bedrooms, the atrium also contained a small shallow pool called an *impluvium* that collected the rainwater from the opening above. The *tablinum* (main reception area) and the *triclinium* (dining room) were immediately behind the atrium and preceded the *peristyle*. Small rooms often surrounded the Greek-inspired peristyle, which functioned as an enclosed colonnaded garden. The open house plan was ideal for the warm, sunny climate, giving the feeling of being outdoors while still receiving shelter from the elements.

Most Roman paintings that are extant come from domestic spaces—primarily wall paintings from Pompeii and Herculaneum, Rome, and surrounding areas. Because the patron/client relationship was extremely important in Roman society, the domus and its decoration reflected the family's wealth and status. At Pompeii, artists imitated architectural features, employed rich colors, experimented with size and perspective, and the representation of reality versus fantasy. Four distinct "styles" of Pompeian painting have been identified chronologically from the second century BC to the eruption of Mount Vesuvius in 79 AD.

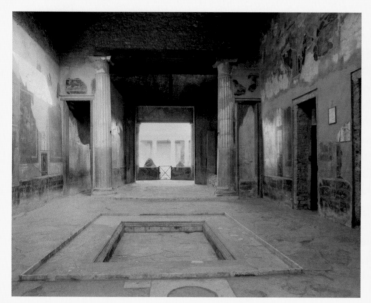

Figure 9.4 View of the Atrium of the House of the Menander.

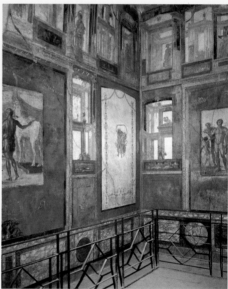

Figure 9.5 Fourth Style wall painting, Ixion Room, House of the Vettii, Pompeii, 63–79 AD.

that, although hereditary, required renewal through mutual exchange of favors with each passing generation. An aristocrat inherited his relatives, friends, and clients from his parents, in other words, but the degree to which the patron/client relationship functioned as an institution depended largely on the energy and success of each individual senator. Senators were expected to assist their clients with matters rising to the level of the senator's own expertise. For example, the senator would lend clients money or find others to do so by acting as the client's surety in a loan. The senator would defend the client's interest in

court by acting as his lawyer or as his character witness. In the Senate house the senator would speak and vote in favor of matters that concerned the interests of wealthy influential clients such as publicans (public contractors), or exert influence on behalf of the same with acting magistrates such as the quaestors whose job it was to disburse funds and to conduct public auctions. As a military commander the senator would command his clients among others in battle and distribute among them portions of the booty obtained through military victory. These represent merely a sample of the kinds of favors clients expected from their senatorial patrons. In exchange, clients were expected to support their patrons by helping to advance their careers, thereby making them more powerful and influential so that they could serve their constituents in greater capacity. Clients were expected to call on a senator at his place of residence and to form part of the entourage that accompanied him to the Forum, thus serving as a symbol of the senator's influence and status. Clients obviously voted for their patron whenever the latter sought political office and helped the senator to canvass for the votes of others, oftentimes through bribery. Clients contributed financially to senatorial electoral campaigns and contributed as well when and if a senator was convicted and fined for some political act of malfeasance. Clients spoke on behalf of senators as witnesses in court and volunteered to serve in any military command a senator might obtain. This process of mutual exchange of favors ultimately benefited everyone and explains why the Roman family structure limited the need for complex political institutions. People sought redress within the family structure by seeking the assistance of the *paterfamilias*, and he in turn shared his successes with them and worked on their behalf. What determined the size and strength of a senator's following ultimately was his success in the political arena. This, in turn, was determined by his electability.

By the Late Republican era, age restrictions were imposed on candidates seeking all offices. The first office an aristocrat could seek was the quaestorship at age 30. The quaestors were financial officials entrusted with dispensing public funds for services rendered to the state, for example, to reimburse publicans for construction of public monuments that had been contracted by higher ranking magistrates. The main job of the quaestors was to carry the war chest of a Roman magistrate entrusted with *imperium* and to dispense funds as required. The 10 aristocrats who obtained this office each year obviously needed to possess significant financial experience and acquired this by attending their fathers and uncles in the Forum, by becoming acquainted with influential financial figures, by borrowing and lending money to friends and clients, and usually by being required as young adults to manage one of the aristocratic family's numerous agricultural estates. Prior to holding the quaestorship, an aristocrat might seek a lesser office at the state mint, where he would supervise the striking of coinage bearing inscribed symbols of his family's political and military success. Once gaining the quaestorship, a young aristocrat entered the Senate for life, but he sat in the back row of the *curia* and would seldom be called on to speak. To gain prominence in the Senate and to advance the interest of his clients, he needed to obtain higher office.

The next office he could seek was the *curule aedileship*. The *aediles* supervised market activities in the Forum and enjoyed limited judicial responsibilities as a result. They might

also be entrusted with letting public contracts and supervising the construction of public monuments, since their responsibilities included the maintenance of the public weal. However, they were mainly known for the week-long festivals they organized for the Roman deities Jupiter and Apollo on behalf of the Roman state. Although the Senate would authorize the expenditure of some limited amount of public funds for the occasion, the *aedile* was expected to raise his own funding, through clients and loans, to host outlandish games. These might include a week's worth of animal hunts and horse races in the Circus Maximus, dramatic performances, and city-wide public banquets where make-shift tables would be erected in the streets to enable the entire Roman population to dine on meat and wine. Mathematically, only two of any ten members of a quaestorial college of a given year could expect to obtain the aedileship, and the voters of the Centuriate Assembly tended to vote for the two candidates most likely to host extravagant games. The notoriety this entailed typically enabled successful *aediles* to obtain the consulship. The games of Julius Caesar were so outlandish that he became the darling of the Roman public, destined to obtain the consulship *suo anno*, that is, in the year that he became eligible for the office at the age of 42.

At age 39, a successful aristocrat, now nine years a senator, could seek the praetorship, as one of the chief judicial officers of the Republic. Praetors did not so much preside as judges as they did oversee legal proceedings. Primarily they listened to legal suits to determine whether they were actionable in a Roman court of law. Through their edicts they also established legal procedures for their year in office by declaring which statutes they would recognize and which they would not. They might also be expected to preside over a public assembly or the Senate in the absence of the consuls, and during major conflicts they could expect to receive a military command either in the form of a provincial governorship or an army in some secondary theater of war, the hot conflicts being reserved for the consuls. Praetors had to know the law, both civil and public, therefore, as well as know how to orate in public. Young aristocrats devoted considerable time to the study of law, again by attending their elders in the Forum and by visiting Senate meetings, standing and observing from somewhere in the back. They gained additional experience by defending the interest of their clients in court and by prosecuting notoriously corrupt Roman ex-magistrates after their year in office. Rome had no office of public prosecutor, but the indictment of abusive Roman officials was regarded as a public duty, particularly if the abused parties were clients of one's own aristocratic family. Although a young prosecutor was hardly expected to succeed with such an indictment (since the ex-magistrate usually had considerable funds with which to sway the minds of the jury), he could nevertheless gain significant visibility through his demonstration of eloquence and legal skills. Julius Caesar conducted several prosecutions in his youth and all but indicted one notoriously corrupt politician, C. Antonius Hybrida (the uncle of the future Mark Antony). However, the defendant was spared by the *auxilium* of a tribune (an Antonian relative in fact), just as the jury was about to convict him.

All this prepared the aristocrat for his most challenging electoral campaign, his pursuit of Rome's highest office, the consulship, at the age of 42. By this point, he would have

demonstrated all the required financial, legal, rhetorical, and military skills. However, of the eight available ex-praetors of any given year, only two at most could succeed to the consulship. The winnowing process of the *cursus honorum* rendered the consulship the most competitive office of all. Political canvassing in the Forum was stiff (literally, with candidates wearing starched, whitened togas as they greeted potential voters), and bribery was rampant. Aristocrats and their families generally went deeply into debt to borrow money in their efforts to influence the outcome. Creditors would base their money-lending decision like gamblers, determining which candidate was the one most likely to succeed, not only during the election but later on the battlefield, where spoils of war would generate revenues sufficient to repay loans with interest. Citizen soldiers would likewise scrutinize the candidates carefully and pay close attention to security conditions outside Rome, knowing full well that whomever they elected to Rome's highest office would likely command them in the field. Once elected the two successful consular candidates achieved the pinnacle of their political careers. They received the authority to pass legislation, to convene the Senate, to govern the state, and most importantly, to command Roman legions on campaign.

To convince Roman citizens-soldiers-farmers that they could successfully command armies, aristocrats obtained military experience like all Roman male citizens by serving with the armies of their relatives as early as 16 years of age. Roman citizens were required to fulfill 16 years of compulsory military service, and most completed as many as 20 before they were exempt from the draft. Aristocratic youths lived in the tents of related officers, they attended officer staff meetings, and they frequently served as messengers riding orders from the general at the center of the army to the officers posted on the wings. In their twenties, young aristocrats could hope to obtain by election or appointment subordinate positions as legates or military tribunes, thereby acquiring some knowledge of military command and control before seeking the quaestorship. The consul had to know not only how to array his army on the field, but also how to protect it by building a fortified military camp, and how to feed and supply it by organizing complex logistical arrangements with merchants and publicans who followed Roman armies in the field. The Roman consul was expected, accordingly, to march his army safely through foreign territory, to defeat foreign armies in battle, and to sell foreign combatants into slavery.

Victory on the battlefield earned the consul potential acclamation as a triumphing Roman general, or **imperator**. Once hailed by his troops in this manner, the consul would dispatch an embassy to the Senate at Rome to describe the scale of his victory and to ask the Senate's leave to march into Rome in triumph. The Senate would actually conduct interviews with witnesses such as merchants returning from the field with prisoners to ascertain the caliber of the victory and whether it truly warranted a triumph. If authorized, the general would return to Rome to an ancient form of ticker-tape parade through the city. The triumphing Roman general would be preceded by his army, his most notable prisoners, and wagon loads of captured booty. Garbed in a red cape, arcane shoes, and a gold crown, the consul, dressed to resemble the god Jupiter, would ride through the city in a chariot drawn by white horses. His children would typically accompany him in

the chariot. The parade would proceed along the Sacred Way, through the Forum, and up the steps of the Capitoline Hill to the Temple of Jupiter Optimus Maximus, where the consul would perform the sacrifices. It would then make its way back to the Circus Maximus where the *imperator* would conduct lavish games and feed the public with the proceeds of his victory. He would devote one-tenth of his profits to the gods in gratitude for his victory, another portion to the state treasury, still more bounties to the officers and soldiers who had served with him, and pay off all the debts he had acquired along his long and difficult career. He would hope in the end to have sufficient funds left over to invest in his family fortune, thereby laying the seed for the career of his own son(s), who would be expected to succeed, if not surpass him, in aristocratic glory. He would then take his place among the front ranks of the Senate and continue to exert his energies on behalf of the family combine he had helped to construct and perpetuate.

CONCLUSION

Originating as a city-state ruled by kings, the Roman populace gradually transited from a small-town monarchy to an oligarchic regime that derived its authority from elections conducted among the freeborn, property-holding citizens of Rome. The conflicts that inherently arose between nobles and commoners, urban artisans and rural farmers, rich and poor, were negotiated through a gradual process of hard-fought political negotiation and innovation. Initially, the oligarchy relied on the Centuriate Assembly to delegate the former powers of the king to its annually elected magistrates. Almost immediately the Roman people appointed plebeian representatives to check the potentially unbridled power of these officials. The likelihood of gridlock between the *curule* and the plebeian magistrates was usually avoided through the workings of the Roman Senate, the members of which used their combined influence and experience to pressure elected officials to achieve compromise. Plebeian status was improved only through concessions granted by a recalcitrant hierarchy. Balance was ultimately achieved through a gradual process of co-option: the best and the brightest of the plebeian leaders were gradually allowed to rise into a mixed aristocracy whose members represented voters from all walks of life. Dual polity was a hybrid political system that harbored numerous risks; however, the strength of the Roman family system and the willingness of Roman leaders to incorporate outsiders gradually and by degrees furnished the Roman state with sufficient flexibility to grow in size and to respond to a rising number of challenges.

FURTHER READING

Abbott, Frank Frost. *A History and Description of Roman Political Institutions*. New York: Ginn, 1963.
Gelzer, Matthias. *The Roman Nobility*. Oxford: Blackwell, 1969.

Raaflaub, Kurt A. *Social Struggles in Archaic Rome. New Perspectives on the Conflict of the Orders*. Oxford: Blackwell, 2005. https://doi.org/10.1002/9780470752753.

Ramage, Nancy H., and Andrew Ramage. *Roman Art: Romulus to Constantine*. 3rd ed. Englewood Cliffs, NJ: Prentice Hall, 2000.

Scullard, H.H., *A History of the Roman World, 753–146 BC*, 4th Edition, London and New York: Routledge, 2007.

Taylor, Lily Ross. *Party Politics in the Age of Caesar*. Berkeley: University of California Press, 1961.

TEN

ROMAN IMPERIALISM AND THE FORMATION OF EMPIRE (275–27 BC)

WHAT HAVE WE LEARNED?

- ► That the populations of Italy were highly diverse and included Etruscan, Gallic, Carthaginian, Greek, and Italian populations, including the Latins (of whom the Romans were a part).
- ► That the patriarchal family remained the basis of social organization in Rome throughout most of its history and was exemplified by the *tria nomina* of Roman nomenclature (first name, family name, and *cognomen*).
- ► That having originated as a city-state ruled by kings, the Roman populace successfully transited from small-town monarchy to an oligarchic regime that derived its authority from elections conducted among the freeborn, property-holding male citizens.
- ► That in 510 BC the aristocracy rebelled and expelled the last Etruscan king of Rome, Tarquin the Proud. Patrician aristocrats (those who could claim descent from members of the Senate of the king) declared themselves a republic and carefully transferred the power of the king to new boards of annually elected magistrates.
- ► Patrician supremacy was resisted in 494 BC by plebeian leaders who organized a board of 10 annually elected plebeian tribunes. Conflict and compromise resulted in dual polity, two governments existing simultaneously in the city.
- ► That Roman senators and their constituents shared a relationship of mutual dependency known as the patron/client relationship. Although hereditary, this relationship needed to be renewed through a mutual exchange of favors with each rising generation.

ROMAN MILITARY EXPANSION, 510–146 BC

Within approximately 200 years the city-state of Rome expanded militarily to become the dominant power on the peninsula of Italy; in the following 200 years, the same military establishment rose to assume authority over the entire Mediterranean world. The success of Roman armies was recognized by contemporaries and marveled at by modern historians. In this chapter we will briefly identify the unique traits of Roman military society that enabled it to transform itself into a Mediterranean-wide empire.

The history of the Roman Republic is largely told through its wars. These can be divided into four categories.

Initially, Roman conflicts were simply struggles for survival. Rome drew on the support of an alliance system—the Latin League, originally created by its kings—to repel the threat of Etruscan and other neighbors. Eventually, the strength of this alliance enabled Rome to expand its network of friendships beyond its home region of Latium by offering security to neighbors in the Apennine Mountains and southward along the western coast. The process of incorporating new member states into the Roman Confederacy resulted, however, in Rome having to accept the "baggage" that accompanied each new state. This typically included a new ally's lingering animosities with other neighboring states. Conflict erupted with the bellicose Samnites, for example, when Rome welcomed Capua and the Campanian states into the confederacy in 342 BC. The Samnites had long regarded central Italy as their sphere of influence. Despite repeated attempts at negotiation, Rome was compelled to engage in a series of hard-fought conflicts (342–290 BC) to secure Samnite cooperation. Similar intervention in southern Italy (the Bay of Tarentum) resulted in the outbreak of conflict with Tarentum whose citizens turned for assistance to King Pyrrhus of Epirus (281–275 BC), a relative of Alexander the Great. This conflict was followed by the outbreak of the First Punic War (264–241 BC). In each instance the Roman Senate attempted to negotiate an alternative to conflict; however, with each step forward Rome found itself dragged increasingly into conflict by the interests of its burgeoning network of allies. Some scholars have identified this process as one of *defensive imperialism*, because Rome expanded its hegemony through warfare largely as a result of the liabilities it thus inherited. According to this interpretation, Rome had no interest in conquest (particularly overseas conquest) and was concerned only with securing peace and stability on the Italian peninsula. Regardless of the correctness of this interpretation, the first conflict with Carthage resulted in Roman acquisition of territories beyond the Italian peninsula (Sicily, Sardinia, and Corsica) and challenged the strategic outlook of the Roman hierarchy. Some factions of the Roman aristocracy preferred to adhere to an isolationist policy of maintaining the peace in Italy while avoiding entangling alliances overseas. Others saw the need to protect wider Italian interests, particularly commercial interests, by projecting Roman force wherever necessary. Roman senators were still entrenched in this debate when renewed conflict with the Carthaginians erupted in Spain (218 BC), this time commanded by a formidable general, Hannibal. For 18 years (the Hannibalic or Second Punic War, 218–201 BC) Rome found itself embroiled in a deadly struggle against

CHRONOLOGY 11. CONFLICT DURING THE ROMAN REPUBLIC

510–290 BC	**Wars for Survival and Local Supremacy within Italy**
389–338 BC	Latin Wars
343–290 BC	Samnite Wars
281–201 BC	**Wars of Defensive Imperialism**
281–276 BC	War with King Pyrrhus of Epirus
264–241 BC	First Punic War
218–201 BC	Second Punic War (Hannibalic War)
200–146 BC	**Wars of Conquest**
201–198 BC	War with Philip V of Macedonia
192–189 BC	War with Antiochus III of Syria
172–168 BC	War with Perseus of Macedonia
146 BC	Destruction of Carthage and Corinth
133–27 BC	**Wars of the Late Republic**
133–129 BC	War with Aristonicus in Asia
136–130 BC	Sicilian Slave Rebellion
126–105 BC	Conquest of Gallia Narbonensis
109–105 BC	War with King Jugurtha of Numidia
105–101 BC	War with the Germanic Cimbri and Teutones
105–100 BC	Second Slave Rebellion
102–67 BC	War against the Cilician Pirates
90–82 BC	Social War against Italian Allies
88–62 BC	Wars with Mithradates VI of Pontus
88–82 BC	Civil War between Marius and Sulla
80–72 BC	War with Q. Sertorius, rebellious general in Spain
73–71 BC	Slave Rebellion of Spartacus
63 BC	War with Cataline, internal Roman conspiracy and rebellion
58–52 BC	Caesar's Conquest of Gaul
54–53 BC	War with Parthia
49–45 BC	Civil War between Pompey and Caesar
43–41 BC	Civil War between Antony/Octavian and Brutus and Cassius
42–36 BC	War with Sex. Pompey
32–31 BC	War between Octavian and Antony/Cleopatra

Based upon a cartoon by Giulio Romano completed during the Italian Renaissance, this late seventeenth-century tapestry depicts the last battle between Scipio Africanus and the Roman army against the Carthaginians during the Second Punic War. At their most utilitarian, tapestries were large decorative panels used primarily during the late medieval and Renaissance periods to insulate castles and churches. These large-scale, multi-paneled tapestries also allowed for the creation of complex narrative cycles often with celebratory or propagandistic themes.

This particular tapestry panel shows Scipio on the front lines of battle wearing a blue mantle adorned with stars, urging his men to use their weapons to push back the Carthaginian army—complete with charging elephants. An excerpt from Livy's *History of Rome* provided the foundation for the tapestry's terrifying and chaotic scene:

> To make his line look more menacing Hannibal posted his elephants in front. He had eighty altogether, a larger number than he had ever brought into action before. Behind them were the auxiliaries, Ligurians and Gauls, with an admixture of Balearics and Moors. The second line was made up of Carthaginians and Africans together with a legion of Macedonians. A short distance behind these were posted his Italian troops in reserve. These were mainly Bruttians who had followed him from Italy more from the compulsion of necessity than of their own free will. Like Scipio, Hannibal covered his flanks with his cavalry, the Carthaginians on the right, the Numidians on the left.
>
> Different words of encouragement were required in an army composed of such diverse elements, where the soldiers had nothing in common, neither language nor custom nor laws nor arms nor dress, nor even the motive which brought them into the ranks.... To the auxiliaries he held out the attraction of the pay which they would receive, and the far greater inducement of the booty they would secure. In the case of the Gauls he appealed to their instinctive and peculiar hatred of the Romans. The Ligurians, drawn from wild mountain fastnesses, were told to look upon the fruitful plains of Italy as the rewards of victory. The Moors and Numidians were threatened by the prospect of being under the unbridled tyranny of Masinissa. Each nationality was swayed by its hopes or fears. The Carthaginians had placed before their eyes, their city walls, their homes, their fathers' sepulchres, their wives and children, the alternative of either slavery and destruction or the empire of the world. There was no middle course, they had either everything to hope for or everything to fear. Whilst the commander-in-chief was thus addressing the Carthaginians, and the officers of the various nationalities were conveying his words to their own people and to the aliens mingled with them mostly through interpreters, the trumpets and horns of the Romans were sounded and such a clangor arose that the elephants, mostly those in front of the left wing, turned upon the Moors and Numidians behind them. Masinissa had no difficulty in turning this disorder into flight and so clearing the Carthaginian left of its cavalry. A few of the animals, however, showed no fear and were urged forward upon the ranks of velites, amongst whom, in spite of the many wounds they received, they did considerable execution. The velites, to avoid being trampled to

a brilliant general and a well-trained army. Hannibal's forces crossed the Alps, annihilated four Roman armies, and roved undefeated throughout the Italian peninsula for 15 years. Despite repeated setbacks, the network of the Roman Confederacy in Italy held firm, enabling Roman generals to concentrate their energies on eliminating Hannibal's supply lines from Carthage and Spain. By defeating Hannibal at the Battle of Zama (201 BC) near Carthage, Rome emerged as the undisputed authority of the entire western Mediterranean sea. Although Republican authorities would endure centuries of native resistance, the populations of the region gradually assimilated a Roman way of life (*Romanization*).

The destruction wrought by Hannibal's army in Italy had a lasting effect, nonetheless, and the Roman oligarchy was determined never to see Italy invaded again. Threats posed by the kings of Macedonian successor states to wider Mediterranean security needed to

death, sprang back to the maniples and thus allowed a path for the elephants, from both sides of which they rained their darts on the beasts. The leading maniples also kept up a fusillade of missiles until these animals too were driven out of the Roman lines on to their own side and put the Carthaginian cavalry, who were covering the right flank, to flight. When Laelius saw the enemy's horse in confusion he at once took advantage of it.[1]

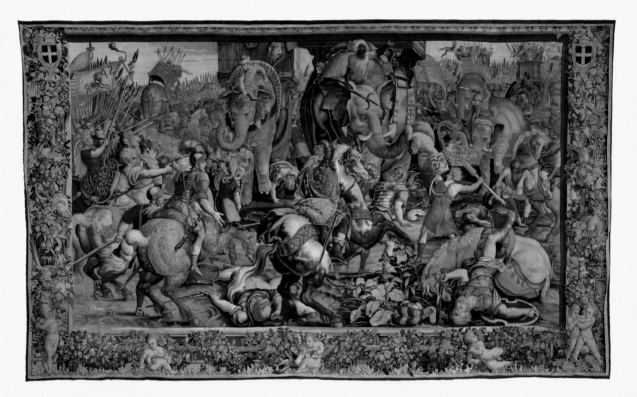

Figure 10.1 After Giulio Romano, *The Battle of Zama*. Tapestry. Late seventeenth century AD. Musée du Louvre, Paris.

1 Livy, *History of Rome* 30. 33. 4–16, trans. Canon Roberts (New York: Dutton, 1912).

be addressed, most particularly, the half-hearted decision of King Philip V of Macedonia (221–279 BC) to align with Hannibal during the Second Punic War. As powerful as they appeared, the Macedonian successor states of Antigonid Macedonia and Seleucid Syria were simply no match for the Roman military establishment that arguably stood at its highest state of readiness. Rome defeated each successor state relatively handily (in three wars between 200 and 168 BC, the Romans defeated Philip V of Macedonia, Antiochus III of Syria, and Perseus of Macedonia), largely with the support of threatened states in the vicinity (Athens, Rhodes, and Attalid Pergamum). Although Roman forces withdrew from the Aegean theater following each conflict, many have interpreted this behavior as a calculated attempt to maintain their welcome in anticipation of renewed intervention. With each succeeding conflict came a discernible change in attitude. Early Roman

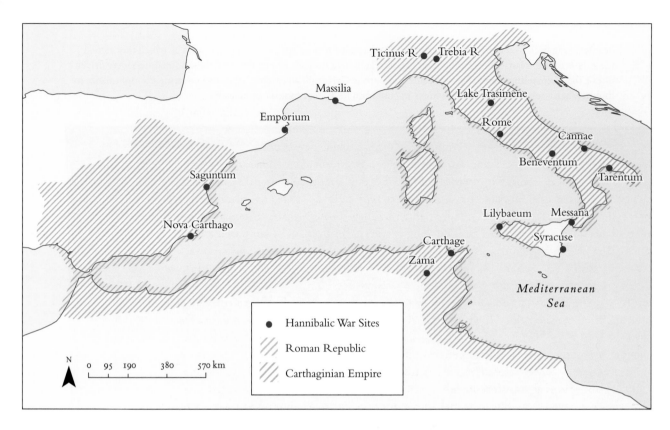

Map 16 Roman and Carthaginian Territories at the Time of the Punic Wars.

interventionists such as T. Quinctius Flamininus (during the war with Philip V) and L. and P. Cornelius Scipio (during the war with Antiochus III) were *Hellenophiles*, that is, nobles educated in Greek language and culture and imbued with admiration for the heritage of this once great civilization. These generals attempted to work together with Greek hierarchies to extend Roman security to the region on a temporary basis. Later generals were less tolerant, avaricious, and in some instances brutish in their treatment of Greek communities. As each Macedonian threat subsided, the Roman hierarchy grew more confident of its position. Early efforts at cooperation yielded to visible instances of Roman impatience; awe for the Greek past yielded to contempt for the perfidy of Greek contemporaries. Most importantly, the patriotism and self-sacrifice exhibited during the long years of the Punic Wars gave way to open desire for conflict as a path to personal enrichment, particularly now that the cities being plundered housed centuries of accumulated wealth and cultural heritage. This phase of Roman expansion can safely be interpreted as wars of outright conquest. With its armies invincible on the battlefield, Rome absorbed most of the northern coast of the Mediterranean Sea into its hegemony: Macedonia was incorporated as a province in 148 BC, Carthage and Corinth were destroyed in 146 BC, and the Attalid kingdom of Pergamum was accepted as an inheritance in 133 BC. Unlike its dealing on the Italian peninsula, Rome incorporated overseas territories as provinces, to be ruled by Roman promagistrates (governors) and subject to annual payments of tribute. The inferior status of so many once free peoples did not sit well with local residents. Not only had Roman attitudes hardened against the once-proud communities of the Hellenistic

east, but an aura of chauvinism began to pervade the actions of the Roman aristocracy whose members increasingly looked down on neighboring peoples as subjects, inferiors, and potential slaves. At the same time, the senatorial oligarchy began to realize that it was incapable of controlling wayward generals armed with *imperium* and the unrestricted might of Roman armies. Abuses by Roman provincial commanders became commonplace alongside patterns of bribery and extortion. By 149 BC permanent courts were created to address these problems, but it was all to no avail. Roman proconsuls guilty of atrocities committed against innocent provincials were repeatedly acquitted by juries of their peers. By 133 BC, Rome had essentially defeated all legitimate Mediterranean rivals, yet it still had not secured peace. The hard-fought wars and turbulent decades that ensued during the Late Republic (133–27 BC) were as much provoked by civil dissension, a lack of accountability, and confusion regarding the best way to govern so far flung an empire, as they were by foreign brush wars and native resistance to Rome.

To put the Roman military experience in perspective, one can point to the venerated tradition for the cult of the two-headed Roman deity, Janus. Janus looked forward into the future and backward into the past, and the doors of his temple were kept open whenever Rome was engaged in open hostilities. During the course of the Republic the doors to the temple were closed only twice (in 715 and 235 BC), so sustained were Rome's military operations against foreign adversaries. By 31 BC the uniqueness of the Roman experience enabled Republican armies to conquer the entire Mediterranean world and much of modern-day northern Europe. The reasons for Roman military success may be summarized as follows.

THE REASONS FOR ROMAN MILITARY SUCCESS

The Roman Aristocratic Ethos

The intense competition for office and the winnowing effect of the *cursus honorum* insured that all Roman generals displayed minimum competency as military commanders. All Roman praetors and consuls knew how to command, supply, and protect their armies in the field. As a result, Rome rarely experienced outright military disasters. Roman generals tended to tread cautiously against dangerous adversaries such as the Carthaginian general Hannibal. Most Roman generals knew how to hold the line and to avoid making tactical mistakes. This enabled the Republic to sustain its forces in the field almost indefinitely. If Roman forces confronted a superior adversary like Hannibal, mediocre generals were able to engage in defensive tactics to minimize losses until such time as a truly capable general, such as M. Claudius Marcellus or P. Cornelius Scipio, emerged to engage Hannibal. In short, if Roman adversaries failed to land significant blows at the outset of a conflict, they were unlikely to score successes later. In one respect, the intensely competitive nature of

Roman political careers enabled Rome to channel its most aggressive energies externally toward foreign adversaries.

Professional Training of the Troops

While conducting the siege of Veii in 410 BC, the Roman Republic was compelled to maintain its forces in the field through the course of the year, forcing Roman soldiers to remain away from their farms indefinitely. From this point onward, the Republic paid its troops under arms, and thereby developed the capacity to dispatch forces to distant theaters for extended periods of time. Although it remained a conscript establishment, with all male citizens liable to compulsory military service, the Roman army evolved into a professional army. By the time of the First Punic War (264–241 BC), weaponry, tactics, and military regimentation were standardized; equipment and supplies were organized through public contracts and furnished to the soldiers by the state (expenses were, however, deducted from military pay).

Although the Roman army began as a hoplite phalanx, during the course of the fourth century BC it adapted to a more maneuverable formation known as the **Manipular Legion**. Companies or maniples of 120 men (5,000 men in all) were arranged in battle in a checkerboard fashion of three lines, with each line extending some 900 yards. The front line contained the *hastati*, young untested conscripts experiencing their first taste of combat; the second line was manned by the *principes*, the seasoned ranks of the army in their prime; the third line by the *triarii*, the survivors of the legion's past conflicts who were close to discharge and were committed to combat only when necessary. This battle formation enabled Roman armies to maneuver through rough terrain and to sustain themselves in the field by resting its various contingents during combat. Roman generals would typically send their soldiers into combat in a rotating sequence—first the *hastati*, ten maniples or 1,800 men, would be ordered to advance. The maniples would approach the enemy uniformly yet independently to circumvent obstacles in the field. Just prior to contact with the enemy, the maniples would form a mini-phalanx by drawing close together and by having troops from the back ranks run forward to fill the gaps. This mini phalanx would then assault the enemy. The chief purpose of the assault by the *hastati* was to test the mettle of the enemy, to probe for weaknesses, and to soften up its lines. As soon as the *hastati* began to incur losses, the Roman general would sound the retreat. The *hastati* would withdraw in organized manner, racing through the gaps behind the advancing maniples of the *principes* to reassemble around their manipular standards. The 10 maniples of the *principes* would meanwhile advance to assault the enemy in the same manner as before. If necessary this second wave could be withdrawn to rest while the *hastati*, now regrouped, were recommitted to the fight. This rotation of formations was standard procedure and enabled the Romans to rely on reserve forces as a way to rest troops, all the while maintaining contact with the enemy.

Through conflict with Samnite mountain tribes and Gallic warriors elsewhere, the Romans adapted to the use of throwing spears (the *pilum*) as missiles and to hand-to-hand combat with short Spanish swords (the *gladius*). The legionaries would hurl their spears just prior to contact and then charge the enemy with swords drawn, by engaging in a uniform motion of cut and thrust. To develop skills in hand-to-hand combat, legionaries were frequently trained in swordplay by professional gladiators. They learned to space themselves at arms' length to allow maximum room for maneuvering. The process of conscription, sustained training, long years of military experience, enhanced maneuverability, reserve formations, and ready adaptation to new weaponry and sophisticated field tactics heightened Roman military preparedness over time. The sustained challenge of the Hannibalic War advanced the Roman legions to the highest state of readiness of any military establishment in the Mediterranean. This explains the rapidity with which they defeated the professional armies of neighboring Macedonian realms.

Professional training of the troops was not restricted to field combat. Most troops carried tools to dig moats and construct palisades for the camp, others cooked or dug latrines. All noncombatant responsibilities, like combat itself, were supervised by noncommissioned officers known as centurions. The tasks of the duty roster focused on the construction and maintenance of the **Roman legionary camp**. Unlike Greek armies that typically posted pickets, Roman armies were required to construct fortified camps everywhere they stopped along their march. In the event of defeat, the army could withdraw within the fortifications of the camp and hold out indefinitely, depending on its stock of supplies. The general could meanwhile dispatch messengers to Rome to inform the Senate of the army's defeat and to request reinforcements or the dispatch of a relief force. The fortified camp played an important part in Rome's ability to project and to sustain military force in the field.

Increasing Manpower from Allies and Expanding Roman Towns

As Rome defeated more and more cities in Italy, it constructed a defensive alliance similar to that of the Spartans, and known as the *Roman Confederacy*. This hegemonial alliance recognized the military authority of the Roman consuls. All allies had to have the same friends and enemies as Rome. They had to maintain the readiness of their native legions and commit them at their own expense to an offensive when summoned by Roman authorities. Otherwise, the allies preserved local autonomy, and Rome did not impose tribute or military contributions. This practical, loose-knit confederacy enabled the Romans to draw on increasing manpower over time. In addition, the Romans engaged in a sustained program of colonization. Land taken from defeated states was used to plant garrison colonies in non-pacified regions. Most colonies were located strategically along choke points such as mountain passes to insure Roman movement, or along the Italian coast to protect against naval assaults and piracy. Like the Greeks, Rome and its Latin allies understood the advantages of colonization as a way to export excess population and to expand

the available pool of manpower eligible for the draft. As colonies became organized in distant theaters, it was more suitable to grant their inhabitants *Latin status* to allow sufficient local autonomy. The result was a patchwork of settlements throughout Italy that grew into communities and helped to assimilate native inhabitants to Roman culture, language, and law. Roman colonization formed an important tool of Romanization and converted the Italian farming population into a large manpower reserve that could be called on in emergencies. According to Roman census figures, as a result of colonization there were 292,000 adult male Roman citizens eligible for the draft in 264 BC. By 225 BC it is estimated that the Italian allies were contributing 375,000 regular troops. Estimates of total available manpower during the Hannibalic War (218–201 BC) are put at one million Romans and two million Italians. This explains the staying power of the Roman military establishment. Hannibal reportedly destroyed 20,000 Roman troops on the Ticinus River in 218 BC, another 30,000 at Lake Trasimene in 217 BC, and reportedly 80,000 at the Battle of Cannae in 216 BC, amounting to more than 120,000 casualties in the first three years of conflict. After a suitable period of shock, disbelief, and mourning, the response of the Senate became predictable—draft another levy of young conscripts and dispatch them to oppose Hannibal. No other military establishment in the Mediterranean could sustain such losses. Most Macedonian realms had one field army that marched with the king, generally a force of some 30,000 to 50,000 troops, apart from mercenary garrisons posted throughout the empires. If the field army was destroyed, the king's ability to project force was essentially finished. Only the Romans could absorb such losses and continue to sustain conflicts in the field.

Rome was therefore willing to incorporate outsiders into its Republican political system gradually and by degrees, albeit at times begrudgingly. This policy enabled Rome to construct a web of interconnected personal and family relationships across mainland Italy, ultimately forging a more cohesive society and alliance structure. Roman status was organized as follows:

Roman citizens were entitled to reside in the city, to vote in the assemblies, to hold office, to enter the Senate, and to obtain trial by a jury of their peers. They were subject to conscription in military service and various taxes. Citizens included:

- ► Roman citizens, living in Rome or on *viritane* land allotments throughout Italy.
- ► Residents of Roman colonies settled on public land, *ager publicus* (local land seized from natives and either held in common by the state or distributed to individual soldiers [*viritane*] as land parcels).
- ► Citizens of towns incorporated into the Roman state, mostly Latin towns such as Tusculum, Lanuvium, or Aricia. These towns retained local magistrates who acted as subordinates to Roman magistrates. They struck no local coinage, and their inhabitants were enrolled into the Roman tribal assembly.

Latin allies were states recognized as enjoying limited civic rights at Rome. These included most Latin states, all Latin colonies (including those manned by Roman citizens but organized as Latin states), and all other allied states that were elevated to Latin status because of loyal service to Rome. Latin states preserved local autonomy, but all ex-magistrates automatically received Roman citizenship. Any Latin citizen could also migrate to Rome, settle there, and obtain Roman citizenship. Generally, this enabled aristocrats in Latin states to obtain Roman citizenship and to participate in Roman political affairs. Members of these families gradually migrated to Rome, took up residence, rose to obtain public office, and entered the Senate for life. Roman senators from Latin states became known as *domi nobiles*, nobles at Rome as well as in their home cities. So many Latin families rose to political distinction in this manner that the majority of senatorial families at Rome at the time of the Hannibalic War originated, in fact, from cities outside Rome. The Roman aristocracy essentially replenished itself by recruiting the best and the brightest elements of its allied states into the Roman body politic. This explains the cohesiveness of the Roman Confederacy and its ability to weather storms, such as the 15-year-long occupation of mainland Italy by Hannibal and his army.

Italian allies, or free states (*civitates liberae*), enjoyed full local autonomy and treaty relations with Rome. They had to accept the same friends and enemies as Rome and furnish their military forces on demand; otherwise, they were left to their own devices. Many tribal elements such as the Samnites, inveterate foes of Rome throughout the Republican era, found this sufficiently tolerable as an arrangement, since the less they had to do with Rome the happier they remained. Over time loyal allied states were invited to accept greater status (Latin or Roman), but it is interesting to note the example of the allied Greek state of Neapolis, whose citizens declined the offer of Roman status in 90 BC because they did not want to abandon their native language and customs in favor of Latin, the required tongue for all Roman public affairs.

Provincials were residents of polities that had been absorbed into Roman *imperium* through conquest or through succession from the protection of other territorial states such as Carthage and the Macedonian successor states. Provincials were subject to governance by a Roman promagistrate and to the annual payment of tithe or tribute to Rome. Otherwise, they were free to conduct their affairs in their native manner with the exception that all disputes between natives and Roman citizens, such as tax-collecting publicans living in their midst, were adjudicated by the tribunal of a Roman governor. Between this requirement and the rising pattern of abuse conducted by governors and tax collectors, Roman Republican rule earned mixed reviews. Overall, Roman Republican provincial administration exhibited an uneven record. Provinces with fiercely independent, rural populations—such as Liguria and Sardinia, the two provinces of Spain, or Thrace—resisted Roman authority for centuries and became notorious sinkholes for Roman garrison commanders. Others, such as the province of Sicily, genuinely flourished under Roman rule, possibly because of the stability it furnished. This marked a decided improvement over the centuries of border wars that had occurred between the Greek settlements on the east coast and the Punic settlements along the west. Still others, such as the Aegean states

of Greece and the Roman province of Asia (formerly the Attalid kingdom of Pergamum), found the presence of thousands of Roman businessmen and publicans in their midst increasingly meddlesome, but they were intimidated by the connections these Romans enjoyed with governors and their tribunals. One by one, Greek communities came to the realization that Roman publicans and moneylenders who entered their communities seldom left. Through usurious rates of interest, they acquired possession of the most profitable assets of the community, gradually marrying into if not actually replacing the local gentry. Much like conditions with the Persian Empire, therefore, nearly every province rebelled from Roman rule at one point or another.

Client states were independent polities, such as Ptolemaic Egypt, Rhodes, Athens, various monarchies in Asia Minor (Cappadocia, Bythinia, Pontus), and Carthage before its destruction in 146 BC. These states enjoyed articles of friendship with the Roman Republic if not actual treaty relations and supported Rome in most of its overseas conflicts. To preserve their independence, the leaders of these polities did their utmost to avoid giving offense to the Roman Senate and otherwise acceded to its wishes. In several instances native kings readily behaved as clients to powerful Roman senators to insure that their interests be protected in the Roman Senate and the assemblies. At the close of the Republican era the tradition of client states ruled by native dynasties was utilized by Roman dynasts such as Mark Antony and Octavian (the Roman emperor Augustus) to pacify and to Romanize lingering tribal elements along the fringes of the empire.

Rome Never Surrendered, nor Negotiated from a Position of Weakness

The reserves of Roman manpower and the network of *domi nobiles* throughout Italy enabled the Romans to weather numerous crises during the Middle Republican era, from military defeat by King Pyrrhus, to the annihilation of whole armies by Hannibal. At no point did the Romans consider negotiating for terms. Moreover, the strength of the alliance network and the interlocking relationships of Roman and local Italian elites meant that the Roman Confederacy held even during the darkest days of the Hannibalic War. Roman adversaries typically isolated themselves by rejecting Roman efforts at negotiation. In fact, the Romans claimed always to have fought just wars (*bellum iustum*), and to a large degree this was true. The sense of the expression was principally religious: the Romans always attempted to conduct the necessary rituals preliminary to conflict to sway the adversary's gods to their favor. However, the argument could be made that no war was ever conducted without full and open debate in the Roman Senate and before the Roman people. At times such as these, Roman advocates, particularly senators who served as patrons to an adversarial party, could be counted on to defend the opponent's interest as well as to demand justification as to why such a conflict was necessary. A decision to go to war had to enjoy sufficiently compelling logic to override these objections.

At the very least this furnished the Roman people with the necessary moral conviction to risk their lives in combat.

THE COLLAPSE OF THE ROMAN REPUBLIC, 133–27 BC

Internal turmoil provoked in 133 BC by economic stagnation in the city of Rome, slave revolts without, and dissension in the military precipitated a period of unrelenting political upheaval known as the Roman Revolution or the Late Roman Republic (133–27 BC). In essence, the republic system of government underwent a painful and violent transition from oligarchic rule to an autocratic form of government. To some degree, collapse reflected the growing pains of a political regime that was originally intended to govern a city-state but had come to dominate a far-flung Mediterranean empire of diverse and in many instances resentful natives. At least four phases are recognizable in the collapse of Republican political institutions.

The Rise of Popular Tribunes

Between 133 and 121 BC, two brothers, Ti. and C. Sempronius Gracchus, exploited previously untested powers of the plebeian tribuneship to pursue popular agendas at Rome. They essentially used their *sacrosanctitas* to veto all other public activity in the city in order to force the Senate and the magistrates to focus on their own immediate political agendas. They tried to restore order to the military by reclaiming public land and by restoring landless poor citizens on it. C. Gracchus also attempted to grant Italian allies Roman citizen status. Both men were killed together with their political followings through mob violence fomented by the aristocracy. From then on, renegade politicians utilized the office of the plebeian tribuneship as a way to circumvent the will of the oligarchy, usually in tandem with generals seeking benefits for their private armies.

The Rise of Private Armies

When the oligarchy failed to resolve various problems that had emerged for the military establishment (recruitment, status, discharge), Roman generals, specifically C. Marius (consul in 106, 104–100 BC) and L. Cornelius Sulla (consul in 88 BC, dictator in 82–79 BC), recruited private armies based on personal loyalty. These armies proved more loyal to their generals than they were to the Roman state. Ultimately, the two rivals came to blows in 88 BC in the midst of the Social War and the Asian rebellion induced by King Mithradates VI of Pontus. So violent were popular feelings at this time that Sulla was able to persuade his field army to expel Marius and his followers from Rome by marching on

the city. So began the First Civil War (88–82 BC) and the gradual transference of soldiers' loyalties from the Republican institutions to the persons of their commanding officers. Sulla ultimately prevailed against both Mithradates's forces in Asia and the Marian resistance in Italy (Marius having died in 86 BC). After seizing control of the capital in 82 BC, he attempted to impose a reactionary political regime on Rome as dictator, or as he defined it, *Dictator rei publicae constituendae causa* (Dictator for the purpose of restoring the Republic).

The First Triumvirate, 59–53 BC

The forcibly imposed military settlement of Sulla failed to diminish smoldering resentment throughout the empire; in most regions, it only made matters worse. In addition, his tinkering with plebeian political institutions induced popular protests in the capital of Rome and an incapacity on the part of the senatorial oligarchy to govern. Under these circumstances three men—Cn. Pompeius Magnus (106–48 BC), M. Licinius Crassus (115–53 BC), and C. Julius Caesar (100–44 BC)—combined their influence to seize power in Rome. Pompey was an extremely popular general who defeated numerous enemies of the oligarchy. Pompey enjoyed the loyalty of a private army, but he proved politically incapable of delivering on his promises of land and bounties. As an officer of Sulla during the Civil War, Crassus had made himself the wealthiest man in Rome by profiting from Sulla's *proscriptions*, that is, the issuance of proscribed lists of Roman citizens wanted dead or alive. All proscribed citizens saw their civil rights nullified and their property confiscated and auctioned off by the state. Crassus exploited the proscriptions to acquire perhaps as much as 20 per cent of the property in the city of Rome and countless estates and production centers throughout Italy. He used his wealth to buy influence in the Senate and throughout the urban populace and emerged as a powerful, but surreptitious figure within the oligarchy. Caesar began his career in a seemingly hopeless situation as the nephew of C. Marius and was threatened personally by Sulla. As a young aristocrat he excelled at the manipulation of the symbols of Marian reform, and through repeated instances of public generosity he made himself the darling of the Roman masses. By offering his political services to aid Pompey and Crassus with their political agendas, he rose to the consulship in 59 BC by serving basically as a tool of his two more powerful partners. He promulgated Pompey's and Crassus's legislation in the face of senatorial opposition and received for his effort an extraordinary 10-year command in Gaul. Intense rivalry persisted among these three dynasts, but so long as they maintained their political association, the senatorial aristocracy was powerless to thwart them. Ultimately, Crassus was killed while fighting the Parthians in Mesopotamia in 53 BC, and Pompey began to distance himself from Caesar. Pompey hoped to exploit the smoldering resentment of the aristocracy to reduce Caesar's influence with his army in Gaul, just as the aristocracy hoped to use Pompey for the same purpose if only to discard him once Caesar was eliminated. However, Caesar's army proved superior during the Second Civil War (49–46 BC). Pompey was defeated at the battle of Pharsalus in 48 BC and murdered shortly thereafter.

The rest of the oligarchs opposing Caesar were eliminated by 45 BC through repeated confrontations across the Mediterranean.

Caesar's Dictatorship, 46–44 BC

Having defeated all his enemies, Caesar was granted a 10-year term of **dictatorship** for the purpose of restoring the Republic, citing Sulla's controversial use of this office as a precedent. Caesar's solution appears to have been to reconstitute himself as a Romanized version of a Hellenistic divine king. In this respect he was possibly influenced by his mistress, young Queen Cleopatra, the last of the Ptolemies. Since 510 BC, however, the Romans had prided themselves with having obtained their freedom through the expulsion of their king. The very word "king," or *rex*, was anathema to Roman sensibilities. Roman citizens believed that they owed a civic duty to suppress any and all attempts at tyranny: provided one could demonstrate to his Roman peers that a fellow citizen was aspiring to absolute authority, one could assassinate a potential tyrant with impunity. Thus, while carefully avoiding overt use of the title *rex*, Caesar attempted to aggregate to himself all aspects of constitutional authority, simultaneously assuming authority as dictator, as consul, as Pontifex Maximus, and as plebeian tribune for life. In January 44 BC he declared himself *Dictator in Perpetuo* (this title was actually inscribed on his coins). He was murdered by a conspiracy of some 60-odd senators a few weeks later. However, at this stage the precedent of rule by one man was becoming increasingly recognized as a solution to Rome's political crisis. The only question remained which of Caesar's supporters was most likely to succeed him. The victor turned out to be his great-grandnephew, C. Julius C. f. Caesar Octavianus, or Octavian, the future Roman emperor, Caesar Augustus.

THE AUGUSTAN SETTLEMENT

After Caesar's heir, Octavian, managed successfully to defeat Caesar's assassins in 41 BC, he then dispatched his Caesarian rivals, Mark Antony and Cleopatra. In 31 BC he stood undefeated and supreme throughout the Roman Mediterranean world. Although he had received his position as member of the Second Triumvirate (42–32 BC) through formal grants of the Roman assembly, Octavian had behaved essentially as a military warlord. To reward Caesar's veterans and to secure his place in Italy, he had resorted to Sullan-styled proscriptions and widespread confiscations of property. After defeating Antony and Cleopatra at the Battle of Actium (31 BC), he seized Egypt as his private domain. Recognizing its significance as a powerbase, he assigned Egypt to the management of his personal attendants for the express purpose of feeding the burgeoning population of Rome. He then returned to Italy to renounce his authority. He proclaimed that all his acts as *triumvir* had been performed illegally, yet done out of necessity to restore republican

A large number of portraits of Augustus have survived in the form of coinage and sculpture. Perhaps the most famous of these is the Prima Porta Augustus, named for his wife's villa at Prima Porta where the sculpture was discovered. The sculpture represents Augustus as a handsome and idealized young man. He stands tall and resolute, his right arm extended in an oratory gesture. Augustus engages the viewer directly and, despite his youthful appearance, commands an authority and respect that is amplified by his military garb—the drapery drawn across his body, the detail of his tunic and sleeves, and careful depiction of the breastplate.

The Hellenizing style of the Prima Porta Augustus is a marked contrast to characteristic veristic portraits from the Republican period. Augustus was only 35 years old when he came to power. Thus an emphasis on the emperor's youthful charisma—images that depicted Augustus as eternally young and in his prime—became the standard for representation, and this "Augustan classicism" had far reaching effects on Roman portraiture after his death. The simplification of facial details, smoothing of the skin and hair, positioning of the body—all these classicizing features demonstrated a preference for the beautiful, the ideal, and godlike.

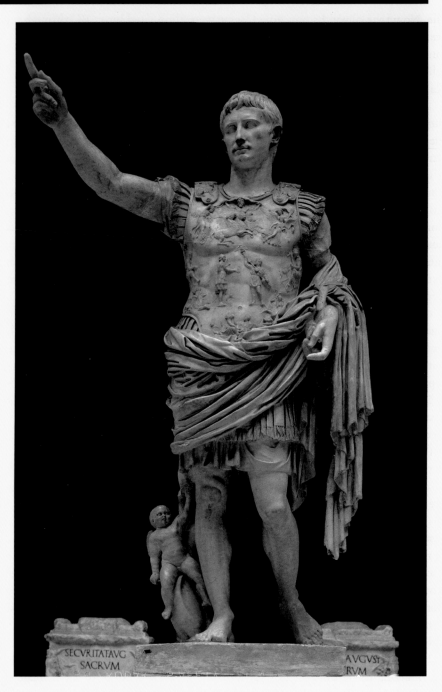

Figure 10.2 Augustus of Prima Porta. Possibly Roman copy of a statue ca. 20 AD. Marble, 2.03 m high. Musei Vaticani, Braccio Nuovo, Rome.

rule. Now that he had accomplished this task, he asked to be relieved of his responsibilities in order to return to private life as an ordinary Roman citizen. The thought of further conflict and confusion was unbearable even to the aristocracy, however, and through a deliberate and carefully orchestrated process of negotiation, Octavian arrived at a solution to the political problem at Rome.

In much the same manner as Caesar, Octavian saw numerous titles and honors given to him by the Roman Senate and people. However, unlike Caesar, he was judicious about his selection, paying careful attention to perceptions and sensibilities at large among the aristocracy. While avoiding all titles that conveyed the aura of military or autocratic authority, he selected those that conveyed a sense of peace, prosperity, and civic duty. For example, the Roman people awarded him the title of *Princeps*, or First Citizen of Rome. Initially, this was purely an honorific title bearing no legally constituted authority. However, it set him apart in Roman society as the leading citizen of his day, and who other than Rome's most distinguished citizen were the Roman Senate and people going to trust with the most significant matters of state? As a result of his elevated position in society, in other words, Octavian received 10-year grants of **proconsular imperium** over all provinces where Roman armies were garrisoned, as well as five-year grants of **tribunician potestas**, or tribunician authority. As proconsul in charge of the military provinces of the empire (more than 15), he maintained his control over the Roman legions and assumed responsibility for their recruitment, maintenance in the field, and discharge with benefits. Through his grant of tribunician *potestas*, he could use his veto power to block any political endeavor he opposed as well as to pass legislation and to offer his *auxilium* to Roman citizens on appeal.

In other words, Octavian learned early on to do more with less: the authority vested in these two appointments essentially gave him all the power he needed to run the city and the provinces. He avoided monopolizing the consulship, and thus enabled young aristocrats to rise through the *cursus honorum* as before in order to make themselves eligible for service as commanders in the military provinces. He also accepted the title **Augustus**, meaning *well augured*. This title implied that the omens for his rule were *auspicious*, or positive for the future. Henceforth, he became known as *Princeps Caesar Augustus*. In none of this terminology could the odious implications of *dictator*, *imperator*, or *rex* be discerned. Augustus carefully covered his tracks with the appearances of power sharing with the Roman Senate and people. More cynical aristocrats remained free to question the legitimacy of his authority—they could continue to seek office, hold commands in nonmilitary provinces, and participate as members of the "loyal opposition" in the Senate. However, if an aristocrat wished to pursue the customary career and to command Roman legions, he had to become an "organizational man" and work within the system of rewards and privileges designated by Augustus.

By assuming sole responsibility for the army, Augustus finally brought accountability to Roman provincial rule. Civil wars, military requisitions, and tax abuses in the provinces ceased. The Roman Mediterranean world emerged from the chaos of the Late Republic to experience two centuries of unprecedented peace and prosperity. Augustus accomplished this success not only by exerting authority over the Roman oligarchy but by working

diligently to make himself beloved by senators and commoners alike. He frequented the urban crowds with tremendous energy, glad-handing people throughout the city, looking after individual senators and their families, spending lavishly on construction, festivals, and games for the Roman population. He tried to set the example of a model citizen and *paterfamilias*, dressing simply, seen often in the streets dressed in an ordinary tunic with a broad straw hat to shield himself from the sun. He remained remarkably approachable and established himself as a beloved, avuncular figure throughout all of Italy. By the end of his career (14 AD), few alive could remember the tragic days of the Late Republic, let alone his own violent role in the proscriptions and the civil wars. Most knew him only as a kindly paternalistic leader who gave his all to secure Roman peace and prosperity. In other words, Augustus succeeded where Sulla and Caesar failed by virtue of his unique personality and behavior. The Roman Principate worked because he made it work, and by doing so he laid the foundation for the most stable era the Mediterranean world would ever know.

FURTHER READING

Badian, Ernst. *Publicans and Sinners: Private Enterprise in the Service of the Roman Republic*. Ithaca: Cornell University Press, 1972.

Bringmann, Klaus. *A History of the Roman Republic*. Trans. W.J. Smyth. Cambridge: Cambridge University Press, 2007.

Gruen, Erich S. *The Hellenistic World and the Coming of Rome*. Berkeley: University of California Press, 1984.

Harris, William V. *War and Imperialism in Republican Rome*. Oxford: Clarendon Press, 1979.

Keppie, Lawrence. *The Making of the Roman Army from Republic to Empire*. Norman: University of Oklahoma Press, 1998.

Ramage, Nancy H., and Andrew Ramage. *Roman Art: Romulus to Constantine*. 3rd ed. Englewood Cliffs, NJ: Prentice Hall, 2000.

Syme, Ronald. *The Roman Revolution*. Oxford: Oxford University Press, 1939.

Zanker, Paul. *Roman Art*. Los Angeles: Getty Museum, 2010.

———. *The Power of Images in the Age of Augustus*. Ann Arbor: University of Michigan Press, 1990.

ELEVEN

THE *PAX ROMANA* AND THE SUSTAINED TRAJECTORY OF THE ROMAN EMPIRE (27 BC–565 AD)

WHAT HAVE WE LEARNED?

► That the history of the Roman Republic is largely told through its wars: wars for survival and local supremacy within Italy (510–290 BC); wars of defensive imperialism (281–201 BC); wars of conquest (200–146 BC); and wars of the Late Republic (133–27 BC).

► That the Roman aristocratic ethos, the intense competition for office, and the winnowing effect of the *cursus honorum* provided all Roman generals with minimum competency as military commanders.

► That the Roman army evolved into a professional army; it adapted to tactical innovations such as the Manipular Legion, and it devised reliable systems such as fortified camps, organized logistics, and a duty roster to sustain its presence on campaign.

► That Rome displayed a willingness to incorporate outsiders into its Republican political system gradually and by degrees, ultimately forging a more cohesive society and alliance structure.

► That internal turmoil provoked in 133 BC by economic stagnation in the city of Rome, slave revolts without, and dissension in the military initiated a period of unrelenting political upheaval known as the Roman Revolution or the Late Republic (133–27 BC).

► That the collapse of Republican institutions can be mapped along a four-step path: the rise of popular tribunes, the rise of private armies, the First Triumvirate (59–53 BC), and the dictatorship of Caesar (46–44 BC).

► That Caesar's successor, Octavian, later known as Caesar Augustus, became the first Roman emperor (27 BC–14 AD).

CHRONOLOGY 12. EARLY ROMAN DYNASTIES (27 BC–180 AD)

27 BC–68 AD	Julio-Claudian Dynasty
27 BC–14 AD	Augustus
14 AD–37 AD	Tiberius
37–41 AD	Caligula
41–54 AD	Claudius
54–68 AD	Nero
68–69 AD	Year of Four Emperors
70–96 AD	Flavian Dynasty
70–79 AD	Vespasian
79–81 AD	Titus
81–96 AD	Domitian
96–180 AD	The Antonines (the Five Good Emperors)
96–98 AD	Nerva
98–117 AD	Trajan
117–138 AD	Hadrian
138–161 AD	Antoninus Pius
161–180 AD	Marcus Aurelius

The Augustan Settlement offered a workable solution to the problem of imperial rule in the Mediterranean. Utilizing a minimal central bureaucracy and relying at the local level on leadership in city councils, Augustus was able to enact legislation and to maintain order for a broad and diverse population. He channeled the aggressive energy of the Roman oligarchy to useful pursuits, ending the abuse of corrupt governors and placing the armies under his direct control. Through wise use of tax revenues, he was able to intervene at the local level throughout the Mediterranean to assist with calamities such as earthquakes in the Aegean and the lack of food in the burgeoning city of Rome. The one problem that he failed to address was the invention of a suitable mechanism for succession. Instead of instituting some constitutional procedure, he fell back on the traditional practice of Roman dynastic politics and selected and groomed members of his immediate family to assume his place. This led to inevitable jockeying for position within the imperial family, known today as the **Julio-Claudian Dynasty**, as well as to reports of conspiracies, intrigues, and assassinations at the imperial court. Roman sources paint his wife, Livia, in a very poor light for attempting to secure the throne for her son by a previous marriage, Tiberius Claudius Nero (14 AD–37 AD), allegedly by poisoning family members more directly in line for the throne.

In any event, Tiberius succeeded Augustus in 14 AD and proved by and large an effective administrator, however unpleasant and morose he seemed as an individual. He was

succeeded in turn by a madman, his grandnephew Gaius or Caligula (37–41 AD). Caligula attempted to humiliate whole segments of the Roman hierarchy—the Senate, the knights, and the army—in a deranged attempt to impose his unique vision of personal divinity and autocracy. After his assassination, he was followed by his uncle, Claudius (41–54 AD). This senior figure at the court was equally untrained for imperial rule. Suffering since birth from severe physical disabilities, Claudius was encouraged by the family to pursue scholarly pursuits and remained out of the public eye. Nonetheless, he proved to be a highly effective, if quirky, administrator. Claudius was succeeded by his stepson and grandnephew Nero (54-68 AD). Having received the best possible education from the celebrated Roman philosopher Seneca, it was hoped by all that this young emperor would emerge as the greatest ruler of the dynasty. However, he proved to be disinterested in the business of government. Left to his own devices by Seneca and his mother, Nero developed interests in theater, music, dance, and the arts. He saw himself as the world's greatest performance artist and began to put on shows not only in Rome but at Olympia in Greece. Much like Caligula, Nero's extravagance and atrocities made him hugely unpopular, and his eventual purges of provincial military commanders incited rebellions. With his death in 68 AD the first Roman imperial dynasty came to an end. A civil war determined imperial succession and reminded the Roman world once again of the bad old days of the Late Republic.

The remarkable thing about these developments was that the solution became once again to restore Augustus's power-sharing relationship between the *princeps*, the Senate, and the military commanders on the frontiers. In other words, the political architecture of Augustus survived both madmen at the helm and internal civil war to provide a lasting model for organizing the resources and manpower of the Mediterranean world. In many respects, the complaints of Roman sources against the Julio-Claudians ring hollow. Effective administrators such as Tiberius and Claudius appear to have been disliked primarily because they made the aristocracy pay its fair share of taxes and because they treated the lower orders of Roman society with greater equity. Even the least effective emperors, Caligula and Nero, were wildly popular with the Roman people and the provincials, if not with the aristocracy. This suggests that the Roman aristocracy endured the worst treatment as a direct result of its close proximity to the source of power. The further removed one was from the power struggles of the imperial dynasty, the better life seemingly was. This development stands in stark contrast with conditions during the Late Republic.

The Augustan Settlement proved successful in a number of other ways. It stabilized the military situation and brought accountability and order to the provinces. Roman army generals were selected for command directly by the emperor and worked on his behalf. Increasingly, the Roman legions became relocated to the borders of Roman territory, far removed from the urban populations, in order to confront barbarian peoples such as Germanic tribes north of the Rhine and Danube. Eventually, the legions became settled into permanent army camps along the ***limes***—a line of natural and man-made barriers that defined the boundaries of the Roman Empire. These included the entire length of the Rhine and Danube Rivers in the north. Augustus likewise curbed the abuses of Roman

MATERIALS AND TECHNIQUES: THE CLAUDIAN AQUEDUCT

The Claudian Aqueduct, or Aqua Claudia, completed by the emperor Claudius (41–54 AD), is one of nine aqueducts of the imperial city of Rome. This aqueduct was remarkable for the quantity of water it conveyed to the city and was by far the grandest architectural effect, inasmuch as it presented, for over 9.5 km outside the city, a continuous range of exceedingly lofty structure, the arches being 33 m tall in some places. The nine aqueducts of imperial Rome brought in water from pristine mountain lakes and springs as far as 80 km away. They had a capacity of more than 1.14 billion liters per day. By employing above ground archways such as these, the more than 700 engineers of the imperial water service maintained a continuous slope from the water's source to the gates of the city, and then relied on gravity and pump houses to drive the water throughout the city—even uphill. Covered water channels were normally constructed of stone or brick coated with hydraulic cement and employed periodic settling basins to reduce water impurities. Lead and terracotta piping was also employed to direct water to locations within the city. The water was distributed all over the city, even to the hilltops, and poured continuously into the many public fountains and the latrines of the public baths. The privileged had water brought to their residences by lead pipe and with some pressure. Three of the Roman aqueducts still function today.

Figure 11.1 View of the Claudian Aqueduct on the outskirts of Rome. Photograph by Peter Aicher.

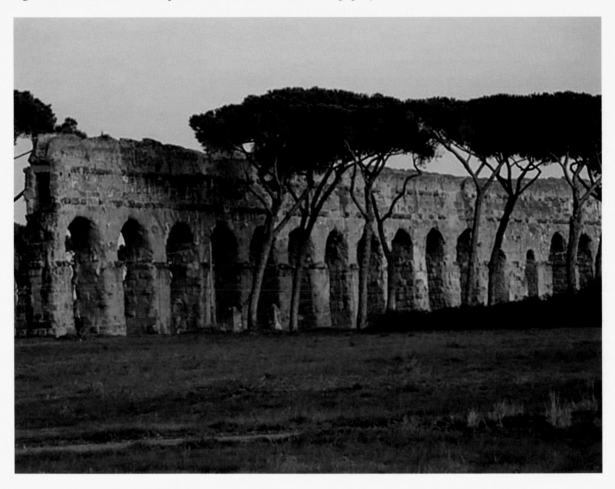

provincial governors and tax collectors in pacified provinces. The reduced burdens of taxes and military requisitions enabled provincials to keep more of their earnings. One theory holds that despite the imposition of the Roman tithe (approximately 10 per cent), productivity in the Roman Mediterranean actually expanded at this time. Wealthy provincials enhanced production in order to reap higher profits over and above the outlay of tithe. With peace and stability guaranteed, people began to invest more extensively in specialized artisan and agricultural production, such as wine and oil for export purposes. The results are evident from the material record: whereas, in the Late Republic (133–27 BC), some eight to ten styles of internationally traded transport jars circulated throughout the Mediterranean, by the first century AD that number jumped to more than 40. So many amphora types were produced during the Roman Empire, in fact, that archaeologists have still not been able to identify points of origin for each of them. In fact, the volume of trade that occurred in the Mediterranean during the Roman era was the largest ever experienced in the ancient world.

The order achieved by the Augustan Settlement furnished the longest period of peace and prosperity to the largest population sustained in ancient times. Some 50 to 100 million people existed under the *Pax Romana*, "the Roman Peace." For nearly two hundred years there was but one brief civil war, no piracy, and no slave revolts. People and goods could travel safely from one end of the Mediterranean to the other. Cities such as Rome and Alexandria burgeoned to more than one million residents. A score of lesser cities, including the recolonized settlements at Carthage and Corinth, blossomed to become important nodes of provincial hierarchy and trade. Rome itself became an open city inundated by upwardly mobile foreigners. Roman critiques such as Juvenal (*Satires* 3.62) complained that the "slime of the Orontes River (in Syria) was now oozing up the Tiber River to Rome." This served as a pointed observation of the inherent success of outsiders in such fields as philosophy, medicine, law, finance, accounting, and trade.

These same sources criticized the growing autonomy of Roman females. With the imperial armies recruited from volunteers, carefully supervised, and placed at a considerable distance from the centers of urban population, the long dominant political and social status of male military populations declined throughout the Mediterranean. In many instances one can detect a growing disinclination of wealthy aristocratic males to bear the burden of local authority, to serve on city councils, or to assume costly priesthoods or other forms of public philanthropy (Hellenistic Greek *liturgies*, known in Latin as *munera*). These duties were increasingly assumed by female members of elite provincial families. Many surviving examples of urban infrastructure, such as the monumental gate and kilometer-long water trough at Perge in Pamphylia, were paid for and constructed by women such as **Plancia Magna of Perge**. In Rome proper, not only did imperial consorts such as Livia, Agrippina, and Messalina obtain unprecedented authority by virtue of their proximity to the source of imperial power, but women on the streets appear to have obtained greater autonomy as well. In their misogynistic attacks on Roman females, male sources list various reasons for their complaints: Roman women were experiencing greater personal and sexual autonomy; they were working publicly as lawyers, doctors,

philosophers, rhetoricians, and teachers; they engaged in marriages of convenience to better control their personal assets and sexual freedom. To what degree this growing female independence extended beyond the precincts of Rome remains difficult to determine. If the example of Plancia Magna of Perge offers any indication, it was potentially widespread throughout urban Mediterranean society.

Most of all, Roman rule enabled the assimilation of a core set of cultural values that had been assembled over centuries by the inhabitants of the Mediterranean. The fusion of Greco-Roman culture across the Mediterranean world resulted in the development of homogeneous standards of living. During the Roman Empire, it was possible to travel from Antioch in Syria to New Carthage in Spain and to expect to see the same social and political institutions, not to mention the same systems of urban infrastructure. The invention of concrete mortar around 100 BC reduced the laboring energy required by building enterprises and greatly expanded the built environment of the Roman Mediterranean. Every major town boasted its temples, its council house, its basilica, its theater, its gymnasium, its stadium, its aqueduct, its bath complex, its porticoed thoroughfares, and in many places its amphitheater. Red-slipped Early Roman fineware such as Arretine ware, Gallic ware, and Eastern Sigillata ware, furnish similar evidence of Mediterranean-wide uniformity in standards of creature comfort. Like Roman-era transport amphoras, these hard, glossy, well-turned bowls, plates, and cups were produced in nearly every corner of the Mediterranean and shipped widely throughout the seas. They appear in large quantities in nearly every Roman-era archaeological context (including trading ports in East Africa and southern India), causing archaeologists to marvel at the sheer quantity of material goods that ordinary inhabitants of the Roman Mediterranean world once possessed. Ceramic production expanded equally in other forms that survive on the landscape, such as ceramic water pipes that directed vast quantities of fresh water and waste water in and out of Roman-era communities. In particular, the use of ceramic roof tiles furnished an unprecedented level of permanence to Mediterranean built environments. Material remains such as transport amphoras, red-slipped Roman fineware, water pipes, and roof tiles represent only a fraction of the likely output of this productive society. They fail to account for the likely volume of trade in other archaeologically invisible commodities such as foodstuffs, textiles, or timber that were shipped around the Mediterranean at this time.

This is not to say that the Roman world was an ideal place to live. Not all peoples found a home in the Roman order, as the repeated Jewish revolts of the first and second centuries AD make clear. Securing the peace in the northwestern provinces of Gaul and Britain imposed a significant drain on the Roman treasury, and the inhabitants there remained far less inclined to assimilate the mainstream cultural attributes of Greco-Roman society. Additionally, slavery remained an essential component to laboring society. Prolonged peace and stability also caused private assets to accumulate into fewer and fewer hands. With fewer opportunities for upward (and downward) mobility, Roman society evolved into a two-tiered society of "haves and have nots," the wealthy and socially superior *honestiores* (respectable citizens) and the masses of *humiliores* (commoners). Liable to corporal

ART IN FOCUS: THE ROMAN COLOSSEUM

The construction of the Roman Colosseum began under Vespasian and, following his death, was inaugurated by his son Titus in 80 AD. Built over of the remains of Nero's "Golden House," the Colosseum (also called the Amphitheatrum Flavium) was the first and grandest permanent amphitheater in Rome whose purpose was to house spectacles of blood sports—gladiators, combats, and hunts of wild animals. Early Roman Christians were persecuted in this manner in the Colosseum. The design of an amphitheater required the construction of two semicircular theaters placed face-to-face. The Colosseum is structurally a completely Roman building that contained vaulted substructures constructed of tile and mortar. Elevators raised and lowered animals to the floor of the arena from caged areas below. With a seating capacity of 50,000 people, the Roman Colosseum was one of the largest single structures in the ancient world. Seventy-six exits allowed the throngs of spectators to leave the building in a timely, organized fashion.

The four-storied exterior of the structure was constructed of *travertine*, an attractive local limestone that proved to be a highly desirable building material during the Renaissance—so much so that the Colosseum became a quarry for builders of grand buildings during the period. The architects of the Colosseum decorated the exterior facade in the Greek decorative tradition with *engaged columns* beginning with the Doric order on the ground floor, Ionic on the second, Corinthian on the third, and Corinthian *pilasters* on the fourth story.

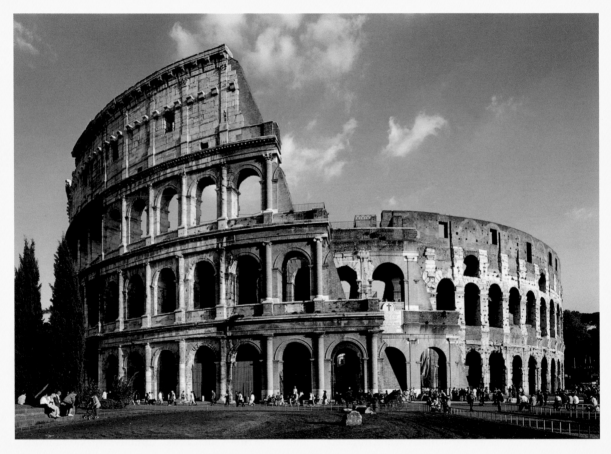

Figure 11.2 The Colosseum, Rome, ca. 72–80 AD. Stone and concrete. Height, 48.5 m; length, 188 m; width, 156 m.

punishment for any number of reasons, the latter element was reminded of its inferior status with stinging regularity.

Overall, it needs to be borne in mind that the Mediterranean furnished one of the easiest climates of the globe for human habitation. The mild climate minimized need for heating or clothing, the non-clay, highly volcanic soils were easy to farm, and the interior lake of the Mediterranean, with its nearly land-locked waters and countervailing winds and currents, facilitated trade in ways inconceivable for land-based societies such as Achaemenid Persia or Han Dynasty China. In view of its limited technological advantages, however, there is no denying the remarkable footprint Greco-Roman society left on its environment. Roman practicality and its engineering feats brought a consistently high standard of life to the entire Mediterranean world. The question remains whether or not Roman inhabitants were capable of sustaining their society at such a high level of development.

THE LATER ROMAN EMPIRE: CRISIS AND COLLAPSE (234–565 AD)

CHRONOLOGY 13. SIGNIFICANT DATES FOR THE LATE ROMAN EMPIRE	
193–211 AD	Severan Dynasty
235–284 AD	Era of the Barracks Emperors
284–305 AD	Diocletian
306–337 AD	Constantine
378–395 AD	Theodosius I
475–476 AD	Romulus Augustulus (last Roman emperor in the West)
527–565 AD	Justinian I

As prosperous as conditions appeared in 180 AD, life in the Roman Empire turned decidedly chaotic within a generation. The plague that accompanied the return of Marcus Aurelius and his troops from Mesopotamia following his military campaign against the Parthians (ca. 166 AD) appears to have wreaked havoc on regional populations and possibly eliminated 25 per cent of the Mediterranean work force. This was followed quickly by Germanic invasions that penetrated all the way to Aquileia on the Adriatic coast in 169 AD. The grasp of the imperial bureaucracy in Rome on events on the periphery began to slip, particularly when directed by ineffective rulers such as M. Aurelius's son Commodus (180–192 AD), who like Caligula and Nero suffered from delusions of grandeur. Following his assassination, civil wars erupted across the empire. By this time, armies based in separate, remote corners of the empire had increasingly come to identify themselves with their

provincial commanders rather than with the distant hierarchy at Rome. Supported by their armies along the frontiers, ambitious military commanders competed for the throne and thus set in motion a violent struggle for succession. The eventual victor was a military strongman, L. Septimius Severus (193–211 AD). Starting from his command in Pannonia on the Danube frontier, Severus exhausted nearly four years combating rivals from Italy to Asia Minor. He then marched into northern Mesopotamia to suppress further uprisings, and still later he suppressed rebellious elements in Britain. His long violent path to imperial authority in Rome (culminating in purges of the senatorial aristocracy) furnished another vivid reminder of the past as well as a hint of what lay ahead.

Septimius Severus had little patience with the formality of the urban aristocracy at Rome and treated the Senate with a soldier's mixture of disdain and intimidation. He also worked to solidify his support throughout the military by raising pay levels for the rank and file and by setting in motion reorganization of the army as well as of the provincial administration. These measures served as a blueprint for later reformers. To make the Roman army more mobile, he and his successors adapted its forces to cavalry formations and reduced the size of legions to a thousand men, while expanding the number of legions from 25 to 60. This made the army more responsive to the asymmetrical character of warfare along the periphery, for example, the swift cavalry assaults of the Persians or the constant leakage of small bands of Germanic warriors across the frontier. By the end of his dynasty, the Severans (Septimius and his sons Caracalla and Geta) had doubled the size of the army (from ca. 150,000 to 300,000). Obviously, this raised the cost of military maintenance that had to be borne by tax-paying citizens and provincials. In a guileful maneuver Caracalla (211–217 AD) elevated potential tax revenues by extending Roman citizenship to all freeborn inhabitants of the empire (212 AD). This had the effect of making all inhabitants liable for the 10 per cent manumission tax and 5 per cent inheritance tax, including Roman citizens previously exempt because they lived in the provinces. Romans and provincials alike succumbed to the same tax burden, with the imperial bureaucracy focusing particularly on the members of the city councils (the *decuriones*, or 10-man boards of local tax collectors) to make up unanticipated shortfalls from their own assets when necessary.

Although Severus momentarily put a lid on mounting crises, imperial stability quickly came unhinged following the death of his descendent Severus Alexander (222–235 AD). During the 50-year interval between 235 and 284 AD, some 24 emperors—known as the **Barracks Emperors**—ascended the imperial throne. The longest reigns were of seven and eight years respectively, and all but two of these emperors died violent deaths. The emperor Decius was killed in 251 AD by the Goths on the Dacian frontier; the emperor Valerian, who posted the longest reign of eight years, was defeated and captured by the Sassanid Persian king Shapur I in Mesopotamia (260 AD). Most of the others were assassinated. Civil wars, Germanic invasions along the northern lines, the secession of border provinces (Palmyra during 270s AD), and mounting pressure by the Sassanids in the east (260–651 AD) threatened the security and stability of the empire. To meet these challenges, military men typically rising from humble origins in barracks communities along the

frontiers assumed the throne. Valerian (253–260 AD), Diocletian (284–305 AD), and Justin (518–527 AD), for example, all emerged from the Danube frontier where the Germanic threat was the greatest. Experiencing firsthand the effectiveness of the Germans as warriors, these and generals like them began to recruit Germans openly into the ranks. By the late third century AD the army on the Rhine River was prevailingly Germanic in origin. In other words, an army that had already grown remote from and indifferent to the concerns of the inhabitants of the empire now increasingly replenished its ranks with foreigners who viewed the same inhabitants with contempt.

After an orgy of violence and confusion, order was restored temporarily by Diocletian (284–305 AD). Imperial authority amounted to dictatorship with a bureaucracy geared toward administering a society trapped in a state of perpetual military emergency. By this point the size of the army had possibly surpassed 500,000, imposing an impossible burden on the tax-paying citizens. **Diocletian's price edict** attempted to dictate the fair value of goods and services, but it failed to reduce the impact of an increasingly devalued currency. To insure the production necessary to maintain the military establishment, all members of society were essentially locked into their stations in life, including members of the city councils. The son of a Decurion had to assume his father's position in the council, just as the son of a tradesman or farmer had to assume his respective place in the economic order. Some trades such as merchants were declared exempt from imperial obligations, but the designation of such exemptions carried with it the implication that they could also be rescinded. The only effective way to escape the burdensome demands and requisitions of the new era was to become a member of the imperial bureaucracy itself. This induced a flight of elite elements from the provincial city councils, leaving the tax burden even heavier for those who lingered behind. Imperial officials stationed at the local level were carefully positioned to collect tax revenues in kind and to see that they be shipped to nearby military forces.

The external threats confronting Diocletian were real nonetheless, and Rome as a capital was too far removed from the most pressing areas of strategic concern. Since it took too long to reach a military crisis from the capital, the emperor gradually relocated his base of operations closer to the frontier. Milan in northern Italy initially became the chief staging ground of imperial response to Germanic threats, but with the renewed vigor of the Sassanid threat in the east (221–651 AD), even this position proved untenable. Diocletian accordingly moved his palace to Nicomedia in Bithynia. To stem the tide of the seemingly relentless conflicts among Roman military commanders and to deal with external threats in all quarters, Diocletian divided the empire into four prefectures: the Oriens, Illyricum, Italia, and Galliae (all the Gauls). A **tetrarchy** of four emperors, two ranked at the top as Augusti, two waiting in succession as Caesars, would command the regions and regularize the succession process, or so it was hoped. In 305 AD after a 20-year reign, Diocletian insisted on a simultaneous abdication of himself and his Augustan colleague, Maximian. Almost instantaneously the move created controversy, when the sons of the two Caesars, Constantine in Britain and Maxentius in Rome, were passed over in favor of appointees by Diocletian. Hailed by their troops as emperors, Constantine and Maxentius

mutinied, setting in motion a prolonged civil war. Through his victory over Maxentius at the Battle of the Milvian Bridge in 312 AD, Constantine was able to secure control of the capital. Although it required another 12 years to secure undisputed authority, Constantine (306–337 AD) eventually succeeded at making himself sole emperor of the Roman world.

THE REFORMS OF CONSTANTINE (312–336 AD)

Constantine is mainly known for his promotion and guidance of Christianity, which until this point was a banned cult that had endured repeated waves of persecution, including an extremely violent purge by the emperor Galerius (293–311 AD). Through his various edicts (the Edict of Toleration and the Edict of Milan, both in 313 AD), Constantine allowed Christians to practice their faith publicly and the church itself to acquire property. He also made Christian clergy exempt from taxation. Since Christians had survived in hidden enclaves for centuries, this sudden spotlight revealed the extent to which the faith had traveled in different directions around the empire. At the urging of bishops, Constantine convened several church councils (for example, the Council of Nicaea in 325 AD) to establish Christian dogma and a church hierarchy. These represented dramatic steps taken on behalf of a religious element that is estimated at a relatively low 10 per cent of the Mediterranean population at this time. The popularity of Christianity had spread to important places, however, such as the army, the provincial hierarchy, and even to the imperial household, where the wife of the emperor Domitian (81–96 AD) and many of her servants were rumored to have been Christians. The religion remained far from popular at Rome, the great capital and center of Roman state religion, where numerous temples dedicated to deified Roman emperors formed the backdrop to public affairs. Constantine completed the creeping movement of the hierarchy toward the frontier by relocating his imperial headquarters to the Greek harbor town of Byzantium on the Bosporus, thereby founding the new Christian capital of Constantinople. Closer in proximity to the threatened *limes* on the Danube and by road to the Sassanid frontier in Syria, this move prepared the ground not only for the creation of a built environment that would feature Christian monuments but also for the eventual bifurcation of the empire into East and West.

The distance of Constantinople from the West, the differing attitudes that prevailed East and West, and the eastern region's disproportionate levels of manpower and resources gradually separated the imperial hierarchy from its western subjects. The eastern provinces were heavily populated, highly productive, and more highly cultured. Surrounded by mountains, deserts, and seas, the eastern part of the empire was in many ways more compact and defensible as well. Extending across the Alps to the wintery landscapes of Gaul and Britain, the western provinces were more rural, less populated, and less well assimilated to mainstream Greco-Roman culture. For centuries the revenues raised in the East had helped to sustain the cost of the military establishment defending the *limes* in the West. By moving the capital to Byzantium, therefore, even though this placed the imperial field army closer

to the most urgent threats on the Roman frontier (the Goths and the Sassanids), it essentially put the western provinces on notice. Incapable of resisting the threat of Germanic invasions, and with an army composed of a significantly high proportion of Germanic warriors in and of itself, the western provinces yielded to renewed German invasions in the century that followed Constantine's death. Already by the reign of Theodosius I (378–395 AD), it became customary to recognize a second emperor in the West and to abandon him to his own devices, assuming that the two leaders were ever actually cooperating.

THE "BARBARIAN" INVASIONS (376–565 AD)

By the 370s AD a Hunnic faction that had split off from the Hsuing Nu in China began to intrude beyond the Caspian into the steppes of the Ukraine, ravaging Germanic tribes lying in its path. By 376 AD the Visigoths residing on the Danube border requested and were granted sanctuary from the Huns inside the Roman frontier. Initially, Roman authorities attempted to settle them on land taken from Roman inhabitants as **dediticii**, or submitted allies, in an attempt to buttress Roman defenses. Treated poorly by their hosts, however, the Visigoths rose in rebellion and defeated the eastern Roman army at the Battle of Adrianople (378 AD). They then rampaged unopposed throughout the Balkans. Led by their king, Alaric, they eventually migrated through Italy, where they shocked the Roman world by sacking the city of Rome in 410 AD. Few events were more illustrative of the collapse of the West than this. The Visigoths eventually settled in southern Gaul and Spain, but similar Germanic invasions were underway elsewhere. On December 31, 406 AD, during a particularly cold winter, the Rhine River froze over, enabling some 50,000 Vandals to scamper across the ice. Dispersed in small bands, they successfully evaded Roman apprehension and migrated across Gaul and Spain to the edge of the Mediterranean Sea. By this point, Roman authorities were so alarmed by the infiltration of Germanic war bands that the emperors issued decrees prohibiting their subjects from furnishing Germans with access to maritime transport. It was hoped that they could thus be contained to the northern shores of the sea. But a Roman general in need of warriors for a civil war raging in North Africa unwisely recruited the Vandals and transported them across the Strait of Gibraltar. Quickly overwhelming their host, they continued their raids across North Africa and seized the city of Carthage in 430 AD. As it happened, a Roman fleet lying at harbor fell into their hands. Soon they began to raid and plunder by sea, sacking Rome for a second and far more devastating time in 455 AD. Their success was possibly aided by the distraction caused by the Huns, who had invaded the Danube provinces around 440 AD and attempted unsuccessfully to besiege Constantinople. Led by their king Attila, the Huns then turned westward and crossed the Rhine into Gaul. Defeated at the Battle of Chalons in 451 AD, Attila's Hunnic menace gradually declined, but the defeat would not have been possible without the assistance of Germanic tribes such as the Franks and the Burgundians, who now exploited the opportunity to occupy Gaul. By 476 AD, the Ostrogoths invaded

Italy, forcing the German praetorian prefect, Odoacer, to depose the last Roman emperor in the West (a youth named Romulus Augustulus). When the Ostrogothic king Theodoric (493–526 AD) sought recognition from the Roman emperor at Constantinople, his request was granted, thus officially sanctioning Germanic rule in the West.

The Eastern empire remained somewhat more resilient. Under the energetic emperor Justinian I (527–565 AD), Roman forces neutralized the Persian threat sufficiently to envision a reconquest of the West. Justinian's forces retook Carthage, parts of Italy, Sicily, and coastal Spain. After a terribly costly siege, they reentered the city of Rome itself. Known equally as much for his buildings (the Church of Haghia Sophia in Constantinople), his formulation of the Roman law code (the *Corpus Iuris Civilis*), and his marriage to the actress Theodora, Justinian's ambitions ultimately surpassed the military capacities of his realm. At the first sign of renewed difficulty with the Sassanids, Justinian's strategy began to unravel. Troops being transferred from the Sassanid frontier to Italy brought along a devastating plague. Most of Justinian's reclaimed territory was quickly lost to Germanic tribes such as the newly arriving Lombards in northern Italy. Within decades of Justinian's campaigns, the eastern empire itself came under attack by Mohammaden Arabs from the East, and Slavic Avars and Bulgars on the Danube. The city of Constantinople itself endured repeated sieges in the following century. Its imposing defenses and admirable water system (with urban cisterns the size of lakes) enabled it to outlast repeated waves of migrating peoples. Unlike the confident military superiority displayed by the armies of the Roman Republic, the conquest of Justinian amounted to something of a gamble that ended disastrously and brought to an end any further notion of a unified Greco-Roman Mediterranean world.

REASONS FOR THE FALL OF THE ROMAN EMPIRE

The Failure of Imperial Succession

Roman historians traditionally point to the inadequate means of imperial succession as the underlying cause of the crisis. Not only did Augustus fail to invent a procedural form of succession, but it was improbable that anyone of his background could have conceived of succession by any other means than dynastic descent. Family remained the basic building block of Roman society, and even during the Reign of Five Good Emperors, succession between Trajan, Hadrian, Antoninus Pius, Marcus Aurelius, and Commodus essentially remained dynastic. As the sons of Diocletian's duly appointed *caesars*, Constantine and Maxentius fully expected to inherit their father's positions and made trouble when these expectations went ignored. The problems with dynastic succession were manifold, but the main one, what to do when the line died out, inevitably provoked heightened competition for the throne.

Mounting Civil Wars

The second cause was the accelerating civil wars that erupted at moments of imperial succession. Roman-on-Roman warfare ultimately was far more costly and burdensome than the external threats of the Germans and the Persians. Had the imperial hierarchy invented a smoother means of transition and avoided the endless internal conflicts that wracked the empire, the external threats might have proven manageable. The internal conflicts ultimately led to a doubling and then a quadrupling of the size of the military establishment as well as to the recruitment of barbarian Germanic troops. Civilians and frequently even emperors such as Nero proved indifferent to the hardships endured by soldiers along the barren frontiers of the empire. Members of the military establishment eventually came to perceive of themselves as a separate culture, and a highly resentful one at that. Already during the Year of the Four Emperors (79–80 AD), the ill will that existed between armies identifying themselves with different regions of the empire revealed itself. In addition, rebellions led by Gallic auxiliary officers during that year of crisis demonstrated that the native populations in the West were neither as pacified nor as assimilated to Roman culture as people had hoped. Once civil war became an option to enrichment, the armies, already suspicious of one another, proved adaptable to new, more violent circumstances.

The Rising Barbarian Threat

The third reason often raised by historians for the fall of Rome was the mounting pressure of barbarian populations on the frontiers. Historical evidence of barbarian migrations during previous eras demonstrates a recurring tendency for migrations to move toward the shores of the Mediterranean (the Indo-European migrations in 2200–2000 BC; the Scythian migrations of the eighth century BC; the Celtic migrations of the fourth century BC; and the Germanic invasion of southern Gaul in the late second century BC). By creating an impenetrable barrier (the *limes*) along the Rhine-Danube frontier, the Romans attempted to barricade what may have been a natural migratory route for these peoples. This possibly heightened pressure along the frontiers that could only be resisted by the construction of larger and better defenses and the recruitment of larger armies. This strategy came unraveled during the fourth century AD.

The Inordinate Cost of the Late Roman Hierarchy

The need for greater military vigilance led to the fourth generally accepted argument, namely, that the cost of maintaining so large a military establishment proved excessively burdensome for what was essentially a primitive agricultural society. The burden of the expanding military establishment can be demonstrated economically in a number of ways:

- ▶ The Price Edict of Diocletian demonstrates the likely impact of devalued currency on the economy.
- ▶ Adaptations in amphora morphology appear to demonstrate a transition from commercial forms to those of a command economy.
- ▶ The need to lock all producers into their stations, from the Decurial class to ordinary farmers and artisans, indicates that if left unattended these jobs risked abandonment.
- ▶ Various reports of farmers abandoning the land and of city councilors fleeing their responsibilities are on record.

In general, people fled to areas of asylum such as those provided by members of the military elite who enjoyed exemptions from taxation. This resulted in the emergence of vast private domains that embraced whole villages, if not dioceses. In addition, people increasingly left their property to the Christian church. Due to the exemptions awarded by Constantine, church leaders were able to divert agricultural production and landholdings to more philanthropic purposes and ultimately acquired the largest landholdings of the Mediterranean. Regardless of the sequence of events, in other words, the fact remains that the Roman Empire, like the Han Dynasty in China and the Gupta Dynasty in India, proved unsustainable. The fact that all three civilizations encountered significant crises at the end of the second century AD and collapsed altogether by the sixth century has not gone unnoticed by world historians, and many have sought to identify some causal link to the synchronous chronology of ancient world societal collapse.

FURTHER READING

Goodman, Martin. *The Roman World, 44 BC–AD 180*. London: Routledge, 2012.

Greene, Kevin. *The Archaeology of the Roman Economy*. Berkeley: University of California Press, 1986.

Mitchell, Stephen. *A History of the Later Roman Empire, AD 284–641: The Transformation of the Ancient World*. Malden, MA: Blackwell, 2007.

Ramage, Nancy H., and Andrew Ramage. *Roman Art: Romulus to Constantine*. 3rd ed. Englewood Cliffs, NJ: Prentice Hall, 2000.

Sear, Frank. *Roman Architecture*. Ithaca: Cornell University Press, 1982.

Southern, Pat. *The Roman Army: A Social and Institutional History*. Oxford: Oxford University Press, 2006.

Perkins, Bryan Ward. *The Fall of Rome and the End of Civilization*. Oxford: Oxford University Press, 2006.

Woolf, Greg. *Rome: An Empire's Story*. Oxford: Oxford University Press, 2012.

CONCLUSION

THE ANCIENT WORLD SYSTEM, NATURAL ADAPTIVE CYCLES, AND PATTERNS OF SOCIETAL COLLAPSE

WHAT HAVE WE LEARNED?

► That the Augustan Settlement furnished a power-sharing relationship between the *princeps*, the Senate, and the military commanders on the frontiers, which survived both madmen at the helm and civil war to provide a lasting model for Mediterranean-wide hegemony.

► That the stability achieved by the Augustan Settlement brought the greatest period of peace and prosperity to the widest possible population found anywhere in ancient times. Some 50 to 100 million people lived under the *Pax Romana*, "the Roman Peace."

► That women in the Roman world enjoyed greater autonomy; they worked publicly as lawyers, doctors, philosophers, rhetoricians, and teachers.

► That military and economic crises beset the Roman Mediterranean world after 180 AD and forced the hierarchy to adapt to a top-down military chain of command. During the 50-year interval between 235 and 284 AD, some 24 emperors ascended the Roman imperial throne.

► That the emperor Constantine (312–336 AD) is mainly known for his promotion and guidance of Christianity, which until his reign was a banned religious cult. At the urging of bishops, Constantine convened several church councils (for example, the Council of Nicaea 327 AD) to establish Christian dogma and a church hierarchy.

► That the four traditional reasons to explain the collapse of the Roman empire were the inadequate means of imperial succession and the rise of civil wars this generated, the mounting pressure of barbarian populations on the frontiers, and the excessive burden of maintaining so large a military establishment.

THE CROSSROADS OF CENTRAL ASIA AND THE ANCIENT GLOBAL WORLD SYSTEM

In 97 AD the Chinese protector general of the western regions, Pan Chao (Ban Zhao), led a sizeable army (reportedly 70,000) across the Pamir Mountains into Bactria and advanced across the Oxus River all the way to the shores of an unnamed sea (presumably the Caspian). Some 50 kings in this nomadic region submitted to his authority en route. While camped beside the sea, he dispatched an officer named Kan Ying to investigate further regarding the location of the "Other China," that is, Rome. Kan Ying reached a neighboring sea, where he was told by inhabitants that Rome could be reached by a sea voyage requiring three years (round trip) and untold quantities of provisions. Since the Chinese army of Pan Chao appears to have taken a northern route across the steppes of Central Asia to the Caspian, it is highly likely that Kan Ying had journeyed across the Caspian to the Caucasus region, perhaps Armenia or Georgia, and had made his way to the eastern shores of the Black Sea. If so, he was indeed a long way from the city of Rome. With his commander and an entire army waiting at a considerable distance behind him, he thought better of the idea of venturing further and returned to his encampment. Pan Chao and his forces returned to the Tarim Basin after an arduous, four-year expedition. Remarkably, a seemingly pointless expedition had brought the Chinese army to the borders of the Roman Mediterranean world. What seems certain is that Pan Chao and his army were trying to gain intelligence about the existence of a distant empire, the one that the Chinese referred to as *Ta Qin* (Ta Chin), the "Other China," or the Roman Empire.

Nor was Pan Chao the first Chinese official to explore beyond the frontiers of the Chinese world system. After the Early Han Dynasty (202 BC–6 AD) secured authority in China, it needed to address the persistent danger of Hsiung Nu depredations along its northern border. As we noted earlier, the Han initially pursued a policy of appeasement, hoping to purchase Hsiung Nu compliance with foodstuffs, bolts of silk, lacquered utensils, and other Chinese products, intended ultimately to lure them into the Chinese sphere of influence. Around 130 BC, the Han attained a sufficient level of internal control to shift from a policy of accommodation with the Hsiung Nu to a more forceful one of expansion. The emperor Wu Ti (Wudi, 141–87 BC) dispatched a courtier named Zhang Qian (Chang Chien) to distant nomadic confederacies along the western flank of the Hsiung Nu. His task was to persuade them to join the Han Dynasty in war against their common foe. Zhang Qian's journey resulted almost immediately in his capture by the Hsiung Nu, where he was forced to remain so long (a decade) that he took a Hsiung Nu bride. Eventually he escaped and proceeded west, taking the northern route beyond the Tien Shien Mountains into Sogdiana and Bactria. His intended destination was the region of the Yuezhi (Yueh Chih), a hybrid people who had been driven westward by the Hsiung Nu into the region of Sogdiana a few decades earlier. According to western sources, these people mixed with the Sacae and became linked through confederate relations with the Kushan rulers of India. Although Zhang Qian was unable to convince Sacae tribesmen to join China in a war against the Hsiung Nu, he traveled extensively through Afghanistan

and the upper Indus Valley gathering crucial intelligence about the urban societies of this region. He observed, for example, that people in the Punjab were using products (bamboo and silk) that originated from his home country. According to the natives these goods had arrived from China not via the Silk Road across the Tarim Basin but by sea. Returning to the court of Wu Ti many years later, Zhang Qian wrote a detailed report of his journey that convinced the Han emperors to explore connections with India via both directions—by establishing a road system through the Pamir Mountains in the west and by constructing a second road system through provinces in the southwest extending from Guangzhou (Canton) to within 150 km of Burma. While the southern route proved impractical, Chinese conquest of the western regions became a viable option. It is important to stress that the motivation for the development of Chinese territories in the west was the enduring conflict with the Hsiung Nu and the need to find allies (not to mention horses) with which to oppose them. Few believe it had anything to do with an overt interest in trade. What the experience of Zhang Qian demonstrated, nonetheless, was that trade between India and China was ongoing at this time and that it flourished sufficiently to warrant the attention of the Han dynasty. A year did not pass without the dispatch of some five to ten caravans of envoys by the Han dynasty to regions to the south and west, each caravan consisting of hundreds of officials and attendants.

The passes through the Pamir and Tien Shien Mountains—one via Sogdiana (Ferghana) to the north, the other through Bactria slightly south—fascinated other rulers of ancient world empires besides the Han. In 329 BC Alexander the Great journeyed northward from Afghanistan across the Oxus River to Bactria and Sogdiana. He established his most remote colony, Alexandria Eschata (Alexandria of the Furthest Extent), somewhere in the valley of Ferghana. He conducted this campaign ostensibly to eradicate Achaemenid Persian connections to the region and to prevent Iranian nobles from provoking uprisings behind the Macedonian supply lines in Afghanistan. By leaving behind settlements of merchants and veterans and by taking as his wife the Bactrian princess Roxana, Alexander hoped to maintain control over this distant region. A handful of Macedonian generals managed to sustain Hellenistic Greek control of Bactria during the confused decades that followed Alexander's death in 323 BC. The last of these, Herocles of Chi Pin, was apparently deposed by a Chinese general named Li Guang in the mid-second century BC. Like the Chinese, in other words, the Macedonians seemingly understood the importance of this remote highland region to world affairs.

The Persians had preceded Alexander to this region. When invading Afghanistan, Alexander followed a road that was first opened up by Darius I, who journeyed through Afghanistan around 515 BC to reassert Persian authority (first imposed by Cyrus I) in Bactria, Sogdiana, and the Indus. Alexander greatly expanded this road network by establishing colonies along its length. The transportation nodes created by Darius and expanded by Alexander appear to have survived not only his demise but the relentless political upheavals of the following century. During his epic conquest of Afghanistan and eastern Iran in the early third century BC, the Mauryan emperor Chandragupta defeated the forces of Seleucus I of Syria and then sealed a peace by shipping the Macedonian general 500 war

elephants along this highway. Antiochus III of Syria (223–287 BC) used this highway somewhat later to invade Bactria and the Upper Indus in 209–205 BC. The Sacae, or Scythians, originally from the region of the Aral Sea, and the Yuezhi (176–160 BC) likewise used the road network of Alexander to invade Central Asia. After them followed Li Guang and Pan Chao. Regardless of the political chaos and topographical difficulties, in other words, the highways leading from Iran to the Tarim Basin, the Indus Valley, and points beyond remained crucial arteries to the network of the ancient world systems. Putting aside for the moment questions regarding the volume of interregional trade (admittedly small) and its content (admittedly restricted to prestige goods), the fact remains that the routes themselves were deemed so important to distant rulers in Persia, India, Macedonia, Syria, and China that they repeatedly dispatched large armies to explore and to conquer the barren regions along this path.

We raise all this by way of introduction to the question of interconnectivity among the ancient world systems and the reasons for their simultaneous collapse. The Roman imperial administration in the Mediterranean, the Kushan dominance in India, and the Later Han Dynasty in China all collapsed toward the end of the second century AD, when all three societies were seemingly at their height with respect to population size, productivity, and general prosperity. Through the implementation of more disciplined, possibly more efficient, administrative practices, the Romans and the Gupta Dynasty in India were able to stabilize things by the late third century AD. They sustained their urban societies for another two centuries before collapse overtook them in the form of external invasions by nomadic peoples from the north. In China, the most distant of the three world systems, a period of confusion, the Era of Disunity, set in with the collapse of the Later Han Dynasty (220 AD). The political situation did not right itself until the emergence of the Tang Dynasty (618–907) in the seventh century AD. During the interim, repeated invasions by nomadic peoples offset each new moment of stability. Collapse came swiftly in each region, in other words, but it was not necessarily similar in form or duration. For example, the eastern half of the Roman Mediterranean where most of the productive capacity of the empire was situated was able to sustain itself relatively intact as the Byzantine Empire for several hundred years. The overall effect, nonetheless, was a general decline in production and living standards throughout the three regions of the ancient global world system. This fact can be demonstrated in a number of ways, archaeologically as well as textually. The levels of airborne pollutants, such as heavy metals that are released during metal smelting, having risen to significant levels during the course of antiquity dropped to nearly Neolithic levels after the fifth century AD. The production of metals worldwide clearly declined at this time. A heavy reliance on firing technologies across Eurasia to produce metal tools and weapons, not to mention the kiln firing necessary to generate massive quantities of roof tiles and ceramic wares, significantly diminished as well. In some regions—such as northwestern Europe, where evidence for the reintroduction of thatched roofs and wooden utensils is certain—firing technology essentially went out of use for a time. Empirical evidence such as this accordingly raises two important questions: first, what did the trade routes across Central Asia have to do with the high

level of prosperity enjoyed by ancient world systems in three distant basins? And second, given the evidence of urban prosperity in all three regions, why did they collapse with such seemingly synchronous timing? To address these questions, we will revisit three themes that are central to this book: the effect of interconnectivity on ancient world growth; the likely causes of recurring, synchronous patterns of societal collapse; and the relevance of the theory of natural adaptive cycles to our understanding of long-term patterns of societal growth and collapse.

CENTRAL ASIAN TRADE ROUTES AND PROSPERITY IN ANCIENT WORLD SYSTEMS

To answer the first question, one needs to define the nature of the trade. Those who believe that transcontinental trade in antiquity was of marginal significance to the economies of the interconnected regions insist that the trade itself amounted to little more than a *high value, low volume* commerce in prestige goods, meaning that trade in prestige goods ultimately did not and could not affect the general well-being in any of the regions in question. Proponents of this line of reasoning argue that the volume of this trade at any given time was minimal and that the sorts of commodities being transported—precious metals, gems, incense, exotic plants and animals, coral, and spices—were nonproductive in character. At best they represented prestige goods obtained from distant regions of the world to be distributed by ruling dynasties as rewards to their subordinates. Even in the Roman Mediterranean, where luxuries were distributed independently of the imperial court at Rome, the difficulties entailed in transshipping these commodities across vast distances ultimately rendered them too rare and expensive to be enjoyed by the general public. Accordingly, their economic impact remained marginal.

As we have noted, however, recent archaeological investigations in East Africa, south India, and Afghanistan have revealed the presence of relatively inexpensive Roman commodities, such as ceramic finewares, metal wares, and glass. Amphoras laden with eastern Mediterranean wines were likewise components to this trade. The weight and size of Mediterranean amphoras recovered in southern India all but necessitated that they traveled in large ocean-going merchant vessels. In other words, Roman merchants appear to have sailed to India to exchange commodities that were essentially Mediterranean staple goods. In return they obtained commodities that were unavailable in the Mediterranean, such as silk, spices, aromatics, and precious stones. Much like Roman wine and oil, many of these products were neither rare nor expensive in the regions of their origination. What affected their prices at the opposite end of the ancient world system were the inherent costs of transport and the manifold layers of tariffs, commissions, and hazards that were incurred along the way. To some degree the widely varying climates of ancient world production regions rendered one region's staple goods another region's luxury commodities. Accordingly, the international luxury trade of the Roman era needs always to be

considered within the context of various socio-economic and political systems in the geographic regions through which it passed. Finds of Chinese jade statuettes in Pompeii and Roman coin hoards in Vietnam and the Tarim Basin indicate that regardless of the actual volume of this trade, adventurous merchants found the necessary incentives to make it happen.

Although archaeological data for the commodities from the eastern ends of this trading network remain inadequate, the amphora evidence at Arikamedu raises the possibility that Roman maritime trade with India during the first centuries BC and AD was vibrant, and that Mediterranean staple commodities circulated in the Indian Ocean at a pace approaching that which occurred in the Mediterranean itself. Roman merchants who established the trading contacts in India utilized those finished goods that the Roman world was most adept at producing. No one would argue that commonplace wines from the eastern Mediterranean bore intrinsic value commensurate with those of spices or silk from the East. Rather, the asymmetrical values of the commodities in circulation may have required much larger shipments of Mediterranean staple goods to obtain sufficient amounts of the goods in question. This would explain not only the presence of so many Roman amphoras at Arikamedu but the perception as well that the trade with India imposed an unfavorable balance of trade on the West. The repeated references to silk garments in Roman literature and the widespread finds of artifacts such as pepper shakers in Mediterranean archaeological contexts indicate, nonetheless, that however expensive these luxuries actually were, they were affordable to wealthy elites beyond the capital city of Rome. Assuming that eastern luxury goods were relatively plentiful in the Roman Mediterranean, the volume of traffic across the Indian Ocean may very well have been significant, at least at times.

Based as it is on archaeological discoveries at a handful of sites that may or may not be representative, any argument for a significant volume of interregional trade during the ancient world era remains speculative. If we accept the prevailing "reductionist" perspective and assume that international trade at this time was minimal and restricted largely to limited quantities of exotic prestige goods, there may still have been ways for long-distance luxury trade to have stimulated the simultaneous development of urban societies across the ancient world. One explanation lies with the effect that globalism has on world systems development in general. As we have demonstrated, each of these regions developed highly integrated civilizations capable of moving locally produced commodities throughout the topographical limits of their world systems. Most production was probably consumed locally in a subsistence manner. Still another significant portion appears to have circulated in conscribed regional networks. However, some portion of the materials produced in each basin was transported across vast distances. It is interesting to note, for example, how often the breakdown of these transport systems, particularly the overland supply of foodstuffs in China, forced the ruling houses to relocate their capitals to settings closer to the centers of production. In short, the progressive development of world systems enabled stratified urban societies to harness resources throughout their respective regions in a manner necessary to sustain more prosperous ways of life.

Globalism, or in this instance the access to exotic prestige goods from regions beyond the immediate confines of a world system, acted as an accelerant to the pace of production in each respective basin. The first tenet of globalism is that the availability of exotic prestige goods in and of itself tends to drive demand. It does not matter how rare or how expensive a commodity was when it reached the opposite end of the globe. Provided that an exotic prestige good was available, some limited element of the population, the wealthiest elites, could afford it. Hence, the relative volume of long-distance trade was less important than the existence of the trade connection. The driving force to this principle rests with the means used to purchase expensive imported goods. To make these purchases, the inhabitants of globally interconnected world systems made use of the most widely accepted media of exchange, such as money in the form of coins, bullion, or goods such as silk or incense, whose ease of transport and intrinsic net worth enabled them to function as liquid capital, that is, as assets that were readily convertible.

To generate the liquid capital necessary to obtain expensive imports, local property-holding elites in all three regions raised productivity by investing in their landholdings. They opened up virgin terrain to agriculture, constructed kilns and forges, built ships and wagons, and ultimately generated surplus staples commodities intended for wider consumption within the world system. This pattern is visible in all three regions, along with evidence of population growth both in terms of its expansion spatially across the landscape and in terms of density at large urban centers. In addition, all three regions exhibited a gradual transition from subsistence production by dispersed rural populations to highly efficient agricultural systems (oftentimes slave driven) intended for the production of surplus commodities. The essential point to be recognized is that globalism, the availability of exotic prestige goods from opposite ends of the world, furnished wealthy elites with the incentive to expand the productivity in their respective localities. The rate and volume of exchange in distantly traded commodities did not flow so much as it pulsated at a variable pace depending on political conditions along the trade routes and the relative success of regional staples production at any given time.

THEORIES FOR WORLD SYSTEM COLLAPSE

If one accepts the premise that globalism functioned as an accelerator of economic production, then why did ancient world systems fail, and fail contemporaneously at the end of the second century AD? If the trade between them was minimal to the point of being immaterial, was it really possible for its demise to have precipitated economic and political collapse in all three basins? To address this question, we need to return to points raised in the introduction concerning the building process of world systems and their natural adaptive cycles. In *The Collapse of Complex Societies*, Joseph A. Tainter identifies 11 different factors that contribute to societal collapse, including: a breakdown in the production of vital resources, the occurrence of some insurmountable catastrophe, the

arrival of foreign intruders, societal contradictions, elite mismanagement or misbehavior, and a chance concatenation of events. Although the range of variables inevitably dilutes his argument, Tainter concludes that collapse is fundamentally a sudden pronounced loss of an established level of sociopolitical complexity. As sociopolitical organizations, states encountered repeated problems that required increased investment merely to preserve the status quo. As we have seen, this typically led to expanded bureaucracies that grew increasingly complex, burdensome, and expensive. Expansion of the hierarchy inevitably imposed greater demands on the supporting population, oftentimes with no visible benefit. As the number and costliness of organizational investments increased, the proportion of a society's budget available for investment in future economic growth invariably declined. Tainter defines this pattern as one of *declining marginal returns*. Eventually declining marginal returns from state institutions precipitate collapse. Sometimes collapse is sudden, sometimes it comes in the form of the slow disintegration of a regime (i.e., some archaeologists have characterized the decline of the many regions of the Roman Empire as a *slow burn*).

Although Tainter's interpretation tends to focus inordinately on the role of central authority or governing institutions in the process of collapse, the model of declining marginal returns does seem to furnish crucial insight to the patterns of collapse that occurred in the Mediterranean, India, and China at this time. Placing appropriate emphasis on the tendency toward growth enables us to identify essential patterns to the growth cycles of past societies. Then as now, growth was viewed as a requirement to the construction of world systems. Growth yielded an array of benefits including better administration of resource storage and distribution, a better investment in agricultural energy and minerals production, improved internal order and external defense, and greater information processing and public works. In so many words, these improvements represent various aspects to the seven criteria of civilization noted at the outset of this book. However, growth in past human societies exhibited ceilings or thresholds that obstructed continued expansion. To move beyond a threshold or ceiling required innovation, new technologies, or new means of conservation. At the same time, it seems clear that no society had the resources to grow indefinitely. **Sustainability** thus becomes an important part of the equation.

It is entirely possible that modern historians of the ancient world have grossly underestimated the impact of firing technologies on the landscapes discussed in this book. The reliance on firing technologies to generate metalwork in the ancient period was so great that its heavy metal byproducts are detectable in the geological record. Unlike modern energy supplied by a variety of fuel sources, including oil, gas, coal, and hydroelectricity, in antiquity the principal source of fuel was wood harvested from nearby forests. To generate the necessary firing temperatures for smelting and glazed ceramics, artisans relied on charcoal, which typically required seven to eight units of wood to generate. The ancient reliance on charcoal for high firing temperatures thus placed even greater demand on timber extracted from neighboring forests. When combined with the expanding land clearance and conversion to agricultural production that is visible in every landscape of

the ancient world, questions arise regarding the sustainability of urban societies of ancient world systems that were overly reliant on wood-based firing technologies.

Many recent scholars have argued that resource depletion played a role in the collapse of ancient societies. J. Donald Hughes, for example, categorically indicts Roman failure to adapt their society and economy to the limits of the natural environment. Hughes points to erosion resulting from deforestation, exhaustion of the most readily accessible minerals, and the overgrazing and excessive utilization of agricultural terrain as evidence of environmental failure. Food shortages and population decline sapped the Roman Empire's strength and ultimately led to collapse. Geoarchaeologists investigating evidence of eroded landscapes (such as declining pollen counts of natural forest cover in alluvial deposits) have in many instances observed a significant change toward the end of the Roman Empire. This transition is characterized by a decline in pollen counts of cereals, arable plants, and pasture weeds, combined with a rise in tree pollen, to indicate a reversion of agricultural terrain to forest cover. This would seem to suggest that agricultural landscapes reverted to a more natural state at the end of antiquity, with woodlands encroaching on formerly cultivated terrain—in other words, a degradation of the natural environment gradually provoked societal collapse. However, if resource depletion did play a role in the societal collapse of the ancient world system, it left little trace in the historical literature. Apart from the generally apocalyptic tone of gloom and doom recorded in most societies at the end of antiquity, there is little in the eyewitness accounts that points directly to evidence of an ecological disaster, certainly nothing that compares with the current debate about the impact of global warming, the depletion of fossil fuels, or the global rise in population in the modern world. The ecological argument may ultimately bear weight, in other words, but the fact remains that the research is in its infancy, and the verdict is inconclusive.

Another much discussed possibility is **climate change**. A mild form of climatic variation, such as a slight drop in temperature, could potentially have placed inordinate stress on ancient societies. Nomadic tribes, for example, became increasingly mobile in the ancient world, moving southward and westward throughout Eurasia. Such an environmental fluctuation could potentially have overwhelmed existing production systems, political hierarchies, and social organization. As Tainter has observed, however, the available environmental data for antiquity are extremely limited, too limited at present to verify an ecological argument for global world system collapse.

Despite the inadequacy of empirical data, the ecological argument remains valuable for another reason altogether: namely, its ability to place human societies within the wider context of the natural ecosystem. This interrelationship has become increasingly evident to specialists who focus on sustainability and human growth. Humans as organisms are (and were) actors engaged in a wider ecosystem that supports numerous additional species of plants and animals. Unlike most other species, humans emerged from the Ice Age with no natural predators. From a natural perspective, that is, human populations have the capacity to expand to the limits of their ecological niche, within the limits of existing technology. During the ancient era that niche was restricted by and large to the

river valleys and temperate zones of the northern hemisphere, extending along an east–west trending line from the Mediterranean to the shores of Asia. Within the limits of ancient technology, this was the region most capable of sustaining large urban populations. Centuries of significant technological innovation were required before any similarly sized populations could emerge in other parts of the globe. If we look at patterns of growth and collapse in ancient world systems, what scientists refer to as sociopolitical organizations, what we find is a rhythm, an ebb and flow in human population growth, that closely resembles the adaptive cycles that are commonplace in nature. The potential role of natural adaptive cycles in patterns of societal expansion and collapse seems to warrant one final inspection, accordingly.

NATURAL ADAPTIVE CYCLES AND THE ANCIENT GLOBAL WORLD SYSTEM

The theory of natural adaptive cycles is best explained in Brian Walker and David Salt's *Resilience Thinking: Sustaining Ecosystems and People in a Changing World*. The chief premise of creative destruction is that change is constant and that for any system within the natural order to survive, it must be resilient to change. Human systems, accordingly, must be sufficiently flexible and adaptive to withstand shocks and disturbances that naturally occur in the wider ecosystem. As we noted in the introduction, natural adaptive cycles progress through four visible states: *rapid growth, conservation, release*, and *reorganization*. The similarities between the phases of the natural adaptive cycle and the repeated pattern of rise and fall of ancient civilizations seem remarkably close. In addition, the progression through natural adaptive cycles also exhibits a pattern of declining marginal returns, as described by Tainter. As we have observed repeatedly with ancient world systems, ancient civilizations typically progressed through fore loop phases of rapid growth and conservation. During the rapid growth phase, successful hierarchies conquered neighboring peoples, expropriated their wealth, and incorporated the energies and skills of their productive population to expand their base. Imperial consolidation was typically followed by a phase of conservation, where an established hierarchy attempted to maintain its supremacy by implementing greater efforts at efficiency and control throughout the system. Landowners adapted from subsistence forms of agriculture that were highly redundant (since each household produces most of its own necessities) to more efficient uses of the landscape that generated agricultural surpluses. Agricultural specialization enabled producers to generate the kinds of products that their immediate landscape was most capable of producing for the express purpose of distribution elsewhere. Egypt generated grain exports; the Aegean wine and oil; Italy, livestock in addition to wine and oil, and so forth. The Han Dynasty harnessed the productive capacity of its eastern agricultural terrain to ship resources to the remote western highlands. Increasing interdependence made the system more efficient and better able to sustain a larger population,

but it simultaneously placed wider and wider populations at the mercy of a technologically constrained distribution system.

This process of integration and heightened efficiency can be applied to nearly every aspect of the seven criteria for civilization. In essence, the seven criteria tend to function in this textbook as signposts of ancient civilizations as they existed in the "conservation phase" of the adaptive cycle. Invariably, this phase was followed by a sudden back loop of release and reorganization. Collapse of a world system due to some unforeseen disturbance, such as a barbarian invasion or climate-induced food shortage, resulted in the breakdown of the distribution system throughout the region. At the very least, inhabitants of surplus-producing landscapes necessarily reverted to subsistence practices in order to survive, some more successfully than others (redundancy). Marginal landscapes that had gradually been colonized and rendered productive were abandoned (release). The ruling hierarchy was defeated or collapsed on its own. Stored wealth, such as the Persian treasure conquered by Alexander the Great at Persepolis and Ecbatana, was released. Having eliminated the hierarchy and plundered its wealth, newcomers such as migrating nomads became the *new actors* who reorganized the system and initiated a renewed cycle of growth.

The model furnished by resilience theory not only captures the essence of world systems' growth (conquest), consolidation (conservation), retrenchment (declining marginal returns—consider, for example, the Roman adaptation to the military emergency of the third century AD, with its doubling and quadrupling of the size of the army), and collapse (barbarian invasions), but it also mimics the chronological patterns that are visible in the adaptive cycle of the world systems themselves. Their fore loops of rapid growth were characterized by the accumulation of capital stability, conservation, and rising standards of living; their back loops were characterized by sudden collapse and a release of resources. Urban societies reaching the end of the conservation phase in the fore loop invariably attempted to sustain themselves, their built environments, and their human and material capital by pursuing a path of sustained growth. Conversely, since the back loop was a time of uncertainty and great change, ruling hierarchies attempted to stem the tide by embarking on even greater measures of efficiency or greater levels of interconnectivity to the same effect. This phenomenon closely resembles the pattern of the Late Roman Empire, for example: the reconstituted military regime appears to have organized production and distribution efficiently (the diocesan reorganization) to sustain its essential production systems; its hierarchy appears to have understood, in other words, how to balance the various components of sustainability and how to orchestrate the fine-tuned maintenance of the world system. What it could not anticipate was some unforeseen shock to the system, a perfect storm of events capable of overturning their carefully managed system, such as the simultaneous invasion of the Huns, the resurgence of the Sassanid Persian Empire, the incessant civil wars, the flight of agricultural labor from the land, and the plague. None of this takes into account, moreover, the likely ecological impact of diminishing resources as growing populations reach the thresholds of their ecological niches. Inevitably, a system such as this became increasingly less resistant to shocks and disturbances that were an inherent part of the natural order.

What is particularly intriguing about this scenario is that the longer the ruling hierarchy of a given society attempted to delay the back loop, the greater the losses that occurred when it ultimately arrived. According to resilience theory, if the collapse phase is greater, it is likely that the start of the next cycle will witness a period of significantly reduced human well-being. In addition, the greater and more widespread the level of creative destruction that occurs, the less impact preserved societal memory will have to reconstitute a system similar to the one that preceded. In other words, the destruction of the **recursive institutions** that were essential to the maintenance of the world system invariably resulted in the development of a new culture that lacked the technological capacity to reconstitute the infrastructure of the previous one. These observations help to explain the dramatic, sudden collapse of the Roman Mediterranean world system, as opposed to the repeated but seemingly less chaotic transitions in Chinese hierarchies at the end of the Classical Era, not to mention the rapid pace at which the Tang Dynasty (618–907 AD) was able to reassemble the constituent parts of the Chinese world system.

In short, the application of the model of natural adaptive cycles to socioecological systems suggests that large urban civilizations were and are not sustainable indefinitely. By positing the rise and fall of civilizations as inevitable components to a natural process, resilience theory and the model of adaptive cycles of socioecological systems offer a useful construct for the pattern of societal expansion and collapse. This also suggests that attempts to resist the cycles only serve to make matters worse, particularly insofar as the well-being of the inhabitants is concerned. Humans are organisms, after all, and they design their cultures to mimic natural patterns of behavior (otherwise, why do we speak of "growing the economy?"). If we can accept this explanation for the collapse of the ancient world systems, the only remaining question concerns the simultaneous timing of the release or collapse phase of these world systems at the end of the second century AD. Why did world systems at distant ends of the Eurasian world experience societal collapse simultaneously, particularly when the trade occurring between them is generally dismissed as *low volume, high value* trade in nonessential prestige goods with marginal impact on the overall well-being of their respective inhabitants?

At this point it might be useful to recall the point made in the chapter discussing the collapse of Bronze Age civilization and to remind ourselves that a similar pattern of simultaneous collapse was visible not only in the eastern Mediterranean but as far away as Denmark, Central Asia (1300–1200 BC), and China (the Shang collapse, ca. 1028 BC). Given the limited scale of the urban economies at that time, the lack of interdependency between these societies, and the vast distances trade in prestige goods had to cover, so similar a pattern at the close of the Bronze Age becomes even more problematic. Our best explanation appears to lie with the principal of globalism, in this instance, the likely economic conjunction of distant world systems. Conceivably, long-distance trade in prestige goods not only functioned as an accelerator of local production but also as a synchronizer to the rhythm of the adaptive cycles of interconnected world systems. Since the availability of prestige goods stimulated increased productivity at distant ends of the trading network, the respective economies of distant civilizations, once linked in a global system, developed

at approximately the same time and pace. Typically, interregional trading networks took hold at the consolidation or rapid-growth phase of state formation, as hierarchies began to accumulate sufficient wealth to engage in the risk-prone and costly enterprise of engaging in long-distance trade. In other words, they were already well advanced in the fore loop cycle of rapid growth and conservation. As an accelerating factor, interregional trade enabled distant trading partners to sustain enhanced productivity through greater efficiencies. The interregional trading networks thus helped to extend the conservation phase of the cycle, to sustain the status quo, and to improve the general well-being of the inhabitants of the respective world system. In one respect, globalism extended the process of greater efficiency across a wider area of the globe, by drawing into the network inhabitants of distant world systems even though they had no genuine knowledge of one another. But it did so by synchronizing the economic cycles of these populations and ultimately by putting these on the same trajectory of release or collapse. This synchronization of ancient world system fore loops may explain why all three world systems appeared to collapse simultaneously, around 200 AD during the initial wave, and then again around 500 AD in Rome and India.

The theory of natural adaptive cycles thus explains the recurring pattern of rise and fall in ancient world civilizations. This theory also has the advantage of placing human societies in their proper place in the natural order. Humans are unquestionably the exceptional species of the current era of this order, unsurpassed as they are in their ability to harness resources furnished by the wider ecosystem. However, they remain biological organisms nonetheless and depend like all others on the sustainability of the ecological systems that surround them. Humans have demonstrated remarkable resilience at adapting their strategies for survival to fit any number of environmental circumstances and have for centuries exploited and invented new ways to utilize natural resources that enhance creature comforts for ever-growing populations. The most important asset of human societies remains the recursive processes that enable their inhabitants to preserve a memory of past and present skills and insights to sustain them through the inevitable challenges of the adaptive cycle. All this notwithstanding, societal notions of continuous, sustained growth ultimately run contrary to the laws of nature. However many human societies attempt to construct systems that enable their populations to grow beyond the earth's carrying capacity; the fore loop/back loop rhythm of natural adaptive cycles will inevitably and inexorably restore a sense of balance. If little else, the experience of the ancient world must teach us this.

FURTHER READING

Chew, Sing C. *World Ecological Degradation: Accumulation, Urbanization, and Deforestation, 3000 BC–AD 2000*. Walnut Creek, CA: AltaMira, 2001.

Horden, Peregrine, and Nicholas Purcell. *The Corrupting Sea: A Study of Mediterranean History*. Oxford: Blackwell, 2000.

Hughes, J. Donald. *Environmental Problems of the Greeks and Romans: Ecology in the Ancient Mediterranean.* 2nd ed. Baltimore: Johns Hopkins University Press, 2014.

Tainter, Joseph A. *The Collapse of Complex Societies.* Cambridge: Cambridge University Press, 1988.

Walker, Brian, and David Salt. *Resilience Thinking: Sustaining Ecosystems and People in a Changing World.* Washington, DC: Island Press, 2006.

Woods, Ngaire, ed. *The Political Economy of Globalization.* New York: St. Martin's, 2000. https://doi.org/10.1007/978-0-333-98562-5.

GLOSSARY

acropolis
 The defensive heights of an ancient Greek city.

agora
 A combined town square, meeting place, and market place in ancient Greece.

Akh
 In Egyptian cosmology a glorified being of light. After death and with the aid of the proper rituals, the pharaoh's Ka would combine with his Ba, or his unique individual soul, to form the Akh, and climb a stairway to the sun to combat forces of evil and to protect the Egyptians from harm.

Akhenaton
 New Kingdom pharaoh Amonhotep IV (1353–1336 BC), who changed his name (Akhenaton meaning *effective for Aton*) in order to pursue a deliberate program of personal deification. He implemented a national cult for the Aton (life-giving disk of the sun).

Akhetaton (Tel el Amarna)
 The relocated capital of New Kingdom pharaoh Akhenaton (1353–1336 BC). Located equidistant from the traditional centers of power, Thebes and Memphis, the site appears to have been chosen deliberately as an alternative capital where Akhenaton could implement the Aton cult in relative seclusion.

Altar of Heaven
 Raised platform where the Shang and then the Zhou kings conducted their sacrifices to T'ien and other deities.

Anaxagoras
 A Greek sophist from Clazomenae (ca. 500–428 BC), who influenced the thinking of Pericles, Socrates, and Euripides. Anaxagoras explained that the divine intellect, or the *nous*, was infinite, omniscient, and the source of order in all things.

apella
 In ancient Sparta the assembly of warriors, consisting of all full-blooded, able-bodied Spartan warriors who possessed their own armaments.

archons
 Nine annually elected chief magistrates in archaic Athens.

Aristotle

Greek philosopher and student of Plato (384–322 BC), who served as tutor to Alexander the Great. Aristotle is credited with organizing and forming bodies of knowledge into specific disciplines.

Aspasia of Miletos

An hetaera from Ionian Miletos who became the mistress and eventually the wife of Pericles; allegedly she was a leading intellectual and teacher of rhetoric.

Augustus

Non-threatening title awarded to Octavian (27 BC–14 AD), meaning "well augured." Together with *princeps* ("first citizen") this formed the basis of his authority for imperial rule: Princeps Caesar Augustus.

Babylonian Captivity

The enslavement of the Israelite hierarchy by the Neo-Babylonian king Nebuchadnezzar in 586 BC. Fifty years later the survivors were permitted to return by the Persian king Cyrus I (539 BC).

Barracks Emperors

During the Roman Empire, a chaotic 50-year interval during which some 24 emperors ascended to the imperial throne (235–284 AD). The longest reigns were of seven and eight years respectively, and all but two of these emperors died violent deaths.

Behistun, the Res Gestae of Darius I

A text inscribed at Behistun in modern-day Iran recording the royal accomplishments of King Darius I of Persia (522–486 BC); inscribed in three languages, Old Persian (Avestan), Elamite, and Babylonian-Akkadian; a crucial document for the translation of cuneiform.

Brahman

The priestly caste in the caste system of Epic Era India (1000–600 BC); Brahman priests served as teachers, judges, assessors, and ministers.

Buddhism

A Shramanic religion in India founded by Siddhartha, emphasizing the law of moral consequences. Moral actions add positive and/or negative values to one's existence and determine one's future in the transmigration of the soul.

caste system
 During the Indian Epic Era (1000–600 BC), with five distinctions: the warrior caste
 (Kshatriyas); priests (Brahmans); merchants and farmers (Vaisyas); subsistence laborers
 (Sudras); and the untouchables (Dasyas).

chiefdom
 An autonomous political unit comprising a number of villages or communities under
 the permanent control of a paramount chief. Chiefdoms were characterized by central-
 ization of authority and pervasive inequality. Much like tribes, chiefdoms remained a
 relatively unstable form of social organization.

civilization
 A social organization that transcended states both in terms of the breadth of its territo-
 rial extent and its population base. A civilization typically incorporated numerous states
 within its reach. As such it might be referred to as an extraterritorial state or an empire.

climate change
 Sudden, brief (ca. 200 years) changes to colder, drier conditions throughout Eurasia as
 the Ice Age subsided. Climate change is frequently posited as the reason for the sudden
 downturns in Near Eastern societal development (the collapse of the Early, Middle,
 and Late Bronze Ages).

Confucianism
 A Chinese philosophy introduced by Confucius or Kung Fu Tzu (551–479 BC). The
 preservation of harmony between the cosmic realm and human society required the
 subordination of the individual to the community according to clearly defined prin-
 ciples of rank. The status of each individual carried with it an obligation to maintain
 the social fabric through proper behavior.

consuls
 The two annually elected chief magistrates of the Roman Republic. Entrusted with
 imperium, the consuls commanded the armies, convened the assemblies and Senate meet-
 ings, and presided over the elections of the republic.

creation myths
 Ancient explanations for the existence of the cosmos. According to traditions in
 various ancient societies, the gods who ruled the universe represented a second or third
 generation of divine beings who had successfully wrested supreme power from their
 predecessors. This earlier generation of gods had acquired power by suppressing an even
 earlier group of primal forces that arose from inchoate matter, such as primordial ether
 or watery abyss. Each generation of new gods grew increasingly anthropomorphic.

cult of the dead pharaohs

Pharaonic ideology and Egyptian beliefs about afterlife in general insisted on a need to preserve the pharaohs' remains after death in order to bind their spirits and hence their divine power to the land of Egypt. An ever-growing portion of the Old Kingdom Egyptian economy became committed to the maintenance of this cult.

cultural diffusion

The assimilation of culturally transmitted knowledge by newly arrived outsiders, or the exportation of this knowledge to neighboring societies, thus enabling outsiders to adapt to their new situation and gradually to merge with a core population.

culture

A uniquely human system of habits and customs acquired by humans through exosomatic processes, carried by their society and used as their primary means of adapting to their environment.

cursus honorum

"The race for the offices"; the pursuit of an ascending (and increasingly competitive) rank of electoral offices in Republican Rome.

Cyclopean fortification walls

Massive circuit walls constructed of large rough-hewn blocks to defend Mycenaean palace complexes at the end of the Late Bronze Age (1350–1200 BC).

Cynic/cynicism

A Greek philosophy propounded by Diogenes (ca. 412–323 BC). It emphasized finding peace of mind by withdrawing from worldly affairs; the only thing that mattered was virtue, and virtue was unattainable to anyone who pursued worldly ambitions.

Dasyas

An element of the caste system that emerged in India during the Epic Era (1000–600 BC). The Dasyas consisted of Dravidian elements that failed to merge successfully with the Indo-Iranian invaders. They resided pricipally as hunter-gatherers in rural hinterlands.

dediticii

"Submitted allies"; German tribal elements that were settled inside the borders of the Late Roman Empire in an attempt to shore up defenses.

Delian League

In ancient Greece a hegemonial alliance led by Athens, 478–447 BC; evolved into the Athenian Empire.

demes

Some 174 geographically distributed voting wards in the Cleisthenic political reforms in Athens.

dharma/karma

In Buddhist philosophy in India dharma represents the law of moral consequences; too many negative actions sent one's soul to a lower state of existence in the next life, while positive acts propelled one forward.

dialectic

In Ancient Greece, intellectual inquiry obtained through reasoned debate; a teacher would direct a student to a rational outcome by posing questions intended to reveal truth to a student through the logic of his or her own answers.

dictatorship

Appointed during times of emergency during the Roman Republic. The dictator represented the temporary restoration of royal power in one leader for six months, by which time normal Republican institutions could resume.

Diocletian's Price Edict

Following the chaos of the Barracks Emperors, Diocletian attempted to regulate prices, restore the value of deflated currency, and reduce inflation by imposing legally sanctioned prices for goods and services (301 AD). By the end of his reign (305 AD), it was largely ignored.

Diogenes

(ca. 412–323 BC), resident of Corinth and contemporary of Alexander the Great, who founded the Cynic school.

domesticated animals

The kinds of animals, such as sheep, cows, and goats, that can be harnessed by humans as a food source with by-products.

domus

An aristocratic house in Republican Rome, symmetrically arranged but focused particularly on interior space and decor.

dukkha

The doctrinal principle of trouble, pain, and suffering in Buddhist philosophy.

Edicts of Ashoka

Some 33 inscriptions in India that record laws and Buddhist teachings written or inspired by the Mauryan Emperor Ashoka (273–236 BC); the earliest surviving historical texts of India.

Elamite

An ancient language recorded in the Near East, particularly in the region of southern Iran. Elamitic is closely related to Dravidian languages spoken today in southern India and Sri Lanka.

empirical method

In Greece a method of inquiry that entailed the collection of data through observation with one's own senses; in essence, inductive reasoning.

en

Sumerian priest king.

ephors

In ancient Sparta five annually elected magistrates entrusted with the maintenance of the Spartan military establishment.

Epicureanism/Epicurus

In Greece a philosophy propounded by Epicurus (342–268 BC), who argued that a truly wise person should seek pleasure, by which he meant absence of pain. In essence, his message was to avoid harmful, immoral experience.

eyes and ears of the king

A system of roving inspectors and spies, organized by King Darius I of Persia (522–486 BC) to monitor the activities of his governors (satraps).

food gatherers/food producers

Prehistoric food gatherers hunted for food, Neolithic food producers stored food through the domestication of plants and animals. Stable food supplies enabled populations to focus on unrelated activities, such as tool manufacture, weaving, ceramic production, and metallurgy. Theorists argue that several cognitive and physiological innovations such as permanent settlement, ownership, and private property, occurred during this transition.

geographical determinism

Topographical constraints that determined the emergence of Neolithic cultures. Eurasia, with its east–west trending geography lying principally in the northern hemisphere, allowed for the spread of those food resources most suitable for domestication from the Mediterranean across central Asia.

gentry class

In Han Dynasty China (201 BC–220 AD), the newly established bureaucratic ruling class recruited from students educated in Confucian literature, such as the *Five Chinese Classics*. The gentry class relied on the support of lineage groups by carefully distributing estates to subordinate branches of the family; these in turn invested in the hierarchy by combining resources to assist high-ranking relatives with their political careers.

gerousia

Council of elders at Sparta, consisting of the two kings plus 28 elders selected by Apella. By requirement eligible candidates were war veterans who had fulfilled their military service and had lived to the age of 60.

global world system

A system on wider, global level that came into being when civilizations emerging in distant continents grew interconnected. A global world system not only drew distant populations into its orbit but also synchronized the economic trajectories of everyone concerned.

globalism

The tendency for urban societies to expand and grow to some undeterminable size. Typically, a society will expand to the limits of the carrying capacity of its immediate ecological niche. Control of peoples and resources on the periphery typically enabled core economies to continue to expand and, thus, come into contact with civilizations further removed.

Great Pyramid of Khufu

The most prominent feature in the mastaba complex at Giza, devoted to the Old Kingdom pharaoh Khufu (2589–2566 BC). The pyramid stood 230 m at the base and 147 m tall.

Great Wall (of China)

An network of east–west trending earthen fortifications extending some 5000 km across northern China; begun as early as the seventh century BC, but completed during the reign of Qin (Ch'in) Shih Huangdi. The purpose of the Great Wall appears to have been to restrict points of access for mounted bands of Hsiung Nu warriors and thereby to reduce their mobility.

Greek tyrant

In ancient Greece a nonhereditary ruler who acquired power through unconstitutional means, usually with widespread popular support—most typically the support of the hoplite phalanx.

gymnasium

The prevalent recursive institution of Greek society, in essence, a school or university that combined athletic regimen with educational instruction.

Gymnosophists

Jainist priests in India who accompanied the army of Alexander the Great back to the Mediterranean.

Habiru/Hapiru

An amalgam of pastoralists, renegades, runaway farmers, and refugees hiding in the deserts and mountains of the Near East at the end of the Bronze Age.

Hatshepsut

A female pharaoh of New Kingdom Egypt (1479–1458 BC). When her husband, Thutmose II, died, Hatshepsut assumed the throne as the king of Egypt and reigned ultimately for 21 years.

Hellenistic style

In Greek art a trend toward larger, more emotive, three-dimensional plastic arts. Sculpture was crafted in the round or projected outward into the space of the viewer; greater emphasis was placed on the portrayal of emotion, pathos, and everyday people.

helots

Spartan neighbors, such as the Messenians, who were suppressed through warfare and reduced to the level of field laborers. Helots farmed Spartan land allotments (*kleroi*) for the warrior elite; they were essentially agricultural serfs.

henotheism

The tendency to focus on one god at the expense of all others.

hetairai

Highly gifted, attractive prostitutes in the Greek world who were typically slaves or of foreign origin.

hieroglyphics

The language of divine words (*medu netjer*), the written language of Ancient Egypt.

hoplite democracy
A temporary stage in the development of Cleisthenes democracy in Athens (ca. 510–500 BC). It favored democratic participation by the property-holding class of hoplites at the expense of the urban poor (*thetes*).

hoplite phalanx
In Greece, a large formation of heavily armored infantry.

Horus
The Egyptian falcon god and son of Osiris, who created all living things. Egyptian pharaohs of the Old Kingdom claimed direct descent from Horus.

household
A large, autonomous unit of people who formed closed, self-contained, and self-sustaining corporate entities; the building block of Bronze Age Sumerian society.

hunting bands
The simplest form of human social ordering. A band typically consisted of a small, loosely organized kinship group of less than 100 individuals. Power tended to be informal and egalitarian with older members of the band typically assuming leadership positions.

hydraulic civilizations
Large urban societies that emerged in riverine environments throughout the globe during the Bronze Age. These societies harnessed water supply by trapping and storing floodwaters for crop production.

Hyksos
In Egypt, "the foreign rulers" (Egyptian Fifteenth Dynasty), a foreign element that invaded the Nile Delta during the Second Intermediate Period (1720–1550 BC).

imperator
A triumphing Roman general in Republican Rome.

imperium
The basis of authority in Republican Rome, in essence, the power of the expelled monarch as transferred to Republican magistrates. Based on the right to consult the auspices, *imperium* gave *curule* magistrates the power to convene the Senate and the assemblies, to command armies, and to conduct tribunals.

proto–Indo-European
> The source language for the family of languages spoken throughout Eurasia (Latin, Greek, Celtic, Germanic, Slavic, Iranian, and Indic languages).

Jainism
> A Shramanic philosophy in India responding to the rising threshold of violence during the Epic Era (1000–600 BC). Jain philosophers were strictly nonviolent; they renounced the *Vedas* and the *Upanishads* as sacred texts; they rejected material comforts and sought wisdom through an austere itinerant lifestyle.

Julio-Claudian Dynasty
> The first five emperors of the Roman Empire (27 BC–68 AD).

Ka
> One of five elements of the Egyptian soul, along with the *Ba* (one's unique individual soul), the *Ib* (one's heart), the *Sheut* (one's shadow), and the *Ren* (one's name). The Ka was perceived as a person's vital essence, that which distinguished between being alive and being dead, with death occurring when the Ka left the body.

khan
> A Mongolian loanword for military leader, employed by princes who ruled isolated settlements (kalas) in central Asia during the Iron Age.

kala
> In the Iron Age, settlement pattern of central Asia, an isolated settlement ruled by a khan. Otherwise, an Iranian loanword for fortress.

kleros
> A Spartan land allotment. Purportedly, all land was controlled by the state and awarded to individual Spartan hoplite warriors upon adulthood (20 years of age) by the ephors. Each allotment included attached helot families who did the actual farming to sustain the family of the Spartan warrior and themselves.

kosmopolitai
> Hellenistic Greek elites who perceived themselves as "citizens of the world." They were people so adept at the practices, customs, and institutions of the Hellenistic order that they found themselves at home anywhere in the Mediterranean world.

kouros
> In Archaic Greece, a statue of a young Greek male in his bloom.

krater
> In ancient Greece a large ceramic bowl-like vase used to mix wine and water; a canonical form used in Greek rituals and drinking parties (*symposium*).

Kshatriyas
> The dominant warrior caste in the caste system of Epic Era India (1000–600 BC).

Kushan hegemony
> A patchwork of recombined nomadic groups in central Asia that furnished interconnected chains of communication and intercultural exchanges linking Iran and the Indus with the Tarim Basin in China (ca. 50 BC–176 AD).

Legalism
> A political ideology in China that insisted on the exclusive authority of the ruler and his ministers, thus, legitimizing the establishment of a centralized, autocratic state.

limen
> The municipal harbor of a Greek polis; like the agora it was supervised by annually elected magistrates.

limes
> A line of natural and man-made barriers that defined the boundaries of the Roman Empire. These included the entire length of the Rhine and Danube Rivers in Europe.

liturgies
> Conscript philanthropy in Greece, or the performance of state duties at private expense; associated with *munera* during the Roman Empire.

logos
> In pre-Socratic philosophy the many proofs for the existence of a divine intellect (the *nous*) that organized an orderly and coherent universe.

lugal
> Sumerian military leader.

Ma'at
> According to Ancient Egyptians, the balance and harmony that prevailed in the universe.

macro-regional world system

The manner in which a more advanced core polity uses its wealth and power to manipulate flows of material, energy, and people through the establishment of ties of super ordinance and dependency. Typically, this resulted from heightened interconnectivity across vast distances.

mahajanapada

Stratified tribal polities in India; literally, "the foothold of a great tribe." Some 16 *mahajanapadas* extended across northern India in the sixth century BC.

Mandate of Heaven

The basis of royal power in Shang Dynasty China, based on the authority of the king to conduct sacrifices at the Altar of Heaven. The king was not merely the earthly sovereign but the deputy of the great ancestor god T'ien. The Zhou Dynasty (1027–221 BC) claimed that this power was commutable under appropriate circumstances.

Manipular Legion

A maneuverable formation of Roman soldiers consisting in companies or maniples of 180 men (5,400 men in all) deployed in a checkerboard fashion of three lines, with each line extending some 900 yards.

mastabas

Tombs where an Egyptian pharaoh's remains, as well as those of members of the Egyptian royal family and hierarchy, were interred.

meander

In Greek finewares an abstract motif of a key pattern used to decorate the rim of a painted vase.

megaron

Royal reception hall with a round central hearth, a salient feature of Mycenaean settlement in Bronze Age Greece.

memory

Recursive processes in human society that are handed down from one generation to the next. Societies rely on past and living memory of their acquired attributes to perpetuate their existence. See **recursive institutions**.

metic (*metoikos*)

A nonnative resident of a Greek city-state; resident alien.

monotheism

The religious belief that causality emanates from the will of a single god who controls every aspect of reality and imparts inherent logic and order to the universe.

Mycenaean Linear B

Recorded on clay tablets, the written language of Mycenaean civilization. Employing monosyllabic characters, Linear B has been firmly identified as a form of proto-Greek.

nearly decomposable state

In anthropological terms, the capacity of Egyptian civilization to reconstruct itself from decentralized nomes into unified kingdoms (Old, Middle, and New Kingdom).

nomarch

Greek term for the independent ruler of a nome in ancient Egypt.

nomes

Administrative districts of the Egyptian United Kingdom. By the Pre-Dynastic Era (3100–2700 BC) there were some 22 nomes in Upper Egypt and 20 in Lower Egypt (the Nile Delta), each governed by a ruler later known as a nomarch.

nous

In pre-Socratic philosophy the divine intellect that organized the universe in a coherent, orderly manner.

oblique phalanx

In ancient Greece a fourth-century BC innovation in tactical warfare; joint force coordination between skirmishers, cavalry, and the hoplite phalanx, with the last mentioned weighted heavily to one side. Devised by the Theban general Epaminondas, it was adopted by Philip II and Alexander the Great of Macedon.

oikos

A large self-sufficient agricultural state that formed the basis of aristocratic wealth in archaic Greece.

Osiris

The Egyptian river god who annually replenished the earth by bearing down the nutrient-rich seed of the flood waters to impregnate the earth, personified by his wife, Isis. According to one Egyptian creation myth, Osiris was murdered by his jealous brother, Seth (the crocodile god); restored to divine life by Isis, he ascended into the heavens to defend the Egyptian people in the afterlife.

ostracism

> An electoral mechanism devised by Cleisthenes to insure the effective maintenance of the Athenian democracy; the politician receiving the most votes would have to leave Attica for a period of ten years, without option of appeal, but without loss of citizenship or property.

palace-based economy

> A Bronze Age Aegean settlement pattern in which a central palace administration assumed control of production, storage, and maritime distribution for its surrounding hinterland.

Panhellenism

> Tendencies such as common sanctuaries, hegemonial alliances, and expanding trading contacts that induced Greek communities to recognize their place in wider Greek culture.

Particularism

> In Greece, the notion of identity with one's immediate community.

paterfamilias

> The head of a Roman household who enjoyed absolute authority over everyone and everything on his estate; typically the oldest surviving male of an aristocratic family.

Peloponnesian League

> A Spartan hegemonial alliance in the Peloponnesus. Allied states retained their autonomy and were exempt from tribute payments; however, they were required to have the same friends and enemies as Sparta and to maintain their national militias at their own cost.

perioikoi

> The neighboring inhabitants (literally, dwellers around the *oikos*) of the Eurotas valley in ancient Sparta. These people preserved their autonomy but remained politically subordinate to the Spartans. When summoned they furnished manpower and logistical support to the Spartan hoplite army; they also manufactured arms.

phiditia

> Spartan mess hall and barracks, representing 20 to 30 hoplites, or a detachment (*ila*) of the phalanx. All adult warriors were required to eat their main daily meal at the phiditia. Provisions had to be furnished by soldiers from their individual land allotments. Cadets from ages seven to twenty lived at the phiditia and waited on the adult hoplite warriors.

Plancia Magna of Perge
 A distinguished priestess descended from an influential Roman family that settled
 in Perge (south coastal Anatolia, early second century AD). A noted philanthropist
 and civic benefactor, she represented the heightened autonomy of women during the
 Roman Empire.

Plato
 Athenian philosopher (428–347 BC) and student of Socrates who arguably surpassed his
 teacher by devising a comprehensive system of ethics, dialectic, physics, and a theory of
 ideas. To Plato, knowledge was a body of true and unchanging wisdom open only to a
 few philosophers whose training, character, and intellect enabled them to grasp reality.

plebeian tribunes
 Ten annually elected representatives of the plebeian assembly during Republican Rome
 whose purpose was to defend individual citizens from abuse by the magistrates.

polis (pl. poleis)
 A separate, autonomous, independent Greek city-state, more than 300 of which were
 scattered along the shores of the Aegean and beyond.

princeps
 The title of "first citizen of Rome," on the basis of which Octavian (Augustus;
 27 BC–14 AD) received 10-year grants of proconsular imperium over all military prov-
 inces, as well as five-year grants of tribunician power to govern the Roman world.

proconsular imperium
 Ten-year grants of *imperium* over all provinces requiring military garrisons, awarded
 to Octavian (Augustus) as the *princeps* of the Roman Empire. Octavian selected his
 provincial commanders (imperial legates) from a pool of ex-consuls in the Senate, but
 he alone remained responsible for recruitment, maintenance, and military discharge.
 Together with tribunician *potestas* this formed the basis of imperial authority during
 the Principate (27 BC–180 AD).

prophets
 See **reforming prophets**.

prytany
 Conscript labor, organized according to work details assigned to perform state labor
 according to the months of the year.

radical democracy

An Athenian political system based on the notion of pay for service. By paying citizens to participate in public affairs, Pericles (495–429 BC) enabled thousands of poor citizens to obtain some portion of their livelihood through state service and thereby won their support.

Ramses II

New Kingdom Egyptian pharaoh (1279–1213 BC), the son of Seti I, an extremely competent general, and one of the greatest builders of antiquity.

recursive institutions/forms of education

Educational systems such as schools that enable cultures to create, store, and transmit skills, technologies, and knowledge from one generation to the next; the basis of cultural memory.

reforming prophets

Hebrew prophets during the Divided Kingdom of Israel and Judah who used their unassailable status as revelationally inspired individuals to challenge the authority of the kings. Reforming prophets expressed the heightened pattern of alienation that emerged between the foreign dominated hierarchies of the cities and the rural peasantry in the countryside; they decried the social inequities and institutional corruption of the kingdoms by interpreting these as offenses against Yahweh.

resilience theory

A theory that posits that the natural world exists generally in a dynamic state of change, invariably cycling through four recognizable phases: rapid growth, conservation, release, and reorganization. In the human historical experience the fore loop of rapid growth and conservation may be identified with eras of large urban civilizations; the back loop of release and reorganization with societal collapse and a reversion back to subsistence forms of production.

ritual vessels

In Chinese culture bronze ceremonial vases used to perform ritual offerings of food and wine to ancestral spirits; the shape of each canonical form matched its intended purpose

Roman legionary camp

A camp protected by a rectangular circuit of earthen walls arranged around two intersecting roads aligned according to cardinal directions. The fortified camp played an important part in Rome's ability to project and to sustain military force in the field.

Royal Road

A well-maintained Persian roadway some 2500 km long that connected the provincial headquarters at Sardis in Lydia (Anatolia) to the Persian winter capital in Susa.

satrapies/satraps

Provinces in the Persian Empire, organized by Darius I into a patchwork of 20 to 30 uniform entities, each ruled by a satrap (governor).

Sea Peoples

Aegean and south Anatolian tribal population that migrated along the sea routes of the eastern Mediterranean, invading Cyprus, Canaan, and Egypt at the close of the Bronze Age (1250–1178 BC); widely recognized as one of the fundamental contributors to the collapse of Late Bronze Age Near Eastern urban societies.

sedentism

Permanent settlement in groups during the Neolithic Era.

Semitic languages

The largest subfamily of the Afro-Asiatic family of languages spoken throughout the Middle East and northern Africa (including Akkadian, Babylonian, Ugaritic, Canaanite, Phoenician, Hebrew, Moabite, Aramaic, and Nabataean).

sentus consulta (sing. *consultum*)

A *Sense of the Senate* resolution in Republican Rome. Although the Senate enjoyed no legally binding authority, it ruled by virtue of its *auctoritas*, that is, the sum total of influence and experience possessed by its members; its resolutions thus possessed the de facto weight of law.

Shramana

Renunciate ascetic traditions that emerged in India around the middle of the first millennium BC. Shramana represented individual, experiential, and free-form traditions, divorced from society and opposed to the Brahmin hierarchy's inordinate emphasis on Vedic ritual.

Socrates

An Athenian philosopher who was generally recognized as the greatest practitioner of the dialectic (470–399 BC). His teachings were recorded in the dialogues of his student, Plato.

sophists

Teachers or "wisdom dealers" in Greek society who were trained in empirical reasoning and dialect and imparted these skills to students for a fee.

Spring and Autumn Period

Corresponds in Chinese history with the first half of the Eastern Zhou Dynasty and its decline (roughly 771–481 BC); derived from the *Spring and Autumn Annals,* an account traditionally associated with Confucius.

state

A community organized according to permanent institutions that existed and perpetuated themselves independent of lineage connections.

state formation

The identification of definable stages in human social organization.

stirrup jar

Small (approximately 30 cm) piriform amphora with central post attached to handles, probably to protect the upright spout; used by Bronze Age Minoan and Mycenaean societies to transport surplus wine and oil overseas.

Stoicism

A Greek philosophy that promoted moral positivism and public engagement; the key tenets were to accept one's fate, to bear it with equanimity, and to fulfill one's assigned role in life to the best of one's ability.

stupa

A domed structure representing a funerary mount or heap ("stup"), built as a ritual center and a reliquary to enshrine the cremated remains of the Buddha.

Sudras

Subsistence laborers in the caste system of Epic Era India (1000–600 BC).

suffetes

Early Hebrew patriarchal councils of elders during the Period of Judges (1200–1000 BC).

Sumerian Kings List

Earliest known world chronology, inscribed on a stone tablet and based on compiled lists of the reigns of kings in contemporary Sumerian city-states and neighboring polities, reliable ca. 2600 BC and after.

sustainability

In ecology, the property of biological systems to remain diverse and productive indefinitely; in sociopolitical entities controlled growth, particularly during the conservation phase of the resilience fore loop when population growth tends to surpass the availability of essential resources; see **resilience theory**.

sympathetic transference

The belief that through spells and rituals one could magically transform a representation of a god or divine entity into the very essence it represented.

Taoism

A Chinese philosophy that professed the *Way of Nature*. As the defining essence of nature, Tao was the standard of all things to which humans must conform.

Taxila (Takshasila)

Capital city of the Gandharan *Mahajanapada* in ancient India; a renowned center of learning and religious pilgrimage.

Thutmosis III

New Kingdom pharaoh (1479–1425 BC) and step-son to Hatshepsut. A great warrior pharaoh, Tutmosis III conducted military campaigns as far removed as Syria, erecting a military trophy at the Euphrates River.

Treaty of Kadesh

Peace treaty signed by the Hittite king Muwatallis and the New Kingdom pharaoh in 1259 BC, following an inconclusive battle at Kadesh (1274 BC). Although the treaty did little more than recognize the prevailing status quo, it freed the Hittites and the Egyptians to address other concerns; one of the first crucial signposts for the collapse of Late Bronze Age societies.

tribe

A social group larger than a hunting band organized largely on the basis of perceived lineage connections between descent groups. Tribes tended to exhibit some limited instances of social rank and prestige; however, leadership and internal organization tended to be *segmentary*, that is, they existed as small and autonomous groups, loosely linked as larger ethnic units, with each kinship group furnishing its own immediate leadership in the form of a patriarch or a warlord supported by a dependent band of warriors.

tribunician potestas

Five-year grants of tribunician power awarded to Octavian (Augustus) to safeguard the rights of the Roman people. This power enabled him to pass legislation, to convene the Senate and the assemblies, to hear cases on appeal, and ultimately to formulate imperial legislation. Together with proconsular imperium this furnished the basis of imperial power during the Principate (27 BC–180 AD).

tritteis

In the democratic reforms of Cleisthenes of Athens, the 10 new voting tribes consisted of three-thirds, or tritties, combining groups consisting of citizens drawn from a cross-section of the Attic population. Artificially, this diminished an individual citizen's tendency to identify with his immediate origin and to view his place in wider societal terms.

urban clusters

A settlement pattern in Bronze Age China (Shang Dynasty); elite enclosures (fortified precincts) surrounded by a scattering of workshops and artisan-supported farm villages.

Vaisyas

Merchants and farmers in the caste system of Epic Era India (1000–600 BC).

Vedic Era

Transitional period following the migration of Indo-Iranian invaders into the Indus valley (1200–1000 BC); characterized by a Vedic oral tradition eventually preserved in Sanskrit as the *Rg veda*.

verism

Characteristic achievement of Roman portraiture that emphasized a careful depiction of small details, including physical imperfections.

Warring States

In Chinese history a particularly violent era (480–222 BC), when the number of competing polities was reduced from fourteen to one (the empire of Qin Shih Huangdi).

world system

A social construct exhibiting asymmetrical relationships between dominant *core polities* and subordinate *periphery polities*. Simply put, a world system emerged when a more advanced civilization assumed control over the economic activities of less advanced neighboring populations, particularly by exploiting the neighboring peoples' available natural resources.

yin and *yang*

In Taoist philosophy, the duality of opposites, Male and Female, Light and Darkness, Being and Nonbeing, all revolving in a state of perpetual dynamic.

Zeno the Stoic

Resident of Athens and founder of Stoic philosophy (390–310 BC).

CREDITS

1.1 Scala/Art Resource, NY; 1.2 Erich Lessing/Art Resource, NY; 1.3 Courtesy of Penn Museum, image # 150424; 2.1 © The Trustees of the British Museum/Art Resource, NY; 2.2 Album/Art Resource, NY; 2.3 Erich Lessing/Art Resource, NY; 2.4 Werner Forman/Art Resource, NY; 2.5 HIP/Art Resource, NY; 2.6 © The Trustees of the British Museum/Art Resource, NY; 2.7 bpk Bildagentur/Aegyptisches Museum, Staatliche Museen/Art Resource, NY; 3.1 Scala/Art Resource, NY; 3.2 Scala/Art Resource, NY; 3.3 © Herb Rauh; 4.1 © The Trustees of the British Museums/Art Resource, NY; 4.2 Erich Lessing/Art Resource, NY; 4.3 © Elizabeth Rauh; 4.4 Erich Lessing/Art Resource, NY; 4.5 Joshua Reynolds, *Thaïs*, 1781; Waddesdon (National Trust); acc. No. 2556. © National Trust, Waddesdon Manor; 5.1 Erich Lessing/Art Resource, NY; 5.2 Erich Lessing/Art Resource, NY; 5.3 Erich Lessing/Art Resource, NY; 5.4 © John Hill; 5.5 SLUB Dresden/Digital Collections/Mscr.Dresd.A.46.a.; 6.1 Scala/Art Resource, NY; 6.2 Borromeo/Art Resource, NY; 6.3 Harvard Art Museums/Arthur M. Sackler Museum, The Stuart Cary Welch Collection, Gift of Edith I. Welch in memory of Stuart Cary Welch. © President and Fellows of Harvard College; 6.4 Borromeo/Art Resource, NY; 6.5 Scala/Art Resource, NY; 7.1 Image copyright © The Metropolitan Museum of Art. Image Source: Art Resource, NY; 7.2 Erich Lessing/Art Resource, NY; 7.3 Image copyright © The Metropolitan Museum of Art. Image source: Art Resource, NY; 7.4 Art Resource, NY; 7.5 Scala/Art Resource, NY; 7.6 Erich Lessing/Art Resource, NY; 7.7 Scala/Art Resource, NY; 7.8 Image copyright © The Metropolitan Museum of Art. Image source: Art Resource, NY; 8.1 Freer Gallery of Art and Arthur M. Sackler Gallery, Smithsonian Institution, Washington, DC: Puchanse—Charles Lange Freer Endowment, F1940.11a-b.; 8.2 © Herb Rauh; 8.3 Erich Lessing/Art Resource, NY; 8.4 © DeA Picture Library/Art Resource, NY; 8.5 © Yann Forget. Licensed under the terms of CC-BY-SA 3.0; 8.6 Erich Lessing/Art Resource, NY; 9.1 Vanni Archive/Art Resource, NY; 9.2 Musée de Louvre, Paris. Photo by Heidi Kraus; 9.3 Alinari/Art Resource, NY; 9.4 Scala/Art Resource, NY; 9.5 Scala/Art Resource, NY; 10.1 Erich Lessing/Art Resource, NY; 10.2 Erich Lessing/Art Resource, NY; 11.1 © Peter Aicher; 11.2 © DeA Picture Library/Art Resource, NY.

INDEX

Maps and tables indicated by page numbers in italics

collapse, 28, 91–92
conquests by, 90
in Egypt, 61, 90
Iron Age transition, 86, 87
Israel, relationship with, 105, 113
map, *73*
Persian conquest of, 95
political and social structure, 90–91
political ascendency, 15, 16, 17
religion, 91, 117
treatment of conquered peoples, 91
urban development, 90
Assyrian Royal Annals, 90
astronomy, 145, 179
Astyages (Medean king), 95
Athenaeus
Deipnosophistae, 186
Athens
overview, 189
Acropolis, 98, 162, 163, 164, 165, 166
ascendency and fall, 166
citizenship, 162
Cleisthenic political reforms, *160*–61
Delian League, 165–66
Greek philosophy, development at, 177
independence post-Alexander the Great,
174
oligarchic political structure, 152
Peisistratid tyranny, 159–60
Peloponnesian War, 166
Pericles' radical democracy, 161–62
Persian Wars, 165–66
political overview, 156, 158–62, 164
power and influence of, 150, 164
Roman Empire and, 243, 250
scholarly interest on, 64
Solon social reforms, 158
See also Greece
Attalid Pergamum, *169*, 170, 172, 189, 243, 244
Attalus III (Attalid king), 172
Attic-Ionic Dialect, *149*
Attic Red Figure (ceramic), 159
Attila (Hunnic king), 268

Augustus (Octavian; Roman emperor)
client states, use of, 250
in Egypt, 173, 253
political system, 255–56, 258, 259
portraits of, 254
seizure of power, 253, 255
succession issues, 258, 269
Augustus (title), 255
Avanti (Indian state), 131
Avaris (Egyptian city), 16, 53, 61
Avestan language Old Persian, 20, 99, 129

Baal cult, 88–89, 109, 111
Babylonia
Alexander the Great conquest of, 168
ascendancy and fall, 15–16
Assyrian conquest of, 90
climate change, impact on, 79–80
farmers, 28–29, 35
Hammurabi's Law Code, 23–26
household structure, 30
Iron Age transition, 86, 87
map, *11*
merchants, 26–27
military, 26
Neo-Babylonia (Chaldea), 93–94
nobility, 26
Persian conquest of, 95
political structure (city councils), 26–27
relations with neighboring states, 74
religion, 27, 117
skilled laborers, 27
slaves, 27–28
social hierarchy, *25*–29, 34
trade routes through, 93–94
Babylonian Captivity (Judah), 93, 104, 108,
113–14, 121
Bactria, 102, 274, 275, 276
Bactrian people, 95
Baltic, 80
Ban Zhao, *see* Pan Chao (Chinese general)
Bardiya (Persian king), 95
Barrack Emperors (Roman Empire), 265–66

Mediterranean, relations and trade with, 80, 143–44, 173, 278
military, 139
political structures, 125, 127, 130–31, 137–38
scientific innovations, 145
trade, 80, 126, 143–44, 173, 193, 278
urban development, 126

Indian subcontinent, history
chronological overview, 126, 138
Alexander the Great invasion, 139, 168
Classical Era, 138–40, 142–43
Epic Era, 129–31
Gupta Dynasty, 143, 276
Indo-Iranian invasion, 66, 127, 129
Indus Valley civilization, 15, 17, 126–27
invasions, 125, 138–39
Kushan Empire, 142–43
Magadha Empire, 131, 139
Mauryan Empire, 130, 139–40, 142, 275–76
Persian conquest, 138

Indian subcontinent, philosophy, religion, and literature
Bhagavad Gita, 133
Buddhism, 135–38, 139–40, 142, 143
Hinduism, 133–34
Jainism, 134–35
Mahabharata, 131–32, 133
Shramana philosophical movements, 134, 135
Upanishads, 133
Vedic tradition, 127, 129
warfare justification, 133

Indo-Europeans
in Central Asia, 101
characteristics, 22
chariot use, 66
languages, 22
migration into Near East and Europe, 15, 17, 66, 85, 220, 270

Indo-Iranians (Aryans)
Central Asian hegemony, 102, 142
in Indian subcontinent, 127, 129, 130, 147
migrations and influences, 15, 66

Persian Empire from, 94–95

Indus Valley civilization, 15, 17, 126–27, 128. *See also* Indian subcontinent

interconnectivity, *see* global world system

interglacials, 2

Iranian hegemony, *101*, 102, 103. *See also* Indo-Iranians

iron, 86, 199

Iron Age, 80–81, 86–87, 103, 107–8

Isaiah (Israelite prophet), 119, 120

Ishbaal (Israelite king), 111

Isis cult, 182

Israel and Judah
overview, 123
black obelisk of Shalmaneser III, 106
on human dignity, 122
on kingship, 121–22
map, *105*
monotheism from, 121
moral code, 117, 118, 120
Old Testament, 104, 105, 107–8, 117
as pastoralists, 116, 117
political and social structure, 109, 116, 117, *119*
prophets, 116, 119, 120, 121, 122
as reflective of Iron Age transition, 107–8, 115
religion, 104, 109, 111, 114–15, 116, 117, 120–21
settlement and urbanization, 117–21

Israel and Judah, history
chronological overview, 104
Assyrian conquest of, 90, 113
Babylonian Captivity, 93, 104, 108, 113–14, 121
Divided Kingdom, 112–14, 119–20
in Egypt, 53
historical authentication issues, 104–5, 107
Judges Period and Canaan settlement, 109, 111
Patriarchs era, 108–9
restoration of Judah, 114–15
Roman conquest of, 115, 262

plebeian tribunes, 227, 251

Pleistocene Era, 2, 9

Pliny (Roman natural philosopher), 144, 224

Plutarch (Greek biographer), 162, 168

polis (poleis), 150, 152

political structure
 acephalous states, 127
 dual polity, 230
 familialistic state, 192
 gentry-based ruling class, 199
 Hittites, 71–72
 importance in urban societies, 124
 Indian subcontinent, 125, 127, 130–31,
 137–38
 Israel, 109, 116, 117, *119*
 Mycenaeans, 67
 Persian Empire, 96
 Phoenicia, 88
 tetrarchy, 266
 thalassocracy, 65
 See also China, political and social
 structures; Egypt, political structure
 and beliefs; Greece, political
 structures; Rome, political structures

politics, definition, 179

pollutants, airborne, 276

Polybius (Greek historian), 224

polygamy, 31–32

Polykleitos (Greek philosopher), 163

Pompeii (Roman city), 232

Pompey the Great (Roman leader), 115, 172,
 252

portraits, Roman, 224

positivism, 177

pottery, *see* ceramics

praetorship, 234

Pre-Dynastic Era (Egypt), 36, 41

prehistory, *see* humans

princeps, 255

private property, 3

proconsular imperium, 255

professions, xiv

prophets, 116, 119, 120, 121, 122

prostitutes
 courtesans (Babylonia), 33–34
 hetairai (Greece), 185–86

proto-Indo-European languages, 22

prytany (conscript) system, 111

Ptolemaic Egypt, *169*, 173, 189, 250

Ptolemy I (Egyptian pharaoh), 40, 61, 173

public wealth, xv

Punic Wars, 240, 242, 244, 248, 250

Purushapura (Kushan city), 142

pyramids, 47–48

Pyrrhus (king of Epirus), 240, 250

Pythagoras of Samos, 176

Qin Dynasty (China), 198, 205–8, 217

Qin Shih Huangdi (Chinese emperor), 205,
 207–8, 217

quaestorship, 233

quality of life, xvi, 3, 183, 262, 264, 285

radical democracy, 161–62

rajahs, 130

Ramses I (Egyptian pharaoh), 61, 72, 109

Ramses II (Egyptian pharaoh), 18, 54, 55, 61

Raphael Sanzio
 School of Athens, 175

ration bowl, 22, 23

Rawlinson, Henry, 20

rebus script, 40

recursive institutions/education, xiii, 284

Red Sea, 21, 173

reforming prophets, *see* prophets

Rehoboam (Judean king), 112–13

religion
 Assyria, 91, 117
 Baal cult, 88–89, 109, 111
 Babylonia, 27, 117
 Buddhism, 135–38, 139–40, 141, 142, 143,
 202
 China, 194, 196
 Christianity, 182–83, 267, 271, 273
 Egypt, 43–46, 46–48, 49, 51–52, 56, 57–60,
 63